This item was purchased
with
contributions from the

FUND FOR

EXCELLENCE

LATE GOTHIC SCULPTURE

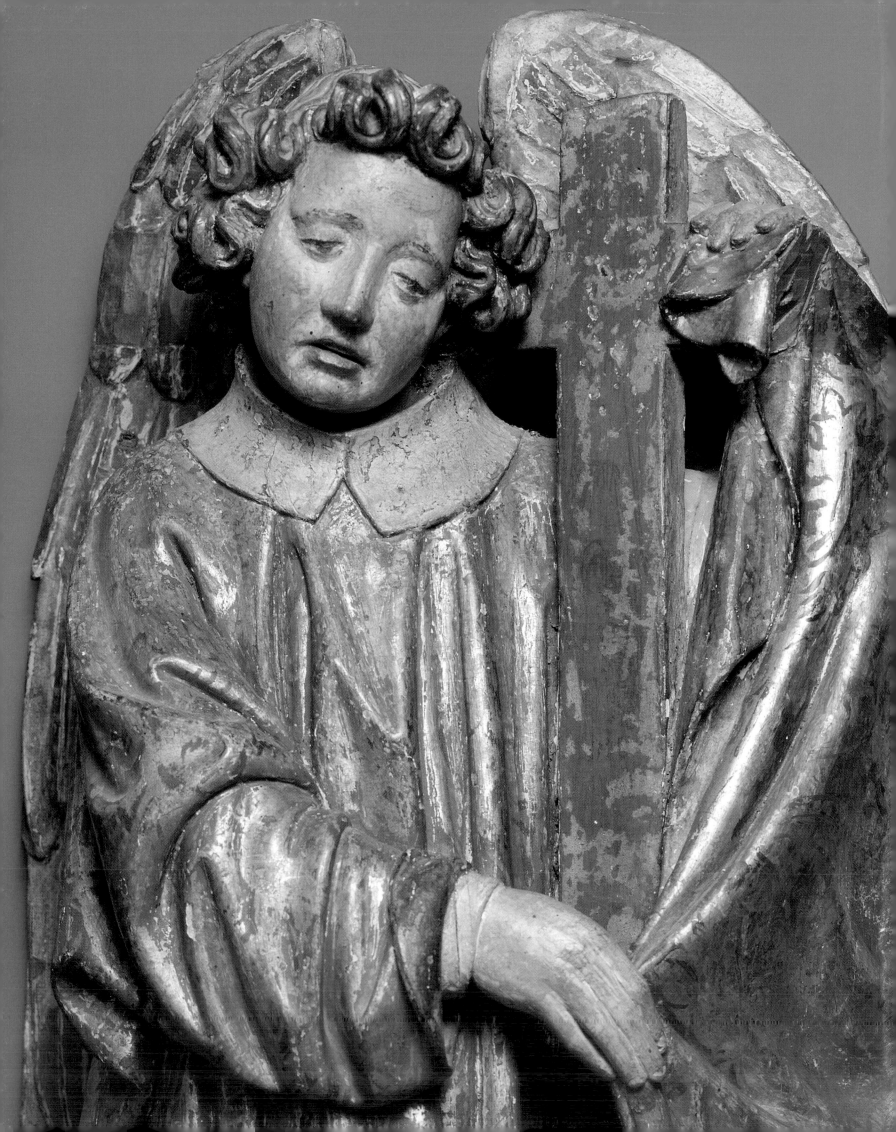

LATE GOTHIC SCULPTURE
The Burgundian Netherlands

JOHN W. STEYAERT

with the collaboration of
MONIQUE TAHON-VANROOSE

and contributions by
Wim Blockmans and Leon Smets

LUDION PRESS, GHENT
Distributed by Harry N. Abrams, Inc., Publishers

This book was first published on the occasion of the exhibition
"Meesterwerken van de gotische beeldhouwkunst" ("Masterpieces of Gothic Sculpture")
Museum voor Schone Kunsten, Ghent, 18 September–27 November 1994

The exhibition was made possible by grants from the City of Ghent,
the Flemish Community, and Kredietbank

Designed by Jean-Jacques Stiefenhofer
Translations by Ted Alkins
Color separations by De Schutter, Antwerp
Printed and bound in Belgium by Erasmus, Wetteren, and Splichal, Turnhout

Library of Congress Catalog Card No. 94–71157
Distributed in 1994 by Harry N. Abrams, Incorporated, New York
A Times Mirror Company
ISBN 0–8109–3577–5

Frontispiece Tydeman Maes, Angel with the Cross (cat. 41), detail
Madrid, Museo del Prado

Contents

Acknowledgments

Rocío Arnaez, Françoise Baligand, Frans Baudouin, Geneviève Becquart, Guy Blazy, M. Brejon de Lavergnée, Kimberly Bretzman, Enrique Campuzano Ruíz, Marcel Cockaerts, Ludo Collin, Sabine De Backer, Johan Decavele, Gerald Decoster, Jean-Paul Delcour, Marcel De Maeyer, Antoine De Schrijver, Guido de Werd, A. L. Dierick, Jan Dirven, Hans Feys, Werner Franck, Yves Fremault, Louis Ghesquières, Francine Gilbert, H. O. Goldschmidt, Sophie Guillot de Suduiraut, Nicole Hany, Bruno Hicguet, A. Huysmans, Steven Janke, Piet Jaspaert, Willy Juwet, Jacques Kuhnmunch, Ginny Larson, Marie-Hélène Lavallée, Albert Lemeunier, Arthur Luysterman, F. Machelart, Michelle Madson, Françoise Magny, Aimée Masié, Mary Meihack, Anedith Nash, Hans Nieuwdorp, Annick Notter, Glad Olinger, Antonius Pfeil, Bernadette Roose, Jacques Sallois, Marie-José Salmon, Jan Scheerlinck, Corinne Schleif, Frits Scholten, Laurens Siebers, Robert Silberman, Claire Steyaert, Bart Suys, Gerard Thienpont, Stephane Vandenberghe, Luc Van den Brande, Christine Van den Bussche, L. C. Van Dijck, Erik Van Lerberghe, Francis Van Noten, Rudy Van Quaquebeke, R. A. Vercauteren, Jan Verlinden, Jan Vermassen, Bernard Vermet, Hugo Weckx, Patrick Wintrebert, Leo Wuyts

The Dioceses of Belgium;
Bestuur Monumenten en Landschappen;
Centrum voor Kunst en Cultuur, Ghent;
Dienst Culturele Zaken, Ghent;
Technische Dienst Gebouwen, Ghent;
Ministère de la Culture, Paris;
De Vrienden van het Museum voor Schone Kunsten Ghent;
vzw Promotie Museum voor Schone Kunsten Ghent;
and special thanks to the Institut Royal du Patrimoine Artistique / Koninklijk Instituut voor het Kunstpatrimonium, Brussels.

Curator's Preface

A great many examples of medieval sculpture have survived, despite the dangers and destruction to which they have been exposed over the centuries. This is also true of the Late Gothic sculpture of the Burgundian Netherlands, although the dissemination and relative inaccessibility of many pieces make it difficult to form an accurate impression of the scale and importance of that stylistic period. Unlike medieval panel painting, of which a fairly comprehensive cross-section has survived, grouped around great masters like Van Eyck and Van der Weyden, a lot of research still needs to be carried out into the Gothic sculpture of the Burgundian Netherlands. Few individual works and ensembles are documented, and most of the survivals are anonymous sculptures that were widely scattered even in their own time, rendering it especially difficult to gain an understanding of the artistic production of the different centers. Furthermore, ideas were exchanged between these centers and between individual painters, sculptors, and miniaturists, giving rise to constant interaction and mutual inspiration.

It is a fascinating task in this rich but confused field to pick out quality works from the run-of-the-mill, to establish links, to identify stylistic groups and to distinguish between works from Germany, France and the Low Countries, Flanders and Brabant, Bruges and Ghent, and from the workshops of different masters. The unraveling of all these links and the placement of important pieces on a geographical and stylistic map is a scholarly activity in which a variety of specialists are engaged, but whose definitive conclusions are not yet in sight. Dr. John Steyaert, Associate Professor at the University of Minnesota, who was responsible for compiling this exhibition, has spent many years cataloging and researching fifteenth-century sculpture in the Low Countries. Monique Tahon-Vanroose, curator of sculpture at Ghent's Museum voor Schone Kunsten, assisted in the selection of the exhibition and the editing of the catalogue.

The exhibition is both the product of this research and a stimulus to further it. The stylistic comparisons that have been ventured certainly need to be tested in the field. An exhibition comprising 105 carefully selected pieces or groups, arranged according to a structure that is sometimes hypothetical but nevertheless highly plausible, offers a rare opportunity to form an overview of a clearly defined stylistic movement within a fixed area.

It has not, of course, been possible to bring together all the sculptures that feature in the debate. Many pieces are too fragile to travel, and there are several large ensembles which cannot be exhibited in their entirety. Numerous illustrations and references to the literature are provided in the catalogue in the hope of placing the selected works in their wider context.

Sculpture occupies an important place in the exhibition and acquisition policy of the Museum voor Schone Kunsten in Ghent, a fact highlighted by its George Minne and Wilhelm Lehmbruck exhibitions and the recent purchase of two medieval statuettes. The

museum's collection includes a small but high-quality ensemble of Late Gothic sculptures, enough at any rate to nurture the idea of this exhibition. Seven pieces from the permanent collection have been selected. Ghent was also an important center of production, although most of the traces of this artistic efflorescence have been erased by the city's turbulent past. The exhibition's partial re-creation of the original context is all the more important as it enhances our knowledge of local stylistic features, and might establish points of reference that will help us pin down the lost or scattered Ghent style.

A strictly academic approach has been adopted for this exhibition. We could have approached several experts on the sculpture of the relevant period, but this would have produced an eclectic and noncommittal exhibition. We chose instead to give one acknowledged specialist the opportunity to present his views. Although the result is more personal in character, it lends the selection a strong conceptual basis and unusual coherence. Many well-known and widely published masterpieces are afforded a place in the narrative, but they are accompanied by works that have never been exhibited before and a number of hitherto forgotten witnesses recovered from remote corners, and often literally emerged from the dust of ages. The selection guarantees an authentic insight to visitors and readers who are unfamiliar with the literature on this subject and who might be rather startled by the detective work associated with its research.

The story of the development of Late Gothic sculpture in this region is illustrated by both grand individual creations and more modest works, insofar as these shed light on the process of evolution and innovation. Some pieces demand a little effort to discover the characteristic Late Gothic strength and simplicity beneath the damage, careless restoration, and later over-painting.

The exhibition was supported by a special grant from the Flemish Community which bestowed on it the title of Cultural Ambassador. We are grateful to Mr Luc Van den Brande, Prime Minister of the Flemish Government, and Mr Hugo Weckx, Flemish Minister of Culture and Brussels Affairs for the confidence they have shown in our project. The City of Ghent, in the person of Mr Rudy Van Quaquebeke, Alderman for Culture, provided the resources to allow this ambitious exhibition to go ahead; additional support was provided by Kredietbank. On behalf of the organizing partners we thank all the museums, churches, and private collectors for their generous loans. We were especially heartened by the enthusiastic response we received from the administrators of many museums and institutions. None of this would have been possible, however, without the hard work of John Steyaert and Monique Tahon-Vanroose, and of the entire museum staff.

ROBERT HOOZEE
Chief Curator

Author's Foreword

The selection of works for the exhibition is based on several assumptions. One is that the most creative period in the development of Late Gothic sculpture in the Netherlands corresponds to the still relatively obscure years c. 1420–1460/80 rather than to the better-studied late phase of the style c. 1500, a contention that is consistent with what we know of painting during the same years. Emphasis is thus placed on this time frame, which coincides closely with the presence of the Burgundian court in the Netherlands. Examples from the preceding c. 1400 years are included in order to clarify the immediate background, although in the process of work on the catalogue it became increasingly evident that there is a great deal of continuity between local interpretations of the International Style and subsequent Late Gothic schools. A selection of sculptures from the later years c. 1500 is intended to complement and to clarify the varied regional manifestations of the Late Gothic.

Another assumption is that these regional schools can be most meaningfully studied in the wider context of the fifteenth-century Burgundian Netherlands from a vantage point that cuts across modern frontiers, especially now that a number of individual centers have become better known. For practical purposes, these conventional modern divisions have been maintained as point of departure for the organization of the catalogue.

Finally, in my view, Late Gothic sculpture cannot be fully understood apart from developments in other media during the same time, especially panel painting. Where possible, this relationship has been documented.

In both the introductory essays concerned with Tournai and Brussels and in the catalogue entries, a traditional method was used that seems pertinent to our still quite limited knowledge of the subject. It represents an attempt to establish a grouping of stylistically similar sculptures, wherever possible in relation to an artistic center, and to propose a rudimentary chronological framework. It was not my intention to define the Netherlandish Late Gothic style in any comprehensive sense, nor to provide a synthesis of the material; it is still too early for that. Instead, the aim was simply to gather, to juxtapose, and to comment on a series of carefully selected works in order to provide elements that can lead to a better understanding and to a fuller appreciation of this very important artistic tradition.

The practical circumstances and limitations that inevitably lend a tentative and incomplete character to any exhibition, along with the fact that certain centers are more familiar to us than others, have meant that not every region is as fully represented as one might wish. Only two works from the north-eastern Netherlands were included, only one from Picardy. The Mosan area might have been more fully treated, commensurate with its great significance. Most other parts of Northern France, Belgium, and the Netherlands are, however, rather well-accounted for.

Bibliographic references accompanying the catalogue entries and the Tournai and Brussels essays are intended only to provide general points of reference. Comments related to

the physical state of works in the exhibition are based on information available at the time of the completion of the text.

I wish to express my gratitude to the Ministry of Culture of the Flemish Community and to the Museum voor Schone Kunsten in Ghent for providing the opportunity to further my research and to present my findings on a subject dear to my heart. The University of Minnesota granted a sabbatical leave which allowed time for preparatory work leading to the exhibition. The assistance of the Museum staff is gratefully acknowledged. Special thanks are due to Monique Tahon-Vanroose for coordinating and overseeing this project from the initial explorations through its final concrete realization. Ruth Monteyne's help proved invaluable in work on the bibliography. I am greatly indebted to the members of the team at Ludion Press for their efforts on behalf of the catalogue, and most particularly to Paul van Calster for his truly collaborative work both in a linguistic and general scholarly sense, as well as for his painstaking and sympathetic editing of the text. Finally, I wish to thank my parents for their unflinching support, Ian and Karl for their understanding and patience, and, of course, most of all, Claire, for her inspiration, her encouragement, and for sharing.

<div align="right">

JOHN W. STEYAERT
Associate Professor, Department of Art History
University of Minnesota, Minneapolis

</div>

EDITOR'S NOTE

Shortened titles have been used throughout in cross-references to essays and illustrations (e.g., see *Brussels*, fig. 10).
Measurements are in centimeters: height x width x depth. Only the height is given for free-standing sculptures, while height and width are stated for tombstones and brasses.

Lenders to the Exhibition

Aalst, Hospitaalzusters-Augustinessen

Amay, Musée Communal d'Archéologie et d'Art Religieux

Amsterdam, Rijksmuseum

Antwerp, Kunsthistorische Musea,
 Museum Mayer van den Bergh

Antwerp, Kunsthistorische Musea, Museum Vleeshuis

Arras, Musée des Beaux-Arts

Arras, Trésor de la Cathédrale

Avesnes-sur-Helpe, Eglise collégiale

Barnard Castle, The Bowes Museum
 (Durham County Council)

Beauvais, Musée départemental de l'Oise

Beerse, Kerkfabriek van Sint-Lambertus

Beringen, Kerkfabriek van Sint-Pietersbanden

Binche, Fabrique d'Eglise Saint-Ursmer

Bruges, Gruuthusemuseum

Bruges, Kerkfabriek van Sint-Jacob

Bruges, Kerkfabriek van Sint-Salvator

Bruges, Oud-Sint-Janshospitaal

Brussels, Karmelietenklooster

Brussels, Koninklijke Musea voor Kunst en Geschiedenis

Brussels, Stedelijk Museum Broodhuis

Cambrai, Musée Diocésain d'Art Sacré

Deux-Acren, Fabrique d'Eglise Saint-Martin

Drogenbos, Kerkfabriek van Sint-Niklaas

Ellezelles, Fabrique d'Eglise Saint-Pierre aux Liens

Ghent, Kerkfabriek Onze-Lieve-Vrouw-Sint-Pieters

Ghent, Bijlokemuseum

Ghent, Sint-Lucasklooster

Hakendover, Kerkfabriek van Sint-Salvator

Halle, Kerkfabriek van Sint-Martinus

Heers, Kerkfabriek van Sint-Martinus

Kortrijk-Dutsel, Kerkfabriek van Sint-Catharina

Lede, Kerkfabriek van Sint-Martinus

Leusden, Kerkfabriek van Sint-Jozef

Leuven, Stedelijke Musea

Liège, Centre Public d'Aide Sociale, Volière

Liège, Musée Curtius

Lille, Musée des Beaux-Arts

Lille, Musée Diocésain

Madrid, Museo del Prado

Marche-les-Dames, Fabrique d'Eglise
 Notre-Dame du Vivier

Marpent, Fabrique d'Eglise Notre-Dame

Namur, Musée des Arts Anciens

Nancy, Musée historique Lorrain

Ramerupt, Fabrique d'Eglise Saint-Roch

Saint-Omer, Musée Sandelin

Thumaide, Fabrique d'Eglise Saint-Pancrace

Tongerlo, Paters Norbertijnen

Tongeren, Kerkfabriek Onze-Lieve-Vrouw-Geboorte

Tongeren, OCMW

Tournai, Musée d'Histoire et des Arts Décoratifs

Trier, Kirchengemeinde St. Matthias

Utrecht, Rijksmuseum Het Catharijneconvent

Vielsalm, Fabrique d'Eglise Saint-Gengoul

Valenciennes, Musée des Beaux-Arts

Wannebecq, Fabrique d'Eglise Saint-Léger

Wodecq, Fabrique d'Eglise Saint-Quentin

and private lenders who wish to remain anonymous

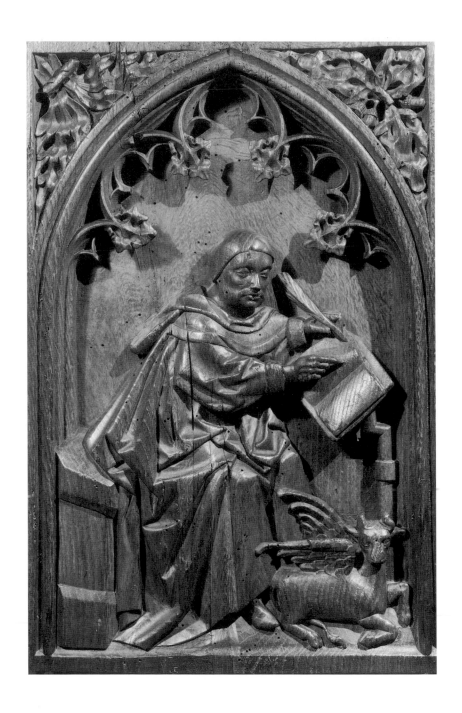

Fig. 1 St. Luke, wood, detail of the choir stalls in
Sint-Salvatorskathedraal, Bruges

INTRODUCTION

Aspects of Late Gothic Sculpture

MONIQUE TAHON-VANROOSE

Sculptors were viewed as craftsmen in the Middle Ages, as were artists, illuminators, goldsmiths, and embroiderers. Like house-painters and joiners, they belonged to a clearly defined category of workers and did not see themselves as engaged in any kind of individual enterprise. Their freedom was controlled by the corporation to which they belonged, which specified in detail the types of sculpture they were permitted to produce, the materials they might use and the techniques that might be applied. The regulations differed from town to town and were frequently amended to take account of changing needs and circumstances.

Surviving records provide a vivid impression of the way these corporations operated. The guild restricted competition and policed the privileges on which its monopoly rested. It also inspected its members' raw materials and finished products. In the period and area that concern us here special marks were used in three cities – Brussels, Antwerp, and Mechelen – to signify official approval. The guilds' strict

regulations and protectionism encouraged a certain rigidity, just as popularity and strong demand for particular types of sculpture fostered serial production which, while not without merit, nevertheless lacked inspiration. The corporate system of working did not, however, prevent sculptors from bringing an element of personal creativity to the trade they had learned in their masters' workshops. Innovation and exceptional skill are thus to be found amongst the run-of-the-mill craftsmanship of the period.

Nor should we overestimate the ties between a sculptor and his particular town. Annual fairs brought him into contact with the work of "foreigners," and he was also permitted (provided he had the wherewithal) to purchase free master status and to set up in other towns. Sculptors were also consulted and given commissions across municipal boundaries. In other words, they were more mobile than might be apparent at first sight.

The names of many sculptors are preserved in the archives, but it is unusual for us to be able

to link a particular name with a specific surviving sculpture or ensemble. The Annunciation group from Tournai Cathedral, for instance, has been attributed to Jean Delemer on the basis of archive material (see *Tournai*, figs. 1–2). Similarly, the beam end from Leuven Town Hall (cat. 24) is known to have been sculpted by Willem Ards. Fifteenth-century sculptors did not ordinarily sign their work, making the two Angels with Instruments of the Passion (cat. 41), which are signed in full on the back by Tydeman Maes, extremely unusual.

The Guild

Sculptors, like all other manual workers, had to be members of a guild. The first requirement for membership was that the person in question had to be a citizen of the town in which he intended to work. Citizenship could be acquired by birth, marriage, or purchase. The guild to which a particular craftsman had to belong could differ from place to place, as illustrated by several prominent fifteenth-century towns that were also leading sculptural centers. The *beeldsnijders* (literally "image-cutters," a term which usually refers to wood-carvers) of Bruges[1] belonged to the carpenters' guild, along with the organ-makers. The stone sculptors, by contrast, appear to have belonged to the masons' *("steenhouwers")* guild. The *beeldsnijders* output was limited in a 1432 charter to wooden altarpieces, large or small wooden statues, and other unspecified works. In Brussels,[2] sculptors in wood and stone belonged to the guild of *Steenbickeleren* (stone workers), which also included the stonecutters, masons and slaters. The *beeldsnijders* of Ghent[3] were enrolled in the painters' corporation – the Guild of St. Luke – along with the stained-glass makers. The city's stone sculptors were members of the masons' guild, which also numbered the tomb sculptors *("zarchouwers")* amongst its ranks. Ghent's *beeldsnijders* were allowed to produce all kinds of stone or wooden sculptures in the round, provided that these could be carried.[4] Stone sculpture was otherwise reserved for the masons' corporation. A similar rule applied in Antwerp.[5] There too, the *beeldsnijders* and painters belonged to the Guild of St. Luke, as did several other "artistic" craftsmen, like the goldsmiths, embroiderers, brocade-makers and stained-glass makers. Artists attached to the Burgundian court were exempt from the control and regulation of the corporations.

Would-be sculptors had to learn the trade from a master, following a guild-regulated apprenticeship lasting several years. The children of master sculptors enjoyed partial or full exemption from the need to serve an apprenticeship. Masters were paid little or nothing for providing this training, but apprentices evidently formed a source of cheap labor. Consequently, the number of apprentices a master was permitted to employ in his workshop at any one time was restricted.

Apprentices did not automatically become masters on completion of their training. Free master status had to be purchased for a considerable sum of money, and so many craftsmen sought employment as journeymen with a master. Once again, the children of established masters enjoyed certain privileges. The master had to be a person of unblemished character: anyone convicted of theft or fraud could be barred from the guild. Furthermore, "any master sharing his home with a woman other than his lawful wife, engaging in usury, or keeping a brothel or a house in which wrongdoing is committed shall be excluded from the corporation until such time as he has mended his ways."[6]

Collaboration between Painters and Sculptors

Polychromy is an essential component of Late Gothic sculpture, and was generally left to a painter or *"stoffeerder."* Where the painters and sculptors belonged to the same guild, as they did in Antwerp, a neat division of labor was possible. Disputes could, however, arise where this was not the case. In Bruges in 1432, for instance, the painters had to be protected from the sculptors by a bylaw prohibiting each side from engaging in or subcontracting the work of the other.[7] A similar situation arose in Brussels twenty years later. A bylaw of 1454 regulated the ability of the painter and sculptor to take orders for, supply and sell painted sculptures.[8]

Agreements were sometimes needed with other guilds too. This was the case in Bruges in the first half of the fifteenth century with the joiners, who supplied the cases for wooden altarpieces. The 1432 charter of Bruges' carpenters specifies that "… organ-makers and image-carvers belonging to the carpenters' guild may carry out the gluing required by the manufacture of organs and sculptures, but not otherwise."[9] This permission to use glue as part of their work should be interpreted as a concession on the part of the joiners, who enjoyed a privilege on such activity.[10]

As early as 1422 Bruges' joiners were permitted to make wood-carvings, providing these were physically part of their work (obviously even *appliqué* work was not allowed).[11]

Polychromy was extremely expensive as the materials used – gold and pigments – were often as rare as the spices that were imported from overseas. The work also took a great deal of time because of the complexity of the techniques used. Dozens of orders survive in which the polychrome decoration of a sculpture cost more than its actual carving. This was the case with the famous Marian altarpiece by the Utrecht sculptor Adriaen van Wesel, commissioned by the Onze-Lieve-Vrouw Broederschap in 's-Hertogenbosch[12] (see cat. 85). It was some considerable time, furthermore, before the altarpiece was painted, possibly due to lack

of money. It was delivered by the sculptor in 1477 and spent three decades unpainted in the Confraternity's chapel in the church of Sint-Jan in 's-Hertogenbosch. The decision to have the altarpiece painted was not taken until 1508.

The rudimentary finish and poor quality of the wood used for certain sculptures might be explained by the intention to paint them. Conversely, some unpainted sculptures are finished with such skill and feeling for the texture of the wood that one can hardly believe they were destined to be covered up. Stone sculptures were also painted, even those intended for display in the open air, exposed to the elements. Ivory, marble, and alabaster, by contrast, were valued for their intrinsic beauty and sculptures in these materials were often left partially or wholly unpainted even before the fifteenth century.

We tend to think of the painting of sculptures as essentially the job of a craftsman, and it is thus surprising to us to find that even the greatest artists of the fifteenth century sometimes engaged in it. The aforementioned Annunciation group by Jean Delemer was painted c. 1428[13] by Robert Campin although none of the original polychromy survives (*Tournai*, figs. 1–2), and we know that in 1435 the city of Bruges paid Jan van Eyck for painting and gilding six statues and matching canopies which had recently been installed on the facade of the new Town Hall. The painting was done *in situ*.[14]

Painters were intimately involved with sculpture, supplying designs and executing the polychrome decoration. Impulses and influence will thus inevitably have flowed in either direction. Special mention ought to be made of the grisailles – monochrome black-and-white paintings – that are often found on the outside of triptych wings, comprising impressive imitations of unpainted stone sculptures. The most famous examples include the two painted statues on the exterior of the Van Eycks' Ghent Altarpiece (fig. 2). Statues of this kind do not simply refer to existing sculptures, although they might have been inspired by them.[15]

Fifteenth-century sculpture is primarily religious in character, a fact borne out not only by the many saints' statues and altarpieces with religious themes that survive, most of which originally came from churches and monasteries, but also by the sculptural decoration of worldly buildings like town and guild halls and by private commissions. The Church was undoubtedly the sculptors' most important patron, but wealthy burghers, too, founded chapels and placed works of art in churches, while guilds and confraternities contributed to the splendor of such buildings through the decoration of the chapels dedicated to their patron saints. Here too, statues and retables were part of the customary "furnishings."

Religion was bound up intimately with everyday life. Medieval people were familiar with the life of the Virgin and the Passion of Christ, and with biblical parables, whose moralizing significance they well understood.[16] Such religious ideas were presented to them in a vivid way by regular performances of mystery plays. The Christian message was visually translated in churches and monasteries into an iconographic "program" worked out consistently in the often abundant decoration of the building. Sculptors created a significant part of this program, including altarpieces, Calvary scenes and saints' statues for church interiors. They were also responsible for decorating the exterior and for providing all kinds of architectural detail, which were finished with equal care, even when destined for installation in virtually inaccessible places.

The celebration of Mass was and is the central focus of church activity, and a complete iconography evolved around the Eucharist. The choir is dominated by the Triumphal Cross, possibly fitted to the rood screen, which can itself be further decorated with sculptural motifs. The Crucified Christ is flanked by the Virgin and St. John. The Apostles look on from the top of the piers in the choir. Columns around the altar often feature Angels with the Instruments of the Passion. An altarpiece refers to the key episodes in the life of the Saint to whom the church or chapel is dedicated (fig. 3) or to the life of Christ, especially his Childhood or Passion.

The Holy Sacrament is ceremonially stored in the church. Wall-mounted and (from the mid-fifteenth century onwards) free-standing tower tabernacles are by far the most impressive receptacles. The architectural scheme of these shrines was carefully conceived and decorated with reliefs recounting the most intense moments of the Passion story: the Last Supper, the Agony in the Garden, the Flagellation, and the Crucifixion itself.

The iconographic program sketched out above reinforced the role of the church building as the setting in which the most important stages in human life, from birth to death, were marked by the administration of the Sacraments. Each branch of art, especially sculpture, helped express the central message in brilliant fashion (fig. 4).

Churches, abbeys and monasteries kept detailed records that provide us with a clear insight into the relationship between artist and patron. Not only did the former receive new commissions, he was also charged with the maintenance and repair of existing works. Church accounts tell us that the building's art treasures were carefully maintained and that artists were constantly being engaged for this purpose. The following entry is typical: "Item: Cornelio Tielman lapiscide pro reparatine digiti ymaginis beate Virginis in navi ecclesie rupti XL s" ("Cornelius Tielman, sculptor, for the repair of the broken fingers of the statue of the Virgin in the nave of the church, 40 shillings").[17]

Major commissions like the making of an altarpiece depended on contracts in which the iconography, dimensions, materials, price and delivery time were set out precisely. The abbess of Flines signed a contract in 1448 with a sculptor from Valenciennes called Ricquart, for the supply of an altarpiece by the following Christmas. The contract describes the work systematically, scene by scene. The setting, the figures

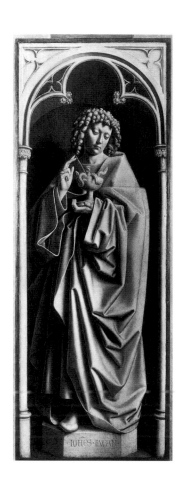

Fig. 2 Hubert and Jan van Eyck, St. John the Evangelist, exterior right wing of the Ghent Altarpiece, oil on panel. Ghent, Sint-Baafskathedraal

Fig. 3 Atelier or follower of Rogier van der Weyden, Exhumation of St. Hubert, oil on panel. London, National Gallery

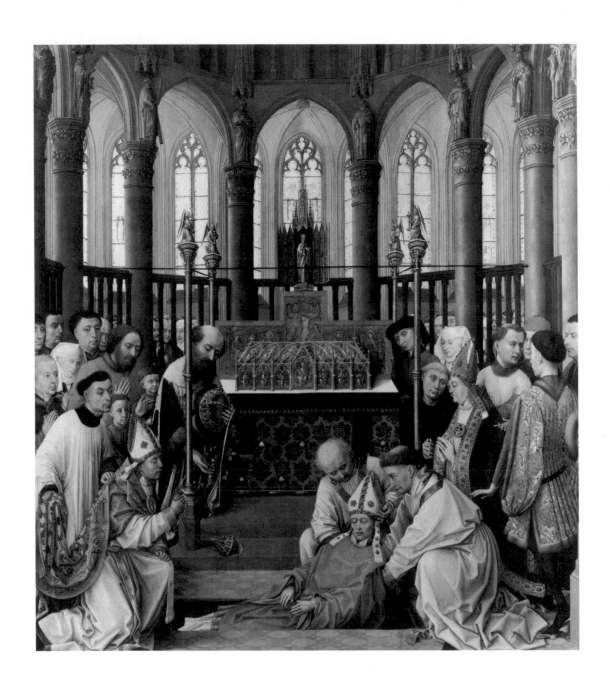

occupying it, and their poses are specified in such vivid detail that one has the impression the contract was drafted with one eye on an existing altarpiece.[18]

Choir stalls are worthy of special mention because of their "double" iconography (figs. 1 and 5). The visible part was reserved for scenes from the Old or New Testament, while "invisible" areas like the *misericords* offered a perfect place for the sculptor to comment on the everyday world in satirical, burlesque, or moralizing scenes that are otherwise restricted to out-of-the-way places like corbels and vault bosses.

The final significant branch of church sculpture was that of epitaphs and funerary monuments. Wealthy people who could afford to be buried in the church often ordered their tomb from a sculptor while still alive, allowing them to oversee its production. The precise nature of the memorial depended on the ideas, tastes, and financial means of the patron. It could vary from a modest tombstone or brass, to wall-mounted reliefs and more elaborate monuments. Constant features of picture epitaphs were an image of the "deceased," sometimes shown in divine company with their patron saint, and an epitaph text summarizing their life and the date of their death. Jean du Clercq, abbot of Saint-Vaast in Arras, spent over thirty years decorating his abbey. Decades before he actually died, he made the arrangements for his final resting place in the Lady Chapel, whose rich decoration is recorded in a number of documents. His tomb consisted of five stone statues placed against the wall in an arcade, which were carved by Collard de Hordain of Arras. They showed the abbot, kneeling in prayer, with his patron saints John the Baptist and John the Evangelist, and the protectors of the institution, SS. Benedict and Vedast. The painter Jacques Daret was responsible for the polychromy. The grave was set into the floor and covered by a circular tombstone in blue marble with an inlaid yellow brass disc bearing the abbot's attributes, his coat of arms and the epitaph.[19]

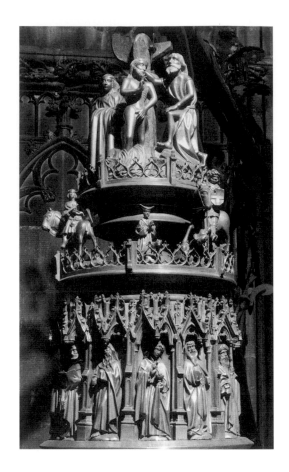

Fig. 4 Baptismal font in Sint-Martinus-basiliek, Halle. Brass, cast by Guillaume Lefèvre

Fig. 5 Misericord from the choir stalls in Sint-Salvatorskathedraal, Bruges, wood

Guillaume Fillastre, confidant of Duke Philip the Good, probably ordered his tomb during a trip to Italy in 1463, ten years before his death. Four fragments of glazed terracotta are all that remain of this remarkable monument. It was produced in the Florentine workshop of Andrea della Robbia and was destined for the abbey of Saint-Bertin in Saint-Omer, of which Fillastre was abbot. It is one of the earliest examples of imported Italian sculpture in Northern France.[20]

The Tombs of Philip the Good

The fifteenth century in the Burgundian Netherlands was dominated by the figure of Philip the Good, who enjoyed an unusually long reign (1419–67). The duke is known to have immersed himself in splendor and luxury at festive events, tournaments and meetings of the Chapter of the Golden Fleece, and it may safely be assumed that he also paid a great deal of attention to the decoration of his everyday surroundings. Nevertheless, it remains difficult to judge the influence of his patronage on the sculpture of his time. Intensive building activity at his Coudenberg palace in Brussels and his residences in Lille, Bruges, and Ghent must have offered a great deal of work to the sculptors, but very little of their output has survived.

Consequently, the name of Philip the Good is chiefly associated, as far as sculpture is concerned, with a number of important tombs that he ordered. Their story is interesting as it reveals the extent to which purely political motives influenced the conception of what were essentially religious monuments. Surviving documents offer a clear insight into the way such commissions came about. Philip's first order was for the tomb of his parents, John the Fearless and Margaret of Bavaria, in the Chartreuse at Champmol (now in Dijon, Musée des Beaux-Arts). The design of the tomb is a familiar one. At its center lies the sarcophagus decorated on all four sides by a procession of *pleurants* (mourners) carved in the round in arcades. The effigies of the deceased rest on a black

marble plinth with two alabaster angels at either head. The latter hold a helmet for the man and a coat of arms for the woman. The tomb was sculpted by Juan de la Huerta of Aragon,[21] and finished by Antoine le Moiturier of Avignon.[22]

The tomb of Philip's first wife, Michelle de France, was also executed along these conventional lines. She died young in 1422 and was buried in the chancel of Sint-Baafs abbey church in Ghent. Her monument was transferred to Sint-Jans (now Cathedral) in 1540 upon the dismantling of the abbey, where it was destroyed by the iconoclasts. The only surviving relic of this splendid tomb is a fragment of the black marble plinth bearing the inscription of her name, which can now be seen in the crypt of the Cathedral.[23] The ducal accounts provide an idea of how it must have looked. The material was once again a combination of black marble and alabaster, and the tomb consisted of an effigy of the young woman beneath a canopy, her head flanked by two angels. A line of *pleurants* processed around the sarcophagus. The earliest known trace of the commission dates from 1434 when the duke ordered alabaster from the Bruges merchant Loys le Blackere.[24] The work was then carried out by Gilles le Blackere, probably also from Bruges, who is described as a "tailleur d'ymaiges d'alabastre." He was paid in 1436 for carving the alabaster tomb and installing it in Sint-Baafs Abbey.[25] In September that same year, five large blocks of black marble were purchased at a quarry in Dinant, the largest piece requiring special transportation to Bruges.[26] Gilles le Blackere only completed the effigy of the princess, the canopy (apart from two pillars) and four of the twenty *pleurants*, as noted by a "progress report" drafted in 1443, when Tydeman Maes, a Bruges sculptor, took over the job. The latter's contribution to the tomb included the carving of the sixteen remaining *pleurants* and a series of twenty canopies in which to place them. He also sculpted the two angels at the young woman's head, and provided the inscription.[27] It is odd that the duke

should have called upon two Bruges sculptors to carve a tomb destined for Ghent, as the latter city also had a significant tradition of monumental sculpture.

Philip the Good also ordered a tomb for his sister, Anne of Burgundy, who died in 1432 and was buried in the church of the Celestine Order in Paris. Like many other royal monuments, it was dismantled during the French Revolution, but the white marble effigy, the black marble base bearing the inscription, and a few *pleurants* have survived.[28] The tomb's appearance may be reconstructed from surviving documents, which tell us that the procession beneath the arcade no longer consisted simply of anonymous mourners but included three individualized figures signifying the family ties of the deceased woman: her husband, the duke of Bedford, her brother (the patron), Philip the Good, and her father, John the Fearless.[29]

In 1454 Philip the Good ordered a tomb for three illustrious forebears who had laid the

foundations for the wealth of the Burgundian Netherlands: Louis of Male (d. 1384), Margaret of Brabant (d. 1368), and their daughter Margaret of Male (d. 1405). The monument was installed in Saint-Pierre, Lille (see fig. 6), where Philip's three ancestors were buried, and consisted of a tomb-chest with three bronze effigies laid side by side. The group of *pleurants* around the sarcophagus was a now even more individualized group of twenty-four richly dressed figures. Some were women, marking a break with tradition, and all were members of the family or descendants of the deceased, including Philip himself. They were identified by coats of arms, suggesting that their presence was intended primarily to stress dynastic ties rather than as a series of family portraits. This tomb, too, was lost during the French Revolution, and is now known only through documents.[30] However, Philip the Good had a second monument along similar lines installed in the Carmelite Church in Brussels for his great-

Fig. 6 Tomb of Louis of Male in Lille. Engraving in A. L. Millin, *Antiquités nationales, ou recueil de monuments*, v, Paris 1795

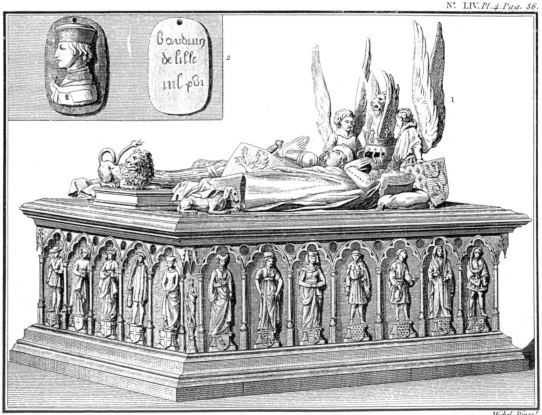

aunt Joan of Brabant (d. 1406) and her great-nephew who died barely a month after his birth. The monument was destroyed in 1695 during the bombardment of Brussels by the armies of Louis XIV. The tomb bore the effigy of Joan with that of the child at her side. Once again the tomb was surrounded by twenty-four little bronze figures of princes and princesses belonging to the House of Burgundy and allied dynasties, identified by coats of arms. The figures were cast by Jacob van Gerines who had done the corresponding work for the Lille monument. The name of Jean Delemer has been linked to the carving of the wooden designs. The bronze figures were painted by Rogier van der Weyden.[31]

The two monuments served as the model for the tomb Mary of Burgundy had constructed for her mother, Isabella of Bourbon, which was installed in Sint-Michiels Abbey in Antwerp in 1476. This tomb, too, was destined to be dismantled. The bronze effigy was moved to Antwerp Cathedral, and ten of the twenty-four statuettes are now in Amsterdam's Rijksmuseum (see cat. 20).

Ironically, Philip the Good himself was buried in the chapel at Champmol but was never given a worthy tomb, despite having commissioned all of these remarkable monuments.

The Towns

A significant proportion of the sculptural decoration and ensembles produced in the fifteenth century was commissioned by the towns. Orders of the most diverse nature are easy to find in virtually any set of municipal accounts: for the decoration of a fountain, the installation of a statue on a bridge, the carving of a saint's figure for a niche at the town gate, or for more substantial enterprises like the sculptural decoration of public chambers or town halls. The examples of Bruges and Leuven are particularly illuminating. The construction of Bruges Town Hall was begun c. 1376.[32] The architecture was decorated with ornamental corbels,

brackets and vault bosses. The remaining facade statues, for which the consoles had already been supplied by Jan van Valenciennes and a number of anonymous assistants, were done in the course of the fifteenth century. The monumental stone statuary ran to no fewer than forty-eight pieces, including a Madonna, an Annunciation group, the Prophets Jeremiah and Zachariah, Kings David and Solomon, and numerous counts and countesses of Flanders. Sculptors whose names are associated with the fifteenth-century facade statues are Colarde de Cats of Tournai, Bruges' Jan van Oosenbrugghe, Gheeraerde Mettertee, Jacob van Oost, and Jan van Cutseghem, and the Brussels sculptor Claise uten Zwane. As the statues were completed, they were installed on the facade of the town hall where they were gilded and painted (by artists including Jan van Eyck).

Things did not always go smoothly. The town signed a contract with Colarde de Cats on 5 January 1424 for the supply of four statues by the following August. The works were stored beneath Sint-Baselis Church in July. Three years later, Jan van Oosenbrugghe was paid to repair the statues which had become damaged in the interim. Only then were preparations made for the installation of the statues on the facade. On 15 August 1433, the Brussels sculptor Claise uten Zwane was paid for a stone Angel and matching canopy, including delivery in chests from Brussels to Bruges. The statue was intended to go with an existing image of the Virgin, which the sculptor had also been asked to alter. Three Bruges sculptors, Jacob van Oost, Gheeraerde Mettertee, and Jan van Cutseghem were paid for another eight statues on 13 August 1435. Interestingly, six of these were paid for not by Bruges but by the nearby town of Sluis in settlement of a fine. The Bruges facade statues were all destroyed during the unrest of 1792. Sixteen consoles were spared and are now on view in the large chamber on the first floor of Bruges Town Hall (see cat. 38).

Another exceptionally fine ensemble created in the mid-fifteenth century survives at

Fig. 7a–d Beam brackets with Church Fathers, wood. Ghent, Muziek-conservatorium

Fig. 8 Fragment of the epitaph of Livinus Blecker, damaged by the iconoclasts. Tournai, Cathedral

Leuven Town Hall and consists of two series of corbels.[33] These are decorated with reliefs and support seven beams in the large chamber on the first floor (the "Wandelzaal") and in the Gothic chamber on the second floor. Leuven's municipal accounts have survived in good condition too, and tell us the period of execution and the name of the maker – the sculptor Willem Ards. He came from Brussels, but settled in Leuven at an unknown time. The carved scenes are significant: on the first floor they chiefly comprise Old Testament episodes, while those on the second floor concentrate on the New Testament, thus symbolizing the way the New Testament built on the foundations of the Old. The images were intended to stand as worthy examples for municipal leaders and judges as they discharged their duties.

The Fate of Sculptures

Circumstances have conspired over the hundreds of years that separate us from the fifteenth century to eradicate much of the near-astonishing wealth of sculpture that existed in the Burgundian Netherlands. In many cases the sculptures disappeared at the same time as the buildings for which they were made: the homes of wealthy burghers, the residences of dukes and noblemen, public buildings, and not

least churches, abbeys, and monasteries, in both the town and the countryside. Fire, riots, war, theft, shifting tastes, indifference, and incompetence have resulted in a trail of destruction.

Especially dramatic was the wave of devastation unleashed by the iconoclastic fury that spread from the Southern to the Northern Netherlands in 1566, sorely testing the region's artistic heritage.[34] All religious images, from paintings and stained glass to book illustrations, were destroyed, but sculptures were particularly vulnerable (fig. 8). There was little order to the actions of the iconoclasts, whose intended "purification" of the churches mostly degenerated into disorder, blind destruction, and plunder. Several areas and towns were spared the worst excesses, but Flanders was badly affected. The county fell prey to a second wave of image-smashing, described by Marcus van Vaernewyck in his chronicle *Van die beroerlicke tijden in die Nederlanden en voornamelijk in Ghendt 1566–1568* ("The troubles in the Low Countries and especially Ghent").[35] His colorful account includes a section in which a fourteen-year-old boy smashes an altarpiece in the church of Sint-Jacobs in Ghent with an iron bar: "The chapel was unlocked (I do not know by what folly) and a lad of fourteen or fifteen came in broad daylight with an iron bar to

smash, gouge, and otherwise damage the faces and hands of the little alabaster figures in the altarpiece. No one had the courage to stop even such youngsters (even though only one or two were involved), because they were all astonished, and afraid that it was done at the behest of some powerful individual. No one knew what led him to commit this act."[36]

Similar events occurred in 1792 in the wake of the French Revolution, when the people vented their wrath against what they saw as symbols of the aristocracy and high clergy. The statues and coats of arms were removed from Bruges Town Hall on 13 December 1792 and stored in the Chapel of the Holy Blood.[37] A meeting of the "Friends of Unity, Liberty, and Equality" was held on 30 December, and passed a motion "… to take all the statues removed from the Town Hall to the marketplace this afternoon and there to smash them publicly."[38] Accounts of the ensuing events tell how the facade statues from the Town Hall were destroyed in the Grote Markt as symbols of the *Ancien Régime*, along with instruments of justice: "The heads of the statues taken from the

Town Hall were brought to the marketplace and smashed to pieces by the people who were extremely angry and embittered. They also burned all traces of the hateful devices that had previously served the Old Law, such as gibbets, gallows, and whips. Throughout these events, the whole market square echoed to the constant cries of the assembled people: 'Long live the Nation! Long live Freedom!' To prevent disorder, the Volunteers and the city's regular troops formed up in a square in the Grote Markt, over which they trained their weapons."[39]

In our own century, two world wars have unleashed new waves of mass destruction upon the region's cultural heritage, resulting in fresh and profound impoverishment. The rich and interesting collection of medieval sculpture at the Museum in Douai twice came under fire, in 1918 and 1944.[40] The establishment of the collection dates back to the French Revolution, when the possessions of the religious houses of the town and surrounding area were confiscated and brought together. Amongst the many ecclesiastical institutions closed down at the time were the famous abbeys of Anchin and Marchiennes.

The Douai Museum lost a substantial part of its collection in an air raid on 11 August 1944, shortly before the town's liberation. It had not been possible to move many of the sculptures to safety, and amongst the items lost was the tomb effigy of Jacques de Lalaing (1421–1453). This Knight of the Golden Fleece was known as "Le bon chevalier" and was something of a legend during his lifetime.[41] He was a remarkable and feared figure at tournaments held in many a European court, and his acts of heroism were already being written about before his death. He died in the army of the Duke of Burgundy at the siege of Poeke in 1453, when the revolt of Ghent was put down. His tomb was located at Sainte-Aldegonde's Church in Lallaing, France, until the French Revolution. The effigy was donated to the Museum by the Prince d'Arenberg in 1848. It was stolen in 1918 by retreating German troops, but was

found in Valenciennes minus its head,[42] and then returned to the Museum. The destruction of the collection in 1944 eradicated the last trace of this "wandering knight." The same fate befell the monumental fifteenth-century statue of Mary Magdalen (fig. 9) from Anchin Abbey,[43] which had belonged to the 1857 bequest to the Museum of the enthusiastic collector Escallier.

Late Gothic Sculpture and its Dissemination in the Burgundian Netherlands

The term "Late Gothic" ought not to be taken as pejorative or as the description of a sterile, old-fashioned style. On the contrary, it takes in the new developments which followed the 1420s and bears witness to a new creative urge that is distinct from the International Style which had dominated the period running approximately from 1370 to 1420. As the term suggests, the International Style was a unitary movement characterized by soft draperies, supple poses and aristocratic faces with charming smiles, which reached its peak with the "Beautiful Madonna" type.

The Late Gothic underwent its own fascinating formal development in the Burgundian Netherlands, as it did elsewhere in Europe. There were numerous sculptural centers in this large region, whose ateliers were chiefly occupied meeting local demand. However, several of them succeeded in establishing a reputation far beyond their borders, in both a northerly and a southerly direction, to Scandinavia, the Hansa towns on the Baltic, England, and Spain.

The new stylistic development was characterized by dynamic poses (fig. 10), realistic facial expressions, and complex, broken folds in the drapery. It gave rise to separate regional "formal dialects," although these naturally had a strong influence on one another. It would thus be wholly unfair to claim that this branch of art merely evolved a narrative, pictorial vocabulary in the wake of developments in the field of painting.

Our knowledge of production in the different areas is strongly dependent on the surviving evidence, which varies from place to place. Archival material can, however, significantly supplement our understanding of the scale and importance of specific centers. Some areas have been studied in greater detail than others depending on the number of surviving works.

Hainaut and Tournai
Hainaut was relatively quick to develop its sculptural output (see *Tournai* essay). The presence of the bluestone quarries – the famous "pierre de Tournai" – will have contributed to this, although whitestone, which is easier to work with, was also used. There were several centers, including Antoing, Ecaussines, Ath, and Mons, but the most important was Tournai.[44] Sculpture from this bishop's see was being exported via the Scheldt basin and even to England from as early as the twelfth century. The carving of tomb monuments made up a significant proportion of this output, and spread vigorously in the thirteenth and fourteenth centuries. Tournai sculptors were also hired to carry out commissions as far afield as France and Spain.

The important stylistic development that occurred in Tournai in the 1420s and its interaction with simultaneous innovations in painting were to have a decisive impact on the further evolution of the Late Gothic in the Burgundian Netherlands. Our principal point of departure for the study of sculpture in the city during this time is the pivotal figure of Jean Delemer whose monumental Annunciation group in Tournai Cathedral can be dated precisely. This enables us to propose certain groupings and hypotheses regarding the history of Tournai sculpture.

Brabant
Brabant formed the heart of the Burgundian Netherlands from the 1430s onwards, with Brussels becoming the capital of Philip the Good's state. The duchy experienced an extraordinary artistic expansion in the fifteenth century, to which artists from outside also made a

Fig. 9 Magdalen from an Entombment, stone. Douai, Musée de la Chartreuse (destroyed during the Second World War)

Fig. 10 Magdalen, figure from the Paschal Candelabrum in Sint-Leonarduskerk, Zoutleeuw. Brass, cast by Renier van Thienen, 1483

significant contribution, chief among them being the Tournai artists Jean Delemer and Rogier van der Weyden. Statues and altarpieces from Brabant were admired and produced for export at an early date. Brussels played a leading role in the development of sculpture in the Burgundian Netherlands by 1450.

The other important center in Brabant was Antwerp, which has traditionally been identified with its production of carved altarpieces in the period after 1500 or so. Documentary evidence reveals, however, that considerable sculptural activity had already existed in the city for some time prior to that date. A series of altarpieces and a number of free-standing statues can hypothetically be attributed to this center, because, although partially based on Brussels models, they display an individual identity – certainly after the mid fifteenth century (see also the *Brabant* essay).

Flanders

The county of Flanders was largely made up of the modern-day provinces of East and West Flanders. The two principal cities, Ghent and Bruges, were also the chief artistic centers. The meager range of sculptures surviving *in situ* might partly be explained by the fragmentary way in which the region of Flanders has been studied to date.

The city of Bruges is an exception in that it is unusually rich in surviving works, which, moreover, demonstrate considerable diversity. Bruges was a leading production center for brass tomb plaques of the highest quality even before 1400. Stone sculpture was also produced in the city, and a series of related works can be grouped around the Madonna of Sint-Donaas (figs. 11–13). A regional style with an "Eyckian" flavor developed here in the 1430s, as it did in other places. The signed Angel figures of Tydeman Maes (cat. 41) and the carving of the choir stalls in the Cathedral (see figs. 1 and 5) are prime examples.

Unlike Bruges, little sculpture has survived in Ghent or in East Flanders in general. The limited number of fifteenth-century sculptures certainly does not help us define the Ghent style. Strictly speaking, the only Ghent groups surviving *in situ* are the two series of beam brackets in the tanners' guild house, Het Toreken, and the Achtersikkel (now Muziekconservatorium) (figs. 7a–d). It is also the case, however, that further study might result in the attribution to Ghent of several works located elsewhere (fig. 14). Like Tournai, Ghent had earned itself a reputation in the fourteenth century as a center for the production of tomb sculpture. So much so, in fact, that the tomb sculptors *("zarchouwers")* were listed as a separate category within the mason and stone sculptors' guild. The clientele of these Ghent *tombiers* spread well beyond the boundaries of the city. Marcus van Vaernewyck's chronicle vividly records the wealth of sculpture that existed in Ghent before sadly being reduced to fragments by sixteenth-century iconoclasm.

Northern France

Present-day Northern France is relatively rich in Late Gothic sculpture, despite the considerable losses that have been suffered there. The region has not been researched in detail, although a meaningful study could be made by linking Northern French sculpture to the output of neighboring areas in the Southern Netherlands. There are clear ties with Tournai, for instance, in the field of funerary sculpture, especially epitaphs. Other links exist with Southern (French) Hainaut, Southern Netherlandish centers like Mons and prominent Mosan centers like Liège (see below), whose influence extended to the Ardennes.

Meuse Valley

The long sculptural tradition of the Meuse Valley, centered on Liège, dates back to the early Middle Ages. Mosan wood, stone, and metal sculpture was exceptionally important and was widely disseminated. The exhibition includes several representative examples of Late Gothic metalwork from the region (see cat. 68–70).

We know much less about the production of

Late Gothic wooden altarpieces in the Meuse region than we do, say, of Brussels. Some impression can, however, be formed on the basis of a number of fragments. The exhibition even has a complete, albeit late, example in the shape of the Ollomont Altarpiece (cat. 78).

Numerous free-standing statues from the Meuse region can be used as points of reference for the study of the rise of the Late Gothic in the area. The finest examples have been attributed to the anonymous Master of the Eyckian Female Figures (see cat. 72).

Northern Netherlands
Recent studies and exhibitions have highlighted the importance of Late Gothic sculpture in the Northern Netherlands, and especially Utrecht, to the development of the style and its radiation in the Burgundian Netherlands as a whole. Characteristic forms can already be discerned in the region by the 1430s, which means that an important regional tradition must have existed before Adriaen van Wesel. Other strong personalities were active there too, including the anonymous master of

the Adoration of the Magi (cat. 80). Cleves–Guelders, the most northerly part of the region, produced Master Arnt, an interesting figure whose expressive art introduced a new formal vocabulary for the Lower Rhine region.

Reliefs and small figures in pipeclay were extremely popular items. Like prints, they offered cheap, serial products of modest size and materials. Utrecht developed a particular specialty in this field. Local or foreign models were used, but inspiration was also drawn from great painters such as Campin or Van Eyck.

Fig. 11 Console with Zacharias and the Angel, detail, stone. Bruges, Gruuthusemuseum

Ivory and Alabaster

The final section of the catalogue brings together examples of ivory and alabaster sculpture, as the precise origins of these remain difficult to determine. Gothic ivory-carving is traditionally associated with Parisian workshops in the thirteenth and fourteenth centuries. Nevertheless, the Burgundian Netherlands also played a significant role in this field in the fifteenth century.

Some of the items are liturgical objects like paxes which the workshops produced in large numbers. The ivory carvings include a number of masterpieces which, despite their small size, are every bit as fine as more monumental sculptures.

A clear distinction can be made as far as alabaster sculpture is concerned between works with a marked regional character and others which were evidently produced for export by specialist workshops. Several undeniable masterpieces are to be found amongst these sculptures, which have been found at a variety of locations in France, the Low Countries, Germany, and Italy.

Fig. 12 Standing Virgin and Child ("Sint-Donaas Madonna"), detail.

Fig. 13 Standing Virgin and Child ("Sint-Donaas Madonna"), stone with polychromy. Antwerp, Museum Mayer van den Bergh

Fig. 14 Two Magi from an
Adoration, retable fragments,
Flanders?, wood with polychromy.
Sitges, Museo del Cau Ferrat

1 Vanroose 1974.

2 Duverger 1933.

3 Van der Haeghen 1898–9.

4 Van der Haeghen 1914.

5 Rombouts and Van Lerius 1864–70.

6 "… die huus houd met enen andren wive danne met zinen
ghetrauweden wive of woukerare ware of bordeele
verhuerde of husen daer men quaet pleit in hilde, die ne sal
niet moeten doen zyn ambochte toter tijt dat hijt wel
ghebetert heift." Quoted from the 1432 charter of the
Bruges woodworkers, preserved in the Rijksarchief, Bruges;
see Vanroose 1974, 176.

7 Vanroose 1974, 177.

8 Nieuwdorp 1981, 87–88.

9 "… oorghelmakers ende beildersniders die den ambochte
vanden temmerlieden toebehoren wel moeten limen dat
oorghelen ende beilden toebehoort ende anderes niet."
Vanroose 1974, 176.

10 Van de Velde 1909, 69.

11 "Dat de scrineweckers gheene beilden maken en zouden
dan up haere lieden werck ende an tzelve hout van haren
wercke zonder eenighe beilden anderssins te makene van
den houte van haren werck." *Ibid.*, 110–111.

12 Swillens 1948; Halsema-Kubes 1992.

13 Rolland 1932b.

14 Janssens de Bisthoven 1944, 12, 75; Vandewalle 1976, 19.

15 Grams-Thieme 1986.

16 J. Huizinga, *The Waning of the Middle Ages*, London 1990.

17 Bruges, Archief van het Bisdom, Kapittel van Sint-Donaas,
Rekeningen der Kerkfabriek, 1450, fol. 13.

18 Pinchart 1860, 43–47.

19 Loriquet 1889, 9–10.

20 Saint-Omer 1992, 111–113.

21 Dijon 1972, 27–30.

22 Dijon 1973, 28.

23 De Busscher 1848–50.

24 De Laborde 1849, 1:340–341, no. 1143.

25 *Ibid.,* 352–353, no. 1196.

26 Pinchart 1860, 129.

27 De Laborde 1849, 1:385–387, no. 1373.

28 Musée du Louvre, and one *pleurant* in the Musée de Cluny, Paris.

29 Baron 1990, 262–274.

30 Leeuwenberg 1951.

31 *Ibid.*

32 Janssens de Bisthoven 1944, 7–8; Vanroose 1971; Vandewalle 1976.

33 Smeyers 1977.

34 See e.g. Ghent 1976 and Amsterdam 1986.

35 Ed. F. Vanderhaeghen, Ghent 1872–6.

36 "Deze capelle (ic en weet niet bij wat dwaesheijt), was ontsloten, ende daert stont bij schoonen daghe een knechtkin van XIIII of XV jaren, met een hijserkin, en clopte ende cretste ende bedarf die aensichten ende handen van die albasteren beeldekins, die daer in de autaer tafel stonden, ende niemant en was zoo vrij van moede diet ooc zulcke jonghe leckerkins (al en wasser maer eene of II) dorste verbieden; want elc was verbaest, ende baerde dat zulcx uut laste van groote machtighe personaigen quam; want niemant en wiste waer hij ghedraeijt was." Van Vaernewyck 1872, 1:151.

37 Janssens de Bisthoven 1944, 16, 78–79.

38 "… om alle de standbeelden die men afgedaen had van voor het Stad-Huys, deze naer-middag, uyt te haelen en in 't openbaer op de markt te verbryzelen." *Vaderlands Nieuws-Blad, dyssendag den 1 januarius 1793*, 30; Janssens de Bisthoven 1944, 79.

39 "De Hoofden der Stand-Beelden, afgedaen van voor het Stad-Huys wierden ook op de Markt gebragt en in stukken geslagen door het Volk, het welke ten uyttersten verbitterd zynde op de zelve plaets ook heeft verbrand alle slag van haetelyke Instrumenten, te vooren gediend hebbende voor het hals-regt, als schavotten, galgen, geesselstaeken, etc. Geduerende deze verrigtingen hoorde men de geheele markt weergalmen van het geduerig geroep der vergaderde Volkeren. Vivat de Natie! Vivat de Vryheyd! en tot voorkoming van alle wanorders, hadden de Volontairen benevens de gesoldeerde Troepen deze Stad zig in een vierkante krygs-gelit op de Markt onder de wapens gestelt." *Byvoegzel Tot het Vaderlands Nieuws-Blad van den eersten January 1793*, 34.

40 J. Guillouet, in *Chefs-d'œuvre du Musée de Douai*, Paris 1956.

41 G. Chastellain, *Le Livre des faits du bon chevalier Messire Jacques de Lalaing*, ed. Kervyn de Lottenhove, *Œuvres*, VIII. The authorship of this biography has been questioned and the name of Antoine La Sale put forward instead; see e.g. P. de Wit, in *Nationaal Biografisch Woordenboek* 14 (1992), 387.

42 Douai (Section d'Archéologie) 1937, 21.

43 *Ibid.*, 49, fig. 318.

44 Tournai, the capital of present-day Hainaut province, was strictly speaking not part of Hainaut nor of Flanders during the fifteenth century. It had been a bishop's see from the sixth century and during the early Middle Ages was largely controlled by the counts of Flanders. In 1188 it was recovered by France and granted a charter. In the fifteenth century it was still under French protection but remote from French influence, thus constituting a virtually republican zone.

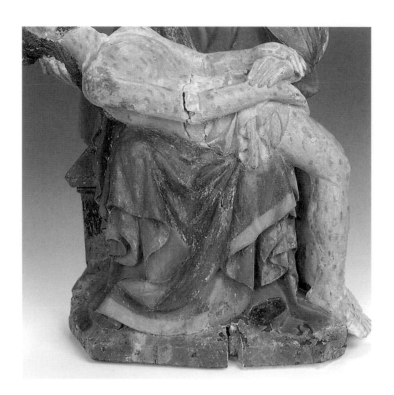

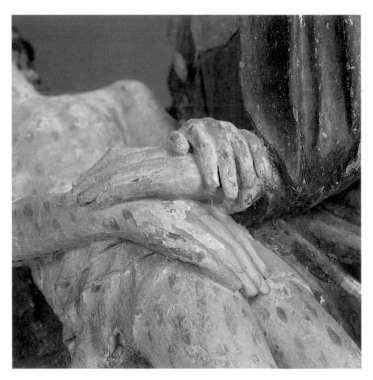

Figs. 1–2 Pietà, Beringen, Sint-Pietersbandenkerk (cat. 71)
(photographed during the restoration)

POLYCHROMY

Notes on the Technique, Conservation, and Restoration of Polychrome Sculpture

LEON SMETS

Several of the sculptures in this exhibition retain some or all of their original polychrome decoration. Others were overpainted at an early stage, covering the initial decoration or what remained of it. Many were robbed of their polychrome finish by poor conservation or, most commonly, by human intervention. The latter was prompted by a specific esthetic viewpoint which believed the colorful finish, often surviving only in fragmentary form, to be an obstacle to the appreciation of the medieval sculptor's mastery. All too often the desire to reveal the "honesty" and natural texture of the old oak led to the stripping away of all traces of paintwork. The notion – heavily influenced by Classicism – that the carving alone is the work of art and the painting mere decoration, held sway throughout the nineteenth and twentieth centuries, and has yet to be fully countered. It is only in recent decades that the polychrome decoration of wooden sculptures has begun to receive the attention it deserves. Scientific analysis has steadily enhanced our understand-ing of the techniques and materials used to decorate sculptures, revealing them to have been much more complex and diverse than was the case in panel painting of the same era. Our understanding of the conservation and restoration of early polychrome sculpture has advanced as our knowledge and appreciation of it has evolved. Emphasis is now placed on conservation rather than restoration to avoid falsifying the originality of the works in question. Extensive preliminary research is carried out before deciding whether or not to remove later overpainting. This essay offers a brief introduction to the techniques used to decorate medieval sculptures and describes the current approach to the conservation of polychrome works.[1]

Northern European sculptures were generally carved from oak in the Middle Ages, with much more sparing use of walnut. A variety of fifteenth- and sixteenth-century contracts and guild bylaws survive, all of which insist that only these two wood types might be used. Wood-carvers needed a supply of the best qual-

ity wood, which had to be properly dried and free of sapwood. The tree must not have died or have been infected with elm disease, as this would have made the wood too brittle for carving. The immense refinement and detail and the perfectly smooth surface finish that characterize the carving of so many late-medieval sculptures from the Burgundian Netherlands, raise the question of whether they were always destined for concealment beneath layers of primer and polychromy. The debate on this matter has been intensified by the systematic stripping in the nineteenth century of every trace of decoration from sculptures and even complete altarpieces. It is possible that certain pieces, usually very small ones, were not intended for painting. A trend arose in certain late-fifteenth-century workshops in the Lower Rhine and Kalkar regions which preferred to avoid polychrome decoration, or to restrict it to lips and pupils. Tilman Riemenschneider opted systematically for a monochrome approach. However, in 1420–80, the period in which we are interested, total decoration was still the rule.

The sculpture had to be prepared before it could be gilded and painted. First to be applied was a layer of primer, consisting of chalk and glue of animal origin, to which a little oil or white lead might occasionally be added. The mixture was brushed onto the sculpture. The smooth surfaces of the wood were sometimes roughened to ensure the primer would adhere properly. Pieces of linen soaked in glue were stuck over cracks and knots in the wood. The wooden core was regularly covered with linen until around 1300. This was designed to reduce the influence of changes in the wood on the less elastic primer layer, to prevent it from cracking and flaking off. The raw texture of the linen also allowed the chalk primer to adhere more effectively. It was discovered during the restoration of the Pietà sculpture from Sint-Pietersbandenkerk in Beringen (cat. 71) that a wide vertical crack at the front had been covered with linen, without first being filled. The old technique was evidently resorted to for many years to disguise flaws in the wood. The primer had to be applied with extreme care and took a great deal of time. Several layers were used, followed by a prolonged drying process. The primer formed the base for gilding and painting and so had to be smoothed down as much as possible to achieve the best optical effect. Sculptural details were then reworked and fine textures could be added to help imitate fabrics in conjunction with the paintwork.

The next stage was to apply the gold leaf. Gold was the most important material in fifteenth-century polychromy. Gilding not only made the finished product more valuable, it also elevated it and lent the work an almost transcendental air. Gold leaf was used liberally for the robes, attributes, and even the hair, and in the architecture and backgrounds of altarpiece cases. Gilding required a great deal of skill on the part of the gilder and was often entrusted to a specialist in larger workshops. Two gilding techniques were used, namely water and mordant gilding. In water gilding, the more common procedure, gold leaf is laid on a ground consisting of bole – a thick clay-like substance which is mixed with a little glue and brushed over the areas of the sculpture to be gilded. The gold leaf is then laid on top. This method is still used by gilders today. The tool used to apply the gold leaf is called a gilder's tip. It is a kind of brush with a row of squirrel hair used to pick up the leaf by static electricity and to position it on the surface. The bole remains slightly damp, ensuring immediate adhesion. When the bole ground is sufficiently dry, the gold leaf can be rubbed or burnished, giving it its characteristic sheen. Burnishing was done using a piece of agate, or sometimes with amethyst, sapphire or even a wolf's tooth. The natural colour of the bole figured strongly in the final effect, varying as it did from white, through yellow and orange to deep red. Red bole was the most common in the fifteenth century, infusing the burnished gold with a warm glow.

Mordant gilding was used primarily for technical reasons, where the gold leaf could not

be burnished because of the unevenness of the surface, or on finely carved fragments like hair or altarpiece tracery. The gold leaf was stuck on using gold size, a medium containing oil or glue. A combination of water and mordant gilding might also be used for esthetic reasons.

Gilders used silver leaf too, although this metal only appears sporadically in fifteenth-century sculptures. It served to color weapons and equipment realistically. Silver leaf was covered with a clear varnish to protect it against the atmospheric effects that would otherwise have turned it black. Gold leaf could be imitated by covering the silver with a pigmented varnish. This technique was eventually prohibited, however, as it basically amounted to falsification.

The painter/gilder could apply a variety of decorative techniques to the gilded parts of the sculpture to further enhance their colorful and luxurious appearance. Clear glazes, for instance, were laid on top of the burnished gold leaf. A more common effect was the sgraffito technique, in which the gold was painted over and then revealed by carefully scraping away the paint to produce ornaments ranging from simple to highly elaborate.

Points and stamps were also widely used to decorate the gold leaf. They were applied before the bole ground had fully hardened and was still elastic. Patterns were pressed in with blunt needles, punches and serrated wheels, on the clothing, attributes, haloes of saints, and the interior walls of altarpieces. The painting of motifs on top of the polychrome surface or the gilding also occurred, usually in combination with the decorative techniques referred to above. This approach was particularly common for decorative hems.

Once the gilding was complete, the sculpture could be painted. Apart from gold, the principal colors in fifteenth-century polychromy were blue and red, and to a much lesser extent green. Blue was the costliest pigment. The semi-precious stone lapis lazuli formed the basis of natural ultramarine, but was extremely expensive, and so azurite was most commonly

used. The mineral was finely ground and bound with glue to create an intense blue colour. The choice of red pigments was less restricted. Madder lake, derived from the madder root, and carmine, of animal origin, were customarily used for the topmost layer of paint, while vermilion, a bright, opaque red, served as an underlayer. Yellow and red ochres, including bole, were also available. Green pigments came in the form of malachite – a cousin of azurite – and the manufactured verdigris. Copper resinate produced a transparent green that could be used as a finish.

One member of the painter/gilder's workshop, usually the apprentice, will customarily have been occupied with the grinding of pigments. Some raw materials did not last for long, especially the binders. These were based on egg, gum, or size tempera which was quick-drying and easy to work. Oil-based paints were used for the flesh parts, as their transparent properties made them the ideal means for realistically imitating the skin's gentle transitions between pink and red.

Fairly common use was also made, finally, of relief elements glued or pinned to the sculptures to imitate brocade motifs. They generally consisted of sheets of pressed brocade in wax, plaster or metal foil.

Sculptures were usually varnished to protect their costly embellishment from rapid ageing and tarnishing, and to heighten the luster and depth of the colors. Only the deep-blue shades were left unvarnished.

Protection, Conservation, Restoration

Medieval sculptures were not deemed complete until their polychrome decoration had been applied. The wood-carving was essentially a core, the carrier of the precious polychromy and gilding. Thanks in particular to the often lavish use of gold leaf, the polychrome finish lent the piece a sumptuous and even supernatural distinction. Medieval polychromy required highly skilled craftsmen; the raw materials were extremely expensive and the

work was highly labor-intensive. Consequently, these craftsmen were better paid than the wood-carvers. The fruits of their labors have rarely come down to us intact, but awareness has grown in our own time that the old painting of sculptures has both an esthetic and a documentary value. It can tell us a great deal about the raw materials used by the medieval craftsman, his techniques and the esthetic standards of his time. The protection, preservation, and conservation of these valuable witnesses thus requires a great deal of knowledge and skill. The first step is to protect the piece from further damage and deterioration. The nature of the materials used and its complicated structure make painted wood extremely delicate. Protective measures have to be taken to prevent it from being damaged by insects or fungus. Atmospheric conditions, especially relative humidity, have to be stabilized and adjusted in accordance with the preservation of the wood. Shifting humidity inevitably causes the wooden core to expand and contract. If the air is too dry, the wood will shrink and crack, forcing the less elastic primer outwards and detaching it from the carrier, thereby resulting in direct material losses. The combination of moisture, dust, and air pollution attacks the surface. If the work of art is to be properly preserved, each of these elements has to be kept under control.

It is often necessary to conserve the sculpture. This might consist of woodworm treatment, reattaching separated fragments, fixing flaking paint layers and carefully cleaning the surface. The conservation of polychrome sculptures requires a thorough knowledge of the original material and the way it was used, and an understanding of the character and results of the selected conservation products.

It is increasingly believed that treatment of polychrome sculpture should be limited to conservation measures. Later additions or overpainting can provide documentary evidence of the work's past, and so their possible removal always has to be carefully considered beforehand. New additions are avoided wherever possible, as such measures may be considered a form of falsification. The cleaning or retouching of darkened or faded wood, the retouching of intrusive areas of white primer or the filling in of unsightly gaps in the polychrome decoration of a face, brings us into the realm of restoration.

Subject to certain conditions, more thorough restoration of a polychrome sculpture might be considered where, for instance, well-preserved and high-quality polychromy has been discovered beneath a less valuable layer of overpainting and can be revealed without undue risk. Such an operation is only embarked upon if systematic analysis of the successive paint layers has been carried out, and the necessary skills, equipment, time (a good deal of it) and financial resources are available. Stratigraphic analysis provides the restorer with vital information concerning the nature, age, and quality of the different paint layers, how they are composed and how much of each one survives. Examination of minute paint samples under the microscope helps establish the successive layers of color and varnish, and allows the pigments to be identified. Other important information is provided by surface analysis using a stereoscopic microscope, and photographic tools like macro and especially x-ray photographs to reveal the condition of the wooden core beneath the polychrome layer. In addition to laboratory examination, archive studies can provide useful information on the materials and techniques used in medieval polychromy. Contracts, legal documents and guild bylaws form a rich vein of knowledge.

As the visitor admires these masterpieces of late-Gothic sculpture from the Burgundian Netherlands, a little of his or her appreciation of the mastery of the medieval wood-carvers, gilders, and painters ought surely to be reserved for the researchers and restorers.

1 The following may be consulted for more detailed information: F. Buchenrieder, *Gefasste Bildwerke, Untersuchung und Beschreibung von Skulpturenfassungen mit Beispielen aus der praktischen Restaurierungswerkstätten des Bayerischen Landesamtes für Denkmalpflege 1958–1986* (Bayerisches Landesamt für Denkmalpflege, Arbeitsheft 40), Munich, 1990; M. Serck-Dewaide, in *Antwerpse retabels. 15de–16de eeuw, 2, Essays*, Antwerp 1993; J. Taubert, *Farbige Skulpturen, Bedeutung – Fassung – Restaurierung*, Munich 1978; K. van Vlierden, Het vergulden en polychromeren van laatgotisch beeldsnijwerk, in *Het laatgotische beeldsnijcentrum Leuven*, Leuven 1979, 394ff; E. Vandamme, *De polychromie van gotische houtsculpturen in de Zuidelijke Nederlanden. Materialen en technieken* (Verhandelingen van de Koninklijke Academie voor Wetenschappen, Letteren en Schone Kunsten van België. Klasse Schone Kunsten 44, no.35), Brussels 1982; R. Didier, C. Schulze-Senger *et al.*, in *Laatgotische beeldsnijkunst uit Limburg en grensland, 2, Handelingen van het Symposium*, Sint-Truiden 1992, *passim.* Journals and yearbooks containing regular items on technology and restoration reports include: *Bulletin de l'Institut Royal du Patrimoine Artistique*, Brussels; *Restauro, Zeitschrift für Kunsttechniken, Restaurierung und Museumsfragen*, Munich; *Zeitschrift für Kunsttechnologie und Konservierung*, Worms am Rhein; the yearbooks of the various German Landesämter für Denkmalpflege, etc.

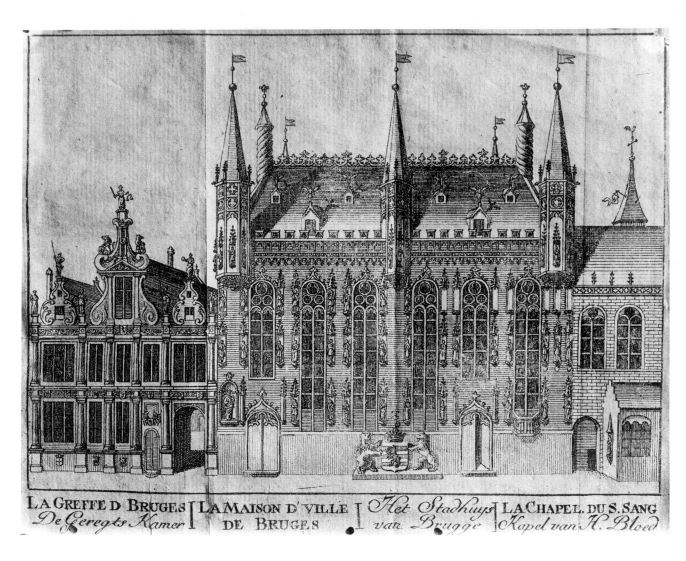

LA GREFFE D BRUGES | LA MAISON D'VILLE | *Het Stadhuys* | LA CHAPEL. DU S. SANG
De Geregts Kamer | DE BRUGES | *van Brugge* | *Kapel van H. Bloed*

Fig. 1 Bruges Town Hall and the office of the rural district
("Griffie van het Brugse Vrije"). Bruges, Stadsarchief

The Cultural Market
in the Burgundian Netherlands

WIM BLOCKMANS

Rulers and priests traditionally exploited the forms of expression deemed exceptional by their society to add prestige to their elevated position. This enabled them to convey their message to their subjects with additional force. The distinction enjoyed by these forms of expression was enhanced by their exclusivity, although the precise degree to which other groups could use the same media differed from society to society. It is also noteworthy that in certain societies the same forms retained their expressive power for centuries, whereas in others innovation itself was the criterion that bestowed the greatest distinction.

The latter was certainly the case in the Low Countries from the late Middle Ages onward. Court circles and especially the towns were centers of cultural innovation in the most wide-ranging of fields. Not all courts or towns were culturally engaged to the same degree, nor did the same branches of art flourish everywhere. What is more, tastes and active artistic centers shifted with time. Those seeking causal

links between the form of a society and the nature of its cultural expression are unlikely to find any simple solutions. This introductory essay will, nevertheless, focus on the specific social context that enabled the Burgundian Netherlands, and especially the towns in the old principalities of Flanders, Brabant, and Artois, to develop a considerably greater and more innovative cultural activity than other European regions in the corresponding period. We will approach the subject from three angles: the political framework, socioeconomic reality and the market for cultural products.

The Political Framework

The plural character of the term "Low Countries/Netherlands" tells us straight away that the area around the lower reaches of the great rivers did not form a single political unit five centuries ago. The territories that had grown up there since the tenth century gradually came to enjoy a fixed place in the minds of the

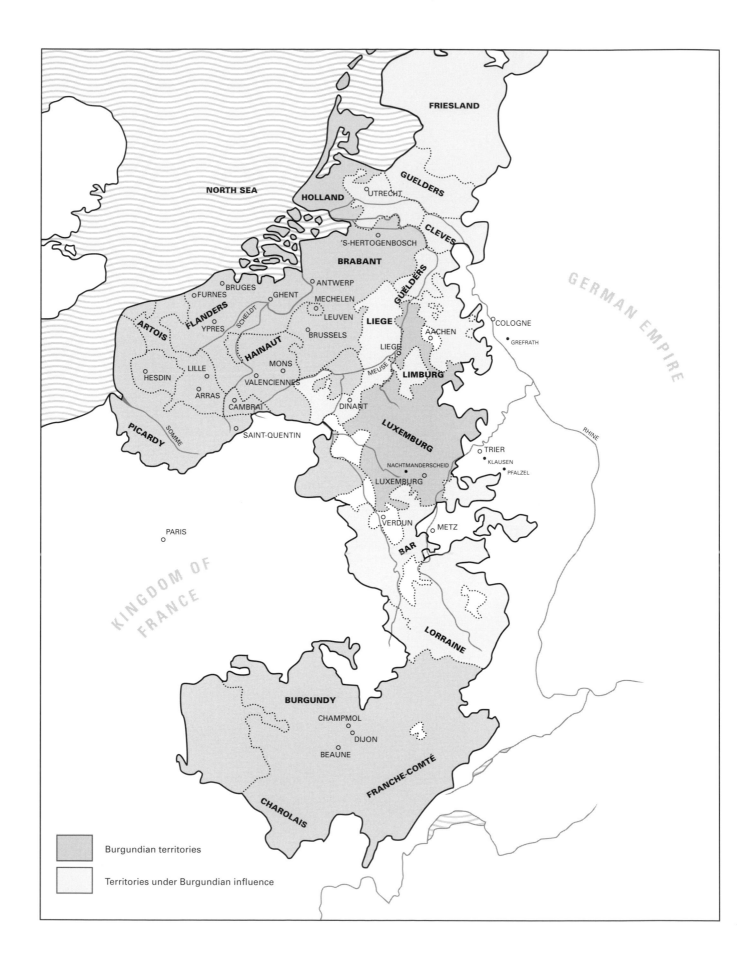

FRIESLAND

NORTH SEA

GUELDERS

HOLLAND

UTRECHT

CLEVES

'S-HERTOGENBOSCH

BRABANT

GUELDERS

ANTWERP

FURNES

BRUGES

GHENT

MECHELEN

FLANDERS

LEUVEN

LIEGE

YPRES

SCHELDT

BRUSSELS

AACHEN

COLOGNE

ARTOIS

GREFRATH

HAINAUT

LIEGE

GERMAN EMPIRE

HESDIN

LILLE

MONS

MEUSE

LIMBURG

ARRAS

VALENCIENNES

CAMBRAI

DINANT

LUXEMBURG

RHINE

PICARDY

SOMME

SAINT-QUENTIN

TRIER

NACHTMANDERSCHEID

KLAUSEN

PFALZEL

LUXEMBURG

PARIS

VERDUN

METZ

KINGDOM OF FRANCE

BAR

LORRAINE

BURGUNDY

CHAMPMOL

DIJON

BEAUNE

FRANCHE-COMTÉ

CHAROLAIS

Burgundian territories

Territories under Burgundian influence

38

ordinary people. The famous Joyous Entries – the constitutional documents which every duke of Brabant had to swear to respect and uphold upon his investiture – specified amongst other things that inhabitants could not be summoned before a court beyond the bounds of the duchy and that outsiders were prohibited from holding public office. Institutions and legal customs, allied with the historical glorification of the ruling dynasty, formed the basis for a collective sense of identity within each territory. Stirring historical episodes, like the resistance offered by Dukes John I and John III of Brabant to coalitions of neighboring potentates in 1288 and 1336 respectively and the Flemish struggle for independence from France around 1300, further nourished the sense of belonging to an illustrious nation. The everyday world of ordinary people in the fifteenth century was, however, much more strongly determined by their locality. Townspeople held a form of citizenship that differed from the legal status of a person living in a nearby village. The town walls provided a physical demonstration of the special character of urban compared to rural society. They delimited a space in which specific rights and duties prevailed, access to which was controlled by gates that were locked at night and at times of emergency. The citizen knew that his town's authorities would furnish him with legal support outside its walls and even abroad, but also that he could be held jointly responsible for the misdeeds of fellow citizens. Countless rules and regulations favored the burgher over the outsider. Laborers, for instance, earned more in the town than in the surrounding countryside, and whereas the townsman was permitted to practise his trade in the country (in the unlikely event that he wished to do so), a village-dweller was prohibited from working in the town. Urban brewers and weavers prevented others – forcibly where necessary – from engaging in their trade for miles around; farmers and shippers were obliged to transport grain to the urban market. Townspeople purchased country estates near the town, both as an in-

vestment and as a means of ensuring their own provisions in times of shortage. Tenant farmers who found themselves in dispute with their town-based landlords were obliged to appear before the urban court, which favored the burgher both formally and informally. The townspeople dominated the countryside in these regions more totally even than a feudal lord. The influence of the major towns was so strong in this period that even aristocrats were obliged to purchase citizenship of a town like Brussels or Leuven to prevent their grip on the countryside from being weakened.

Urban consciousness was thus very strongly developed in the Low Countries, which is hardly surprising when one considers that one in three inhabitants of Flanders and Brabant lived in a town. And they lived well, or at least better than elsewhere. People were clearly aware of this fact as the differences were constantly visible in everyday life. The region's towns were also exceptionally large. No reliable calculations exist for fifteenth-century Ghent and Bruges, but the population of the two towns in the mid-fourteenth century must have been around 64,000 and 46,000 respectively. This makes them the biggest cities in north-western Europe after Paris. Their populations might have declined somewhat in the fifteenth century, especially in Ghent, but reliable sources are lacking. Ypres was the third largest city in Flanders with approximately 10,000 inhabitants. It was already in decline by the fifteenth century after an eminent past as a center of cloth-making and trade. Second-ranking towns with populations between 5,000 and 10,000 included Kortrijk, Oudenaarde, Dendermonde, and Sluis. In the neighboring region, Lille, Douai, Tournai, and Valenciennes all had populations of over 10,000, while Arras, capital of Artois, had around 20,000 inhabitants. As for Brabant, Leuven's population had declined to 17,700 by 1480, while Brussels, Mechelen, and Antwerp had grown to 30,000, 20,000, and 40,000 respectively. These cities were located relatively close together, forming an exceptionally dense network only rivalled in

this period by Northern Italy. By way of comparison, Holland's biggest city, Leiden, had a population of barely 14,000 in 1500, while Amsterdam, Dordrecht, Delft, and Haarlem could only run to between 10,000 and 12,500.

The immense demographic and economic potential of the Southern Netherlandish cities inevitably led to bids for political power. They had already won a substantial degree of self-government by as early as the thirteenth century, largely in exchange for subsidizing their rulers. In the second half of the thirteenth century, wealthy citizens of Arras and Ghent loaned the count of Flanders sums exceeding his regular annual income. The battlefields of the fourteenth century were dominated by the town militias, made up of artisans, which managed both to withstand the armies of count and king and to establish their own town's hegemony over the surrounding countryside and smaller towns. The county could not be ruled without the towns, but could manage without the count who was regularly obliged to flee to France and whose power could only be restored with royal assistance.

The cities of Brabant also put a great deal of pressure on the country's rulers, not least because of the recurring periods of weakness experienced by the ducal dynasty. But their dominance was less pronounced than that of their counterparts in Flanders, where Ghent and Bruges especially showed a lasting desire to carve the county up into spheres of influence under their respective control. It was in the throes of such a highly-charged political situation that the powers of the count passed by marriage to Philip the Bold, duke of Burgundy, and son, brother, and uncle of successive kings of France. The transition was initially viewed by Paris as a means of returning the counties of Flanders and Artois to the French crown by inheritance after force of arms had failed. However, a string of unforeseen dynastic developments, political fixes, and conquests was destined to transform the area into the nucleus of a new political unit. Although Ghent was still in revolt at the time of his succession,

Philip rapidly succeeded in establishing a peace acceptable to all parties. His reign ushered in a remarkable economic revival for the cities of Flanders. Bruges in particular benefited from the restoration of good relations with England and the number of foreign merchants settling in the city increased rapidly in the 1390s. In the meantime, Philip's attention had fixed itself on the neighboring duchy of Brabant, which was ruled by an elderly, childless aunt of his consort. Protracted negotiations finally resulted in 1406 in the succession in Brabant of Philip's younger son, considerably strengthening the Burgundians' position in the Low Countries. For the time being, however, the move was seen principally as a means of lending weight to the duke of Burgundy's claim as *premier pair de France* – the kingdom's leading peer after the king – to regency over the feeble-minded King Charles VI.

There is always a temptation to view history as if it were the only possible, logical, or even desirable outcome. Things were very different, though, for contemporaries, who could have no knowledge of their capricious future. In addition to Brabant, Duke Philip the Bold had also established close ties with the House of Bavaria, which ruled over Hainaut, Holland, and Zealand – counties surrounding his own – and which had also provided France with its queen. A double marriage of the two heirs to each other's sisters in 1385 had assured Philip good neighbors in both France and the Netherlands and immense potential dynastic rights. After many trials and tribulations, Duke Philip the Good of Burgundy was finally able to call on these rights in 1425 and beyond as the basis for his claim on Hainaut, Holland, and Zealand. The heiress to these territories, Jacqueline of Bavaria, was childless and her support weak, leaving her no match for the military and diplomatic vigor of Philip the Good who gained control over the three counties in 1427. So it was that the possibility of an entirely different power structure held out by Jacqueline's marriage to Duke John IV of Brabant came to nothing because of the latter's

evident weakness. Her brother, the elected bishop of Liège, John of Bavaria, who much preferred worldly affairs to matters ecclesiastical, might also have sent the union of territories in an entirely different direction had he not been poisoned in 1425. By 1433 Hainaut, Holland, and Zealand had all been brought under the formal authority of Duke Philip the Good. In the meantime he had also purchased the county of Namur and had been recognized in 1430 as the heir of his cousin, Duke Philip of Saint-Pol, Brabant, and Limburg, who died childless. In the space of less than eight years, entirely unpredictable dynastic and political events had confounded all earlier political calculations. Numerous territories, to wit three duchies, eight counties, and three seigneuries, from Charolles and Arras to Enkhuizen, were henceforth ruled by the same monarch.

Duke Philip the Good was to make one or two further territorial acquisitions, but these related to peripheral regions: Picardy and Mâcon in 1435, Luxemburg in 1443, and the appointment of his son David as bishop of Utrecht in 1455. From 1430 onward, his outlook was governed by the fact of his rule over a contiguous complex of prosperous territories in the Low Countries. His patrimonial domains in Burgundy had been permanently eclipsed (they were yielding a mere quarter of his regular income by this time) and Philip was obliged to shift his gaze from France and to focus instead on the German Empire, where most of the territories under his control were now located. This made him the most prominent vassal of the king or emperor of Germany, with whom he had already clashed – the king having done everything in his power to prevent a member of the House of Valois from succeeding in the imperial fiefs of Holland, Zealand, and Brabant. Now that these moves had proved abortive, Philip's ambition grew and he began to think of a king's title, which would after all be in keeping with his eminent status. Negotiations held during the 1454 imperial diet and subsequently by Philip's son Charles the Bold in 1473 were, however, destined to achieve the opposite result. Charles's sole legal heir was his daughter Mary who was engaged to Maximilian, son of the emperor. Consequently, upon Charles's death in 1477, all Burgundian territories within the Empire passed into the hands of the Habsburg dynasty.

The territorial gains achieved by Charles the Bold by means of persistent and sometimes brutal military campaigns immediately reverted upon his death. As far as the Netherlands were concerned, these included the prince-bishopric of Liège and the duchy of Guelders. The latter was to remain a thorn in the Habsburg flesh until deep into the sixteenth century and continued to foment conflict for many years after. The fact that it took until 1543 for a region that was neither particularly wealthy nor tightly organized to be annexed by Europe's most powerful monarchy can be explained by the Low Countries' lack of a clearly defined eastern boundary. Under different circumstances, an alternative, rival power structure might have arisen in which Guelders was linked to Gulik, Berg, and Cleves to the east, and Drenthe, Friesland, and Groningen to the north. Moves in this direction were certainly attempted, but were destined to come to nothing because of the lack of cohesion in each of the areas in question, as a result of which more broadly-based unions were constantly undermined by competing factions. Although France supported Guelders against Burgundy as part of its strategies, the dukes of Burgundy responded by forming successful alliances with the lords of Cleves. This long-lasting and unstable situation often hindered trading relations via the great rivers linking the areas around the Rhine, Maas, Waal, and IJssel with the rich areas to the west and the towns of the Hanseatic League.

Meanwhile the unification of the most important territories in the Netherlands encouraged the ruling dynasty to seek to consolidate its authority there. However, the long-standing tradition of separate institutions and legal systems in each territory rendered this a far from simple objective. The dominance of the towns

over their hinterlands was a particularly intransigent obstacle to the consolidation of central power. It is hardly surprising, then, that the process led repeatedly to serious conflicts, revolts, and even years of war between the duke and his principal cities. The roots lay in the distribution of power, with the cities watching the autonomy they had gained over the centuries being whittled away by the dukes' attempts to exercise direct control over all their subjects. The issue was one of competence – who should exercise legal and fiscal authority and the power to appoint aldermen – and the hegemony of the city over its surrounding area.

The first major confrontation was the Bruges revolt of 1436–8, which followed the military debacle of the Burgundian blockade of the English bridgehead of Calais. Duke Philip the Good found himself in acute personal danger upon entering Bruges and he lost dozens of noblemen from his entourage. The city was finally forced to surrender by a military and economic blockade, exacerbated by a Europe-wide failure of the harvest and the subsequent outbreak of plague. Subjection curtailed the city's administrative autonomy, robbed it of its supremacy over Sluis and the surrounding area known as the "Brugse Vrije" (Free territory of Bruges) and imposed a crushing fine. Ghent was to experience similar treatment a decade later. This time the conflict was sparked off by the city's refusal to introduce a tax on salt, which, following the French king's example, would have guaranteed the duke an adequate, regular income, without the need for constant negotiation with the representatives of the main cities and the Free territory of Bruges (which together formed the so-called "Four Members"). The conflict escalated, seemingly fanned by the duke himself as a pretext for clipping the wings and making an example of the biggest city in all his territories, and the one with the strongest tradition of self-determination. Once again the outcome was sieges, the sacking of towns in Ghent's "quarter," raids, the blockade of Ghent, and a pitched battle at Gavere in 1453, where the military superiority

of the duke's armies proved decisive. To achieve this victory, the duke had disrupted normal political life in the county of Flanders for five years, lost a son in battle, and been obliged to seek financial assistance from other regions before finally bringing the great city to its knees. The subjection of Ghent took on a ritual character, as was to be the case on other occasions in the city's history, right through to 1540, when Charles v paraded the defeated rebel leaders in public with a noose around their necks. The representatives of the city were forced to kneel before the duke, bareheaded and barefoot, wearing only their shirts, to beg for his forgiveness. Three city gates were sealed, the craft guilds lost their banners and much of their political influence, the Ghent judiciary was made subordinate to that of the duke, and another enormous financial penalty was exacted.

The people of Ghent tried hard in 1458 to receive the duke with the greatest possible splendor and humility, calling upon artistic representation of biblical themes like David and Abigail, Solomon and the Queen of Sheba, Gideon's Fleece, the Prodigal Son, and the Good Shepherd. Nevertheless, the humiliation they had been forced to suffer in 1453 erupted once again into revolt during the Joyous Entry of Charles the Bold in 1467. The rebellion achieved nothing but the further humiliation of the city and even greater restriction of its political autonomy. The townspeople, especially the craftsmen, reacted against this in turn during the revolt that followed the death of Charles the Bold in 1477. On this occasion they managed to regain many of the rights of which they had been stripped in previous decades. A similar process occurred in other towns and regions, but as soon as the new ruler, Maximilian of Austria, saw his chance, he too picked up the threads of his predecessors' centralizing policy, provoking further revolts and even a civil war that dragged on from 1484 to 1492. At the outset only the Hook party (consisting largely of nobles, burghers, and artisans) in Holland, Zealand, and Utrecht resisted, fol-

lowed by Ghent, Bruges, and in their wake, the rest of Flanders. In 1488, however, uprisings occurred in Leuven and Brussels and there was renewed unrest in Holland. Military blockades led to the subjection of one town after another, each capitulation followed by financial bloodletting, the restriction of the craft guilds' political influence, and the consolidation of the judicial and administrative grip of the central government, all of which had been on the duke's agenda since 1438.

Political evolution in the fifteenth century thus swung back and forth like a pendulum between the duke's urge to centralize and resistance to this from towns and regions. The trial of strength was to continue until the revolt against Philip II of Spain. The changing dynastic and foreign policy fortunes of the ruler were the primary reason why he was repeatedly forced to make concessions. Whenever the immense cost of military campaigning began to weigh too heavily, he had to turn to the representatives of his subjects for finance, enabling them to impose their demands. Similarly, if the heir to the throne was in a weak position, his subjects were able to exact respect for their privileges and customary rights. This was most clearly apparent in 1477 when the eighteen-year-old Mary of Burgundy was obliged by the disastrous setbacks of her father to submit to virtually everything demanded of her throughout the Low Countries. Five years later, her fatal fall from a horse unleashed another succession crisis, during which her former subjects were once again able to call the shots.

Surveying the political landscape in the year 1500, it is evident that the position of the sovereign and his centralized institutions had gained considerable strength in the course of a century. The sovereign's regional courts and the Great Council (known after 1504 as the Great Council of Mechelen) acted as central courts of appeal or cassation in an increasing number of cases, usually at the request of the parties involved. In so doing they systematically undermined the judicial hegemony of the principal cities, partly in the interest of injured parties.

The volume of centrally imposed taxes in Flanders was three times higher on average in 1500 than in 1400, and twice as high as in 1450. The political freedom of the cities had been significantly curtailed. They had pursued an active foreign policy until around 1435, geared towards promoting their own commercial interests. But by 1500, the ruler alone was permitted to conclude treaties, which he did to suit his own political needs, pushing commercial considerations into second place. City councils came under the control of the government which reduced the influence of the craft guilds and rewarded compliant politicians. In this way, and at the price of much bloodshed, a stronger state was created which reduced the autonomy of towns and regions, but which was still obliged to take account of their deeply-rooted privileges and rights. The cities of Flanders certainly lost ground demographically and economically, but they remained significant concentrations of power and wealth.

Craft and Trade

The material foundations for the relative prosperity of Flanders and Brabant lay in the centuries-old combination of export-centered textile production and long-distance trade. The two regions had already built up a strong position in the international markets by the thirteenth century. Brabant had developed somewhat later in response to Flemish competition, but in some respects it was less vulnerable for that very reason. The average basic cloth requirement in the Middle Ages was two to three ells per person. In the early fourteenth century, the typical cloth-producing town of Ypres was turning out between 69 and 83 ells per inhabitant. The figure for Leuven around 1350 was 42 ells, with a similar output in Leiden c. 1500. Most of the cloth produced in those towns was evidently destined for external sale, often on foreign markets, as virtually all the towns in the Netherlands produced ordinary fabrics of their own. The large scale of production in centers like Ypres and Ghent,

where thousands of weavers and fullers were active, allowed highly rational organization. There was also scope for specialization: the exceptional quality of Flemish and Brabant luxury fabrics arose from the many successive processes to which they were subjected, rendering them compact, fine, and multicolored. This required raw materials, some of which relied on specialist rearing, like the wool of particular breeds of sheep, woad, and dyer's rocket, and other materials which had to be imported regularly from overseas. The commercial success of Flemish and Brabant cloth thus derived from a long-established craft tradition, large-scale production with scope for specialization, and integration with specialist agriculture and international trade routes.

As the fourteenth century progressed, the cloth industry in Flanders and Brabant was increasingly exposed to competition from England itself, Northern Italy and Holland. A solution was found in the shape of further specialization. Simple products could be imitated elsewhere, but the most refined retained their appeal. New varieties were also produced (including cheaper ones) and the weaving of linen introduced. The development of tapestry-weaving was particularly remarkable, being highly capital- and labor-intensive and demanding great skill. The number of tapestry-weavers increased in most towns in the Southern Netherlands in the course of the fifteenth century, with particularly active centers in Arras, Tournai, Ghent, Oudenaarde, and above all Brussels. The complex techniques associated with the craft could only be developed on the basis of experience gained in the cloth industry. The high price and lengthy production period made tapestries, especially large ones, a highly exclusive product, which could only be manufactured for court circles. This factor too rendered a tie-in with international trading networks essential.

The German Hanseatic League had long been Flanders' most important trading partner. It bought up the textile output of entire small towns and villages to sell in the markets around the Baltic. Italy continued to be an important customer, even after domestic production began to siphon off some of the demand. England bought linen from the Low Countries on an immense scale. A characteristic of the cities of Flanders and Brabant was the wide range of auxiliary crafts that grew up around the basic structure of the textile industry. These included fashion tailoring which was particularly well established in Bruges. The city's craftsmen used the fur and amber shipped from Prussia by the Hansa to create expensive clothes and jewelry, a proportion of which was then re-exported. Dozens of goldsmiths, leather-workers, furriers, milliners, pewterers, weapon-makers, and practitioners of many other crafts were located in the large trading towns. They found sufficient work because of the inflow of every imaginable raw material and the presence of the biggest possible circle of customers. Hundreds of merchants from Italy and the Iberian Peninsula, the German Empire, France, England, and Scotland converged at the fairs, of which those in Bruges, Antwerp, and Bergen-op-Zoom were the most important in the fifteenth century. The fairs at Deventer were vitally important to the link between the Rhineland, Holland, and the Hansa region.

The Italians, who occupied by far the strongest position when it came to long-distance trade, did not penetrate much further north than Bruges. They established merchant colonies in the Flemish city in the late fourteenth century, and were granted certain privileges there. The houses of the Genoese and Florentine merchants and the famous inn run by the Van der Beurse family of brokers were located in what was then called "Beursplein" (modern-day Theaterplein). The Luccan merchants settled nearby. The Biscayans, Castilians, and Scots, meanwhile, had houses on the opposite side of Kraanplein, while the English and the Hansa merchants were based two streets further to the north. In other words, the headquarters of most of the foreign merchants were located within a few blocks of houses round three city squares to the north of the

main market square (Grote Markt). Dozens more must have bought or rented houses or stayed in inns in the same area. There was a branch of the Medici bank a hundred meters or so from Beursplein. A total of at least five hundred foreign merchants used to reside in Bruges in the summer months. The rates for bills of exchange were displayed each evening on Beursplein. The modern word "bourse," or stock exchange, thus evolved from the name of a family of Bruges brokers.

Fifteenth-century Bruges was, more than any other city in the Low Countries, an international trading metropolis. Antwerp was growing in its shadow, and in a certain sense complementing it commercially. Bruges emptied during Antwerp's Whit fair, its merchants flocking with those of other nations to rented or purchased buildings, apartments, and rooms around Antwerp's Grote Markt. They came into contact there with large numbers of traders from the German Empire, particularly the southern regions which were growing rapidly on the strength of their trade in copper, silver, and fustian – fabric woven from a mixture of linen and cotton. For the time being the leading trading houses retained their bases in Bruges, only transferring to Antwerp in the crisis years after 1484. Archduke Maximilian's conflict with his rebellious cities caused him to order foreign merchants to quit Bruges in favor of the more peaceful and loyal Antwerp. The unrest and the associated trading blockades had anyway persuaded merchants to look elsewhere. Art-dealers had been renting stalls at Antwerp's fairs since the fifteenth century, with altarpieces as their main product. This custom did not take root in Bruges until 1512, possibly suggesting a difference in quality between the items offered for sale.

Bruges' century of greatness thus stretched from 1384 to 1484 – characteristically from one rebellion to another, with a further uprising in the middle. The city enjoyed the most important concentration of international trade and so its economic development was synonymous with that of the Southern Netherlands as a whole. Bruges' commercial activity grew until around the middle of the fifteenth century and remained at a very high, though slightly declining, level until around 1480. The city experienced a series of shocks in the 1430s when political disputes between England and Burgundy were fought out through economic sanctions and blockades. These led to the uprising of 1436–8 and – though a logical outcome of the troubles, the most painful blow of all – the exodus of the Hanseatic merchants. The latter imposed another trade boycott in 1451–7 to pressurize Bruges into settling a series of disputes. It was hardly coincidental that this too occurred during a period of rebellion, this time on the part of Ghent. The Antwerp market grew steadily throughout the fifteenth century, unhindered by serious political, economic, or social conflict. It was thus perfectly placed around 1480 to leave behind its complementary role and resolutely to take over Bruges' hegemony.

The commercial boom was naturally underpinned by the availability in Bruges of products from an extensive hinterland taking in the entire basin of the River Scheldt. The attraction of Bruges' labor market is apparent from the number of citizens who migrated there. New registrations peaked in the 1420s and 1440s (separated by the crisis years of the 1430s) at an average of 239 and 233 a year respectively. It should be borne in mind, too, that only the heads of families were obliged to register, along with anyone wishing to engage as a master craftsman. The quoted figures thus have to be raised to allow for family members and non-registered immigrants. It is possible, therefore, that around a thousand people a year were settling in Bruges in the decades in question. The average figures for the two successive decades were 165 and 159, falling to 127 in the 1470s, and to below 100 in the 1480s. In the period 1420 to 1478, 48.66% of the new citizens came from over 50 km away, or from outside the county. This figure rose to as much as 53% in the peak period 1440–59. Twenty-six percent of the immigrants worked in the clothing sec-

tor, 13.4% in the (other) luxury trades, 18.7% in the cloth industry, and 11.9% in construction. Over 31% of the new masters enrolling in the Bruges guild of image-makers in the fifteenth century came from outside the city, even though they were obliged to pay a Flemish pound (a *"pond groten,"* equivalent to 24 times the daily wage of a trained craftsman) more than existing citizens, and three pounds more than the son of an established master. The attractiveness of the Bruges labor market was certainly influenced by the favorable employment opportunities and high wages it offered. Wages in the city's construction industry were raised by 10% in 1440, and people in Bruges earned significantly more in real terms than anywhere else in the Netherlands. In the cheap years 1465–8, a Bruges master mason could purchase 68.5 liters of rye with his theoretical annual wage, which was 2.4 times as much as a colleague in Haarlem. It is hardly surprising, then, that so many breadwinners from Holland and Brabant chose to resettle in Bruges.

An unparalleled number of specialized crafts were present in Bruges, the favorable market conditions offering their practitioners extra rewards on top of high wages. It is evident that, viewed in the long term, grain prices in Flanders and Brabant in the period 1440 to 1475 were low. Grain was a crucial item of family expenditure (generally accounting for around 44% of available income), and so low grain prices allowed relatively large financial scope for spending on craft products and, for the better-off, on luxury spending and investment. The level of prosperity in the fifteenth century (up to 1480) was generally good compared to previous and subsequent centuries, with a particularly favorable period between 1440 and 1475. We know next to nothing about the profit margins realized by merchants and entrepreneurs in this era, but the mark-up they enjoyed over craftsmen's wages suggest that they did excellent business indeed, leaving them with ample reserves for investment in luxury products. The economic downturn that began in 1475 had a two-fold impact on cultural out-

put. In the first place Bruges' attractiveness as a labor market declined sharply. The number of new masters enrolling in the image-makers' guild halved, and the recruitment of apprentices fell to a third of its peak level. Secondly, 77% of masters no longer took on apprentices, compared to only 40% prior to 1475. This means that the average number of apprentices for masters who did continue to employ them rose from 2 to 3.25, a concentration facilitating the production of cheaper, serial work.

The Market for Cultural Products

No sharp distinction yet existed in the fifteenth-century Low Countries between craftsman and artist. All producers worked within the craft guild structure. Bruges' sculptors *("beeldsnijders")* and organ-builders, for instance, belonged to the carpenters' guild, while Ghent's sculptors were allied with the painters and its stone-cutters with the stone masons. The Bruges guild of image- and saddle-makers included the painters, glaziers, mirror-, and harness-makers. In Antwerp the sculptors formed a corporation with the gold- and silversmiths, painters, glass-makers, and embroiderers. They were subject, as were all guild members, to regulations that strictly delineated their field of activity from that of related crafts and rivals from outside the city. No-one viewed them as "artists" in the sense first established in Renaissance Italy.

The Bruges city bylaws of 1432 reveal how the fair organized in April and May for general trade also functioned as an art market. Craftsmen from outside the city could only offer wooden altarpieces and carved statues or other work of the kind produced by the Bruges image-makers and painters on the market's three *toochedaghen* or "showing days." The relationship between art and general trade is shown even more clearly in article fifteen of the carpenters' charter. This permitted wood-carvers and organ-makers to work in the evening and on the eve of feastdays, but only if the merchant to whom they were contracted was still await-

ing delivery while his ship was ready to sail. The measure will have been aimed at the galleys of Venice, Florence, and Genoa which put into Sluis once a year to bring Mediterranean and Oriental products to the annual market. They embarked on their return voyage a few weeks later, laden with English wool and cloth from the Netherlands, possibly with grain and wood from the Baltic, and certainly with a variety of art objects.

The presence of the foreign traders undoubtedly acted as a significant stimulus to artistic production, as they were wealthy patrons and dealers who showed a great interest in the exceptional products of the Flemish and Brabantine markets. Illuminated manuscripts from Bruges were already being shipped all over Europe well before 1400, establishing intensive trading relations: they have been found in the valley of the River Vistula; the Lower Rhine region; Westphalia and Lübeck; South-East England; the valleys of the Seine, Marne, Saône, Rhône, and Po; Aragon and Navarra; Portugal and Bohemia.

This pattern was reinforced from around 1430 onward, when Flemish painting began to develop a new, individual style that came to occupy the center of the European stage. The balance of trade between Italy and the Low Countries showed a clear surplus on the Italian side, leaving the Southern merchants with both large profits and plenty of free cargo space aboard their galleys for the return voyage. They used a significant proportion of these to purchase art objects for their own collections and possibly for selling on. The representative of the Medici bank in Bruges, Tommaso Portinari, shipped a triptych he had commissioned from Hugo van der Goes back to his native city of Florence, where it was hung in his family chapel at Santa Maria Novella. The marvelous hues of the oil paint caused a sensation in the Italian city. Memling's *Last Judgment*, which he also intended to ship to Florence, was waylaid by pirates and ended up in Danzig (Gdansk). The Luccan cloth merchant Giovanni Arnolfini supplied large quantities of expensive cloth to the court

of Duke Philip the Good and had his portrait done by Philip's court painter, Jan van Eyck. Hundreds of altarpieces and other wood-carvings also found their way to England and the Hansa region, the two other principal trading partners of the Southern Netherlands. The fairs of Bruges and Antwerp provided the ideal opportunity for English and Hanseatic merchants to stock up with all kinds of refined products that they were not capable of producing at home. Their vessels mostly carried raw materials to Bruges, and returned home with expensive fabrics, finished products, wines and fruit from the Mediterranean, Oriental fabrics and spices, and everything the Flemish and Brabant art markets had to offer. The strong foreign presence in Bruges and Antwerp thus acted as an additional stimulus to the Low Countries' art producers, whose market was widened considerably thanks to the general goods trade.

Foreign merchants were, nevertheless, only able to take advantage of a potential that already existed, and whose roots have to be sought in the Low Countries themselves. Nor can the role played by the Burgundian court be overlooked. The French royal House of Valois, from which the ducal dynasty sprang, had shown a keen interest in artistic expression, particularly in exquisitely illuminated manuscripts, since the mid-fourteenth century. It was precisely in this period that the position of the French monarchy was sharply undermined by the English conquest of the whole of southwestern France and parts of Normandy and Picardy. One might thus venture the hypothesis that the French kings were seeking through their increased investment in art to strengthen the legitimacy of their power, which was being so sorely tested in reality. The position of the dukes of Burgundy and their patronage of the arts might be interpreted in a similar way. These younger scions of the House of Valois, the first two of whom, Philip the Bold and John the Fearless, retained their close connections with the French court, were no doubt brought up with a taste for artistic splendor, as were Philip's brothers, the dukes of Berry,

Bourbon, and Anjou. Apart from a personal affinity for artistic expression, these rivals for the control of the underage and later feeble-minded King Charles VI (1380–1422) will also have recognized that artistic patronage was capable not only of adding luster to their court but also of subtly conveying a political message.

When Duke Philip the Bold founded the Chartreuse de Champmol near Dijon and recruited the finest sculptors in the Netherlands to execute the building's monumental statues and funerary monuments, his aim was to create for his new dynasty a monument equal to the royal mausoleum at Saint-Denis. Philip the Good appointed the already famous Jan van Eyck as his court painter, whose principal task was to portray members of the ducal dynasty and their forebears. The great painter will, however, also have helped fashion the glorious spectacle of the Burgundian court – at the end of the day he remained a craftsman, albeit an extremely accomplished one.

The Burgundian dynasty grew up in the shadow of the French royal house to become one of the most powerful in Europe. So much so, that Philip the Good and Charles the Bold both aspired to a king's crown of their own. Viewed in this light, their immense interest in the means of cultural expression that went with their political status can hardly be interpreted as anything other than compensation for the relatively young and humble (ducal) rank of their dynasty. It also explains the assiduousness with which they commissioned historians to prove the descent of the dukes of Burgundy from all the great heroes of Christendom and Antiquity, themes that they then had portrayed in miniatures, tapestries, dramas, and performances mounted during court feasts and Joyous Entries into their cities. Such works conveyed the dukes' ambitions to all their subjects, and the message was passed on in many different languages by the ambassadors and foreign merchants who had witnessed the spectacle.

The coinciding of the dukes' ambitions with the perfect environment in which to nurture them explains the exceptional cultural radiance of the "Burgundian" Netherlands. Political stability certainly contributed towards prosperity and a favorable climate for investment in art. Apart from the uprisings and certain regional troop movements, the Low Countries did, indeed, enjoy a rather unusual peace. The cultural explosion did not take place in the dynastic homeland of Burgundy, despite the efforts of the first duke to promote Dijon, a town of barely 10,000 inhabitants, located far from the major flows of international traffic. The big cities of the Southern Netherlands, by contrast, offered the ideal environment, as they were sufficiently large and prosperous to generate substantial domestic demand for art products which was then enhanced by commissions from foreign merchants and courtiers.

The dukes invested relatively little in architecture, the most expensive form of cultural expression. The need to keep all their territories under control obliged them to travel around almost incessantly. This prevented them from devoting a great deal of attention to their palaces. Alterations to the royal residences in Ghent, Bruges, and especially Coudenberg in Brussels, were basically financed by the city authorities. The dukes were, however, interested in art objects on a smaller scale, which they could take with them on their travels and show off wherever they went: tapestries, expensive clothes, jewelry, metalwork, manuscripts, altarpieces, wood-carvings, and paintings. These items were also attractive to other purchasers because they could be readily transported to distant destinations. Smaller or cheaper versions of the same items could also prove tempting to less wealthy customers, as a result of which the craftsmen enjoyed a fairly stable level of demand, irrespective of whether or not the court was present at the time. Production as intensive and varied as that of the Southern Netherlands could not, therefore, arise in other regions where there were no wealthy patrons other than the court. Local elites and institutions ought thus to be numbered amongst the most important customers for the Southern Netherlands' substantial artistic output.

The urge of the lower classes to imitate the elite doubtlessly served as a constant stimulus towards innovation on the part of the wealthiest patrons. Recent research has shown that the religious confraternities functioned as important meeting points where members of the ruling dynasty, noblemen, foreign merchants, the local elite, and the clergy could meet artists. As members of the same organizations they will have influenced each other's artistic preferences, and artists were brought into contact with prospective customers. A vibrant and diverse setting of this kind, with artists and patrons from all over Europe and an equal spread of destinations for the commissioned works of art, was more strongly present in Bruges than in any other European region with the exception of Italy. Whether or not these quantitative stimuli had a matching qualitative impact in terms of originality and execution is a fascinating question for the art historians to answer.

Selected Bibliography

M. W. Ainsworth and M. P. J. Martens, *Petrus Christus, Renaissance Master of Bruges*, New York 1994.

W. Blockmans and W. Prevenier, *Under the Spell of Burgundy,* Philadelphia (forthcoming).

W. Brulez, *Cultuur en getal. Aspecten van de relatie economie–maatschappij–cultuur in Europa tussen 1400 en 1800,* Amsterdam 1986.

M.P.J. Martens, New Information on Petrus Christus' Biography and the Patronage of His Brussels *Lamentation, Simiolus* 20 (1990–1), 5–23.

Idem, Artistic Patronage in Bruges Institutions, ca. 1440–1482, Ph.D diss., University of California, 1992.

W. Prevenier and W. Blockmans, *The Burgundian Netherlands*, Antwerp 1985.

M. Smeyers *et al., Naer natueren ghelike. Vlaamse miniaturen voor Van Eyck (ca. 1350–ca. 1420),* Leuven 1993.

H. Thoen, Immigration to Bruges during the Late Middle Ages, in *Le Migrazione in Europa secc. XIII–XVIII*, Prato 1993, 335–353.

M. Vanroose, Twee onbekende 15de-eeuwse dokumenten in verband met de Brugse "beildesniders," in *Handelingen van het genootschap "Société d'Emulation" te Brugge* 110 (1973), 168–178.

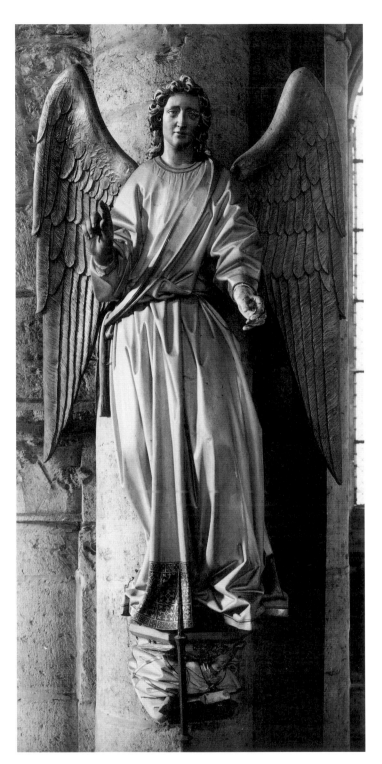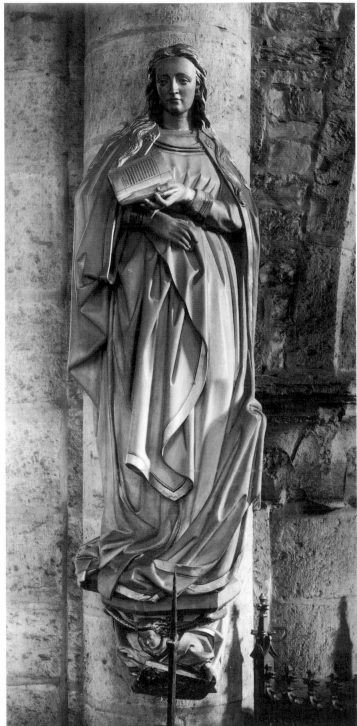

Figs. 1–2 Jean Delemer, Annunciation, stone with polychromy. Tournai, Cathedral
(here shown in its former location, the church of Sainte-Marie-Madeleine)

LATE GOTHIC SCULPTURE: AN OUTLINE OF ITS STYLISTIC DEVELOPMENT

Sculpture in Tournai c. 1400–80

JOHN W. STEYAERT

The important role of Tournai in the development of Gothic sculpture, especially in the domain of funerary monuments, and its extensive range of influence in the Netherlandish and Northern French areas has long been recognized.[1] In the early 1300s, a distinctive Scheldt School style based on Parisian precedents was developed here, known to us primarily through the impressive west portal Madonna of Tournai Cathedral.[2] During the second half of the century, this regional style was developed and raised to the level of a wider European significance in the work of André Beauneveu of Valenciennes (active c. 1360–1400), perhaps the single most influential European sculptor of his time. The basically conservative and therefore accessible style of Beauneveu as we know it in his St. Catherine (Kortrijk, Onze-Lieve-Vrouwekerk, c. 1372–3; fig. 3), characterized by a tendency toward simplification and monumentality combined with a more voluminous and softer treatment of detail, is reflected quite directly in Tournaisian Madonnas surviving in

Arbois, in Halle (fig. 4), and elsewhere.[3] Given the great influence of Beauneveu throughout the Netherlandish area and the fragmentary survival of his *œuvre*, these works are among the most important points of reference for our understanding of Netherlandish sculpture of the years c. 1400. The remarkably pervasive influence of the sculptor can also be seen in a series of picture epitaphs, a specialty of Tournaisian ateliers, beginning with the monument of the Sacquespée family in Arras (c. 1376; fig. 12) and extending into the first decades of the fifteenth century.[4]

Alongside these works which testify to the remarkable longevity of the Beauneveu current, others represent the emergence of a full-blown Soft Style, marked by more ample, expansive drapery. Our best evidence for this tendency is provided by the work of the expatriate Tournai sculptor Janin Lomme, active in Spain c. 1411–49.[5] An exquisite alabaster statuette from Olite (fig. 5) that has been convincingly associated with this artist, while it retains

51

Fig. 3 André Beauneveu,
St. Catherine, alabaster. Kortrijk,
Onze-Lieve-Vrouwekerk

Fig. 4 Standing Virgin and Child,
stone. Halle, Sint-Martinusbasiliek,
north portal

Fig. 5 Janin Lomme, Standing Virgin
and Child, alabaster. Pamplona,
Museo de Navarra

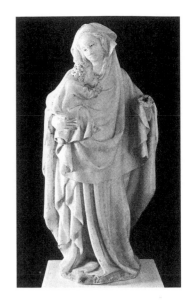

Fig. 6 St. Matthias, alabaster.
Brussels, Musées Royaux d'Art
et d'Histoire

Figs. 7–8 Jean Delemer, Angel and
Virgin of the Annunciation group
in Tournai Cathedral

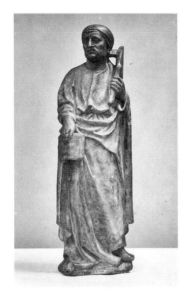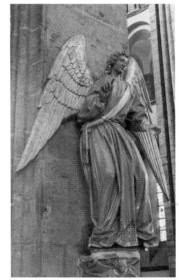

Fig. 9 Epitaph of Jehan Daniaus,
Tournai stone, detail. Cambrai,
Musée Municipal

Fig. 10 Jean Delemer, Angel
of the Annunciation group
in Tournai Cathedral

Fig. 11 Jean Aloul (?), Effigy of
Mahaut d'Artois (?), Tournai stone.
Saint-Denis, Abbey Church

certain fourteenth-century Tournaisian formulae, such as the concentric curving folds at the upper front of Mary's mantle, moves beyond the Beauneveu tradition in its greater breadth, and a more ample, expansive, and spatial treatment of drapery (note the deep hollow below Mary's left arm) characteristic of the fully developed Soft Style.[6] Although the relation of Lomme's style to that of his native city has not been studied, certain Tournaisian works, such as the funerary monument of Jehan Daniaus (d. 1408; fig. 9), may be cited as stylistic antecedents for this master's œuvre.[7] It is also interesting to note that a recurrent motif of Lomme's works, seen in the Olite Madonna – the two parallel diagonal folds that diverge against the base between the Virgin's feet – also appears in two alabaster Apostles from Arneke, now in the Musées Royaux d'Art et d'Histoire, Brussels (c. 1420).[8] Especially important is the figure of Matthias (fig. 6), whose realistically molded face and sober drapery, free of ornamental edges, mark a decisive break with the idealizing tendencies of the c. 1400 "Beautiful Style" to bring us to the threshold of a new artistic vision.

Jean Delemer and the Emergence of the Late Gothic Style

The seminal role of the Tournai School in the development of the Late Gothic style is known to us primarily in the realm of painting: the formal and iconographic innovations introduced by Robert Campin (the "Master of Flémalle," active 1404–44) extended and modified by his pupils Rogier van der Weyden (active in Brussels c. 1435–64) and to a lesser extent Jacques Daret (active as an independent master 1432–68) reached all parts of the Netherlands and most of Europe. Although we know far less about contemporary sculpture – due to the destruction, the lack of study, or even the identification of examples – the name of at least one master, Jean Delemer, cited in Tournai in the later 1420s and established in Brussels from at least c. 1440 on, can be associated with these painters.

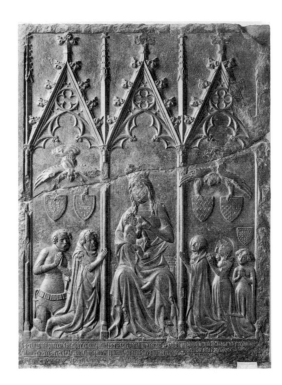

Fig. 12 Epitaph of the Sacquespée family, Tournai stone. Arras, Musée des Beaux-Arts

By a most fortunate coincidence, the only important fifteenth-century sculpture extant in the city, a stone Annunciation group presently housed in Tournai Cathedral (entrance to the south ambulatory, figs. 1–2), can be linked with a contemporary text.[9] In spite of their poor state of preservation – the heads and apparently also the hands of both figures as well as the Angel's wings are later replacements – these statues remain of capital importance. Their authorship and time of origin are fully documented: the lifesize stone statues were commissioned for the (now destroyed) church of Saint-Pierre, Tournai, by Agnes Pietarde in her testament of 1426, and were carved in or immediately before 1428 by Jean Delemer and polychromed by no less an artist than Robert Campin.[10] The two shield-bearing Angels on the supporting consoles, though not mentioned in the commission, are clearly in the same style as the figures above and may therefore be attributed to the same sculptor or his atelier (fig. 13).[11] As the earliest dated example of the Late Gothic ars nova – preceding the completion of the Ghent Altarpiece – and as the only documented surviving work associated with the name of Campin, this ensemble

Fig. 13 Jean Delemer, Console with a shield-bearing Angel, stone. Tournai, Cathedral

occupies a foremost place in the history of European art.

Perhaps the most striking aspect of these figures, placed at a considerable distance from each other as originally intended, resides in their dramatic actualization of this traditional subject in terms of spatial movement. Whereas earlier c. 1400-style Annunciations usually favor a relatively static and lyrical interpretation, here the Angel, dressed as a deacon, bursts upon the scene in an abrupt dynamic pose, his knees bent, his upper body thrust forward, his garment trailing back against the base in the wake of his sudden advance (fig. 7). Mary, wearing a long tunic and open mantle, responds in a pose of calm anticipation (fig. 8); the stool at her feet and the open book in her hands suggest that she has just risen at the arrival of the heavenly messenger. Delemer's dramatization presents an interesting parallel to a well-known liturgical play, the *Missa aurea* of Tournai, performed in the very church interior where the group is now located. Stage directions found in the sixteenth-century text of this play (no doubt following an existing local tradition) include references to the Annunciation Angel's slightly bending pose ("flectendo mediocriter genua sua") and to the more restrained attitude of Mary ("assurget et vertet modicum faciem suam ad Angelum cum gravitas et modestia non aliter se movendo").[12]

In view of the exceptional importance of this group – clearly the work of a fully accom-

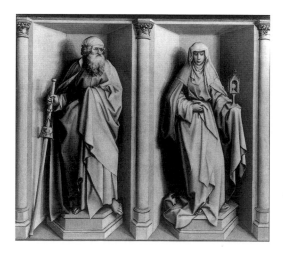

Fig. 14 Robert Campin, SS. James and Clare, oil on panel. Madrid, Museo del Prado

plished master – it is most unfortunate that nothing is known about Delemer's career, or even of his whereabouts, before 1426. A possible indication of the sculptor's familiarity with the important local tradition of tomb sculpture is suggested by a comparison of an *en face* view of his Annunciation Angel to the effigy of Mahaut d'Artois, carved a century earlier by Jean Aloul (figs. 10 and 11).[13] Notwithstanding obvious differences of a more planar versus a more sculptural approach, these works exhibit a remarkable degree of continuity both in motifs and in their linear definition of surfaces which has rightly been cited as a constant feature of the Tournaisian School.[14]

As has long been recognized, however, the innovative aspects of Delemer's style can only be understood in relation to contemporary painting.[15] These rather heavy, monumental figures, their organically credible poses, and their nervously broken, though still ample drapery have direct counterparts in those of Robert Campin's paintings, and to a lesser extent, in the early work of Van der Weyden. But there is no reason to assume that this eminently spatial group is simply a three-dimensional translation of a design by Campin, whose own figure style was unquestionably influenced by sculpture. A comparison of Delemer's Virgin of the Annunciation to Campin's grisaille of St. Clare (c. 1420; fig. 14), and of his Angel to the same figure in Campin's contemporary Mérode Triptych (c. 1428; fig. 15) on the one hand, and to Rogier van der Weyden's later Louvre *Annunciation* (c. 1435; fig. 16) on the other, suggests a development marked by a close interdependence – a give and take – between the two media. In other words, Delemer's group partakes of and contributes to the creative symbiosis that marks the Tournai artistic milieu in the late 1420s and early 1430s and that was to be of such crucial significance for the development of later Netherlandish art.[16]

The two principal figures of Delemer's group allow us to identify and associate other Tournaisian works of the following decades. The dynamic pose of his Angel, possibly the

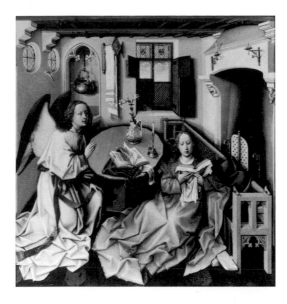

Fig. 15 Robert Campin, Mérode Triptych, oil on panel. New York, Metropolitan Museum of Art, The Cloisters

Fig. 16 Rogier van der Weyden, Annunciation, oil on panel. Paris, Musée du Louvre

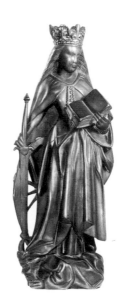

Fig. 17 Angel of the Annunciation, white stone. Paris, Musée du Louvre

Fig. 18 Console with Angel, white stone. Cambrai, Musée Municipal

Fig. 19 St. Catherine, lectern, detail, brass. Brussels, Musées Royaux d'Art et d'Histoire

single most influential formal type of the Late Gothic period, is adopted by a St Michael calmly battling the dragon in Ellezelles (cat. 3) and closely copied, though revised toward a greater lightness and fluidity of movement, in an Annunciation Angel in the Louvre (c. 1440–50; fig. 17).[17] Related to this latter figure but perhaps slightly earlier in date are two consoles with Angels in the Musée Municipal, Cambrai (c. 1430–40; fig. 18), shown as if flying

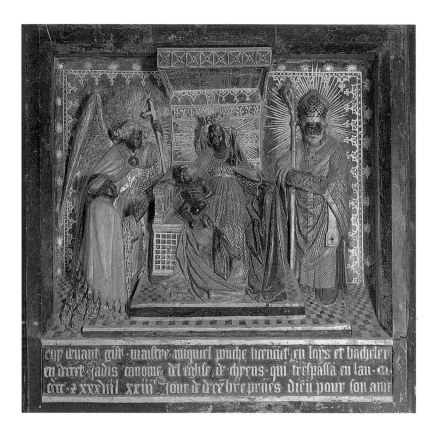

Fig. 20 Epitaph of Michel Ponche, Tournai stone with polychromy and gilding. Saint-Omer, Cathedral

Fig. 21 Epitaph of Marie Folette, Tournai stone. Tournai, Cathedral

Fig. 22 Circle of Robert Campin, Virgin and Child with Saints and Donors, pen and wash. Paris, Musée du Louvre

Fig. 23 Circle of Robert Campin, Virgin and Child with Saints, oil on panel. Washington, National Gallery of Art

forward, their hair and garments streaming back against the ground.[18]

Delemer's Annunciation Virgin's contrapuntal stance and distinctive drapery arrangement – one side of the mantle drawn across the lower body, forming a broad undulation terminating in a prominent point, the other loosely suspended – represents a formulation so frequently encountered in the later local tradition that it might be considered as something of a "hallmark" of the Tournai School.[19] Early dated examples survive in the brass statuette of St. Catherine decorating the lectern from Saint-Ghislain (1442; fig. 19)[20] and in several

Apostles on the Halle baptismal font (cat. 6), signed works by the Tournaisian founder Guillaume Lefèvre, thus confirming the local origin of these works also in terms of style. The self-assured, organically consistent pose of the St. Catherine, a small masterpiece of impressive monumentality, suggests the possibility of Delemer's direct intervention (by way of a wooden model?). The formal schema survives throughout the Late Gothic period, as for instance in an important variant in the Wodecq Madonna (cat. 7) and in a series of Calvary Virgins (cat. 9 and 10).[21]

An analogous formal solution, applied to the theme of the Enthroned Madonna, can be seen in the splendid bluestone epitaph of Canon Michel Ponche in Saint-Omer Cathedral (1431 or 1436; fig. 20), important for its exceptional quality and its secure date.[22] The restless advancing movement of the Child reaching out toward the donor; Mary's half-seated, turning pose; and the arrangement and detailing of her mantle, one edge of which covers the side of the throne, are so consistent with the style of Delemer's Annunciation that an attribution of this relief to the sculptor's atelier appears warranted. Along with other enthroned Madonnas, including the one in the unfortunately defaced epitaph of Marie Folette in Tournai Cathedral (c. 1440; fig. 21)[23] and the wooden group in Houtaing (cat. 4), the Ponche epitaph provides some idea of the interpretation of this theme in the Tournai School. It is interesting to observe that certain details seen in these works, such as the treatment of Mary's hair, the Child's lively cross-legged or half-kneeling pose, and his long robe with a tiny triangular collar and a central lower slit, also appear in the work of Robert Campin and his atelier (cf. figs. 22 and 23).

The tendency to vitalize themes through the suggestion of movement found in many of these works, so characteristic of the new style, also appears in the epitaph of Canon Livinus Blecker in Tournai Cathedral (c. 1430?; fig. 24).[24] This heavily damaged but important relief by a secondary though spirited sculptor,

transforms the subject of the Last Judgment, common in earlier works of this kind, into an event of restless convulsion by means of Late Gothic staccato drapery rhythms that derive quite directly from Delemer's work (as for instance in the garments of the trumpeting Angels; fig. 24). A consistent "hard style" expression can be seen in the head of St. Livinus in this relief with its realistic detailing of facial features (furrowed forehead; heavy-lidded, elongated eyes set beneath irregular, roughened brows; fig. 27).

But all of these works simply copy or reflect at a secondary level or, at most slightly modify, the style of Delemer's Annunciation, and, no doubt, other works by the same sculptor now lost to us. Only one ensemble in this region fully assimilates and extends this sculptor's style in a creative sense: the Entombment group in the church of Saint-Vincent, Soignies, an indubitable masterpiece of the Late Gothic and a work of comparably pivotal significance for Netherlandish and wider European developments (figs. 25 and 28).[25] As in the best examples of the mature Netherlandish Late Gothic Style, the strength of this ensemble results from the expressive tension between the intensity of emotions etched in the faces, heightened by a jagged abstraction of hard-breaking folds, and an overall restraint of pose and gesture. In this sense, and in certain elements such as the elegant eurhythmic stance of the Magdalen and the faces with their carefully defined melancholy eyes, the Soignies Entombment represents the creative equivalent of Van der Weyden's early paintings (fig. 26). Although it marks a stage of development beyond Delemer's group, these two ensembles also show a degree of continuity – in their organically rendered poses, in their bulky draperies quickened by an armature of linear movement, and even in certain specific zig-zag and pitchfork-shaped surface patterns, though in the later work these forms acquire a more hard-edged character.

The stylistic distance that separates these two ultimately isolated masterpieces can be bridged to some extent by several Tournaisian

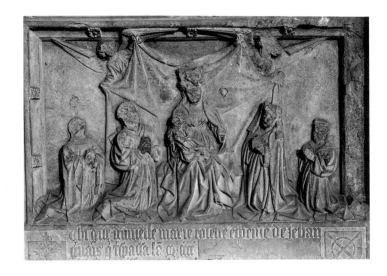

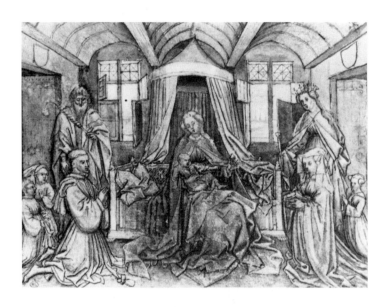

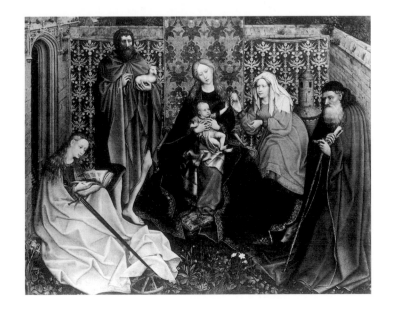

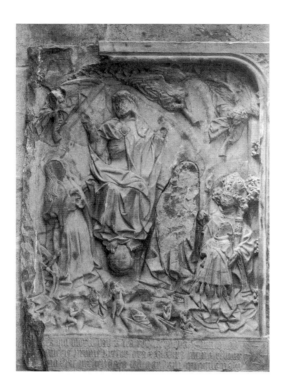

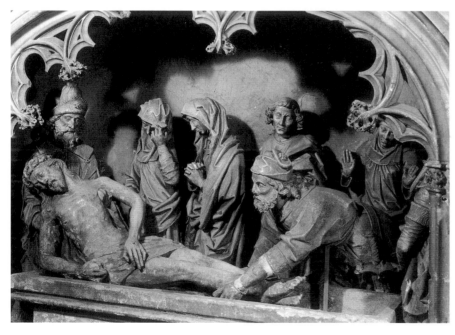

Fig. 25 Entombment, white stone.
Soignies, Collégiale Saint-Vincent

by Delemer, appears to anticipate that of Nicodemus (at Christ's feet) in the Soignies Entombment, though the latter is a far more accomplished work (cf. figs. 27 and 28). Such comparisons serve to suggest at once a relatively early origin for the Soignies group, possibly in the years c. 1435–40, and to integrate this important ensemble into the Tournaisian tradition.

While they vary in quality, taken together the sculptures cited above share an emphatically hard, linear, and expressive character that constitutes the basis of a distinctive Tournaisian Late Gothic style which, transplanted by Delemer and Van der Weyden to the Brussels milieu, was to have a major impact on artistic developments there. In its native city and its surroundings, this artistic "dialect" survives over the following decades and into the sixteenth century in a sometimes sharpened and ultimately mannered but essentially unaltered form.

After 1450

The gradual, basically conservative development of an indigenous style during the third quarter of the fifteenth century can be represented by two works that remain closely dependent on Delemer: a Madonna in Wodecq (cat. 7) and two small but particularly fine wooden historiated corbels in Montrœul-au-Bois (c. 1450–70; figs. 29–30).[27] The latter still closely reflect with remarkable fidelity the dynamic spatial dialogue of Delemer's prototype, though in a more modest format and with minor changes in detail, such as the "cubistic" play of flattened triangular folds.[28] Also typical is the more elongated definition of the faces, particularly that of Mary with its long, flat cheeks and pronounced chin, a type that survives through the end of the Late Gothic tradition in Tournai, e.g., in Calvary Virgins in Baltimore (fig. 31) and in the Musée Lescarts in Mons (fig. 32).[29]

The stage-like *mise-en-scène* of small narrative and votive groups known to us elsewhere in wooden retables have their counterpart here

funerary monuments. The gradual modification of the drapery of Delemer's group toward an increasingly brittle, rectilinear formulation can be traced through the epitaphs of Livinus Blecker (fig. 24), Marie Folette (fig. 21), and another epitaph in Tournai Cathedral showing a Calvary with donors, datable c. 1440–1450 (?).[26] And the head of St. Livinus in the Blecker epitaph, presumably reflecting a model

in an abundance of stone epitaph reliefs, increasingly elaborated with miniature vaults and lateral doorways and windows. A study of these works documents the growing influence of painting that becomes increasingly marked during this time. The Flémallesque style, already encountered as early as the Ponche epitaph (fig. 20), survives in later works[30] but is gradually superseded by the influence of Van der Weyden; the epitaph of Jean Dusart and Marguerite Degerles in Tournai Cathedral (in or before 1456; fig. 33) appears to mark the point of transition between these two currents. Occasionally, we encounter quite literal translations of Rogier's style, possibly transmitted by the intermediary of Brussels sculpture, as in the epitaph of Canon Jean Lamelin also in Tournai Cathedral (in or before 1470).[31]

The Lamelin epitaph (fig. 36), imposing in both quality and size, is perhaps the single most important work in the city from this period. It is, characteristically, retrospective: in its iconography, a peculiar form of Calvary that includes the double intercession of Mary and Christ (the latter figure is lost) as part of a "stairway to heaven," as well as in its basic composition, the relief is almost certainly based on an influential lost prototype, probably a painting, executed in Tournai during the 1430s.[32] The figure style, however, represents the earliest dated appearance in the city of the "style of the long lines." Typified by thin, elongated proportions emphasized by parallel vertical folds, this formal tendency, developed in the later paintings of Van der Weyden during his Brussels period, found not surprisingly a very sympathetic reception in his city of birth, where a latent preference for linearization of forms can be seen throughout the Gothic period. Even in this work, directly influenced by Rogier, the interpretation betrays an unmistakably local accent in its remarkably stiff, somewhat monotonous regularity and strict repetition of tubular folds.

By the 1480s, this stylistic current evolves toward an increasingly abstract, mannered multiplication of surface lines in two consoles of Angels with coats of arms in the former Hos-

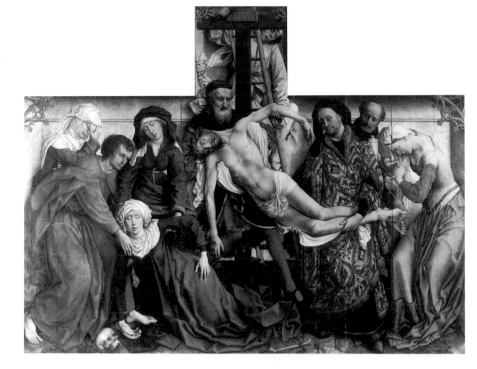

Fig. 26 Rogier van der Weyden, Deposition, oil on panel. Madrid, Museo del Prado

Fig. 27 Epitaph of Livinus Blecker, detail. Tournai, Cathedral

Fig. 28 Entombment, detail: Nicodemus. Soignies, Collégiale Saint-Vincent

Figs. 29–30 Corbels with Annunciation, wood. Montrœul-au-Bois, Saint-Martin

Fig. 31 Virgin from a Calvary, wood with polychromy. Baltimore, Walters Art Gallery

 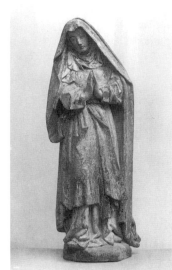

Fig. 32 Virgin from a Calvary, wood. Mons, Musée Lescarts

Fig. 33 Epitaph of Jean Dusart and Marguerite Degerles, stone with polychromy. Tournai, Cathedral

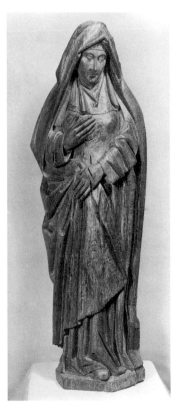 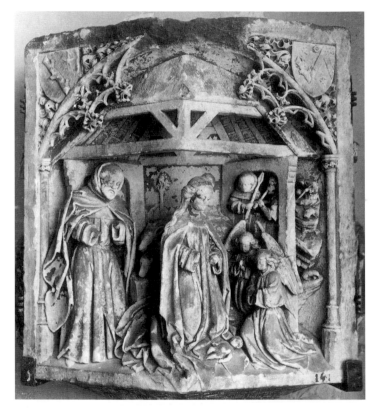

Figs. 34–35 Consoles with Angels holding coats of arms. Tournai, former Hospice de la Vieillesse

pice de la Vieillesse in Tournai (figs. 34–35).[33] It is interesting to note that, unlike in other parts of the Netherlands, notably in Brabant, this approach survives in Tournai to the very end of the Late Gothic, c. 1530. Occasionally, in the hands of an especially capable artist, this linearization can be used to inform the theme of Christ's Passion with a very moving, astringent expressive intensity (Rebaix Calvary, c. 1520–1530; see fig. 39). More often, however, it is reduced to a dry, formulaic mode (epitaph of Jean Lenoit in Basècles; 1520; fig. 37).[34]

While the above comments can provide some chronological scaffolding for a particularly characteristic Tournai stylistic current, the overall artistic picture is far more complex. The eclectic tendencies, survivals, and outright copying of much earlier works so common in Netherlandish sculpture and painting of this time, appear to have been especially prevalent here.[35] There is a need to isolate important prototypes and characteristic local formal solutions from the vast number of surviving works, especially now that the photographic inventory provides an essentially complete overview of the local patrimony.

One such work is a Christ on the Cross in Montrœul-au-Bois (c. 1450–70; fig. 38),[36] an early example of a Tournaisian series that share a characteristically expressive, hirsute figure of Christ, stretched on an ornate Cross with large Evangelist symbols framed by ogee arches and fleur-de-lys extensions (cf. cat. 9). Assistant figures that once formed part of stylistically related Calvary ensembles but are now dispersed include sculptures in Saint-Omer (cat. 8), Baltimore (figs. 31 and 40) and elsewhere. Preeminent among intact ensembles of this theme is the group in the church of Saint-Pierre, Antoing, probably carved soon after the mid-fifteenth century.[37] Especially impressive here is Mary's grandiloquent, richly contrasted pose, turned away from Christ, evidently to the faithful in the church below, and her gestures, the left hand at her breast, implying her motherhood and thence her role as mediatrix (fig. 41).[38]

A multitude of Madonna statues of probable Tournaisian or Northern Hainaut origin survive, some of which have been erroneously attributed to Brabantine sculptors. A fine example is the Madonna in a private collection (c. 1450–70; fig. 42).[39] Nevertheless, it is undeniable that influences from Brabant, and Brussels in particular, made themselves felt in Tournai probably as early as the mid-fifteenth century and became increasingly strong by c. 1500, as testified to by a number of imported works.[40] Significantly, two unquestionably Tournaisian sculptures of these late years, a stone Madonna in Grandmetz (c. 1520–30; fig. 43) and a Madonna in the funerary relief of Jean Lenoit (see fig. 37), are based on the much finer Brussels wooden Madonna in Marcq (fig. 44).[41]

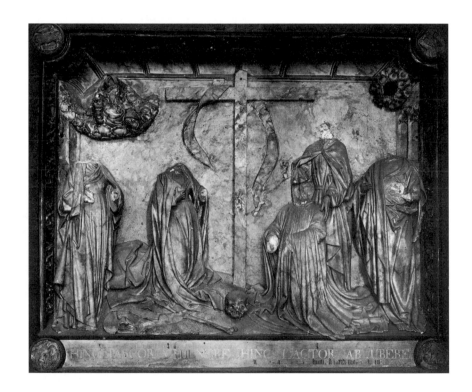

Fig. 36 Epitaph of Jean Lamelin, painted white stone. Tournai, Cathedral

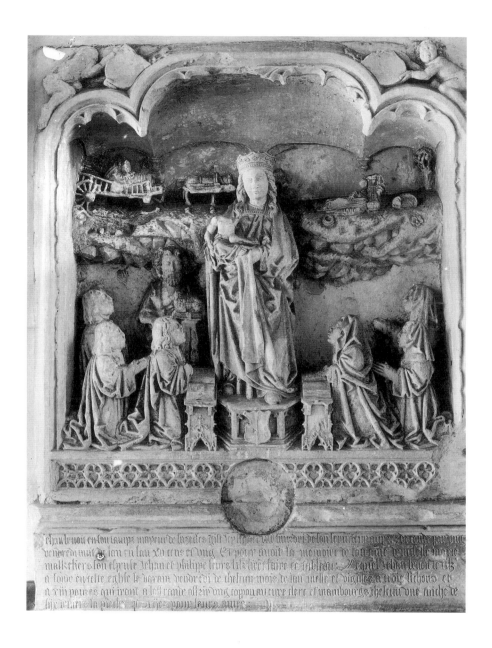

Fig. 37 Epitaph of Jean Lenoit,
white stone. Basècles, Saint-Martin

Fig. 38 Christ on the Cross, detail,
wood. Montrœul-au-Bois, Collégiale
Saint-Martin

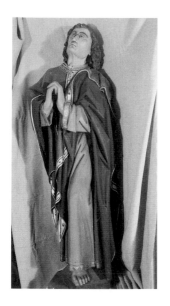

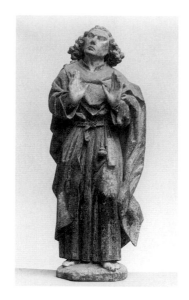

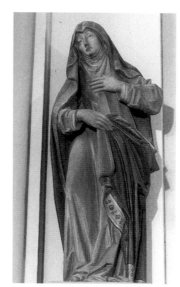

Fig. 39 St. John from a Calvary, wood with polychromy. Rebaix, Saint-Amand

Fig. 40 St. John from a Calvary, wood with polychromy. Baltimore, Walters Art Gallery

Fig. 41 Virgin from a Calvary, wood with polychromy. Antoing, Saint-Pierre

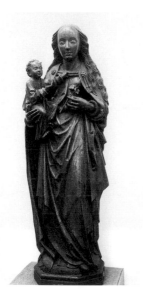

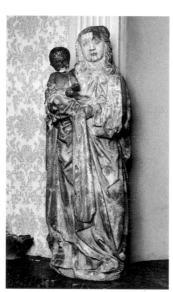

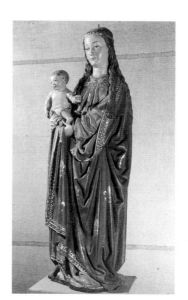

Fig. 42 Standing Virgin and Child, wood. Private collection

Fig. 43 Standing Virgin and Child, stone. Grandmetz, Chapelle Notre-Dame de Grâce

Fig. 44 Standing Virgin and Child, wood with polychromy. Marcq, Saint-Martin

1 Among the more important studies of later medieval sculpture in Tournai may be cited: de la Grange and Cloquet 1887, 80–239 (most comprehensive publication of written sources); Soil de Moriamé 1912; Ring 1923 (important study of funerary monuments); Rolland 1932a (consideration of parallel between Tournai painting and sculpture); Rolland 1944; De Valkeneer 1963; Didier, Henss, and Schmoll gen. Eisenwerth 1970 (pioneering study of Madonnas c. 1400); de Borchgrave d'Altena and Mambour, 1971–4; Didier 1983 (first overview of stylistic development); Nijs 1990.

2 The style of this Madonna is reflected in lesser works, such as the wooden Virgin and Child statuette in Lecelles (dép. Nord). For a discussion of this regional style, see Schwarz 1986, 80–84.

3 See the Madonna in the church of Saint-Just, Arbois (dép. Jura). The Tournaisian origin of these works was established by Didier, Henss, and Schmoll gen. Eisenwerth 1970.

4 Epitaphs of Simon de Leval, 1407, Basècles and of Pierre de Perenchies, 1412, Lille, Musée des Beaux-Arts. For these, see Soil de Moriamé 1912, pls. XXXII, XXXVII, XXXVIII.

5 See the monograph by Janke 1977.

6 Janke 1977, 185–187. This Madonna, recently transferred to the Museo de Navarra in Pamplona, represents a very typical example of Lomme's manner, even if, as Janke believes, it was carved by a follower as late as the mid-fifteenth century.

7 See also the statue of St. Anthony in Saint-Antoine-en-Barbefosse near Mons (c. 1408?) and compare the *pleurants* decorating the tomb of Charles the Noble (Janke 1977, figs. 19 and 23). For the attribution of the St. Anthony to the Tournai School, see Didier 1983, 367–377.

8 For the attribution of these Apostles to Tournai, see Didier 1983, 378.

9 Although this group has not been thoroughly studied, it has often been cited in the literature. A selection: Maeterlinck 1901, 275–276 (attributed to Rogier van der Weyden); Soil de Moriamé 1912, 26–27; Ring 1923, 287–288; Rolland 1932 (influenced and possibly designed by Campin); Bergius 1936, 91–95; Müller 1966, 60–61; Didier 1977, 398–400; 1983, *passim*; Châtelet 1990. Until recent years, and probably since the sixteenth century, the group was located in the church of Sainte-Marie-Madeleine, Tournai. A few years ago it was moved to the Cathedral.

10 For the documents concerning the restoration of 1858, see Rolland 1932, 345. The console Angels and the draperies of the principal figures appear to be original, with only minor damage. The polychromy appears to be entirely renewed. These sculptures have sustained additional damage recently (lower body, left hand, and book of Mary; stole and hands of Angel; faces and hands of console Angels), presumably when they were moved to their present location. For reasons unclear to me the supporting consoles were switched around that time.

11 For these documents, see Rolland 1932.

12 The text is reproduced in its entirety and discussed by Voisin 1860. It has been cited by several authors in relation to Flemish painting of the time; see, for instance, Lane 1984, 47–50.

13 For this effigy, see Bauch 1976, 103, and fig. 158. Although the identification as Mahaut d'Artois is not absolutely certain, its Tournaisian origin is beyond doubt.

14 See Didier 1977, *passim*.

15 For a discussion of the interrelation between Tournaisian sculpture and painting, see Rolland 1932.

16 While in paintings of this period the figures are rendered in a sculptural way, Delemer's group includes a markedly pictorial detail in the stool at Mary's feet, partly covered by her mantle (see fig. 8).

17 For an alternative attribution of the Louvre Angel to Brabant, see Pradel 1947, 10–11 ("région brabançonne, milieu du xvᵉ siècle"), and Didier 1989, 66 ("Tournai ou Bruxelles, vers 1430"). Another related work is a damaged Angel patron saint (St. Michael?) presenting a donor in Tournai Cathedral, c. 1425–30; see Didier 1983, fig. 19.

18 One of these consoles was exhibited in Lille 1978–9 (no. 57: "première moitié du xvᵉ siècle").

19 See also Didier 1983, *passim*.

20 See Tournai 1971, no. 27. A mediocre though literal copy of the St. Catherine can be seen in the decoration of a capital in the church of Ellignies-Sainte-Anne. A more important and original variant on the same formal type is the St. Catherine believed to have come from the abbey of Cambron (Private collection; see Didier 1983, fig. 38) which has been tentatively attributed to a Brussels sculptor, but whose Tournaisian origin appears more likely in view of the work's style (cf. the Madonna in Isières, Mambour 1981, ill. p. 93) and of decorative motifs (such as the Saint's richly jeweled crown; cf. the crown in the Michel Ponche epitaph, Saint-Omer; fig. 20).

21 See also the early-sixteenth-century statues of two Angels and a Bishop Saint from the church of Willaupuis near Leuze (arr. Tournai). One of these Angels is discussed by Didier 1983, 383, and fig. 22.

22 The relief may date as early as 1431, when Michel Ponche informed the Cathedral chapter that he had ordered "ponendi et faciendi quamdam representationem in opere marmoreo contra pilare in navi ecclesie" (Deschamps de Pas 1892, 201), presumably referring to his epitaph. The accompanying inscription records the donor's 1436 date of death. The importance of this work has been recognized by Müller (1966, 59–60) and by Schädler (1969, 45) who convincingly compares its style to that of Delemer and notes its possible influence on the work of the Swabian sculptor Hans Multscher. In certain details, including the Child type, the Ponche epitaph also exhibits an affinity with the work of the Viennese sculptor Jakob Kaschauer.

23 See Rolland 1932, 69, and more recently Didier 1983, 383.

24 Rolland 1932, 79–80.

25 The figures, carved in white stone, are approximately three-quarters lifesize. The group was first published by Ring 1922, which remains the most extensive study. See also Ring 1923, 288–290; Forsyth 1970, 133; de Borchgrave d'Altena and Mambour 1974, 38–39; Didier 1977, 401–402. The richly ornamented niche in which the group is placed is closely comparable to the decoration of the chapel commissioned by Michel de Gand before 1447 in the church of Saint-Piat, Tournai (see Rolland 1932, pls. I–III). A recent restoration has revealed that the back wall of this niche originally included a painted Calvary; fragmentary remains showing the Bad Thief on the Cross and a section of landscape indicate the hand of an artist familiar with the style of Robert Campin (ill. in Guislain-Wittermann, in *Bulletin van het Koninklijk Instituut voor het Kunstpatrimonium* 19 [1982–3], 190–191).

26 Rolland 1932, fig. 22.

27 Historiated corbels of the Annunciation decorating the Neo-Gothic choir vault in the pilgrimage church. The drapery composition of the Virgin of the Annunciation literally repeats, in a stiffened form, that of the brass St. Catherine statuette on the lectern from Saint-Ghislain (1442; fig. 19).

28 Cf. similar drapery forms in a vault boss showing a couple playing checkers (Antoing, Château).

29 A more expressive, hardened, perhaps more characteristically Picard, variant of this type can be seen in the inscrutable visage of an enthroned Madonna, "Notre-Dame des Joyaux" (c. 1470?), in the church in Montrœul-au-Bois (see Mambour 1981, ill. p. 76, "fin du xive siècle") and in a roughly contemporary silver reliquary head of St. Margaret in the church of Sainte-Marguerite, Tournai.

30 E.g. a Nativity relief illustrated in Rolland 1944, fig. 42.

31 Canon Lamelin may well have commissioned this epitaph sometime before his death in 1470: a "Jehan Lamelin, chanoine de Tournai," presumably the same person, drew up his testament in Valenciennes as early as 1434 (see Valenciennes 1987–8, 68–69). Another work, equally related to Rogier van der Weyden, is a damaged relief of the Deposition in Tournai Cathedral, c. 1450–75; see Rolland 1932, fig. 23.

32 The iconography of the epitaph has been elucidated by Gorissen 1973, 990–995, who has convincingly argued that it derives from a lost Flémallesque model. To the many reflections of this prototype cited by the author should be added a miniature in a Rouen manuscript of c. 1520 (Plummer and Clark 1982, fig. 120) and a brass plaque (1547) formerly in Jeumont (Norris 1978, 1: fig. 194). It is interesting to observe that the theme was already known in Tournai in the years c. 1400 (lost epitaph of Jeanne Becquette, Franciscan Church: see Bozière 1860, 75, and Rolland 1932, 92, no. 2). On the subject, see also Lane 1973.

33 The hospice is the former hospital of Saint-Jean-Baptiste founded by Jacques de le Planque and his wife Jeanne de le Vestre in 1483 (Cousin 1619–20, 4:261) and appears to have been completed by the donatrix's death in 1490 (see her testament in de la Grange 1897, 333, no. 1170).

34 The same tendency toward linearization is evident in contemporary Tournaisian tapestries, as e.g. a series illustrating the Months (Asselberghs 1968, figs. 14–15), based on Brussels models, as is also true of the Lenoit epitaph (fig. 37).

35 It is symptomatic that numerous works of the years c. 1500, such as a St. Elizabeth in Ath (Hôpital de la Madeleine) or two Apostles in Evregnies (church of Saint-Vaast, arr. Tournai) might easily be dated a half-century earlier, were it not for the broad-tipped shoes worn by these figures that only became fashionable at the very end of the century (!). The Entombment group in Arc (arr. Ath), freely copied after the early-fifteenth-century Tournaisian group of the same theme from Mainvault (now Ath, Museum), exhibits a style perfectly consistent with an origin c. 1450, but can only

have seen the light of day toward c. 1520, judging by the garment worn by the Magdalen that forms part of this group (see Didier 1970 and the same author's comments in Tournai 1971, no. 165).

36 Tournai 1971, no. 162 ("atelier du Hainaut septentrional… second quart du xve siècle"); de Borchgrave d'Altena and Mambour 1972, 41 ("début du 16e siècle"). The sculptor of the Montrœul Christ probably also carved the corbels with an Annunciation in the same church (cited above, figs. 29–30). Another important representative, notable for its exceptional quality, is a Christ in Ellignies-Sainte-Anne, c. 1440–50 (?), apparently unpublished; see photograph ACL 92713M. The Christ is attached to a Cross of more recent date.

37 De Borchgrave d'Altena and Mambour 1972, 15–16 ("fin du xve siècle").

38 In other comparable but derivative Calvary Virgins, the logic and motivation of this type loses much of its meaning through simplification (fig. 32), formulaic repetition (mirror-reverse copy in Moulbaix, arr. Ath), or mannered confusion, in which the meaning of the original becomes completely garbled (Chièvres, church of Saint-Martin). For these works, see de Borchgrave d'Altena and Mambour 1972, 41, 69–70, 76.

39 A nearly identical work of slightly lesser quality, from the same atelier, is in the Musée Puissant, Mons. For these works, see Mambour 1981, 89–90. In this context, though of second-rate quality, the Virgin and Child statuette in Isières (Chapelle Notre-Dame de la Cavée, c. 1450–75; Mambour 1981, ill. p. 92) is of interest since it relates in stance and drapery composition to a standard treatment of female *gisant* figures in Tournaisian tomb sculpture. See for instance the two wives of Jean de Saint-Pierre du Maisnil (d. 1459) from the church of Fretin, formerly in the Douai Museum (ill. in Weise 1925–30, 39). The relatively early origin of these two wood sculptures is suggested by their correspondence of head type and vestimentary detail to the Madonna in the epitaph of the Cambier family in Saint-Pierre, Lessines (c. 1464; Mambour 1981, ill. p. 56). A stone Madonna in the Sun (c. 1460–70) in the Musée Archéologique, Ath (Mambour 1981, ill. p. 71) is directly related in style and probably contemporary with this epitaph.

40 This schema survives through the years c. 1500; see the tomb of Antoine van Houtte and Barbe van Belle in Flêtre (Lotthé 1940, pl. LXXIVa).

41 A similar derivation can explain the style of the well-known Madonna in the castle chapel, Antoing, formerly part of a tomb ensemble (Mambour 1981, ill. p. 102).

Fig. 1 Halle, Sint-Martinusbasiliek: view of the choir
with the Triumphal Cross and the Apostle statues inset in the piers

Sculpture in Brussels c. 1400–80

JOHN W. STEYAERT*

Our knowledge about Brabantine sculpture of the fourteenth century remains unfortunately quite limited. A handful of statues that can be dated around the mid-century along with a series of small decorative sculptures do reveal the existence of a regional school, presumably centered in Brussels.[1] But insofar as can be deduced from such fragmentary remains, this school appears to have been overshadowed and probably influenced by the more important neighboring Scheldt and Mosan traditions.

We are only slightly better informed concerning the later half of the fourteenth century, a time when a distinctive architectural style was developed here that was to dominate the Netherlandish area through the early sixteenth century. In spite of a thorough and diligent search for the stylistic origins of Claus Sluter, cited c. 1379 in the list of the Brussels *Steenbickeleren* (stone workers), no local works by this artist's hand, nor, it would seem, any that reveal his influence have been convincingly identified.[2] Documentary and stylistic evidence points instead to the important role of André Beauneveu.

When the sculptural decoration of the Aldermen's Hall ("Schepenhuis") in Mechelen was undertaken in the early 1370s, the most important commission, a series of stone statues including a Madonna, was significantly awarded to "Andries van Valencinis" rather than to a Brabantine master.[3] And although none of these works has survived, Beauneveu's influence is evident in a cycle of historiated stone corbels inside the same building, ordered from Jan Kelderman of Brussels. On the other hand, the contemporary narrative scenes decorating the wooden beam ends here, carved by local sculptors of Mechelen, exhibit a provincial survival of the indigenous Brabantine manner, though in a heightened raucous realism at times verging on the caricatural.[4] This hierarchy of commissions and coexisting style currents provides a presumably characteristic insight into the late-fourteenth-century state of local sculpture, though it should be emphasized

that, due to lack of study, we still do not have a complete overview of the material.[5]

The Master of the Hakendover Altarpiece

We know far more about the development of Brabantine sculpture of the early fifteenth century, when a Brussels tradition emerges that, as in no other Netherlandish center, can be followed continuously for more than a century. This development is not without diversity – no doubt due to the fact that the city appears to have become, as evidenced by names inscribed in the list of *Steenbickeleren* during these years, something of a melting pot, attracting artists from elsewhere (notably from Tournai), drawn to what was soon to become the artistic capital of the Burgundian Netherlands with its lucrative commissions, ducal, ecclesiastic, and bourgeois.

Insofar as we can determine at present, the "founding father" who initiated this development is the anonymous sculptor who has been dubbed the Master of the Hakendover Altarpiece after his earliest intact work.[6] Possibly of Mosan or north-eastern Netherlandish origin but established in Brussels by c. 1400, this artist appears to have played a leading role in the Brussels milieu during the first third of the century. His production was both prolific and versatile, including large and small stone sculpture as well as wooden retables, and indicates that he stood at the head of a large workshop. His earliest works are clearly indebted to the art of Beauneveu; those of his middle period count among the finest examples of the Netherlandish Soft Style. The sculptural decoration of the choir of the Basilica in Halle, completed 1399–1409, a gem of "Brabantine High Gothic" architecture, offers the most extensive and diversified ensemble of the sculptor's work (figs. 1–3, 5, 7, 9).[7] The series of lifesize stone Apostles, often associated with the influence or even the authorship of Sluter, inadmissible on either stylistic or chronological grounds, reveal the master's acquaintance with the late work of Beauneveu.[8] A comparison of the St. James

Minor to Beauneveu's St. Catherine (fig. 2 and *Tournai*, fig. 3) demonstrates both this fundamental indebtedness (overall drapery composition; details such as the oblique undulating "butterfly" edge at lower mantle) as well as the Master of Hakendover's "revision" toward Soft Style features (more ample, loosely layered, "peeling" folds). The same is true of the grave, realistic heads of the disciples, more rugged versions of types encountered in the later style of Beauneveu as we know it through the head of an Apostle from Mehun-sur-Yèvre (see figs. 3 and 4).[9] There is every reason to assume that these changes form part of a normal Netherlandish evolution that needs no explanation in terms of "Burgundian" influences.

Another aspect of the realism of these years – of interpreting established themes in terms of contemporary life – can be seen in the wall tabernacle reliefs (dated 1409) in the choir of Halle's Basilica (fig. 9). Although executed by the same master, they represent a different stylistic mode that in its intricacy of detail suggests familiarity with the tradition of ivory carving.[10] Their style also rivals Jacob de Baerze's in the vivid genre treatment of religious narrative, spiced with anecdotal motifs – transforming the Last Supper into a hearty peasant meal. The master's forte in the domain of small-scale sculpture is fully evident in two wooden retables: his name work in Hakendover (cat. 21) and what may be considered his masterpiece, a Calvary retable in Dortmund (1415–20; figs. 6, 8 and 10). In the latter, he introduces the classic Brabantine altarpiece: a triptych consisting of a horizontal rectangular center with surelevated top, articulated on the interior by intricate architectural elements that define miniature "chapel" spaces, and equipped at the top and sides with hinged panels painted on both sides.[11] As the stage-like setting of these altarpieces acquires a more spatial character (defined by tiny vaults above and blind tracery at the back), so the actors become freer: instead of the reliefs and flat conception typical of earlier retable tradition, we now find an assemblage of statuettes and groups developed in

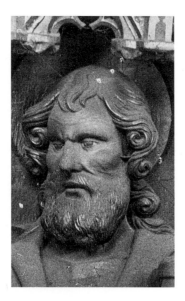
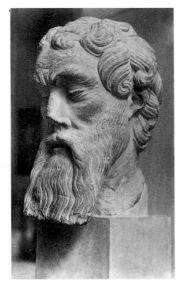

Fig. 2 St. James Minor, stone. Halle, Sint-Martinusbasiliek

Fig. 3 St. Thomas, detail, stone. Halle, Sint-Martinusbasiliek, choir

Fig. 4 André Beauneveu (?), Apostle head, stone. Paris, Musée du Louvre

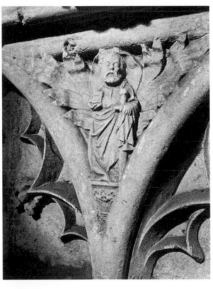
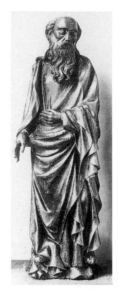

Fig. 5 Spandrel with St. Paul, stone. Halle, Sint-Martinusbasiliek, ambulatory

Fig. 6 St. Paul from the Calvary Altarpiece, wood. Dortmund, St. Reinoldikirche

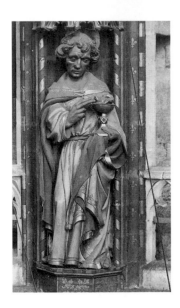
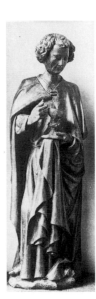
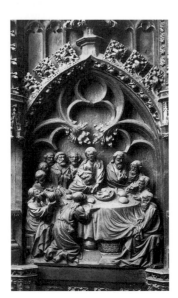

Fig. 7 St. John the Evangelist, stone. Halle, Sint-Martinusbasiliek, choir

Fig. 8 St. John the Baptist from the Calvary Altarpiece, wood. Dortmund, St. Reinoldikirche

Fig. 9 Wall tabernacle, detail: Last Supper, stone. Halle, Sint-Martinusbasiliek, ambulatory

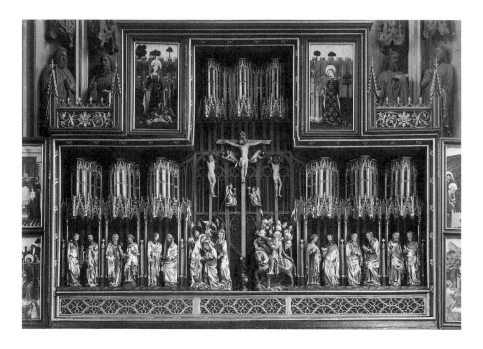

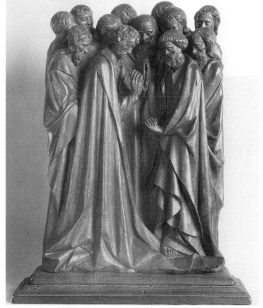

Fig. 10 Calvary Altarpiece, central part, wood with polychromy. Dortmund, St. Reinoldikirche (before conservation treatment)

Fig. 11 Retable fragment with Apostles in Prayer, oak. New York, Metropolitan Museum of Art

layered planes presented in front of a ground and often carved fully in the round.

Of special interest in our context are the fragmentary remains of the Hakendover Master's *ultima maniera*, works of his old age that form a stylistic bridge from the Soft Style to the Late Gothic. His highly personal, late interpretation of the former can be seen in an extraordinary retable fragment of the Apostles in Prayer (c. 1420–25; fig. 11), composed in terms of highly simplified and hence monumental forms.[12] The closely huddled quasi-unanimous grouping of the disciples, forming a central spatial niche that accentuates three pairs of praying hands with a rich chiaroscuro, and the prominent triangular mantle of the aged St. John, which expands below into a wonderfully abstract base of fluid triangles, rank this small work among the finest creations of fifteenth-century Netherlandish art.

It also occupies a key place of stylistic transition, immediately followed by a fragment of St. Peter in Penance (cat. 23) and a Gethsemane group in Amsterdam (c. 1430, fig. 12),[13] the latter probably carved by a workshop assistant or a close follower of the Hakendover Master. A Late Gothic drapery vocabulary emerges in these works quite unobtrusively: the drapery gradually loses its fluid, curvilinear continuity,

to fold and then break into separate, discontinuous, increasingly angular rhythms, without however abandoning the underlying amplitude of the Soft Style. In terms of motif, a new style is born. And yet, little else has changed. In the Brussels tradition as we see it here, the new style emerges. But this is achieved with a remarkable degree of ease and continuity with the past.

Were these changes affected by painting? Scarcely anything is known about Brussels painting of these years.[14] But a glance at contemporary developments elsewhere does reveal close formal parallels, as in the Ghent Altarpiece, especially in the Annunciation by Hubert van Eyck and even more clearly in the works of Campin of the 1420s (fig. 13).

Brussels Altarpieces c. 1420–50

The late work of the Master of the Hakendover Altarpiece can serve as a point of reference for an identification and a chronological ordering of other Brussels masters active at about the same time and in the immediately subsequent years. One such master carved the retable groups of the Visitation and the Nativity in Ramerupt, Champagne (c. 1420–5; cat. 22). The latter group is of special interest as an early

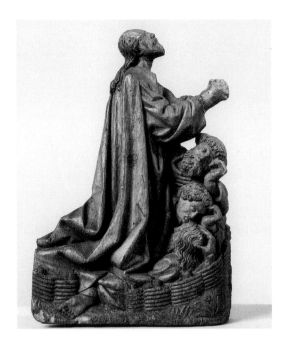

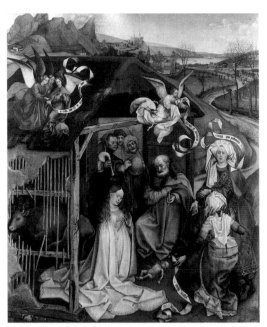

Fig. 12 Christ in Gethsemane, oak. Amsterdam, Rijksmuseum

Fig. 13 Robert Campin, Nativity, oil on panel. Dijon, Musée des Beaux-Arts

Netherlandish interpretation of the Nativity "according to St. Bridget" that has a close counterpart in and may perhaps have been influenced by the famous painting by Robert Campin in Dijon. For the history of Brussels retable sculpture, the Ramerupt Nativity is important, since it introduces a classic type to be followed and varied for decades to come.

A more enigmatic but fascinating work is the Nativity retable in the parish church of Santibañez de Zarzaguda near Burgos, which can be attributed to a direct follower, probably a pupil of the Master of the Hakendover Altarpiece (fig. 14).[15] The unusual, apparently unique silhouette of undulating ogee forms allows for the possibility that the altarpiece was carved in a different Netherlandish center or perhaps by an expatriate sculptor in Spain. At any rate, the figure style leaves no doubt about his training in the Brussels milieu. The semi-circular grouping of figures centered around a pair of praying hands in the Circumcision of Christ (right wing; cf. Apostles in Prayer, New York, fig. 11) was obviously inspired by the Hakendover Master.[16] It is all the more interesting therefore that the scene of the Annunciation, equally "Hakendoverian" in certain respects, also shows an unmistakable affinity with the treatment of this subject in the Tournai tra-

dition in general and with Delemer's work in particular (see *Tournai*, figs. 1–2).[17] An established Brussels style of ample volume is juxtaposed with the quickened linear rhythms of the Tournaisian School. A similar formal combination can be seen in the remarkable central "Crowded Nativity," which includes, besides a multitude of shepherds and a squadron of adoring Angels, a superposed grouping of the Meeting of the Magi. In its overall Italianate character (cave setting) – in the spirit of Jacob de Baerze's Calvary retable – and in the mannered elongation of Mary and Joseph, the conception remains rooted in the years c. 1400.[18] But here too, we encounter, somewhat incongruously, a full-fledged Late Gothic flying Angel (above St. Joseph). And in certain details, such as the long, trailing edges of Mary's mantle sweeping

Fig. 14 Nativity retable, wood with polychromy. Santibañez de Zarzaguda, church

diagonally outward in crumpled edges, the new style appears grafted, quite literally, unto the old. Given the fact that no pre-1428 works by Delemer are known, along with our very limited understanding of Brussels art of the 1420s (was Van der Weyden active here in the early 1420s as sometimes suggested?), it seems prudent to date the Santibañez retable within a date span of c. 1425–35.

However that may be, beginning in the decade of the 1430s, marking the arrival in Brussels of two Tournaisian artists, the painter Rogier de le Pasture / Van der Weyden (by 1435) and Jean Delemer (first cited here c. 1440),[19] a distinctly Brussels style was forged here that would reverberate throughout Europe, but that from its inception included an important Tournaisian component. The brief moment of artistic flourishing in Tournai in the years c. 1430, was transferred to and bore fruit in Brussels, by now "capital" of the Burgundian dukes and their entourage.

Among the earliest masterpieces of this development is the Triumphal Cross in the Basilica in Halle (figs. 1, 15–17).[20] Although variously dated, the style of this work can be situated precisely at the point where the manner of the Hakendover Master intersects with that of the early Jean Delemer, suggesting that it was carved in Brussels, possibly as early as c. 1430–5. Of particular interest are the medallions with the Evangelist symbols and Church Fathers at the Cross terminals, treated here in a spatial

sense as statuettes contained in deep, shadowy frames and carved partly *ajour* – i.e., presented in a setting like that found in contemporary altarpieces. These figures present a direct extension of the Hakendover Master's late works in general formal type (most clearly in the triangular composition of the Church Father at the base of the Cross) and in the realistically creased and wrinkled faces with prominently marked cheekbones. At the same time, certain drapery passages exhibit a decidedly Campinesque character (pitchfork-like and puffy triangular folds; see St. Jerome, fig. 16) quite similar to those in Delemer's Annunciation Virgin in Tournai (*Tournai*, figs. 1–2). An even more obvious parallel to the latter's work can be seen in the symbol of St. Matthew at the front of the Cross, interestingly interpreted here in the manner of an Angel of the Annunciation, in an advancing profile pose, his hair flying back in a series of corkscrew curls (fig. 17).

Beginning in the 1430s, intact Brussels retables survive in relatively large numbers. The majority of these were produced in secondary ateliers where artistic solutions, once established, were repeated in what amounts to a quasi-industrial production, much of it seemingly intended for export. While remarkably conservative, we do witness in these works a gradual infiltration of new elements, derived principally from the paintings of Campin.

Representative in this respect is the *œuvre* of the Master of the Rieden Altarpiece (active

Fig. 15 Triumphal Cross, detail: Church Father, wood with polychromy. Halle, Sint-Martinusbasiliek

Figs. 16–17 Triumphal Cross, details: St. Jerome and Angel (Symbol of Matthew), wood with polychromy. Halle, Sint-Martinusbasiliek

c. 1430–45),[21] whose name work (figs. 18–20) includes a central Nativity (fig. 19) closely reminiscent of that in Ramerupt (cat. 22) but incorporating elements from Campin such as the beturbaned midwife, St. Joseph holding a (lost) candle, and a shed with a truss gable (see fig. 13).[22] The Rieden Master's familiarity with Campin's work is further confirmed by his square, compact grouping of the Adoration of the Magi scene (fig. 20)[23] and, to a lesser extent, in his Marriage of the Virgin (see cat. 17, fig. 17a). This derivation is not simply limited to overall conception, but extends to quotes of individual figures; for instance, the Moorish Magus with his broad jaw and curly hair at the upper left, in a cross-stepping, turning pose shows an unmistakable ancestry in Tournaisian tradition.[24]

The works of the Rieden Master's atelier, including an altarpiece in Funchal (Madeira) and a group of the Marriage of the Virgin in Brussels (Musées Royaux des Beaux-Arts de Belgique), resemble each other to the point of near interchangeability – in a spirit of repetition that has its mechanical counterpart in Netherlandish pipeclay multiples reproduced by way of molds.

Another, perhaps the principal sculptor responsible for the vulgarization of the Brussels style of these years is Willem Ards (active in Brussels and Leuven c. 1415–54), who, judging by the large number and wide distribution of his works from the Netherlandish area to Southern Germany and Spain, appears to have been a particularly important entrepreneur at the head of a large shop.[25] The most extensive ensemble of Ards's work can be seen in the decoration of the beam ends and corbels in the City Hall, Leuven (see cat. 24); on the basis of style and the "signature" male head types of the artist, at least some of the historiated corbels from the exterior of the same building may also be attributed to him. Among the numerous retables and retable fragments produced in the sculptor's atelier, a Nativity group in Sotopalacios near Burgos (c. 1430; fig. 21) is of interest in providing an insight into Willem Ards's artis-

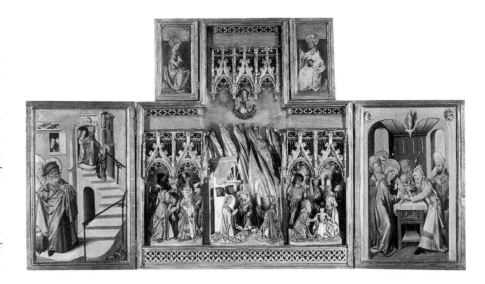

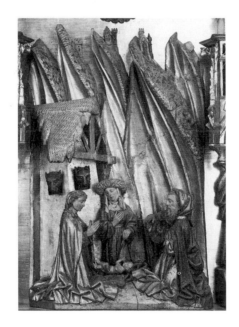
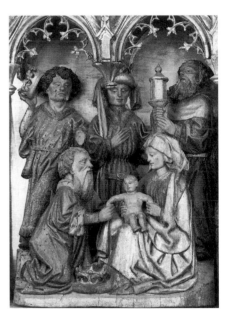

tic sources in the Brussels milieu of the 1420s as known through the Master of the Ramerupt Altarpiece. Over the following decades the sculptor's style undergoes only superficial change, although his later works do exhibit the influence of more progressive works.

Fig. 18 Rieden Altarpiece, wood with polychromy. Stuttgart, Württembergisches Landesmuseum

Fig. 19 Rieden Altarpiece, detail: Nativity

Fig. 20 Rieden Altarpiece, detail: Adoration of the Magi

Fig. 21 Retable fragment with the Nativity, wood with polychromy. Sotopalacios, parish church

Fig. 22 Altarpiece of the Virgin, wood with polychromy. Laredo, Santa Maria

The Laredo Altarpiece

Fundamentally however, Willem Ards, like his contemporary the Master of the Rieden Altarpiece, remains a representative of a conservative current in Brussels sculpture that extends to the mid-century and beyond. But such works do throw into relief the significance of what is surely the masterpiece of Late Gothic Netherlandish retable sculpture, the Altarpiece of the Virgin in the parish church of Santa Maria, Laredo, now restructured and incorporated into a gigantic baroque *retablo* that dwarfs the altar below it.[26] While it is not possible here to do justice to this little-known, crucial ensemble which merits an in-depth monographic treatment, some initial observations may be presented.

The Laredo Altarpiece (figs. 22–24) represents a decisive, defining moment in the history of Late Gothic Brussels sculpture, comparable to that of Delemer's Annunciation in the Tournaisian tradition. Here, as there, its style cannot be understood without taking into account developments in painting, increasingly influential as we approach the middle of the century. Along with another masterpiece of the Brussels School, roughly contemporary in date, the embroidered vestments of the Chapel of the Golden Fleece in Vienna, this altarpiece marks the transition from the style of Campin to that of Van der Weyden. In its physical structure and in

a basic sense also in its iconography, the ensemble closely parallels and was probably influenced by Rogier's paintings, particularly the Granada and Miraflores altarpieces (c. 1440–5), both also exported to Spain.[27] As in these paintings, all four principal groups emphasize the role of Mary in relation to her Son: the center is dominated by an exceptionally large group of the Nursing Madonna, *mediatrix* of mankind, surmounted by a pair of Angels supporting a (lost) crown (fig. 29); directly above, she is enthroned alongside Christ, crowned as queen of heaven; at the sides are groups of the Annunciation and Calvary, composed not in the usual symmetry but in terms of complementary diagonals, so that Mary occupies a salient position, closest to the viewer.[28] For the first time in the development of retable sculpture, we encounter a conception apparently introduced by Rogier but itself influenced by sculpture: the composition focuses on a single central devotional group housed in an ideal, traceried "chapel" setting, while the narrative is relegated to small groups (some extending the New Testament cycle, others consisting of typologically pertinent Old Testament themes) set in the concave arch framework – a solution that will become standard in later Brabantine retable sculpture through the early sixteenth century.

While all of the sculptures share a common style, they differ in emphasis and in quality: the principal groups, carved by an outstanding sculptor, exhibit a more progressive "Rogierian" style; the smaller groups in the frames, more conservative atelier work, are more "Flémallesque" in character, though also superficially "overlaid" with influences from Van der Weyden. So, for instance, the archivolt group of the Adoration of the Magi (fig. 26) derives, at least ultimately, from a work by Campin known through a copy in Berlin,[29] or one of its many variants, and the veiled head of the Virgin, slightly inclined, is identical to that of the same painter's "Flémalle Madonna" in Frankfurt (fig. 27). Other details, such as the Swooning Virgin supported by St. John in the archivolt group of the Deposition, occupy a position exactly midway between Campin and Van der Weyden.[30]

Also transitional in style is the extraordinarily monumental central Virgin and Child, for which, or more probably after which, a drawing survives in Stockholm (figs. 29–30).[31] But here and in the other large groups of the retable (figs. 23–24), the disciplined, continuous series of long, parallel diagonal folds trailing against the base and dominating the lower half of the composition, reveal the unmistakable influence of Van der Weyden's paintings of the later 1430s

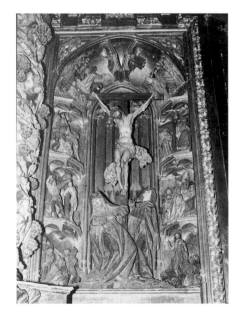

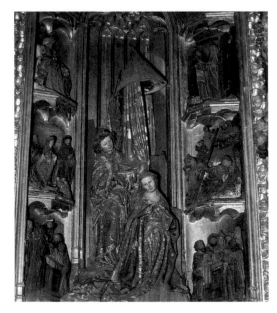

Fig. 23 Laredo Altarpiece, detail: Calvary

Fig. 24 Laredo Altarpiece, detail: Annunciation

(fig. 25). And the diagonally placed Child, thoroughly Campinesque in both type and basic pose – one leg bent, the other stretched forward – is nevertheless *interpreted* here in the spirit of Van der Weyden's striding figures.[32]

Throughout the retable, correspondences to painting abound.[33] When such close parallels between the two media appear, it is generally assumed that the painter influenced the carver's work. Was this also true here? Perhaps. And yet the head master of the Laredo Altarpiece has an individual personality of his own, suggesting the possibility of a collaborative effort involving a creative discourse between sculpture and painting comparable to that of the Tournaisian School in the years c. 1430.[34] He may well have been influenced by Tournaisian sculpture: in figure types and in the intense pathos, his Calvary is reminiscent of the Entombment group in Soignies (*Tournai*, fig. 25); and the grand rhetoric of Mary's *svenimento* pose and gesture reveals a spirit akin to that of the (later) Calvary Virgin in Antoing (*Tournai*, fig. 41). But these comparisons also serve to bring out meaningful differences: even these most "Tournaisian" of Brabantine sculptures lack the incisive, harsh characterization and crisp linearity so typical of the Tournaisian School and of Van der Weyden's fundamentally graphic style. That is, the incipient "style of the long lines" as it appears

here retains an underlying sense of ample volume, confirming the artist's Brabantine origin or at least his acclimatization to the local artistic tradition.[35]

Taken together, the above observations suggest that the Laredo Altarpiece was carved c. 1440 or immediately thereafter. It is of course tempting to attribute the retable to the hand of the Tournaisian sculptor Jean Delemer, active in Brussels from 1440 at the latest, and whose activity corresponds to the Laredo master's artistic "profile" as suggested here. Unfortunately, this elusive artist's later style, known to us only indirectly by way of the bronze statuettes in Amsterdam (cat. 20), does not warrant such an attribution.

In any case, further evidence for the interaction of sculpture and painting is provided by the Apostle statuettes now set in the predella of the Laredo Altarpiece, works that occupy a crucial place for the study of the Late Gothic Brussels sculpture comparable to those of the Hakendover Master's for the years c. 1400. Several of these figures are absolutely identical to the Apostles in the painting of the Exhumation of St. Hubert, by an assistant or follower of Van der Weyden (cf. figs. 31–34). This relationship is interesting in two respects. Since the painting, which formed part of a diptych formerly in Brussels Cathedral, was almost certainly executed immediately around 1440, it provides supporting evidence for the proposed chronological placement of the Laredo Altarpiece.[36] The carved statuettes cannot be dependent on those in the painting (nor on related drawings), since the latter are shown from varied vantage points, including pure profile, whereas those in Laredo are consistently carved in the round. Since, on the other hand, the statuettes, while grand and highly original in *conception* are clearly weak in *execution*, one is led to the conclusion that both derive from an important monumental Brussels statue cycle of c. 1435–40 now lost to us.[37]

Fig. 25 Rogier van der Weyden, Reading Magdalen, fragment, oil on panel. London, National Gallery

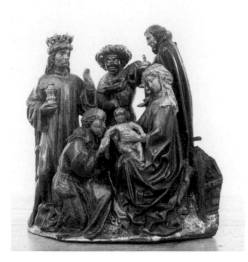

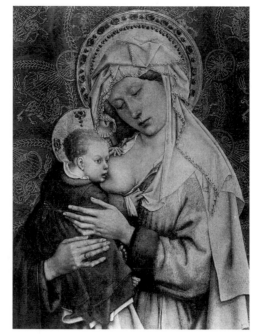

Fig. 26 Laredo Altarpiece, detail: Adoration of the Magi

Fig. 27 Robert Campin, Virgin and Child, detail, oil on panel. Frankfurt, Städelsches Kunstinstitut

Fig. 28 Laredo Altarpiece, detail: Entombment

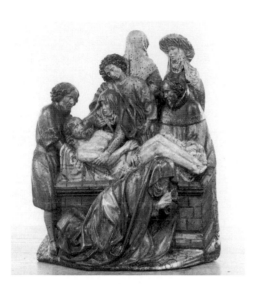

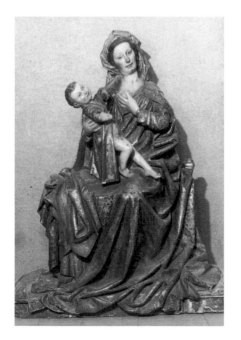

Fig. 29 Laredo Altarpiece, detail: Seated Virgin and Child

Fig. 30 Seated Virgin and Child, ink drawing. Stockholm, Nationalmuseum

Fig. 31 Atelier or follower of Rogier
van der Weyden, Exhumation of
St. Hubert, detail: Apostle statues, oil
on panel. London, National Gallery

Fig. 32 Laredo Altarpiece,
detail: St. Andrew

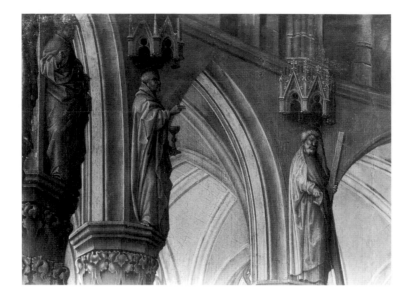

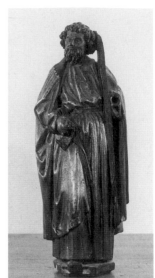

Fig. 33 Atelier or follower of Rogier
van der Weyden, Exhumation of
St. Hubert, detail: Apostle statues

Fig. 34 Laredo Altarpiece,
detail: Apostle

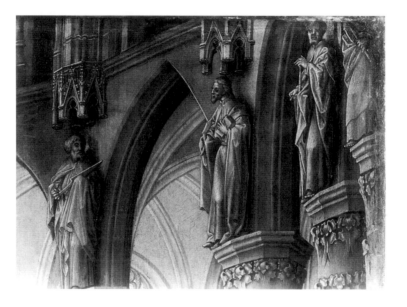

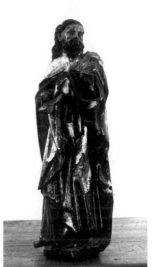

Later Brussels Retables

It is not possible here to discuss, even summari-
ly, the wealth of surviving Brussels retables of
the second half of the fifteenth century, al-
though some representative fragments are in-
cluded in the exhibition (cat. 27–29).[38] Instead,
two exceptional retable ensembles of unusually
large size and fine quality, though lacking their
original architectural enframement, can serve
to define alternative formal possibilities of
these years in the Brussels milieu.

One is a well-known masterpiece, the Aren-
berg Lamentation (c. 1460–70; fig. 36).[39] Among

the numerous sculptures that reflect the style of
Van der Weyden, it holds a place apart: rarely
do we encounter such a precise and convincing
translation of both the master's form and spirit
into the three-dimensional medium, at a level
of quality comparable to the original.

But the Arenberg Lamentation master is also
important in his own right and appears to have
played a significant role in the development of
sculpture, since his interpretation of Rogier's
style directly announces the c. 1500 Brussels
manner associated with Jan Borman "the
Great" (active c. 1479–1520). His influence is
reflected in Bormanesque works such as the

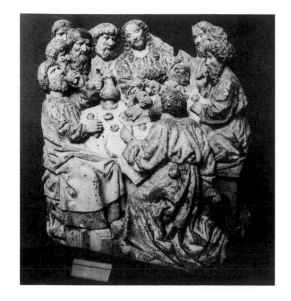

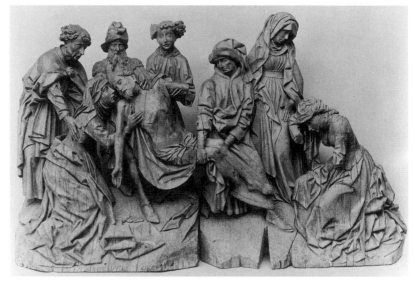

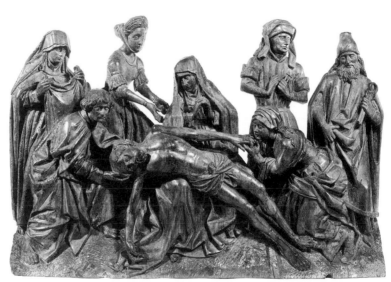

Passion retables in Barnard Castle (cat. 29), Strängnäs 1, Sweden (fig. 39; cf. especially the kneeling Magdalen and the Mary at left in the Lamentation scene), and in Sint-Dymphna, Geel (fig. 40; the Deposition here is an abbreviated, more popular version influenced by the Arenberg Lamentation rather than Rogier's painting).[40] This is also evident in details: the head of Nicodemus (at the center) in the Detroit group occupies a development position precisely midway between Rogier's types and the solemn, craggy male heads encountered in works attributed to Borman, such as the splendid St. Hubert in Leuven (fig. 37).[41] The Aren-

berg Lamentation can therefore to some extent bridge the stylistic gap between two consecutive phases of Brussels sculpture: the "Rogierian" mode especially prevalent in the third quarter of the century and the Borman style that becomes dominant in the years c. 1490–1530.

But Van der Weyden's influence, however important and ubiquitous, provides only a partial explanation of the style of the years c. 1500, which involves a synthesis of Rogierian and what might still be called, for want of a better term, "Flémallesque" sources. For if the impact of Rogier's *compositions* and *figure types* is in-

Fig. 35 Laredo Altarpiece, detail: Last Supper

Fig. 36 Arenberg Lamentation, oak, traces of polychromy. Detroit Institute of Arts

Fig. 37 St. Hubert, detail, wood with polychromy. Leuven, Stedelijke Musea

Fig. 38 Lamentation, walnut. Brussels, Musées Royaux d'Art et d'Histoire

79

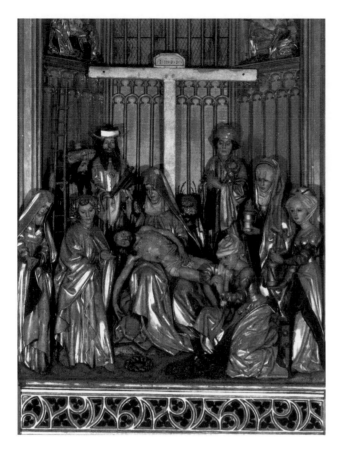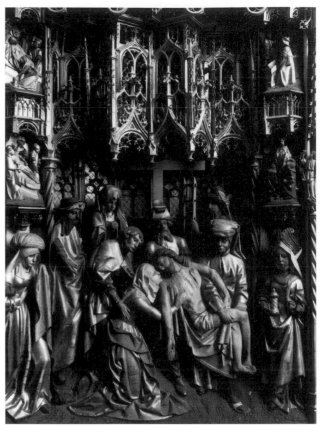

Fig. 39 Passion Altarpiece of Strängnäs I, detail: Lamentation, wood with polychromy and gilding. Strängnäs, Cathedral

Fig. 40 Passion Altarpiece, detail: Deposition, oak with polychromy and gilding. Geel, Sint-Dymphnakerk

contestable, literal transcriptions of his *style* are quite rare. Most often, as in the Laredo Altarpiece, the painter's models are modified to a greater or lesser degree by the indigenous predilection for more voluminous forms.

An excellent example of the continued survival of a "Flémallesque" figure style even in a composition clearly inspired by Rogier can be seen in a Lamentation group in Brussels (fig. 38).[42] Similar to the Detroit example in its broad, frieze-like arrangement of linked figures in parallel planes as well as in the quiet, restrained expression of sorrow, it differs fundamentally in drapery and in figure style, which are rooted in an earlier tradition. The time of origin of the Brussels Lamentation remains problematic. It is often dated toward the end of the fifteenth century, but there is good reason to assume that it was executed about the same time as or somewhat later than the ensemble in Detroit, probably c. 1460–70.[43] Such problems of dating are themselves symptomatic of the

evolution of later Brussels and Netherlandish sculpture generally, marked during this time by a variety of stylistic possibilities, including survivals and revivals of earlier styles, eclecticism alongside more original achievements, especially as we approach the later fifteenth century. Whether the two groups under discussion represent two successive stages of development or, as is more likely in my view, whether they evidence contemporary stylistic alternatives – a situation also common in Flemish painting of this time – the continued coexistence and interpenetration of these two stylistic modes is clear. In the years c. 1500 at the hands of Jan Borman and other sculptors, they are once more creatively combined in a final blossoming of a Brussels stylistic synthesis.

Brabantine Madonnas c. 1400–50

If Brabantine Madonnas of the years c. 1500 have been studied to some degree and are relatively familiar to us, earlier examples have received little attention. The following summary comments are intended to provide a skeletal chronological framework for the treatment of this theme, principally in Brussels, during the first half of the fifteenth century.

Only a rather small, heterogeneous group of examples is known in the Brabantine area from the years c. 1400, and these are by no means comparable in significance to the important Tournaisian series. It is clear, however, that here too, the formulation of the subject during these years was largely determined by the influence of Beauneveu. Examples in Onze-Lieve-Vrouw-Lombeek (fig. 41) and in Tubize ("Notre-Dame de Stierbecq") represent archaizing, provincial reflections of the style of Beauneveu's St. Catherine in Kortrijk (see *Tournai*, fig. 3); the same sculptor's influence probably also explains the style of Madonnas in Leuven (from the house "Het Woud"; fig. 46) and in the church of Sint-Catharina, Brussels (heavily restored).[44] One is struck by the mediocrity of these works, although this may result from the loss or simply the lack of identification of more important examples.

An exception to the rule is an especially fine Madonna in the Beguinage Church, Lier (c. 1370–1400; fig. 43).[45] Although seemingly isolated in the duchy, this work partakes of a wider European style current that ranges geographically from the Netherlandish area to Cologne, Westphalia,[46] and the Baltic region – a tendency that may well have its origin in the Southern Netherlands.[47]

Although no Madonnas by the Master of the Hakendover Altarpiece appear to survive, several examples may reflect this sculptor's influence, albeit at a much lower level of quality, and may thus be considered as of local origin and dated to the early fifteenth century. One of these is the Virgin and Child (fig. 44) flanked by smaller figures of SS. Catherine and Barbara

that are in the south portal tympanum of the church in Huldenberg (c. 1410–20?), one of the few ensembles of this sort to survive. Another is a typologically related but later and clearly archaizing example in the church of Dongelberg (c. 1430–40?; fig. 45).[48] Only rarely do we encounter a creative use of the Hakendover Master's style, as in the important group in Drogenbos (cat. 15).

An unusual instance of a Netherlandish "Beautiful Madonna" survives in Leuven (c. 1410–20?; fig. 42).[49] The sculptor's approach reveals a stylistic compromise between the Beauneveu tradition (upper half of the composition, including the upright pose of the Child) and the serpentine, elegant gliding movement and flowing lower drapery of hairpin folds typical of the "Beautiful Style."

These neo-courtly stylistic features offer a perfect foil for a study of a key example of the nascent Late Gothic, the monumental Madonna in Tongerlo (Abbey Church) that can be dated to the year 1422 (cat. 14).[50] Mary is shown here in a frontal stance, her head turned slightly to the side and holding the Child, who seems to reach down to an imaginary donor below. This too little-known but very important work, in some respects reminiscent of Tournaisian 1400-style Madonnas, is nonetheless wholly distinctive in its sense of *gravitas*. The curving movement common in earlier works is replaced by a static, massive presence, Mary's silhouette, defined laterally by long, continuous verticals, is simplified to an extreme. The drapery retains the amplitude, soft texture, and many motifs of the past. But throughout, the folds tend to lose their sense of flow; the edge of Mary's mantle at the lower center is folded into a flattened sequence of zig-zag triangles; long verticals hook at abrupt right angles at the base; and minor details such as the sleeves of Christ's shirt present an irregular, accordion-like fold pattern that will reappear in a more sculpturally contrasted and higher relief interpretation in Delemer's later Angel of the Annunciation (*Tournai*, fig. 1). These incipient Late Gothic details seem to

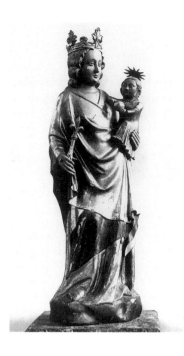
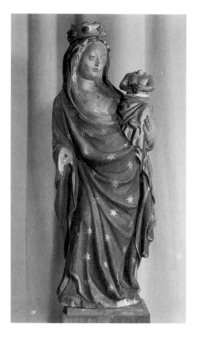
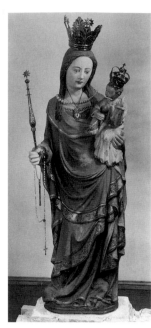

Fig. 41 Standing Virgin and Child, wood with polychromy and gilding. Church of Onze-Lieve-Vrouw-Lombeek

Fig. 42 Standing Virgin and Child, stone, modern polychromy. Leuven, Stedelijke Musea

Fig. 43 Standing Virgin and Child, wood, modern polychromy. Lier, Begijnhofkerk

make their earliest appearance here in the history of Netherlandish sculpture. In the wider context of the origins of the *ars nova*, the Tongerlo Madonna occupies an important moment of transition, in which earlier forms survive but have lost their vitality, and which in its grave, sober expression heralds the comparably monumental but more evolved grisaille figures in Netherlandish painting, particularly the two St. Johns in the Ghent Altarpiece, that can be attributed, at least in basic conception, to Hubert van Eyck (see *Introduction*, fig. 2).

In the development of local sculpture, it is the earliest in a series of Brabantine, probably Brussels Madonnas. Two stone groups now set side by side in the Brussels Museum (see cat. 16 and fig. 47), while smaller in size, exhibit a similarly full-bodied appearance. The Madonna on a Crescent Moon (c. 1435–40; fig. 47), one of the best examples of the fifteenth century, retains the bulk and amplitude of the Tongerlo Virgin, but the drapery is now articulated by a fully developed Late Gothic pattern of fragmented though still softly modeled surface forms.[51] The solemn spirit of the previous example is replaced by one of great warmth and tenderness that reminds one of Rogier's early, still Flémallesque, Madonnas. Touches of realism make their appearance; whereas the hands

of the Virgin in Tongerlo retain traces of a traditional courtly stylization, those in the Brussels work are more realistically formed (including the pudgy hands of the Child). Parallels to Rogier's paintings are manifold,[52] but this involves parallelism rather than influence; significantly, no identical Madonna by either Campin or Van der Weyden is known.

A slightly later stage of development is represented by the enthroned Madonna in the funerary monument of the court physician Ditmar van Bremen (d. 1439), a small but impressively spatial, shadow-rich "tableau" in Anderlecht (fig. 48).[53] Here the face of Mary (the Child's head is restored), clearly of Brabantine lineage, is more refined, its features rendered in a more taut and crisp manner. Similar changes are evident in the drapery, which acquires a harder, more linear and dynamic character. Directly related in formal type is an enthroned Madonna said to have come from the Beguinage in Leuven (formerly in a Belgian private collection), softer in expression and more pictorial in surface modeling (fig. 49).[54] Both groups (especially the latter) are in turn akin to the Nursing Virgin in the Laredo Altarpiece (fig. 29). While they differ in specifics and interpretation, indicating the hands of three different Brussels sculptors, all three may well

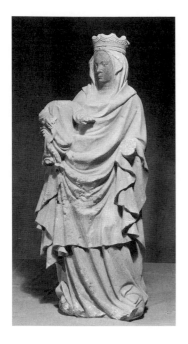 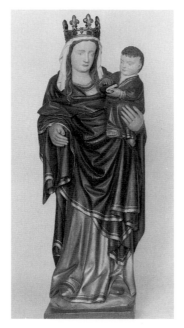 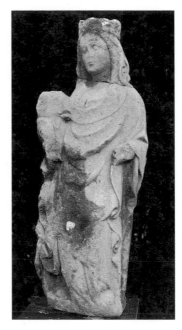

Fig. 44 Standing Virgin and Child, stone. Church of Huldenberg, portal

Fig. 45 Standing Virgin and Child, wood with modern polychromy. Church of Dongelberg

Fig. 46 Standing Virgin and Child, sandstone. Leuven, Stedelijke Musea

date from about the same time, not far from the years c. 1440. Together, they testify to the merging of Tournaisian influences with the local tradition. The Tournaisian component is particularly evident in Laredo, closely related to contemporary paintings in this theme. But it is also present to an extent in the Madonnas from Leuven (fig. 49) and in Anderlecht (fig. 48) – where we see drapery forms such as the mantle edge at the lower center of the composition, descending from Mary's hand in loosely undulating, overlapping edges and terminating in a sharp point below, that recall motifs in Delemer's Annunciation Virgin (*Tournai*, fig. 2) – and interestingly to a lesser degree also in the Tongerlo Madonna (cat. 14). It is probable that these three works are somehow linked, directly or indirectly, with Delemer's activity in Brussels during these years, although the precise nature of this relationship requires further study.

Although it remains to be explained in detail, the stylistic synthesis manifested here is unmistakably clear. In addition, this synthesis served as a basis for subsequent artistic developments in Brussels, by reflection in the entire Netherlandish area, and ultimately in many parts of Europe. For, as in contemporary painting, these are the most original, creative years of the Brussels School, a time when formal so-

lutions – and themes – were developed that were to be of lasting significance in the coming decades, and that were often repeated in relatively unaltered form. Two last examples, probably from the 1440s, can cast some light on these points.

A recently identified work of Brussels origin is the outstanding Madonna in the Brigittine Convent in Vadstena, Sweden (fig. 50).[55] In its basic features, including the facial types with their calm, tempered realism, the Virgin's contrapuntal stance, and her drapery, drawn to one side, forming an irregular broken fold passage at the center and a series of diagonals below, represents what becomes a classic Brabantine schema best known through numerous variants in the years c. 1500.[56] It is a telling fact that the dating of this group in the literature has gradually shifted over the years to an ever earlier time of origin. It has recently been convincingly placed as early as 1443.[57] The earliest appearance of this formal solution, at least in terms of basic pose and drapery design, can be found in Campin's painting of St. Veronica in Frankfurt (c. 1428; fig. 51), a work known in Brussels at an early date, since it was copied in one of the embroideries of the Chapel of the Golden Fleece in Vienna (cope of the Virgin). An analogous example in sculpture, more Tournaisian

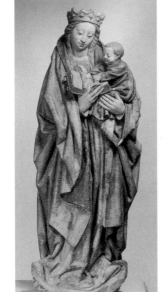 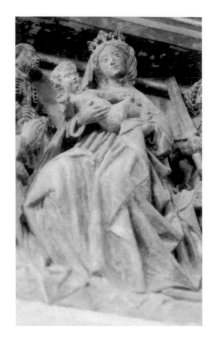 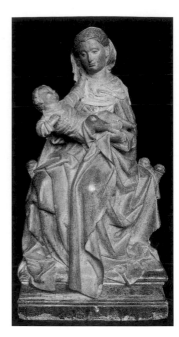

Fig. 47 Standing Virgin and Child, stone with polychromy. Brussels, Musées Royaux d'Art et d'Histoire

Fig. 48 Epitaph of Ditmar van Bremen, stone with polychromy, detail. Anderlecht, Sint-Guidokerk

Fig. 49 Seated Virgin and Child, stone with polychromy. Whereabouts unknown

in character and therefore perhaps earlier in origin is the Madonna in Herent near Leuven (c. 1440?; fig. 52).

Whereas the style of the Virgin in Vadstena is consistent with a large number of other Brussels works, mostly of later date, a Madonna in the Broodhuis, Brussels, is a more isolated masterpiece (cat. 19). In its youthful, dainty, and very appealing facial types, its richly contrasted, spatial movement, and an abundant, expansive flow of sweeping folds that anchor the composition to the base, this is a sort of Late Gothic "Beautiful Madonna." Were it not for its known provenance — a niche in the facade of a building in Brussels — this group might easily have been classified as a seminal example of the Utrecht School in the manner of Adriaen van Wesel, given the head type of Mary with its high *bombé* forehead and her long, swirling, spaghetti-like hairstrands. As it is, it is probably a work of an exceptionally talented Brussels sculptor whose style can help us understand the artistic sources of the Utrecht artistic milieu.[58]

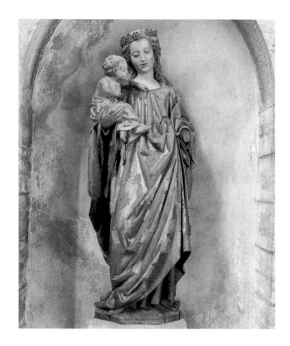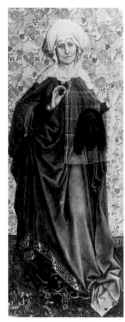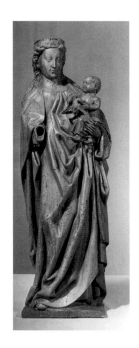

Fig. 50 Standing Virgin and Child, walnut with polychromy and gilding. Vadstena, Church of the Brigittine Convent

Fig. 51 Robert Campin, St. Veronica, oil on panel. Frankfurt, Städelsches Kunstinstitut

Fig. 52 Standing Virgin and Child, wood. Herent, Klooster Studiehuis der Priesters van het H. Hart

* The observations presented here are based in part on joint research conducted over a considerable number of years with Robert Didier of the Institut Royal du Patrimoine Artistique, Brussels, published by and large by Didier, primarily in *Sculptures et retables des anciens Pays-Bas méridionaux des années 1430–1460* (Didier 1989), to which publication I refer the reader for further reference.

1 Examples of the first category are a Christ on the Cross, Orp-le-Grand, arr. Nivelles, and gable statues in Sint-Kwintens-Lennik, arr. Brussels; examples of the second category are the easternmost choir consoles in the Onze-Lieve-Vrouwekerk, Vilvoorde. I have dealt with some of these works in my thesis (Steyaert 1974, 8–51). See also Didier and Steyaert, in Cologne 1978, 1:87.

2 This important citation was first published by Duverger 1933, 40. For recent discussions of Sluter's Netherlandish background, see Morand 1984 and 1991, 23–42. Sluter's possible activity in and stylistic indebtedness to the Parisian milieu has lately been emphasized (see e.g. Didier 1993). The definition of Sluter's stylistic roots remains a difficult matter, especially in view of the close links between the Netherlandish and French court milieu. This exceptional sculptor's art may well have been influenced by that of Jean de Marville, as Schmidt has recently proposed (1992, 295–304). A most interesting attribution to Sluter of several figural consoles in the Tour du Village, Vincennes, by Heinrichs-Schreiber (1991) also merits serious attention. These works might then in turn be compared with the somewhat similar but more traditional Prophets in the vault bosses of the archive room, Utrecht Cathedral (see Geisler 1956, especially fig. 112). No single source can of course explain the work of this artistic genius, but the search for Sluter's stylistic roots cannot ignore, it seems to me, the tradition of his North-Netherlandish homeland.

3 Roggen (1936) rightly called attention to the importance of this building's decoration as evidence of the Brabantine artistic situation. However, his attempt to link the stone consoles with a Sluterian style supposedly current in Brussels is entirely unconvincing.

4 The most impressive examples of this Brabantine regional style survive in three huge statues of kings at Reims Cathedral (destroyed in the Second World War; first

identified as Netherlandish by Schmidt 1972). See also Steyaert 1974, 12–16.

5 Among the important ensembles of Brabantine architectural sculpture of these years that still await a thorough study and evaluation are the historiated capitals and corbels in the church of Sint-Waldetrudis, Herentals; the fragmentary remains of small-scale sculpture of the church of Onze-Lieve-Vrouw-ten-Poel, Tienen, some of which appear to be of Mosan, others of Brabantine origin; and the corbels and bosses (partially destroyed in the Second World War) in the cloister of Sint-Gertrudis, Leuven (first published by Doutrepont 1937; see also Demuynck 1982), some of which are comparable to the corbels in the castle of Vincennes. Such works of small-scale sculpture can often be helpful in localizing large statues. Interesting in this regard, for instance, are two small but exquisite consoles showing a modishly garbed male and female musician from the Schepenhuis, Mechelen (now Busleiden Museum there; see Verheyden, 1943, 43–44) rarely cited, apparently because they are believed to be modern restorations. Stylistically they offer points of comparison to the important statues of the Magi in the south-west portal, Halle Basilica (see Steyaert 1974, 99, and Didier and Steyaert, in Cologne 1978, 1:92–93).

6 For this sculptor, see Steyaert 1974, 111–148, and Didier and Steyaert, in Cologne 1978, 1:88–90, 94–95 (with additional bibliography). The only works in Brussels itself that can be attributed to the Hakendover Master or at least to his shop are the archivolt Prophets and the consoles from the Belfry portal of the City Hall. Two vault bosses and six historiated corbels decorating the interior passageway and the inner face of the same portal, virtually ignored in the literature, were carved in the same atelier.

7 For an excellent and in a basic sense still valid analysis of the Halle choir sculptures, see Hamann 1923, 214–240. See also Steyaert 1974, 123–133.

8 The attribution to Sluter was proposed by Medding 1934. Since the Apostles form an integral part of the choir decoration in an iconographic as well as a physical sense (set in niches cut into the piers as "pillars of the Church"), they were certainly completed in or shortly before the dedication of this part of the building in 1409. The influence of

Beauneveu, active in central France after c. 1385, does not exclude the possibility that the Hakendover Master's style follows an indigenous Netherlandish tradition of realism; on the contrary: it is precisely in their earthy, rather coarse appearance that the Apostle heads differ in emphasis from the more refined characterization of the head from Mehun. In this regard, one should also note the striking similarity of the facial features of the St. Peter in Halle to those of St. Joseph in Melchior Broederlam's painting of the Flight into Egypt (right wing of de Baerze's Calvary retable, Dijon).

9 Concerning the head from Mehun, see the recent discussion by Scher (1992). Although the attribution of this masterful work to Beauneveu is not universally accepted, its immediate dependence on this master's late style appears in any case clear, as convincingly argued by Bober (1953).

10 The very distinctive, ornamentally treated hair, set out from the face in large waves, is comparable to that seen in ivory carving, e.g., in the works attributed to the Master of the Berlin Triptych (see esp. Gaborit-Chopin 1978, fig. 204).

11 The dynamic, spatial formulation of miniature architectural baldachins seen here has an antecedent in funerary sculpture in Jean de Marville's design for the tomb of Philip the Bold and in Jacob de Baerze's Calvary retable (Dijon Museum). Paatz (1936, 58–60) first recognized and defined the significance of this altarpiece type. See also von Euw 1965, esp. 114–116. An excellent overview of the typological and conceptual development of fifteenth-century Netherlandish retables can be found in Skubiszewski 1989, 23–30. Reinke's (1988, 53) tentative localization of the Dortmund Altarpiece sculptures to Antwerp, apparently based on the discovery of an open hand carved into the bottom of one of the statuettes, is unacceptable given the preponderant stylistic evidence favoring a Brussels origin.

12 Inv. 16.32.214. The similarity of this fragment to the Halle choir sculpture was first recognized by Verdier, in Baltimore 1962, no. 87; see also Steyaert 1974, 137–138; Didier 1989, 56.

13 Oak, high relief, h. 45, inv. NM2482. Leeuwenberg and Halsema-Kubes 1973, no. 83 ("Noordnederlands, begin 16de eeuw"). Most of Christ's head and his hands have been renewed. This work is an updated, more compact version of the earlier, stone Gethsemane relief by an assistant of the Hakendover Master that forms apart of the Halle wall tabernacle (Steyaert 1974, figs. 235, 239). As the latter, it may originally have included a group of approaching soldiers at the left side, where the relief seems incomplete (dowel marks). Although entirely typical of the Hakendover Master's style (semi-circular composition, figure style), the crude interpretation of details (Apostles' faces) in the Amsterdam work precludes an attribution to this sculptor's own hand.

14 The painted shutters of the Dortmund Altarpiece, the

largest single ensemble of early-fifteenth-century Netherlandish painting, still await a thorough study. Von Euw (1965) has convincingly argued that the well-known Calvary of the Tanners ("Huidevetters Kalvarie," Bruges, Cathedral) was executed in the same atelier. In view of the Brussels origin of the carved center of the retable, the same artistic provenance is indicated for these paintings, even though this cannot presently be substantiated on a stylistic basis. See Didier and Steyaert 1978, 1:96–97. It might be noted that the Dortmund panels showing SS. Catherine and Barbara in a garden setting enclosed at the back by a high wall parallel to the picture plane (von Euw 1965, fig. 69) represents a formula frequently encountered in later Brussels painting (as e.g. in the Master of St. Goedele).

15 Weise 1930, 3:1, 4 (c. 1450; attribution to Netherlands; "Charakterisch sind die weichen, fliessenden Mantelfalten ... die an ältere Brabanter Arbeiten wie den Altar von Haekendover oder das steinerne Tabernakel zu Hal erinnern"). Weise's observations on Netherlandish sculpture are, however laconic, remarkably precocious and sharp-sighted; Valladolid 1988, 81–82 ("obra flamenca, siglo XV"); Didier 1989, 55–56, 77 no. 42 ("Maître bruxellois?, vers 1430").

16 In spite of the strange shape of the framework, it is interesting to observe that the small bits of remaining interior tracery (top of central compartment; right wing) consist of elements identical to those in the Dortmund Calvary retable by the Hakendover Master.

17 It is instructive to contrast this Annunciation with a more "normative" (and probably also earlier) treatment of this subject in the circle of the Hakendover Master, preserved in a retable fragment in Utrecht (Catharijneconvent; see Geisler 1956, 151–152, and fig. 118).

18 The three-tiered composition of the Nativity, surmounted by a Meeting of the Magi (in the spirit of the Limbourg Brothers) and a Blessing God the Father with Angels, survives as a distinctive formulation in many later Brussels carved altarpieces, including those by the Master of the Fuentes Altarpiece (Steyaert, in Gillerman 1989, 240–242).

19 Duverger 1933, 55.

20 For this neglected but highly important Cross, see Hamann 1923, 242–244 (c. 1450); Ohnmacht 1973, 39–40 and note 17 (c. 1430–50; convincingly relates it to earlier Halle choir sculptures as well as to Delemer); Didier 1989, 66–67 ("Brabant, 1420–30"; correctly identified with a "courant flémallien" in Brussels).

21 The Rieden Master's œuvre was first constituted by Nieuwdorp (1971) and Vandevivere (1972); see also Deutsch 1985, 157ff; Didier 1989, 56–57 ("Bruxelles, vers 1440").

22 See also the Nativity panel of 1435 by Campin's pupil Jacques Daret.

23 Cf. copy after Campin in Berlin, Friedländer 1967, 2:pl. 102.

24 See the head types in Campin's fragment with the Good Thief in Frankfurt (cat. 10, fig. 10f). For the pose of the Magus, see the drawing illustrated in Sonkes 1959, pl. XLIIIa.

25 From the extensive bibliography concerned with Ards may be cited Smeyers 1977, 257–349 (in-depth study of core documented works in Leuven); Deutsch 1985 (focus on retable in Schwäbisch Hall; extensive bibliography); Didier 1989, 59–60 (establishes chronology of œuvre, integrates Ards into conservative current of Brabantine sculpture).

26 Wood with polychromy, h. c. 150 (central Madonna); c. 45 (Apostle statuettes); c. 40 (archivolt groups). Weise 1930, 3:1, 7–8 ("Niederländischer Herkunft, um 1480"); Proske 1951, 57; Leuven 1965, Add. 28–33; Campuzano-Ruíz 1985, 467–481 ("Flandes, segunda mitad del siglo XV"; with further bibliography); Didier 1989, 63 ("maître bruxellois, 1440–50"); Campuzano-Ruíz 1989 (unpaginated; "ultimo tercio del siglo XV"). The author wishes to express his thanks to Mr. Campuzano-Ruíz, who provided the photographs used in this article, for his generous assistance.

27 For a discussion of the iconography, see Campuzano-Ruíz 1985, 468–480; for Rogier's altarpieces, see Panofsky 1953, 259–264. The correspondence to Rogier's paintings also extends to the openwork tracery on the interior of the arches (cf. also the embroidered vestments of the Golden Fleece Chapel).

28 In my opinion, the Coronation group is consistent in style and must therefore have formed part of the same ensemble. As today, it probably occupied a central position directly above the Madonna, and may have been contained in a separate small retable, an arrangement not unknown in earlier Netherlandish retables (see the Grönau Altarpiece, Lübeck, Sankt-Annen-Museum).

29 Friedländer 1967, 2:pl. 102, where the theme of Mary's humility is also emphasized by the presence of a pillow.

30 See Campin's Deposition Triptych, central panel, in Liverpool (Friedländer 1967, 2:pl. 86), and Van der Weyden's archivolt group in the Granada and Miraflores Altarpieces (Van Schoute 1963, pl. 182); cf. also the exterior grisaille of the Edelheer Triptych (Friedländer 1967, 2:pl. 8).

31 The drawing is discussed by Sonkes 1969, 104–106, no. C9 ("ne semble pas dépendre d'un modèle flamand … plutôt allemande?"). The precise relation of the drawing to the carved group needs further study. I would not exclude the possibility that it is based on the Laredo group, which is superior in quality. Sonkes has rightly compared the drawing to a painted Madonna in a triptych now in the church of Sint-Maria-ter-Heide, Brasschaat (c. 1513–5) by "Meester Johannes" (see also Antwerp 1954, pl. XLII). It is interesting to note that this clearly archaizing triptych also exhibits iconographic points of correspondence to the Laredo ensemble (including the presence of the Apostles composing the Credo on the exterior wings).

32 Cf. Joseph of Arimathea supporting Christ's upper body in the Prado Deposition (Tournai, fig. 26). The pudgy Christ Child wearing a long skirt with rolled-up sleeves and a prominent lower slit (cf. Steinberg 1983) is a characteristic type seen in late works of Campin's circle (cf. esp. the Holy Family, Le Puy; Friedländer 1967, 2:pl. 143).

33 For additional comparisons, see Campuzano-Ruíz 1985, 481, no. 48.

34 Cf. Campuzano-Ruíz 1985, 481 ("el Maestro de Laredo no copia a Van der Weyden, sino que, fundamentado en su obra, sabe conceder una personalidad indiscutible a sus figuras, así como una maestría en la talla"), and Didier 1989, 63 ("dû assurément à un maître bruxellois … progressiste … qui ne doit pas ignorer les œuvres du tournaisien Jean Delemer").

35 Several of his groups suggest that the Laredo Master was acquainted with the Brabantine tradition reaching back to the years c. 1400. His archivolt group of the Last Supper (executed by an assistant; fig. 35) still basically recalls the interpretation of this subject by the Master of the Hakendover Altarpiece in the Halle wall tabernacle (Brussels, fig. 9), both in its semi-circular grouping and in the lively genre detail. Compare also the Last Supper reliefs in Saint-Antoine-en-Barbefosse near Mons, probably carved 1438–9 by a Mons sculptor influenced by Brussels models (Tondreau 1973–5, 209 and no. 2; ill. in Didier 1983, fig. 15), and in the church of Sint-Dymphna, Geel. The Coronation group in Laredo, in spite of its rich play of (thick) lines, is reminiscent of earlier Brabantine treatments such as that seen in the easternmost choir boss in the church of Onze-Lieve-Vrouw, Breda (c. 1430–40?; see Kalf 1912, pl. VIII). The Late Gothic style of this boss indicates that the choir was completed some years later than the traditionally accepted date of 1416.

36 The other panel of the diptych, representing the Dream of Pope Sergius, is preserved in the J. Paul Getty Museum, Malibu. The original was once in the Chapel of St. Hubert founded in 1437 (for an overview of this evidence and detail photographs, see Davies 1954, 179–193). Although various attributions and dates have been proposed for this work, the style appears to me perfectly consistent with a date in the later 1430s.

37 One naturally thinks here of the Gothic Apostle statues that were once placed against the nave piers in Brussels Cathedral (Lefèvre 1942, 66); unfortunately, we do not know when these works, destroyed by the iconoclasts, were carved.

38 Among earlier studies of these works, that by Destrée (1894–9) remains important. For an excellent more recent discussion of Brabantine retables, see Jacobs 1986. See also Becker's analysis (1989) of an important series of Brussels retables of the years c. 1470.

CATALOGUE

* catalogue entries 14, 19, 24, 25, 42, 45, 48, 52, and 53
written in collaboration with Monique Tahon-Vanroose

Tournai and Hainaut

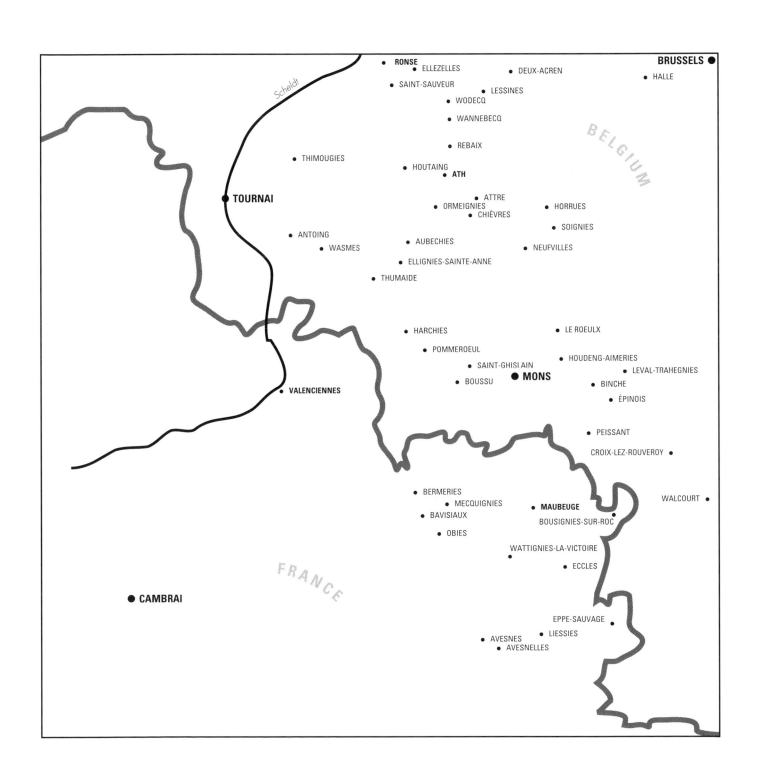

2 Seated Virgin and Child

Atelier of Jean Delemer

Tournai, c. 1425–30

Stone, h. 54

Principal losses: head and lower left arm of Virgin, head, shoulders, lower

forearms and feet of Child

Tournai, Private collection (former Godin Collection)

In spite of its condition, this small though monumental fragment is of key importance in the history of Tournaisian sculpture, since it marks the precise moment of transition from the Soft Style of the early fifteenth century to the incipient appearance of a Late Gothic formal vocabulary. The overall composition exhibits a more simplified, sober character: the decorative play of calligraphic edges so typical of the earlier Tournai tradition is almost entirely eliminated. And while the drapery retains an ample, softly textured appearance, the flowing rhythms of the Soft Style are here modified to a discontinuous pattern of triangular forms, especially in the lower half of the composition. In this respect, this statue is quite directly related to, though somewhat more traditional than, the Annunciation group by Jean Delemer (1426–28; *Tournai*, figs. 1 and 2), where identical motifs are interpreted in a more sculptural manner. On the basis of this comparison, the late-1420s date proposed for the Madonna by Didier appears perfectly plausible. Given its fragmentary and somewhat more conservative style, it is difficult to decide whether it is an earlier work by the same artist or whether it was carved under his direct influence. In any case, an attribution to his atelier appears in order. As such, it serves to anchor this sculptor's *œuvre* more firmly in the artistic milieu of Tournai.

> Tournai 1956, 41, no. 10; Tournai 1960, no. 14; Didier 1983, 375–376 ("Tournai, c. 1425–30").

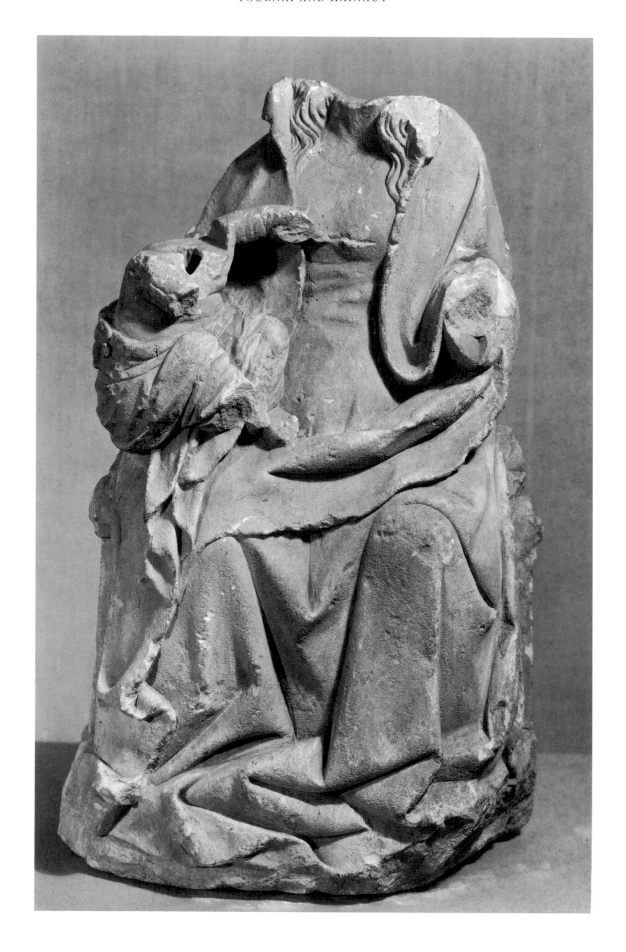

3 Saint Michael

Tournai, c. 1425 or c. 1500 (?)

Wood with (modern) gilding, h. 58.8

Ellezelles, Saint-Pierre aux Liens

St. Michael, often garbed as a warrior, is here shown in liturgical dress. Carrying a notched shield in his left hand, he crushes the dragon underfoot, thrusting his spear into its open mouth. This excellent statuette has been convincingly associated with Jean Delemer (Didier), based principally on its undeniable similarity to this sculptor's Annunciation Angel in Tournai Cathedral (*Tournai*, fig. 1). Closely related to the latter in stance and drapery, the St. Michael exhibits a more decorative, less forceful movement and a more discreet treatment of folds. In this regard, the figure shows an affinity to the same Saint in the epitaph of Michel Ponche (*Tournai*, fig. 20).

But in spite of this clearcut relation to Delemer's style, an attribution to this artist's hand and even the work's origin are not without problems, since it includes a number of motifs (such as the nested triangular folds at the Angel's sleeve) that are absolutely identical to those found in other, admittedly less fine but definitely late works in the same church (figs. 3a–b). Therefore, the possibility that the St. Michael is a much later work after a Delemer original cannot be excluded.

However that may be, the existence of this formal type at an early date is attested to by a copy dating from c. 1450 in "Het Toreken" (House of the Tanners) in Ghent (fig. 3c).

Figs. 3a–b SS. Roch and Agnes.
Ellezelles, Saint-Pierre aux Liens

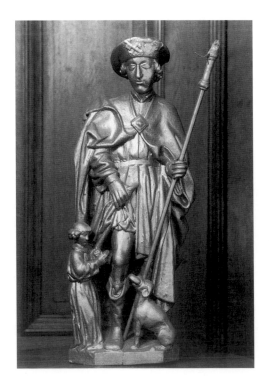

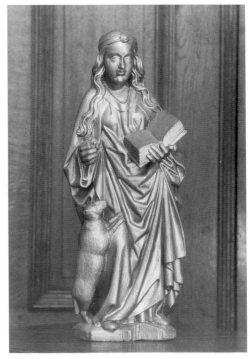

4 Virgin and Child Enthroned ("Notre-Dame des Affligés")

Tournai, c. 1430–40

Wood with original (?) polychromy, h. 80

Losses: feet and lower part of Mary's drapery

Private collection

The enthroned Virgin is crowned and wears a girt tunic and a mantle fastened by a double cord. In her left hand she holds a fruit, apparently a pomegranate. The diagonal, half-kneeling pose of the Christ Child and the gesture of his left hand suggest an attitude of rejection rather than acceptance. Both figures look out to the viewer.

This Madonna is important as a rare example of the initial phase of the Late Gothic in Tournai. The heavy proportions and ample drapery are comparable to the Madonna from the former Godin Collection (cat. 2), but here all parts of the garments are folded, broken, and pinched into a discontinuous pattern of folds.

The work belongs to an important and geographically widespread family of Madonnas in the Netherlands (see e.g. cat. 74), the origin of which can probably be traced back to the Tournai milieu of the 1430s. Characteristic features of this group such as Mary's full, rather fleshy face, framed by thick hairstrands flowing away from the temples, and the chubby Christ Child with close-cropped hair appear in the epitaph of Michel Ponche (1431 or 1436; *Tournai*, fig. 20). Also comparable in a number of motifs, including Christ's garment with its lower slit, is the Madonna in the epitaph of Marie Folette (c. 1440; *Tournai*, fig. 21). While these Madonnas differ in specific style features, all appear to have been influenced by Jean Delemer.

The impressive conception of this Madonna seems strangely at odds with the weak execution of certain details – as for instance in the lack of clearcut expression in the faces – suggesting that it was carved by an able though less creative sculptor after an important lost model, presumably by Delemer. The latter's direct influence is in any case evident here in motifs such as the repetition of flattened Z-shaped folds at the lower hem of Christ's robe, identical to those of Delemer's Annunciation Angel (*Tournai*, fig. 1) or in a more reduced form, in the accordion-like pattern of his sleeves.

Tournai 1958, no. 8; Tournai 1960, no. 12; Mambour 1981, 68–69 ("entre 1450 et 1470"); Didier 1983, 389 ("vers 1440").

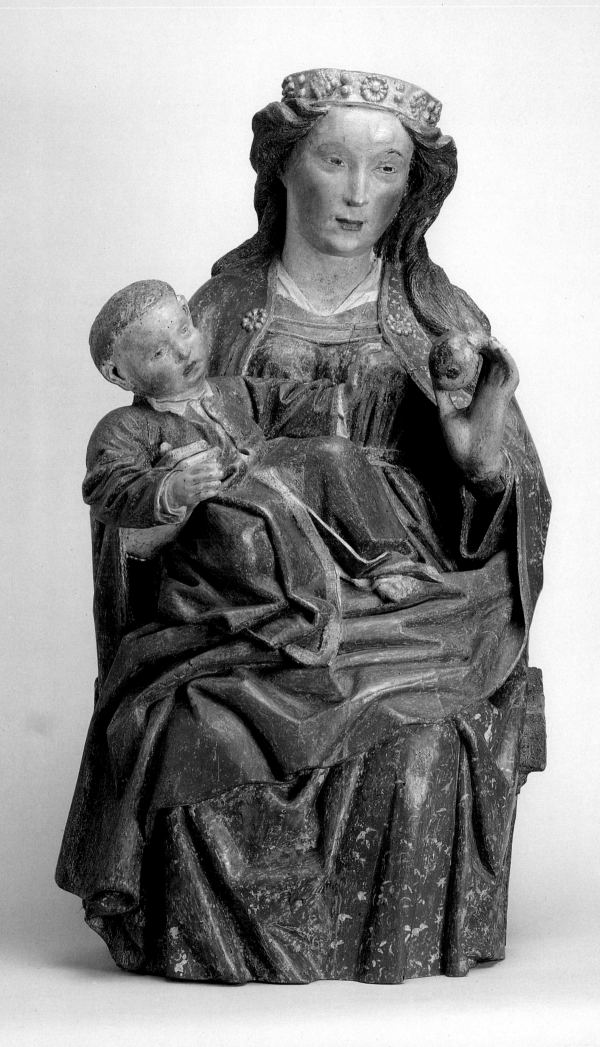

5 Trinity ("Throne of Grace")

Tournai, c. 1430–40/50

Oak with polychromy, 62.4 x 31 x 16

Losses: hands and forearms of Christ

Lille, Musée Diocésain, inv. AC 220

This extraordinary group shows an enthroned God the Father supporting a smaller Christ crowned with thorns, marching precariously on the orb of the world. It symbolizes the reconciliation of God and mankind, the appeasement of the Father's anger through the sacrifice of the Son. Now lost is the dove of the Holy Spirit, probably once perched on Christ's left shoulder.

The so-called Throne of Grace type of this Trinity group was highly favored in the art of the Low Countries during the late Middle Ages, especially in the work of the Tournai painter Robert Campin (see Steppe, in Leuven 1975). The present work differs from other treatments of this subject in the highly unusual dance-like, cross-stepping pose of Christ. This formula, familiar especially in Late Gothic German art soon after the mid-fifteenth century when it appears in the prints of Master E.S. and the sculpture of Nicolaus Gerhaert, may well be of Netherlandish and perhaps Tournai origin; at any rate, it makes a relatively early appearance in the miniatures of Jean le Tavernier, cited as a member of the Tournai illuminators' guild in 1434.

The Lille Trinity appears to be a rather early and important work of the Tournai School, possibly dating from the 1430s. The softly textured drapery, articulated by parallel diagonally arching lines that break against the base as successive waves, and the dynamic spatial pose of Christ directly presuppose the work of Delemer, while at the same time announcing certain basic features of the style of Master Arnt (stance, drapery motifs; see cat. 87). The harsh, expressive ugliness of the head of God the Father, a radical Late Gothic rejection of Soft Style idealization, is closely related to types encountered in the paintings of Campin and the early Van der Weyden (cf. fig. 5a).

Lotthé 1940, 247 ("fin du XVᵉ siècle ou début du XVIᵉ"); Tournai 1958, 20, no. 9 ("art flamand du XVᵉ siècle"); Tournai 1971, 146–147, no. 154.

Fig. 5a Rogier van der Weyden, Deposition, detail: Joseph of Arimathea. Madrid, Museo del Prado

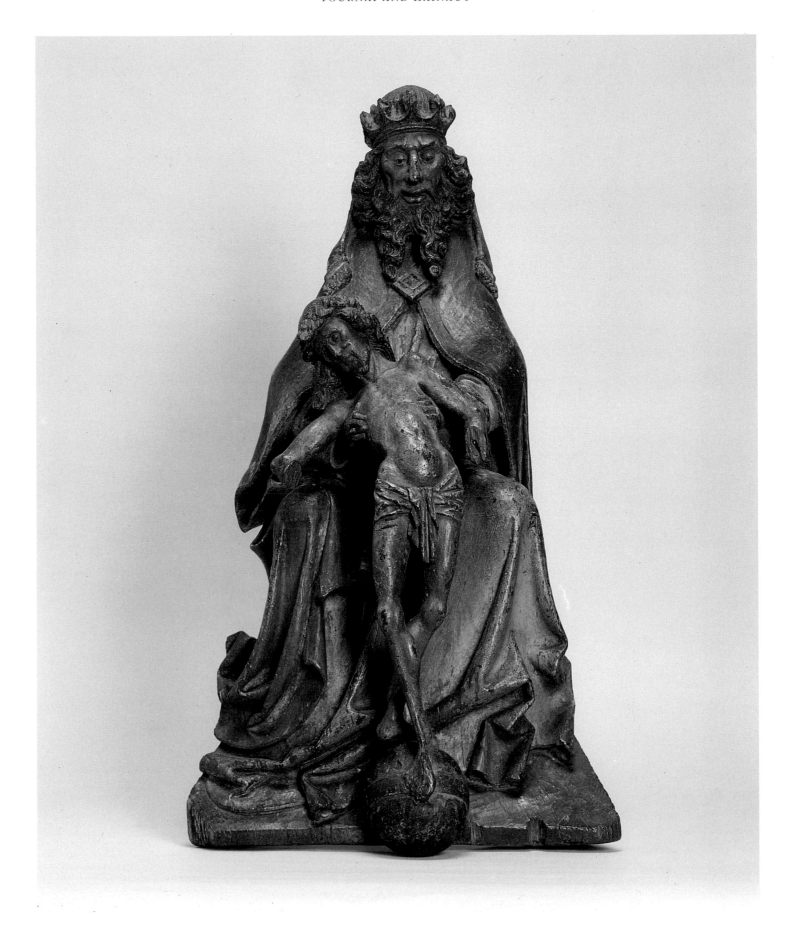

6A–B Two Apostles

Tournai, 1446, cast by Guillaume Le Fèvre

Brass, h. 23 (John); h. 23.5 (Apostle)

Halle, Sint-Martinusbasiliek

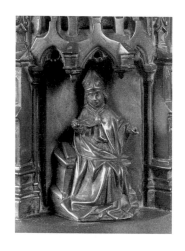

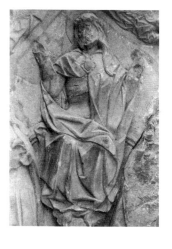

These two statuettes representing St. John the Evangelist blessing the poisoned chalice and an unidentified Apostle with a book form part of an apostle series decorating the monumental baptismal font in the church of Halle. An inscription on the base informs us that it was cast by the Tournai founder Guillaume Le Fèvre (active *c.* 1431–76) in 1446. Often cited in the literature though little studied in terms of style, the sheer quantity of figures on the font, also including statuettes of the Church Fathers as well as several especially fine narrative groups (Baptism of Christ; equestrian groups of SS. Martin, Hubert, and George), constitute perhaps the most important ensemble for the study of later Gothic sculpture in Tournai. As has recently been observed (Didier), its Tournaisian origin can be established on stylistic grounds, i.e. the wooden models utilized were carved by a sculptor active in Le Fèvre's home city. The two apostles exhibited here provide a case in point. They are variants on the same standard Tournaisian formal type also seen in the majestic little St. Catherine on the lectern from Saint-Ghislain (1442; *Tournai*, fig. 19) by the same founder, quite similar in style but clearly superior in quality. The same is true for other figures on the font. The marching pose developed in counterpoint and the drapery of St. James (see also Vandevivere, 53, and his comments on p. 54) are comparable to St. John the Evangelist in the Calvary, Antoing (Church of Saint-Pierre); a frontalized version of the same type survives in a St. Ghislain in Ellezelles (fig. 6c; Amorison and De Reymaeker 1980, no. 338, fig. 203). And the enthroned Church Fathers against the base (fig. 6a) are equally variations of a Tournaisian repertoire that also includes the Madonna in the epitaph of Marie Folette (*Tournai*, fig. 21) and the Christ Judge in Canon Blecker's epitaph (fig. 6b). Such parallels testify once again to the pervasive influence of Delemer's style on the Late Gothic as it develops in this Scheldt city.

Fig. 6a Baptismal font,
detail: St. Augustine.
Halle, Sint-Martinusbasiliek

Fig. 6b Epitaph of Livinus Blecker,
detail. Tournai, Cathedral

Fig. 6c St. Ghislain. Ellezelles,
Saint-Pierre aux Liens

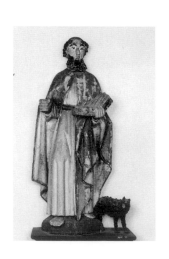

Hamann 1923, 244–245; Collon-Gevaert 1951, 258–259; Achter 1960, 233–236 (first attempt to integrate statuettes into context of the Netherlands: stylistic comparison to stone Apostles in choir of same church; localization to Halle–Brussels area); Tournai 1964, no. 38; Vandevivere 1971, 50–54 (rejects Achter's stylistic comparisons; notes stylistic parallel to St. Ghislain statuette, attribution of model to same sculptor); Didier 1983, 385 (first identification and analysis of style as typically Tournaisian); de Ruette *et al.* 1988–9, 112–124.

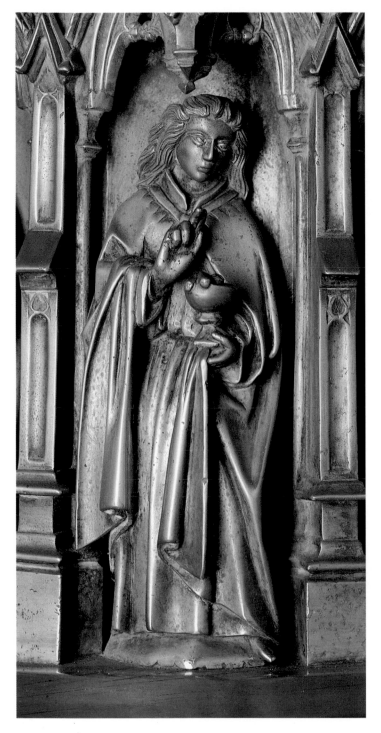

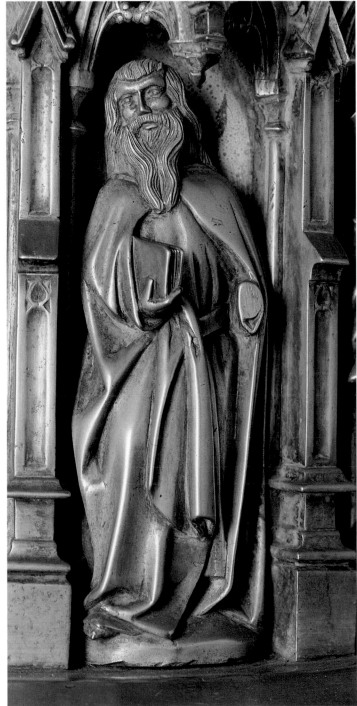

7 Standing Virgin and Child

Tournai, c. 1460
Oak, h. 85
Wodecq, Saint-Quentin

The Madonna in Wodecq, among the finest treatments of this theme extant in Hainaut, may be attributed to a Tournaisian sculptor active soon after the mid-fifteenth century but whose basic stylistic premises derive from the very beginnings of the Late Gothic. Mary's mantle, which combines loosely layered undulations with more angular folds, represents an interesting and skillful variant of a Tournaisian formal motif introduced in Delemer's Annunciation Virgin (*Tournai*, fig. 2). As in the latter, the mantle is formed into what one is tempted to call a "Tournaisian false sleeve" at Mary's right arm and a zig-zag series of triangles directly below. But these forms, and the drapery in general, are rendered in a somewhat harder and crisped manner indicating a later origin.

Mary's winsome, ovoid face that tapers to a pointed chin, her high bombé forehead, her delicate, crisply cut features expressing a sensitive tenderness, may be seen as an early and masterful interpretation of an ideal type that makes its appearance in the Tournai tradition toward the years c. 1450. Later versions, however – among the better of which is a St. Elizabeth in the church of Sainte-Vierge in Pommerœul (c. 1470?; fig. 7a) – rarely attain the same quality level.

Cat. 7

Fig. 7a St. Elizabeth. Pommerœul, Sainte-Vierge

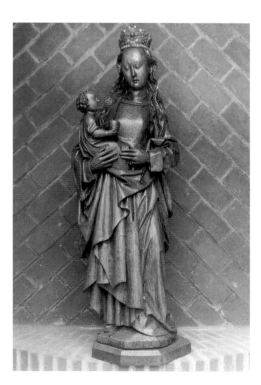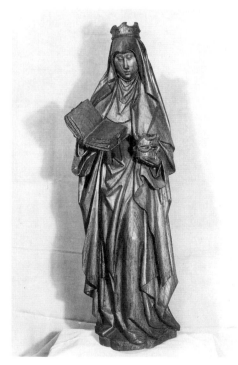

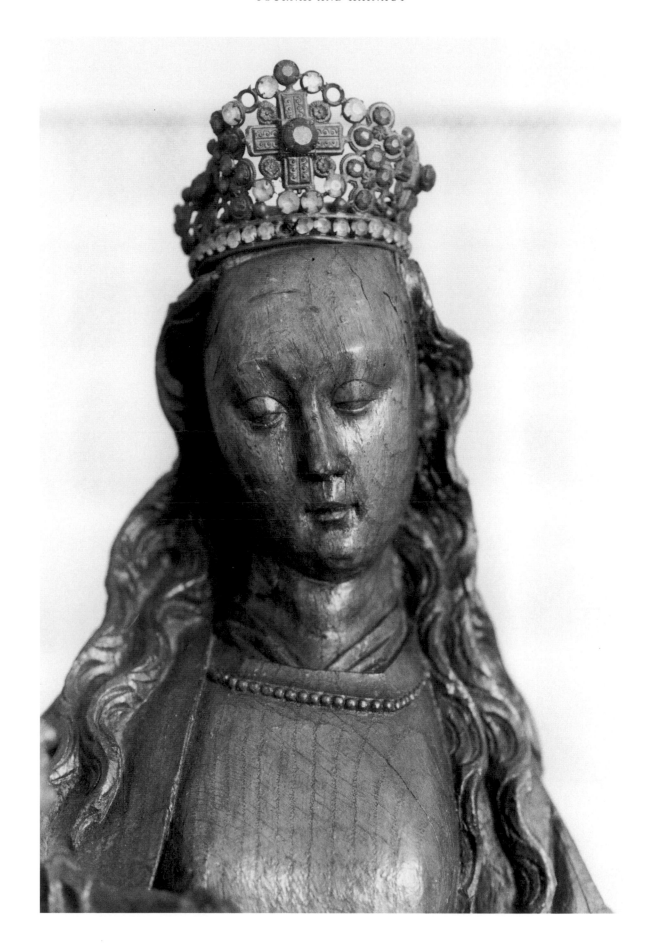

8 Mourning Virgin from a Calvary

Tournai, c. 1450–70

Oak, h. 86

Mary's left hand is lost

Saint-Omer, Musée Sandelin, inv. 586CD

This svelte figure of the mourning Mary, framed by ample folds, originally formed part of a Calvary of probable Tournaisian origin. The motif of the mantle drawn over Mary's head, forming a shadowy hollow that sets off and partly covers her face, best known through the *pleurant* statuettes of the ducal tombs in Dijon, does not represent a Burgundian influence, as has been alleged: by this time the formula was widespread and well established in the ateliers of the South-Netherlandish *tombiers*.

Evidence for the work's artistic provenance is provided by a comparison with two assistant figures from a Calvary (c. 1470?; fig. 8a) consisting of a statue of Mary identical to ours in type and a characteristically Tournaisian "stepping" St. John (compare cat. 9). In style, the Saint-Omer Virgin is closely akin to the kneeling Mary beneath the Cross in the epitaph of Canon Lamelin in Tournai Cathedral (in or before 1470; *Tournai*, fig. 36); in both, motifs inherited from Delemer, such as the advancing movement of Mary's leg and associated drapery forms including the diagonal fold lines that break against the base, are treated in a very similar manner.

Boccador 1974, 2:33 ("France du Nord, fin du XVᵉ siècle"); Gravelines 1981–2, no. 5 ("fin XVᵉ siècle").

Fig. 8a Virgin and St. John from a Calvary (sale London, Sotheby's, 15 December 1977, no. 44)

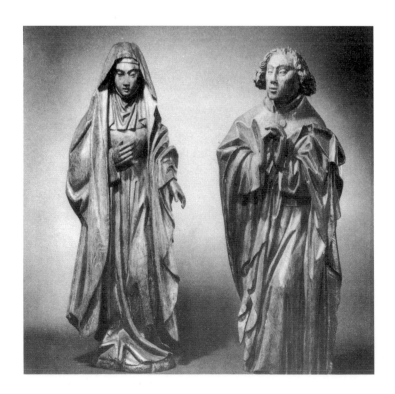

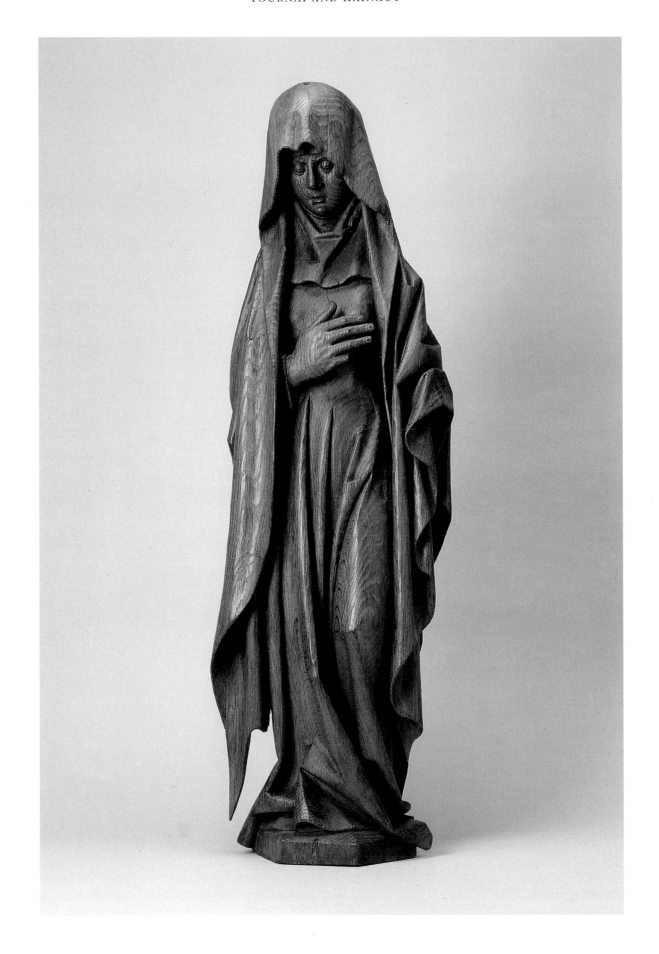

9 Calvary

Tournai or north-western Hainaut, c. 1480–1500?
Wood with modern polychromy, h. 103 (Virgin); h. 105 (John); 270 x 200 (Cross)
Minor losses to Mary's hands, St. John's left foot, base of Cross
Wannebecq, Saint-Léger

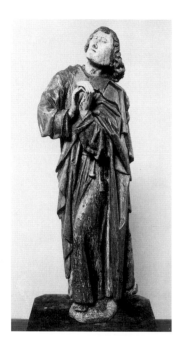

This group forms part of a series of Calvaries represented by about a dozen more or less similar examples in the province of Hainaut (see de Borchgrave d'Altena and Mambour 1972, *passim*, and Didier 1977, 402–403). They can be most readily identified by the relatively large and emphatically decorative form of the Cross with inset Flamboyant tracery panels and elaborate, sharply pointed terminal elements. While the Christ figures vary somewhat, most exhibit an abundant growth of hair and beard (the latter articulated into a series of strands that end in round curls). Equally characteristic are the assistant figures, especially the "stepping" St. John seen here, who is closely related to the same figure in the Calvaries of Rebaix and Chièvres. Indeed, these works represent such stock types that comparable sculptures surviving elsewhere, such as a St. John in the Detroit Institute of Arts (fig. 9a) or a figure of Mary formerly in the Demotte Collection (fig. 9c; Pijoan 1947, 218, fig. 362), can be easily recognized as part of the same series.

The geographic distribution of examples in churches of north-western Hainaut, an area that lies within the immediate artistic hinterland of Tournai, suggests that they were carved in this city or at least directly influenced by Tournaisian models.

This conclusion is supported by style: the tall, thin, verticalized appearance of the Wannebecq Virgin and St. John may be seen as an extreme, characteristically Tournaisian

Fig. 9a St. John from a Calvary. Detroit Institute of Arts

Fig. 9b Tree of Life of the Franciscan Order, detail. Tournai, Musée des Beaux-Arts

Fig. 9c Virgin from a Calvary. Former Demotte Collection

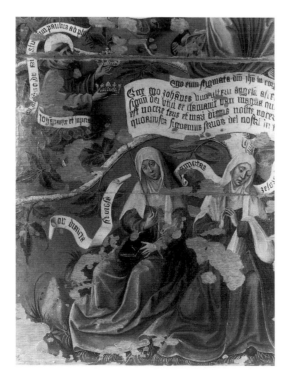

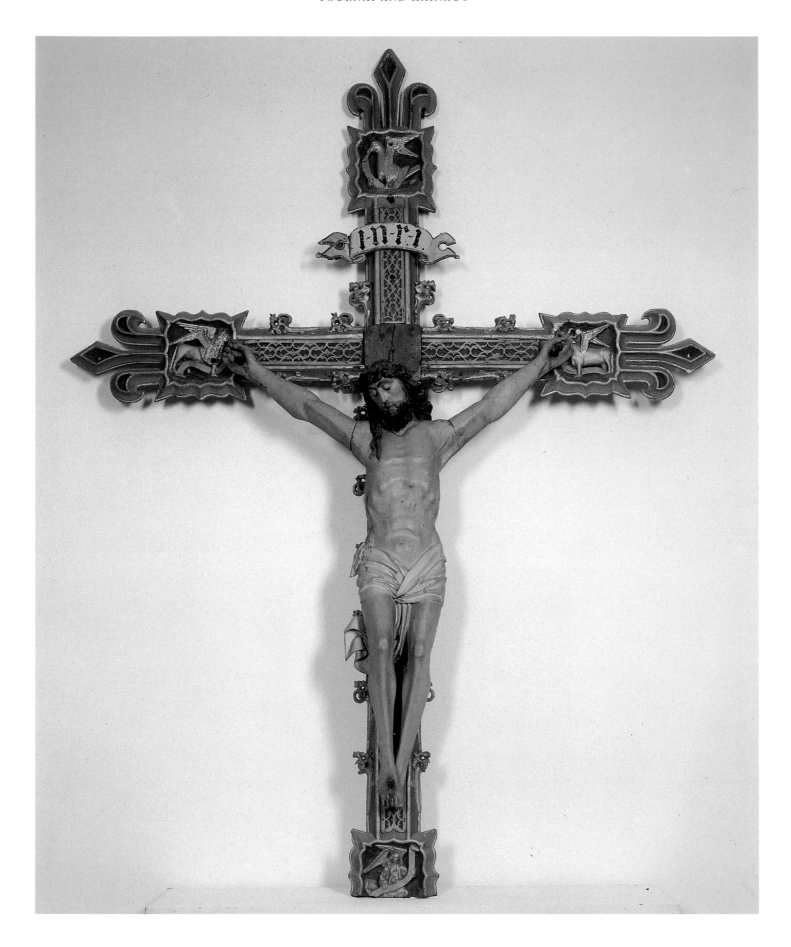

interpretation of the "style of the long lines" that has a close antecedent in the epitaph of Jean Lamelin in Tournai Cathedral (in or before 1470; *Tournai*, fig. 36). The head types of all three figures are typically Tournaisian. For instance, the face of Mary with its prominent eyelids, long straight nose, and small mouth with pouting lower lip resembles that of the female Virtues in the Franciscan Tree of Life (fig. 9b), a rare but neglected example of Tournaisian painting from the later fifteenth century (see also the head of a St. Elizabeth statue in the Hôpital de la Madeleine, Ath; fig. 9d).

The advancing, complex pose of the St. John (cf. the Christ in the Lille Trinity, cat. 5), among the most interesting and influential creations of the Netherlandish Late Gothic, probably derives from a prototype introduced before 1450. The dynamic conception and the fact that in the Netherlands this figure type appears exclusively in the sculpture of Tournai (cf. fig. 9e) and Brussels (e.g. Calvary retable in Paimpol; Paschal Candelabrum, Zoutleeuw) make it tempting to assume that this prototype may have been carved by Jean Delemer, who was active in both cities. In any case, its influence was considerable: the type appears to have been transmitted to the German area through the prints of Master E.S. (esp. Lehrs 44; see Ohnmacht 1973, 68–70, and Hessig 1935, 32).

Tournai 1960, no. 57 ("XVIᵉ siècle"); Didier 1970a ("c. 1480–1500" and "vers 1520?"); de Borchgrave d'Altena and Mambour 1972, 32; Amorison and De Reymaeker 1980, 527, no. 349 ("1520–30").

Fig. 9d St. Elizabeth.
Ath, Hôpital de la Madeleine

Fig. 9e St. John from a Calvary.
Chièvres, Saint-Martin

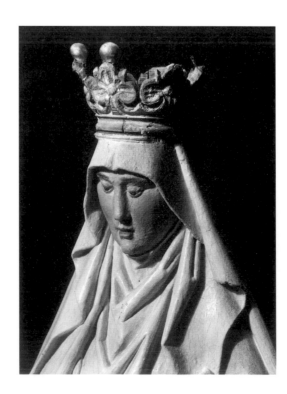

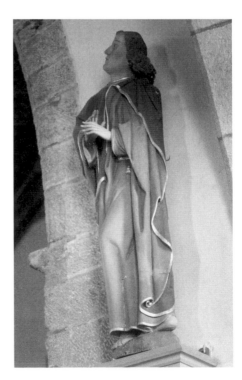

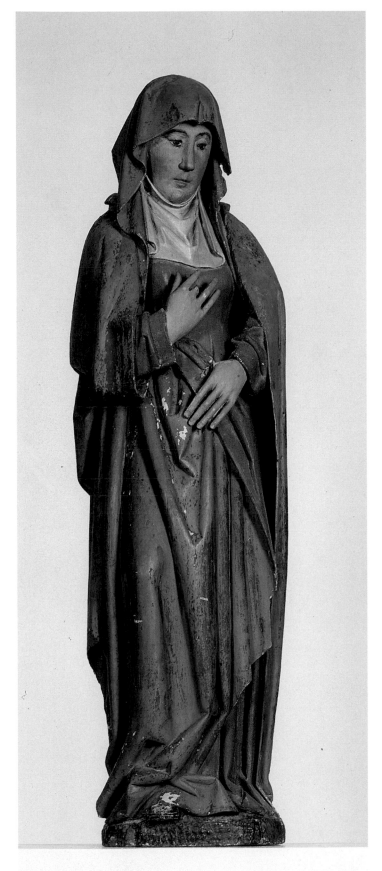
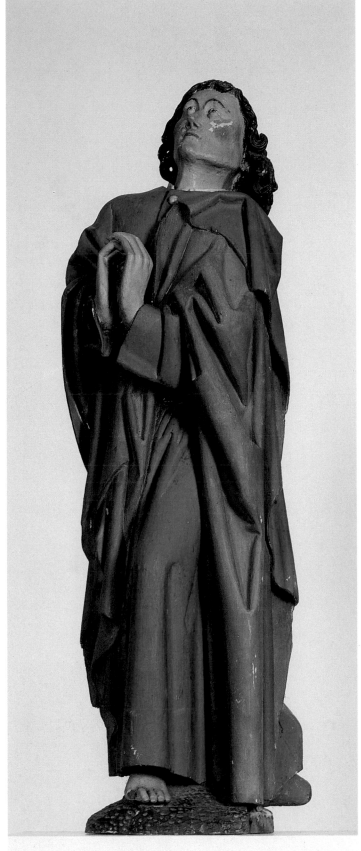

IOA–B Mourning Virgin and Saint John from a Calvary

Tournai or north-western Hainaut, c. 1480–1500?

Oak, h. 83 (Virgin); h. 90 (St. John)

The hands of St. John and the adjoining sleeves appear to be later replacements; backs left uncarved

Thumaide, Saint-Pancrace

Typical of Netherlandish Calvary ensembles are the contrasting attitudes of these figures placed to either side and below a central Christ on the Cross (not exhibited). St. John the Evangelist, his attributes of inkwell and pencase suspended from his belt, the edge of his mantle nervously broken, looks directly up to the crucified Christ. Mary, the *stabat mater*, her suffering interiorized, directs her gaze downward, away from the Cross, seemingly toward those in the church below. The Thumaide Calvary belongs to a close-knit group of Tournai origin or derivation virtually identical in type though varied in quality. The finest and probably the earliest examples are the assistant figures in the Walters Art Gallery, Baltimore (c. 1450–75; *Tournai*, figs. 31, 40); later in date and of lesser quality is the Calvary in the Chapelle Saint-Jacques, Harchies (early sixteenth century);[1] and an isolated statuette of St. John (whereabouts unknown).[2] Evidence for the localization of the series is provided by the general style and figure types. For instance, the face of the Thumaide John with its markedly broad, square jawline represents a late, rather mild version of a Tournaisian type that appears as early as the opening years of the fifteenth century (fig. 10a) and that receives a typically hard Late Gothic formulation in the mature works of Campin (fig. 10b; cf. a similar taut intensity of expression in the Baltimore St. John, *Tournai*, fig. 40; and in the Entombment, Soignies, fig. 10c).

A comparison of the Thumaide figures to those in Wannebecq (cat. 9) offers a revealing insight into the problem of date versus style so prevalent in sculpture of this time in Tournai and elsewhere. Both are derivative works by secondary sculptors dependent on earlier models that differ in style: in terms of fifteenth-century painting, the statues in Wannebecq might be called "Rogierian" (emphasis on line), those in Thumaide "Flémallesque" (emphasis on volume) and therefore relatively "earlier," at least in their derivation.

Fig. 10a Mainvault Entombment, detail. Ath, Musée

Fig. 10b Robert Campin, The Bad Thief. Frankfurt, Städelsches Kunstinstitut

Fig. 10c Entombment, detail. Soignies, Saint-Vincent

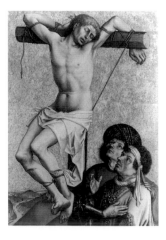

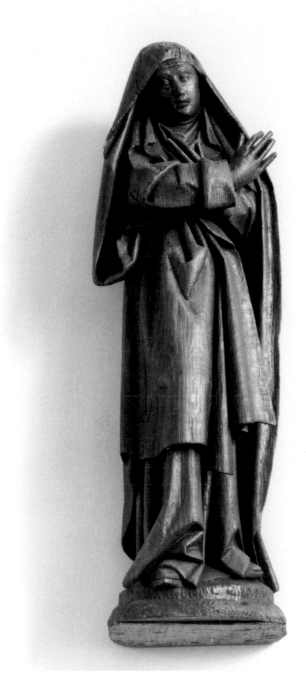
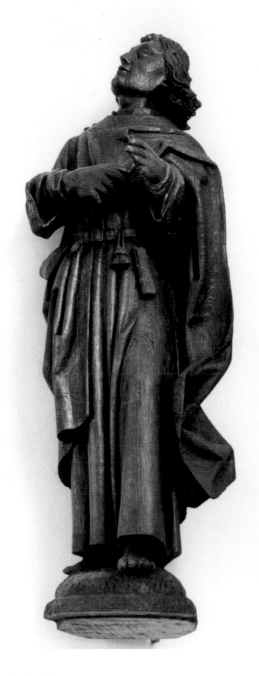

At the same time, both pairs share very similar crucifixes and are nearly identical in a number of details, including their youthful facial types and certain drapery motifs – an indication that they are probably contemporary and might even have been carved in the same atelier.

1 See de Borchgrave d'Altena and Mambour 1972, fig. p. 24.

2 Sale New York, Sotheby's, 22–23 Nov. 1985, no. 30.

Didier 1970, 68 (c. 1520–30; attribution to a sculptor influenced by the Master of the Hautrage Entombment); de Borchgrave d'Altena and Mambour 1972, 31.

11 Saint Martin and the Beggar

Atelier of the Master of the Wannebecq Calvary (?)

Tournai or north-western Hainaut, c. 1500

Oak, remains of polychromy, 82 x 58 x 40

Carved in the round; right upper part of horse's head restored; minor losses elsewhere

Belœil, Private collection

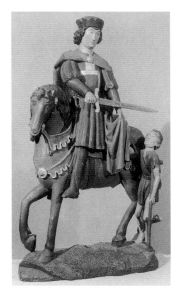

Fig. 11a St. Martin and the Beggar. Attre, Saint-Martin

Carved groups of St. Martin on horseback shown sharing his cloak with the beggar are among the most delightful creations of the Gothic period.[1] In their overall composition these works vary relatively little from one generation to the next, although the present work is unusual insofar as it shows the horse stepping toward the right rather than to the left as in all other carved Netherlandish examples known to the author. The fascination of such groups lies in the varied renderings of the pathetic, crippled beggar, often shown, as we see him here, hobbling behind the horse on a single crutch, and in the always modish appearance of the Saint himself, whose garments provide an interesting overview of changing late-medieval fashion. This latter aspect also helps in dating, at least by approximation: in our example, Martin's flat cap with turned-up brim points to an origin toward the years c. 1500 (assorted types of comparable headgear can be found in Gerard David's *Judgment of Cambyses* panels, 1498; Bruges, Groeningemuseum).

Though obviously not by an outstanding sculptor, it is among the better and certainly the most charming interpretations of this subject in the Hainaut region. Related to some extent are groups in the church of Saint-Martin, Attre (fig. 11a; Amorison and De Reymaeker 1980, no. 341), slightly later and perhaps influenced by ours, and, at a greater stylistic distance, in Saint-Martin, Wasmes. These are at least sufficiently close to suggest the existence of a regional St. Martin type, presumably dependent on more important models in the city of Tournai.

Finally, it should be noted that the youthful face of St. Martin shows a family resemblance to the Calvary Virgin from Wannebecq exhibited here (cat. 9) and may well be the product of the same, apparently quite prolific and influential atelier.[2]

1 For Netherlandish examples, see Aalst 1980.

2 Cf., at a more popular level, a St. Roch with the Angel in the church of Ormeignies.

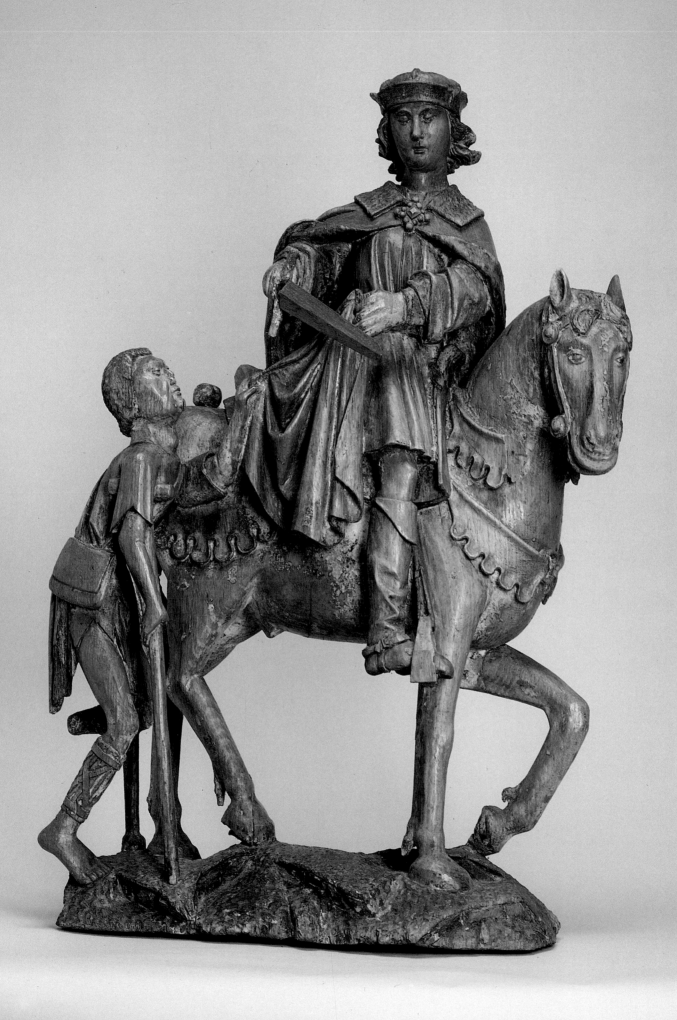

12 Retable Group: Deposition

Atelier of the Master of the Hautrage Entombment

(active in Tournai or north-western Hainaut c. 1450–1500)

Walnut with traces of polychromy, 44 x 30 x 15

Worm damage; right side heavily damaged, with loss of a figure behind Christ, heavy

damage to kneeling figure at Christ's feet; other losses: Christ's left arm, Mary's hands

Ghent, Museum voor Schone Kunsten, inv. 1914–EB

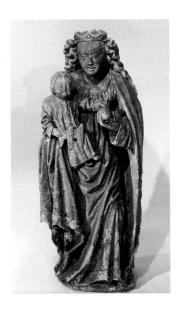

This Deposition of Christ from the Cross, once part of an altarpiece dedicated to the Passion, is among the earliest such works that can be localized to the Hainaut. Along with a number of other sculptures in or from the same province, the group has been convincingly attributed to an anonymous Master of the Hautrage Entombment, whose principal work is now in the Brussels Museum (fig. 12b). Other works that can be attributed to this interesting though secondary sculptor's atelier include a stone Madonna with a Pomegranate also in Brussels (fig. 12a) and a Christ on the Cross in Attre.

Stylistic evidence suggests that the sculptor was active during the second half of the fifteenth century either in Tournai or within this center's direct range of influence. His figures of Joseph of Arimathea and Nicodemus in the Brussels Entombment, characteristically charming, juvenile types, nonetheless distantly but unmistakably reflect their counterparts in Soignies (*Tournai*, fig. 25) in head type and in ornamental garment edges. And the interlaced arch pattern on the sarcophagus in the same ensemble as well as the master's drapery schemas in general have an immediate parallel in the funerary monument of the Cambier family in Lessines (c. 1464).

Didier 1970a, 69–70 ("entre 1500 et 1520, Hainaut, peut-être Mons ou Ath"): Hoozee 1988, 24 ("Zuidelijke Nederlanden ca. 1500–10").

Fig. 12a Virgin with a Pomegranate. Brussels, Musées Royaux d'Art et d'Histoire

Fig. 12b Hautrage Entombment. Brussels, Musées Royaux d'Art et d'Histoire

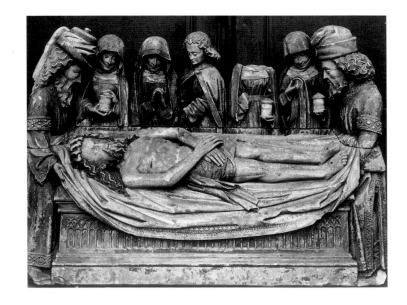

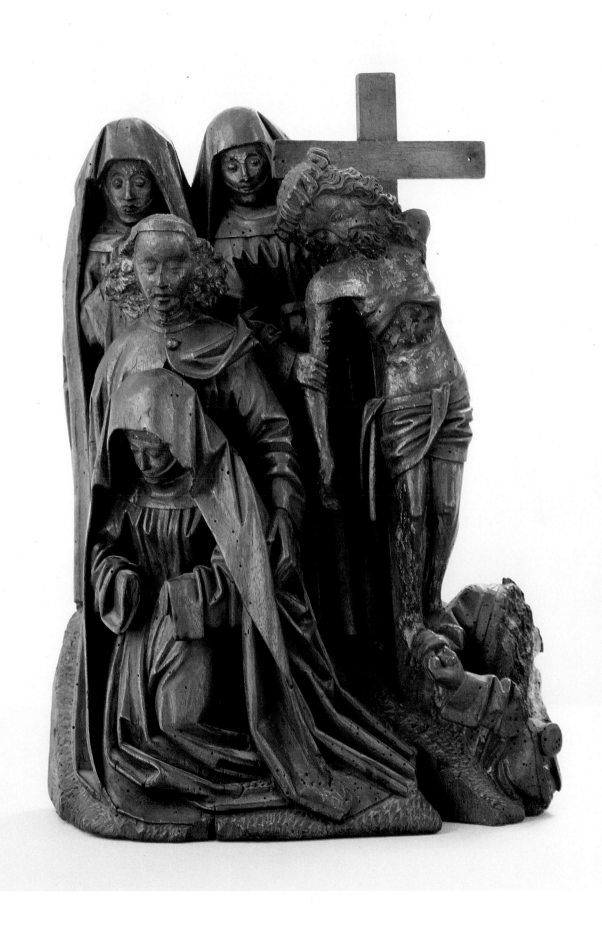

13 Standing Virgin and Child

Mons, c. 1500–30

Stone, h. 52

Principal losses: left arm of Virgin and both hands of Child

Ghent, Museum voor Schone Kunsten, inv. 1955–B

This very appealing statuette belongs to one of the most distinctive and extensive groups of sculptures of the Netherlandish Late Gothic. Especially characteristic are the heads with their round, pudgy, softly modeled faces; peculiar crescent-shaped eyes defined by a slightly puffy lower and a high, flat, ribbon-like upper lid; the precious mouth drawn into a somewhat shy smile; and hair defined in lively serpentine strands (Mary) or in a series of thick, circular spirals terminating in a central button (Child). The statuette can be meaningfully related to two other sculptures: her more demure, serene sister in a stone high-relief Madonna in the Sun from the abbey of Saint-Ghislain near Mons, known to have been completed between 1494 and 1528 (fig. 13b; Destrée 1927), and a Virgin of the Assumption in a wooden retable in the church of Boussu-lez-Mons (fig. 13c) – the latter a more vulgarized version of this type which, however, shares a similar rhythmic pose and drapery, arching from the Virgin's hip to her opposite foot.

All three sculptures belong to a series represented by numerous works in both wood and stone (apparently in most if not all cases white Avesnes limestone), retables as well as individual statues, that are distributed throughout the eastern and southern parts of the former county of Hainaut, corresponding to the modern Franco-Belgian frontier region. These works represent a Brabantine and particularly Brussels artistic expansion into the Hainaut during the first third of the sixteenth century. At times, their Brussels

Cat. 13, detail

Fig. 13a St. Stephen, detail of a retable. Horrues, Saint-Martin

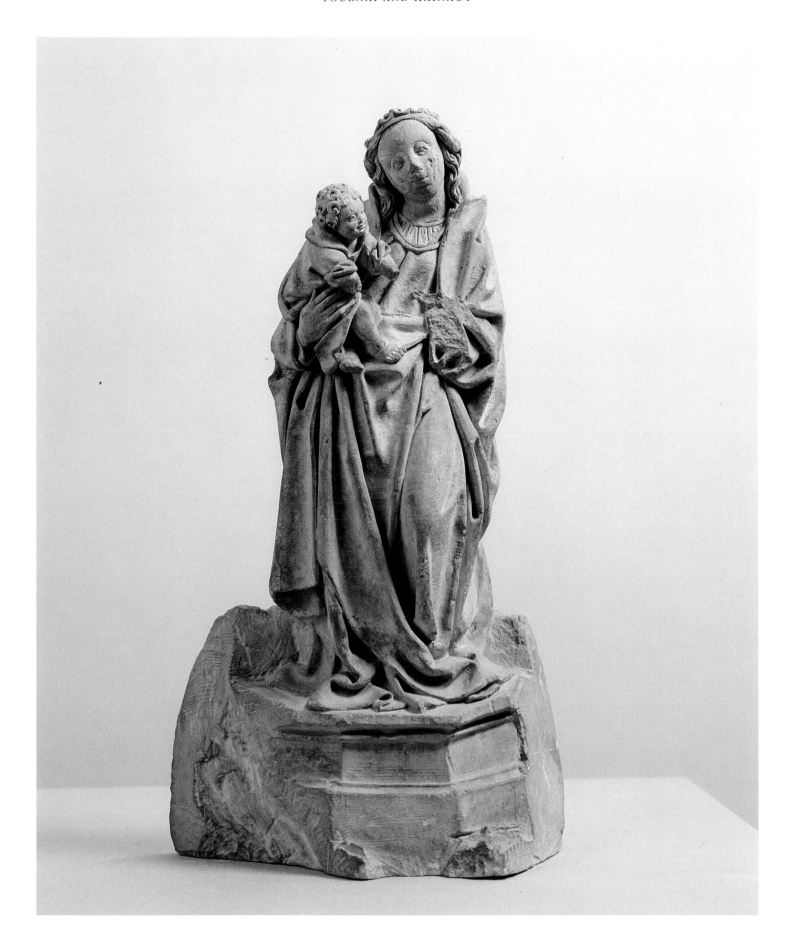

(Bormanesque) character is so strongly marked that one is tempted to explain them as products of emigré workshops, although their local "accent" is never in doubt. Strong circumstantial evidence suggests that the majority of these works were carved in the city of Mons,[1] where Brussels influences made themselves strongly felt at least as early as the mid-fifteenth century. Although of Brussels derivation – these head types, clearly represent a Mons variant of c. 1500 Bormanesque types – their distinctive character is unmistakable, and at least in part follows a local preference for cute, round facial types reaching back to the early fifteenth century.[2]

Among the many statues representative of this style may be cited on the Belgian side of the frontier a wooden statue of St. Job in Le Rœulx (convent of Saint-Jacques; Tournai 1956, no. 21) and a stone Brussels-inspired "Christ on the Cold Stone" in the church of Houdeng-Aimeries (Saint-Jean-Baptiste; Lequeux 1980, 18) with its distinctive large spiky crown.[3] Among stone retables, that in Horrues (fig. 13a; de Borchgrave d'Altena and Mambour 1968a, 25–27) probably dating c. 1520 (Didier 1977, 403, dating supported by the dry, angular draperies), is especially important, since it includes figure types that also appear in related wooden retables of almost certain Mons origin. These include, besides the example in Boussu, two altarpieces formerly in the abbey church of Liessies (see de Borchgrave d'Altena and Mambour 1968b, 20–29) and a number of retable fragments: a Mass of St. Gregory in the Musée Puissant, Mons (*Ibid.*, 56), a group of an Evangelist (?) flanked by Angels in the Chapelle Notre-Dame de Grâce in Neufvilles (see Lequeux 1979, 46), and a Swooning Virgin group recently on the art market (see fig. 13d).[4] Perhaps the single most important work representative of this style to have emerged in the last few years is an altarpiece with scenes from the life of St. Dominic (sale Munich, Neumeister, 30 June 1992, no. 8).

1 Principal examples preserved in the city: a stone retable in the Chapelle des Féries de Notre-Dame (see cat. 66, fig. 66a), and a St. Michael, both in the church of Sainte-Waudru.

2 E.g. the epitaph of Gérard and Jehanne Parent in Mons (Sainte-Waudru); Tondreau 1967, fig. 6 and the Mons epitaph of Godefroid Clauwet, Antwerp, Museum voor Schone Kunsten.

3 Cf. Christ in Coronation group, retable in Sainte-Waudru, Mons.

4 Formerly in the Delacre Collection, Brussels; sale London, Sotheby's, 12 Dec. 1985, no. 75.

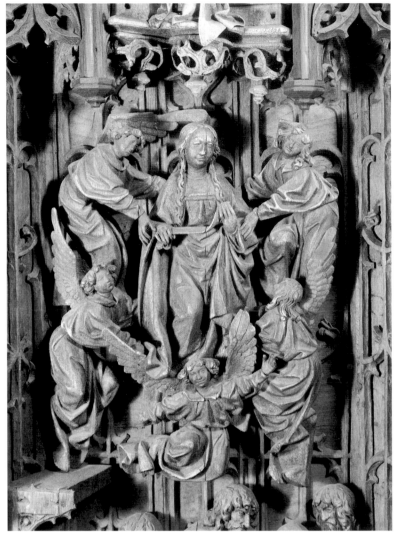

Fig. 13b Madonna in the Sun.
Brussels, Musées Royaux d'Art et
d'Histoire

Fig. 13c Altarpiece of the Virgin,
detail. Church of Boussu-lez-Mons

Fig. 13d Swooning Mary. Former
Delacre Collection

15 Standing Virgin and Child

Brussels, c. 1420–30

Wood, modern polychromy, h. 62

Drogenbos, Sint-Niklaaskerk

Fig. 15a Female Saint from the Hakendover Altarpiece. Hakendover, Sint-Salvatorskerk

Fig. 15b Standing Virgin and Child (photographed before World War II). Cologne, St. Kolumbakirche

This in some respect most "Burgundian" of all Brabantine Madonnas ranks with the finest such works produced in the duchy during the first half of the fifteenth century, although the neo-Gothic polychromy sadly impairs its obvious underlying quality. Along with a Tournaisian group (of Brabantine influence?) in Thimougies (Mambour 1981, 62; Didier 1983, fig. 37), it is analogous in formal type to works produced in the atelier of Claus de Werve,[1] with which it shares a characteristic frontalized composition and the organizing motif of a folded-over mantle edge describing a sinuous diagonal path from Mary's right shoulder, across her left hip, and terminating in a pendant vertical edge. But this (partial) similarity is in part fortuitous, probably due to parallelism resulting from dependence on common Netherlandish sources, since the Drogenbos Madonna has a close antecedent in the style of the Master of the Hakendover Altarpiece, as in the statuette of the female Saint from this sculptor's name work (fig. 15a), where a similar drapery arrangement is combined with a comparable pose of "gliding," basically planar, S-curving movement. Compared to the retable statuette, the Madonna's drapery represents a more advanced stage of development: the interlocking hairpin folds at the lower center acquire a more stiffened, triangular appearance, the lateral undulations intimate a flattened zig-zag.

Although it shows more continuity with the past, this Virgin and Child group appears to date from about the same time or not long after the very different Madonna in Tongerlo (fig. 14; the near-perfect spherical shape of the Child's head is quite similar, though better in quality than that in Tongerlo). In other respects, it announces later local developments: the quiet, serene, tempered naturalism of the Virgin's face is a precocious representative of a characteristically Brussels type that can be followed in many later versions such as the Madonna in St. Kolumba, Cologne (fig. 15b). Also notable is the genre motif – though undoubtedly with deeper, religious significance – of the Child reaching out to crush the pages of Mary's book, which seems to appear here for the first time in Brussels sculpture, and may have influenced Van der Weyden.[2]

De Borchgrave d'Altena 1947, 87 ("xve siècle").

1 For these Madonnas, see e.g. de Winter 1987, figs. 46–48.

2 See Van der Weyden's Duran Madonna (Friedländer 1967, 2 : pl. 137); for a discussion of this motif, see Rademacher-Chorus 1972.

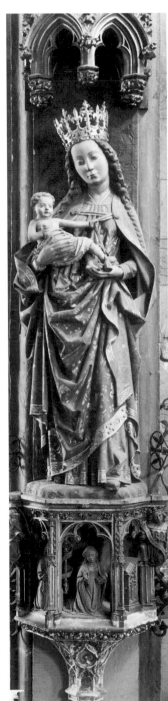

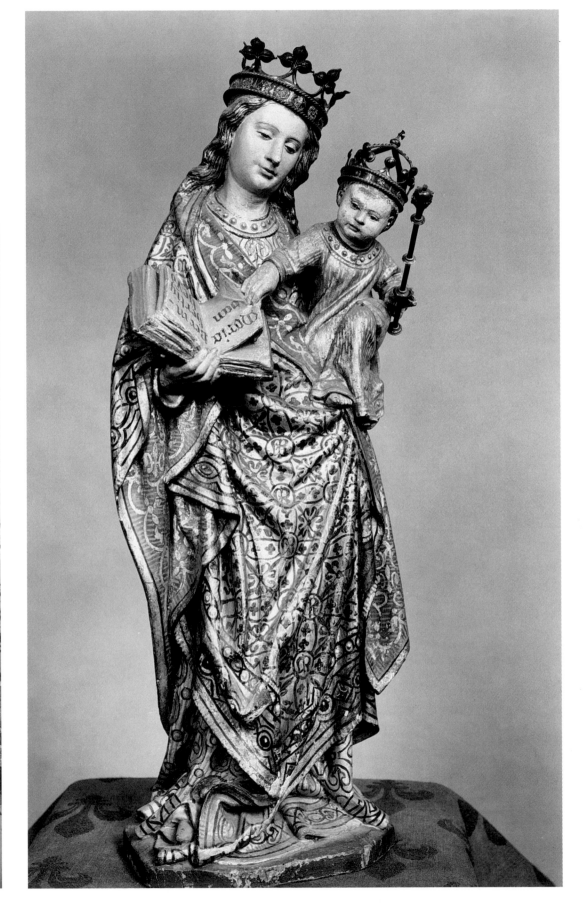

16 Standing Virgin and Child

Brussels (?), c. 1435–40

White stone with remains of polychromy, h. 82

Principal loss: head of Child

Brussels, Musées Royaux d'Art et d'Histoire, inv. 1344

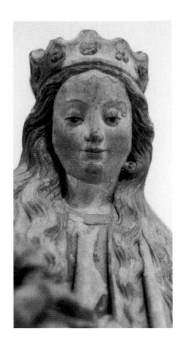

Cat. 16, detail

As in some early Bohemian "Beautiful Madonnas" of the years c. 1400, Mary holds the Child with both hands and out to the side in a near-horizontal position, as if confronting and offering an apple to a kneeling donor below (for this type, see Schmidt 1978, 75). The statue forms part of a small but important group of Brabantine, probably Brussels Madonnas from the early phase of the Late Gothic style that share a sense of monumentality, breadth, and ample drapery forms. The relatively early origin of these works is supported by their similarity to the works of the first generation of Flemish painters; the Brussels Madonna calls to mind especially the *œuvre* of the Van Eyck brothers.

Although lacking the nuances of her roughly contemporary sister in the same museum (*Brussels*, fig. 47), the decidedly charming, rather plump face of Mary, framed by an abundance of ornamental hairstrands with a single curl near her left cheek (a peculiar detail also seen in the Tongerlo Madonna, cat. 14), reveals the hand of a very talented sculptor. While it differs in detail from other known Brussels examples of this theme, certain motifs do suggest that the sculptor was active there. For instance, the way Mary's mantle tautly envelops her left arm, forming a series of jagged folds, is an arrangement also encountered in the Laredo Altarpiece (e.g. the Angel of the Annunciation; *Brussels*, fig. 24) and the drapery at the Virgin's left, where the (damaged) mantle edge sweeps out in a slight undulation (as if stirred by a slight breeze) has a close counterpart in the Vadstena Madonna (*Brussels*, fig. 50; see profile view in Didier 1989, fig. 4). Since the two works cited can be dated toward c. 1440 or immediately thereafter and are somewhat more evolved in style, a slightly earlier origin for this group appears probable.

De Borchgrave d'Altena 1934, 206 ("xvᵉ siècle"); Jansen 1964, no. 234 ("Art brabançon, première moitié du xvᵉ siècle").

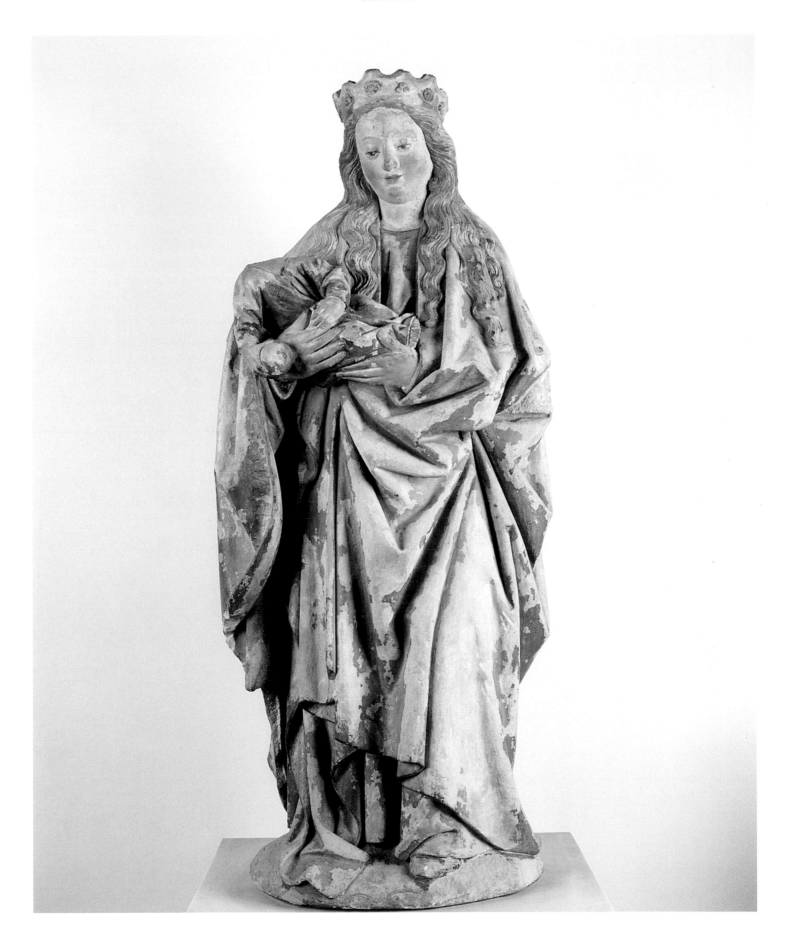

17 Standing Virgin and Child

Master of the Rieden Altarpiece (?)
Brussels, c. 1440
Avesnes limestone with original polychromy, h. 89
Mary's right hand is lost, the Child's head appears to be a later replacement
Leuven, Stedelijke Musea, inv. C/77

Secular as well as ecclesiastical structures were decorated with religious statuary during this time. This Madonna is believed to have been set in one of the fortified city gates of Leuven, the Wijngaardenpoort, located on the west side of the city. The combination of angular, broken draperies within an overall composition that derives from the 1400 style (the way Mary's left hand is covered by the edges of her mantle is a typical motif of this tradition) suggests an origin for this group in the second quarter of the fifteenth century.

The bold if somewhat crudely defined, emphatic facial features of Mary suggest that this work was carved by a secondary master, although one with a distinctive personality. Very similar drapery forms and head types appear in the Nativity Altarpiece from Rieden (cf. e.g. the female heads in the Marriage of the Virgin group; fig. 17a), suggesting that the Madonna may have been produced in the same atelier at about the same time and certainly by the head master.

Leuven 1975, no. L/14 ("Leuven?, tweede helft 15de eeuw").

Fig. 17a Marriage of the Virgin, group from the Rieden Altarpiece. Stuttgart, Württembergisches Landesmuseum

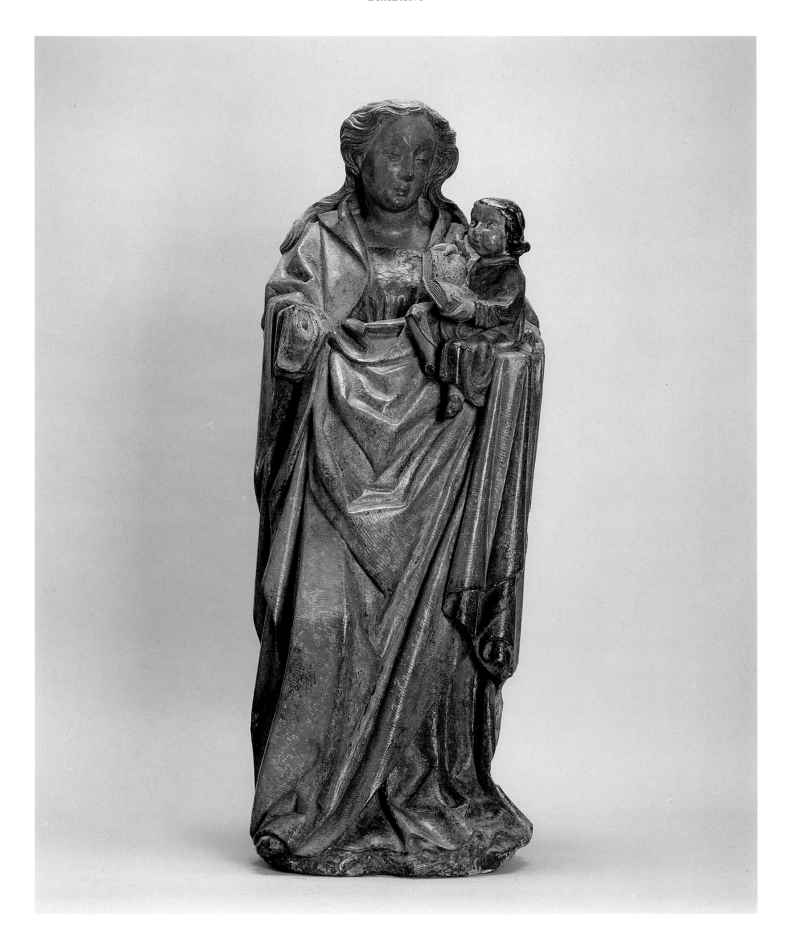

18 Saint Barbara

Brabant, c. 1435–40

Walnut (?), h. 86

Extensive worm damage; principal losses: fingers of the Saint's hand, part of tower

Kortrijk-Dutsel, Sint-Catharinakerk

Cat. 18, profile view

This impressive figure of St. Barbara with her tower attribute, though somewhat crude in the treatment of detail, is a very important example of Brabantine sculpture. Essentially a "stranger" within the local artistic milieu, the Saint exhibits features more reminiscent of the Tournaisian School: a dynamic, turning pose (treated here in a disjointed manner: the right leg moves independently from the rest of the body!); thick hairtufts framing the face (cf. Ponche epitaph; *Tournai*, fig. 20), and an exceptionally rich pattern of restless, angular folds. More specifically, the St. Barbara shows a close dependence on Delemer's Virgin of the Annunciation in Tournai Cathedral (*Tournai*, fig. 2), as is especially clear in a profile view of the Saint's right side, where we find a similar though somewhat more voluminous pattern of interconnected triangles as well as an arrangement of Mary's mantle around her arm, forming a Tournaisian "false sleeve."

These observations leave little doubt that the style of this work reflects the activity of Delemer in Brussels (as Didier has noted). The closest local formal parallels survive in the embroideries of the Chapel of the Golden Fleece (Vienna), probably themselves due to a Tournaisian artist active in Brussels and certainly reflecting quite directly the style of the Tournaisian School.

Leuven 1962, no. B102 ("Brabant, einde 15de eeuw"); Didier 1989, 68 ("Maître bruxellois, 1435–40; reflète très probablement et directement une œuvre importante de la période bruxelloise de Jean Delemer").

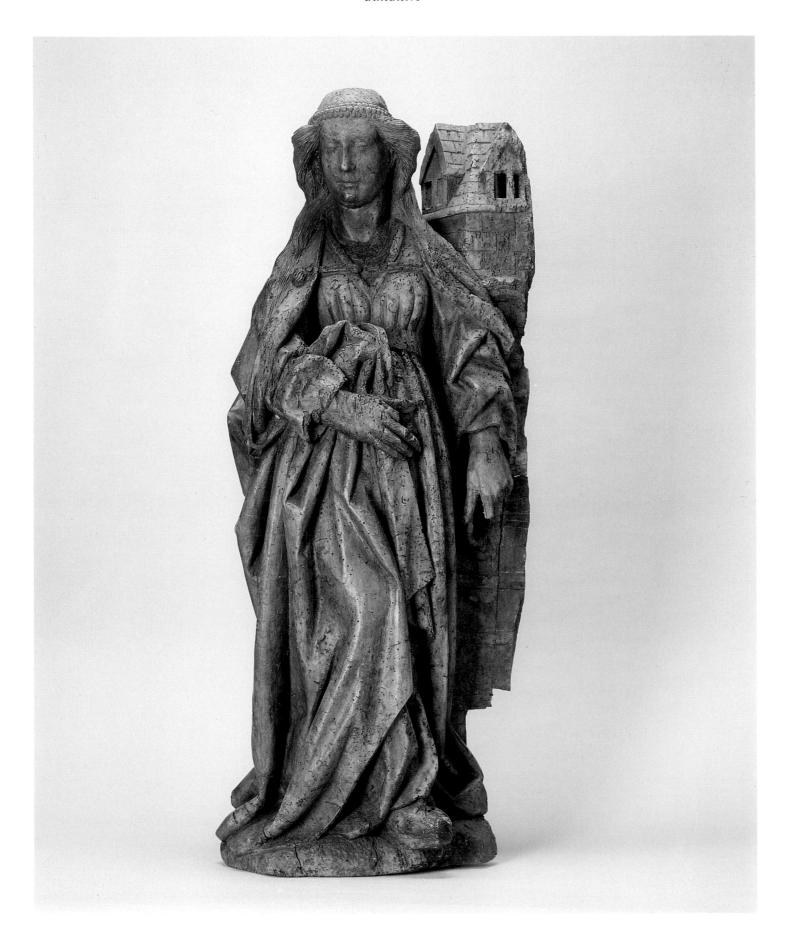

19 Standing Virgin and Child

Brussels, c. 1440–50

Oak, h. 65

Brussels, Stedelijk Museum Broodhuis, inv. B 4232

This statuette was made in Brussels, although it differs in its playful elegance from more stately Brabantine Madonnas such as the Madonna of Vadstena (see *Brussels*, fig. 50). Its exceptionally high quality can be seen for instance in the movement of the pose and the vigorous and dynamic drapery. The Brussels Madonna is similar in some respects to works produced in Utrecht. It is readily comparable, for instance, with the Virgin of the Annunciation in the Gruuthusemuseum, Bruges (cat. 85), especially in terms of physiognomy and the treatment of the hair (see also *Brussels* essay, p. 84).

Brussels 1968, no. 86 ("begin van de 16de eeuw"); Didier 1989, 68 ("Maître bruxellois, 1430–40").

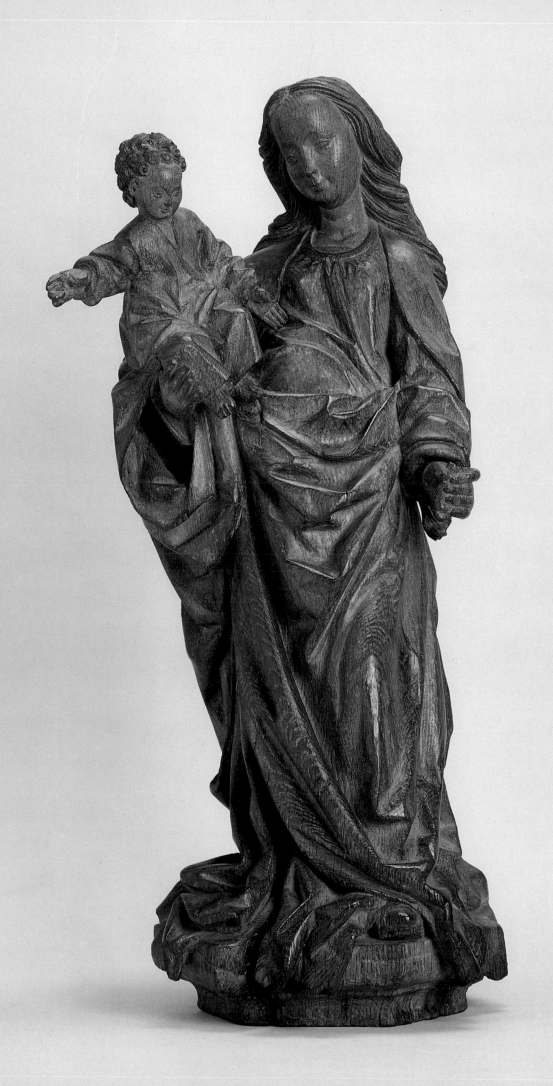

20A–B Two Statuettes from the Tomb of Isabella of Bourbon: Emperor Louis of Bavaria and an Unknown Female Figure

After Jean Delemer

Brussels, 1476

Bronze with natural patina, h. 55.5 (emperor), h. 55.2 (woman)

Principal losses: right hand of both statues

Amsterdam, Rijksmuseum, inv. AM 33–A, 33–I, on loan from the City of Amsterdam

Fig. 20a Jean Delemer, Console with a shield-bearing Angel. Tournai, Cathedral

These two remarkable and very well-known statuettes form part of a series of ten (originally twenty-four) bronzes that – as is now, after long controversy, generally agreed – once decorated the tomb of Isabella of Bourbon (d. 1465), wife of Duke Charles the Bold, formerly in the abbey church of Sint-Michiels outside of Antwerp (the *gisant* survives in Antwerp Cathedral).[1] Though no contemporary documentation concerning the commission is extant, a (lost) inscription informs us that it was erected by Mary of Burgundy for her mother, in 1476 (Leeuwenberg 1951; Leeuwenberg and Halsema-Kubes 1973, 44).

Important in type, this "dynastic" tomb represents a characteristic secular iconography possibly of indigenous Netherlandish origin, the immediate ancestry of which can be traced back to earlier Burgundian and Parisian tomb commissions (see Baron 1990). The specific identification of individual statuettes has given rise to a rich and fascinating literature. Such attempts have in turn involved two earlier very similar tombs, commissioned by Philip the Good: that of Louis of Male, his wife Margaret and daughter (erected 1454/5) in Lille, and of Joan of Brabant and her great-nephew Willem in the Carmelite Church, Brussels (1457/1458), both destroyed but known through a number of later drawings and engravings. Since the Lille and Brussels tombs are nearly identical and since the latter is known to have been executed by the Brussels founder Jacob van Gerines (who also signed the Lille tomb), the sculptor Jean Delemer and the painter Rogier van der Weyden, it is assumed that the same team of artists was involved in both projects. The statuettes in Amsterdam are very closely based on those of the two earlier ensembles, although for an as yet unexplained reason, they follow their models in mirror-reverse.

Whereas the fascinating iconography of these sepulchral monuments has rightly received a great deal of scholarly attention, their style and the related question of authorship have been addressed in a very limited sense only. In spite of general agreement that the wooden models of the Brussels tomb, and therefore logically also those in Lille, were carved by Jean Delemer, these figures, and occasionally also by extension the Amsterdam series (!), continue to be credited to Jacob van Gerines (d. 1463/4).[2] But in a creative sense, they are of course primarily the achievement of Jean Delemer.[3] This lack of recognition is certainly in part due to our limited information and lack of study regarding this important sculptor, who is cited in Brussels as a member of the *Steenbickeleren* in 1440 (Duverger 1933, 55) and perhaps also later in the accounts of Molenbeek over the years c. 1455–70/1 (see Destrée 1899, 326). It appears in any case certain that the sculptor mentioned in Brussels is also the author of the monumental Annunciation group in Tournai Cathedral (see *Tournai*, figs. 1 and 2; an identification implied by Duverger 1935, 16; see also Weinberger 1940, 188).

Although it is not entirely impossible, it seems unlikely that Delemer was directly involved in work on the Antwerp tomb – his death date is unknown, but on the assumption that he was born in the first decade of the century, he would have been at least around the

1 See the decisive study of the question in Leeuwenberg 1951 and Leeuwenberg and Halsema-Kubes 1973.

2 Interestingly a viewpoint shared by fifteenth-century contemporaries: the tomb in Lille carried exclusively the signature of the founder.

3 Four related drawings, allegedly preparatory designs by Van der Weyden or his workshop for the Lille tomb (an attribution unacceptable in view of the varied style of these works – one is unmistakably Eyckian), are more probably based on the sculptures, as Leeuwenberg (1951, 24–25) and others have suggested. For these drawings, see Sonkes 1969, no. E15–18.

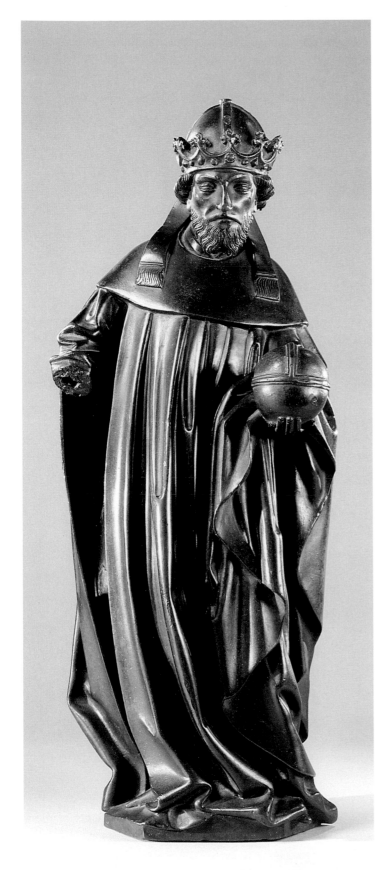
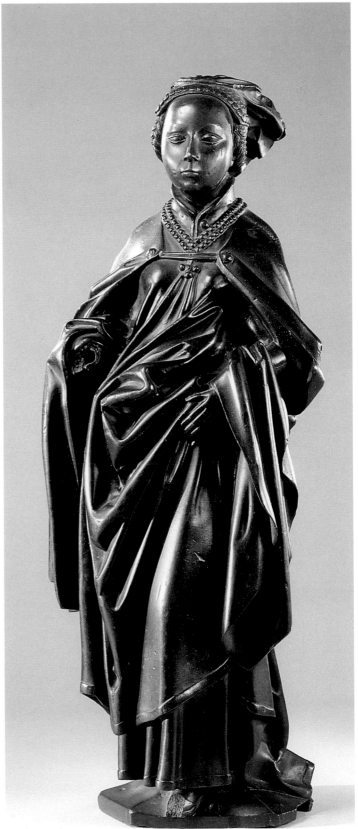

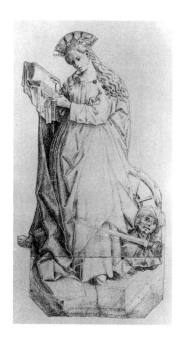

Fig. 20b Rogier van der Weyden, St. Catherine. Vienna, Kunst-historisches Museum

Fig. 20c After Robert Campin, St. Catherine. Amsterdam, Rijksmuseum

age of seventy when this monument was completed. And yet, the Amsterdam bronzes provide unmistakable though probably indirect evidence of this important sculptor's style, thus confirming the documentary link with his activity in Tournai. In spite of their thematic distinction, the probable requirement by the patron to follow earlier sepulchral figures of this sort,[4] and in view of the distance in time, the bronzes remain surprisingly similar to the stone Annunciation group in Tournai.

The lively pose of the Emperor statuette, underlined by an arching movement of parallel fold lines that hook and flatten against the base, echoes that of the Annunciation Angel, where we also find similar motifs ("accordion" forms of sleeve, albeit in a more reduced form). And the way the mantle is raised at the Emperor's left hand, forming layered pinched folds and descending in a flattened undulating zig-zag pattern is precisely like that seen at the right arm of the supporting Angel console in Tournai (fig. 20a). Moreover, the general formal type of our bronze is among the most ubiquitous in the immediate vicinity of Tournai, where it occurs in a more static form in a number of minor sculptures such as a St. Ghislain in Ellezelles (see cat. 6, fig. 6c), a St. Gervase in Bois-de-Lessines (formerly an Angel?; see Coekelberghs and Lequeux 1980, 15), as well as in numerous variants (St. John in Calvary, Antoing; some Apostles, Halle Baptismal font), all presumably following models by Delemer probably carved in Tournai toward or soon after 1430. Not surprisingly, in view of the artist's career, related formal solutions also appear in the Brussels milieu toward c. 1440 (Golden Fleece embroideries, Vienna; as motif in a Brussels Madonna, see cat. 16).

Although no such directly comparable Tournaisian sculpture series is available for the elegant female bronze exhibited here, the drapery elements of this figure are not inconsistent with Delemer's Annunciation Virgin (*Tournai*, fig. 2). This type does however appear in Tournai at an early date: the earliest version may be the small painting of St. Catherine attributed to the young Van der Weyden c. 1430? (fig. 20b), itself probably a revised version of a Campin model known through a drawing in Amsterdam (fig. 20c; Boon 1978, no. 10), which in turn was possibly based on a sculpture. A juxtaposition of these three works, similar and interdependent in type but differing in individual stylistic temperament, provides an especially interesting reflection of the creative interaction between sculpture and painting representative of the Tournai milieu toward 1430. These formal types become extremely common throughout Netherlandish art, first of all in Brabant (e.g. Mary in the Rieden Altarpiece Marriage group, cat. 17, fig. 17a; Female Saint, Zoutleeuw, ill. in Engelen 1993, 179; for Utrecht versions, see cat. 90).

More surprising is the fact that even the head types of these bronzes, so markedly different from Van der Weyden's, are reminiscent of Tournaisian works reflecting Delemer: the male faces with their crisply defined features and notably elongated, thin curvilinear eye slits are comparable to the St. Livinus in the Blecker epitaph (see *Tournai*, fig. 27); the perfectly egg-shaped, "aristocratic mask" face seen in another female mourner (fig. 20d; Leeuwenberg-Halsema-Kubes 1973, 43) appears to be a purified and stylized version of Tournaisian types such as the Wodecq Virgin (cat. 7). It is interesting to observe that this type appears to have influenced the beturbaned Mary in the Lamentation of c. 1460–70 in the Brussels Museum (fig. 20e) confirming the existence of this type before 1460.[5]

Such comparisons, extending to minor details, indicate the remarkable fidelity with which these bronzes reflect the style of Delemer. This leads one to wonder whether somehow he was not involved in the execution of this series through a "missing link," perhaps a lost series of already mirror-reversed models. Whatever the reason, the style of the tomb in general,[6] and the statuettes in particular, are remarkably pure (presumably

posthumous!) examples of this great sculptor's style. At the same time, they exhibit a far greater restraint, in both a sculptural and expressive sense, than the master's youthful work in Tournai. However, this is no doubt due to a development in Delemer's style – a development unfortunately known to us only by a heavily damaged work of his early years and in this late ensemble.

Leeuwenberg 1951 (with critical discussion of earlier literature); Leeuwenberg and Halsema-Kubes 1973, 40–45; Comblen-Sonkes and Van den Bergen-Pantens 1977, *passim* (analysis of Lille and Brussels tombs); Baron 1990, 262–274 (iconographic and formal ancestry of tomb type).

4 Some of the Amsterdam bronzes appear to be descendants of figures of the tomb of Anne of Burgundy, 1442; see Baron 1990, fig. 3.

5 This type seems to form the basis of analogous Bormanesque Brussels types c. 1500; cf. female figures in the Altarpiece of St. George (fig. 20f), Brussels; see also de Borchgrave d'Altena 1947, fig. 45.

6 Even the *gisant* in Antwerp exhibits drapery forms that are closely reminiscent of those in the earliest tomb.

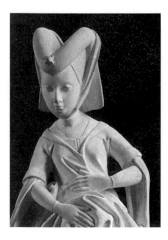
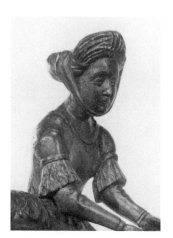
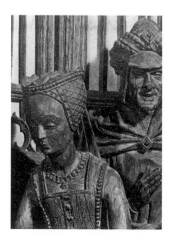

Fig. 20d Female figure from the Tomb of Isabella of Bourbon, detail. Amsterdam, Rijksmuseum

Fig. 20e Lamentation, detail. Brussels, Musées Royaux d'Art et d'Histoire

Fig. 20f Jan Borman, St. George Altarpiece, detail. Brussels, Musées Royaux d'Art et d'Histoire

21 Enthroned God the Father from the Hakendover Altarpiece

Master of the Hakendover Altarpiece

Brussels, c. 1400–5

Wood, h. 48.5

Restorations include: right hand, fleurons of crown, parts of the reverse

Hakendover, Goddelijke Zaligmakerkerk

1 For the restoration, see Marijnissen and Van Liefferinge 1967.

This statuette, probably once part of a Trinity group, forms part of the earliest wooden retable to survive intact (though restored) in the Netherlandish area.[1] Sadly, all but a few of the statuettes and groups were stolen c. 1980. Before the theft, the triptych included a lower tier of narrative groups recounting the miraculous foundation of the church in Hakendover, placed to either side of a central Calvary group; in the upper zone, the enthroned God the Father, flanked by Apostles and Saints (fig. 21d).

The time of origin of this important and much-studied retable is quite controversial. However, a stylistic comparison to the sculpture in the choir of the Basilica, Halle (fig. 21c and *Brussels*, fig. 1), known to have been completed by 1409 and which may be attributed to the same atelier, suggests a relatively early date for the altarpiece, probably around or immediately after 1400. The sculptures of the retable exhibit a remarkable diversity in terms of both quality and style, indicating that they were carved by different hands (probably as many as seven!) in the same atelier. Most however, including this God the Father, may be attributed to the head master of the shop.

Although the identity of this "Hakendover Master" is unknown, circumstantial evidence is sufficiently strong to affirm that he was active in Brussels during the first third

Fig. 21a Coronation of the Virgin. Liège, Saint-Jacques

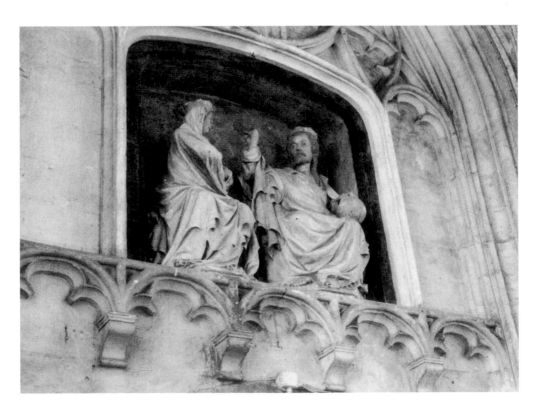

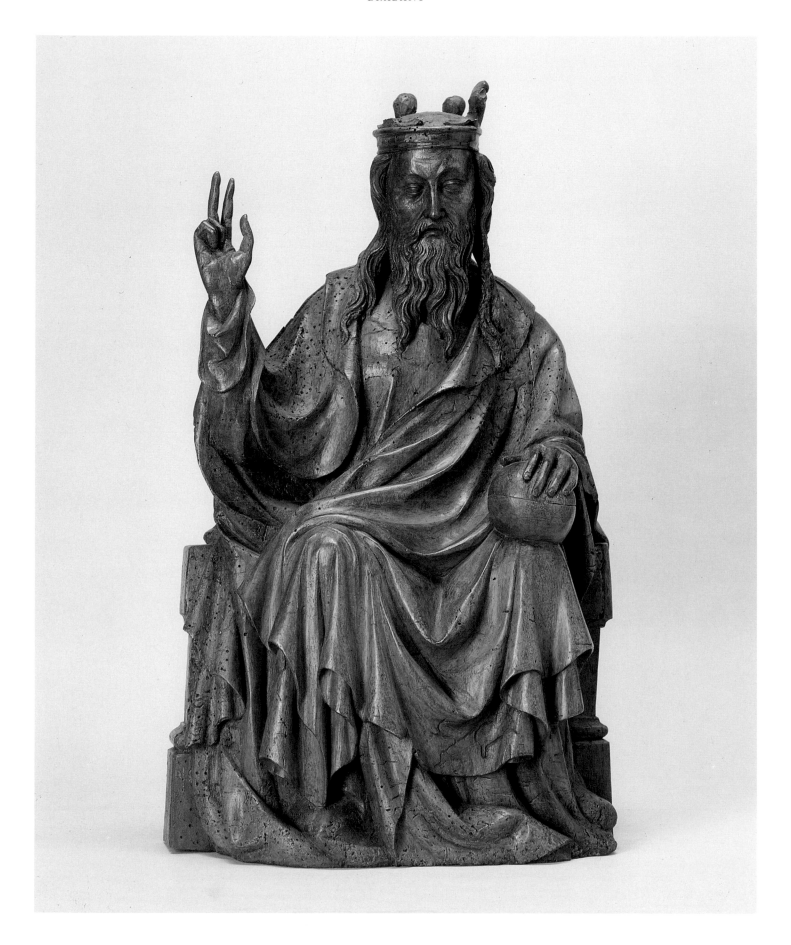

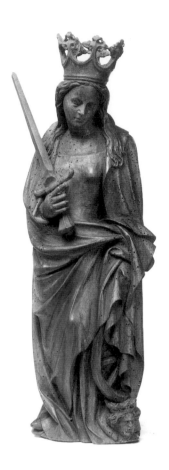

of the fifteenth century. As his earliest known work, the Hakendover Altarpiece can provide some insight into the sculptor's artistic sources and possible origin. If in a general sense the sculptor is indebted to Beauneveu, the specific features of his style have their closest antecedent not in Brabant, but in a work in the Mosan region, the Coronation group in Saint-Jacques, Liège (c. 1390–1400?; fig. 21a). The drapery seen in this group is based on Beauneveu but modified in terms of more "modern" Soft Style tendencies and consists of ornamental, rolled-up edges, in cross-section forming nested conical shapes, nearly identical to those in the Hakendover God the Father.

This close parallel is confirmed by other sculptures in the retable: the cascading edges of enrolled forms below the Liège Christ's raised hand and the fold that flows down from his left knee to peel over against the base have a direct correspondence in the drapery of a Female Saint ("St. Barbara") in Hakendover. And the way the Liège Virgin's mantle is drawn across the right side of her body, forming a series of fold lines that describe depth movement, recurs in several of the figures in the retable, such as the St. Catherine (fig. 21b).

These analogies are sufficiently strong to propose, at least by way of hypothesis, that the Master of the Hakendover Altarpiece may have trained in the shop of the sculptor of the Liège Coronation, or at the very least that he was formed in the same artistic center, presumably Liège.

Didier and Steyaert, in Cologne 1978, 1:89–90, with additional bibliography ("Master of the Hakendover Altarpiece, c. 1400–4"); Van Eeckhoudt 1988, 15–38.

Fig. 21b St. Catherine from the Hakendover Altarpiece. Hakendover, Goddelijke Zaligmakerkerk

Fig. 21c St. James. Halle, Sint-Martinusbasiliek

Cat. 21

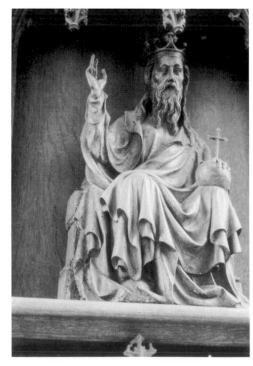

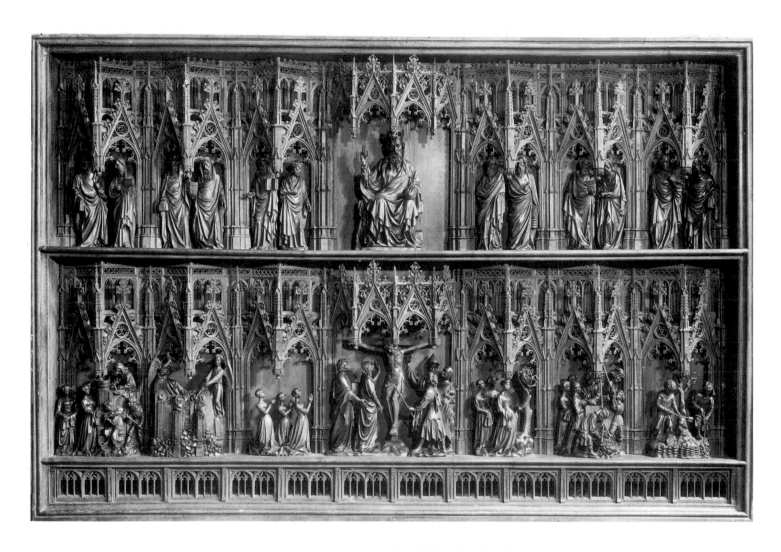

Fig. 21d Hakendover Altarpiece, central
part, before the theft. Hakendover,
Goddelijke Zaligmakerkerk

22 Retable Fragment: Nativity

Brussels, c. 1420–5

Walnut, h. 75

Heavily worm-eaten; the Child, originally located on the ground

between the two figures, is lost

Ramerupt, Saint-Roch

Along with a smaller Visitation group formerly in the same church (fig. 22a), this relief was once placed in a narrative retable dedicated to the Virgin and Christ's Childhood, where it probably occupied the central surelevated compartment, whereas the Visitation, approximately half as tall, would have been located in a lower side section to the left. Iconographically, it is important as the earliest example in Netherlandish sculpture of the Nativity type known to us from the writings of the Swedish mystic St. Bridget, in which the Virgin kneels in adoration before the Child (rather than in a reclining or half-seated pose in the bed of childbirth), an interpretation first introduced in fourteenth-century Italian painting (see Meiss 1967, *passim*). Another important "modern" feature is the unusual prominence and dignified treatment of St. Joseph, typical of the positive reevaluation of Christ's foster father at this time (see Foster 1979). Equally in the spirit of the time are the tiny but remarkably detailed fortified castles and cities placed atop obliquely rising mountain peaks. These formulae of Italian origin are here partially interpreted in local terms with touches such as the houses with stepped gables (as first seen in the painted miniatures of Jacquemart de Hesdin). This interpretation of the subject represents – along with Campin's contemporary painting in Dijon – a classic composition to be followed in subsequent art of the Low Countries; the formula of Italo-Byzantine mountains survives in Brussels retables into the third quarter of the century.

 The stylistic similarity to the *œuvre* of the Master of the Hakendover Altarpiece, especially to this sculptor's later works (*Brussels*, fig. 11), where we see a similar design of very ample, loosely descending draperies, suggests a Brussels provenance for this work and a date in the closing years of the Soft Style. Such a relatively early origin is not inconsistent with the dated Madonna in Tongerlo (1422; cat. 14), related in its unusual breadth and garments (irregular hairpin-like folds; long trailing verticals that break at right angles against the ground; cf. for instance the Visitation group), even though quite different in other respects. The sculptor of the Ramerupt fragments appears to have had a significant impact on the Brussels milieu of the second quarter of the century. He seems to have exercised a formative influence on lesser masters of the next generation such as the Master of the Rieden Altarpiece (where we see e.g. a similar St. Joseph with an unusually long curly beard, differing from Campin's type; see *Brussels*, fig. 19), and perhaps also on Willem Ards (see *Brussels*, fig. 21).

Paris 1959, no. 53 ("fin du xv^e siècle"); Nieuwdorp 1971, 18 ("Zuidnederlands meester, 15de eeuw"); Didier 1989, 76, note 30 ("vers 1420–30").

Fig. 22a Visitation (sale Amsterdam,
Christie's, 8 March 1984, no. 75)

23 Retable Fragment: Saint Peter in Penance

Master of the Hakendover Altarpiece
Brussels, c. 1425–30
Oak, 34.6 x 33.5 x 12
Private collection

Fig. 23a St. Peter, detail of the
Hakendover Altarpiece. Hakendover,
Goddelijke Zaligmakerkerk

Fig. 23b Passion Altarpiece, detail:
Mourners beneath the Cross.
Dortmund, Reinoldikirche

This apparently unpublished retable fragment is of exceptional interest, first of all due to the rarity of its theme. Although the theme makes an occasional appearance as a bit of narrative staffage in fifteenth-century Netherlandish paintings and carved groups (e.g. in a Deposition group in the Musée d'Art et d'Histoire, Brussels), the Penance of St. Peter becomes common only beginning with the Counter-Reformation. The relatively large size of this relief suggests that it once formed an autonomous element of what must have been an exceptional retable dedicated to Christ's Passion or possibly to the life of St. Peter.

It is, in addition, a miniature masterpiece of Netherlandish sculpture which renders St. Peter's sorrow at his denial of Christ in a dramatic and a penetrating psychological sense. The prince of the Apostles is shown in a twisted, kneeling pose that involves an anatomically inconsistent but highly effective angular juxtaposition of elements: the averted head with its aged and deeply anguished features, the hands joined in an eloquent gesture of grief, and above all the sides of his mantle that sweep out to the lower corners of the relief, its edges forming a restless rhythm of bounding, irregular folds. A comparably expressive, rather than simply ornamental, use of drapery can be seen in the New York Apostles in Prayer (*Brussels*, fig. 11). But whereas in the latter the folds create a sense of harmonious unity, they here dramatize the intense conflict of St. Peter's inner struggle. All elements of the composition partake, including the rocks of the shadowy cave that suggest a precarious, physically threatening presence.

For sculpture in the Netherlands, the relief is of cardinal significance, since it is clearly a work of the Master of the Hakendover Altarpiece. The head of St. Peter follows a physical type that can be traced through the sculptor's *œuvre* beginning with his name work (fig. 23a). The ample drapery forms that expand in long trailing edges linking figures with their surroundings represent a "signature" solution that recurs in all of the sculptor's narrative ensembles. It is equally clear that it is a late, and probably his last (known) work. The continuous and harmonious rhythms of complementary curves enhanced by a system of ornamental edges that typify the sculptor's earlier works (e.g. Mourners beneath the Cross, Dortmund Altarpiece, fig. 23b) are here replaced by a composition of contrasting diagonals and irregular restless fragmented forms. Within the master's oeuvre, the St. Peter in Penance can be placed a few years later than the New York group, where we find similarly wrinkled, expressive facial types but more traditional drapery forms.

24 Beam End: Christ's Entry into Jerusalem

Atelier of Willem Ards (active in Brussels and Leuven, c. 1415–54)

1450–1

Oak, 59 x 61

Leuven, Stedelijke Musea, inv. C/13

This piece comes from the Town Hall of Leuven and has been extensively studied in the context of that town's art history. It is a relief carving on a beam end, executed in 1450–1 for a small chamber on the second floor. Willem Ards was commissioned to carve two such reliefs for the ceiling, only one of which has survived.

Ards was a member of the sculptors' corporation in Brussels, but settled in Leuven at an unknown date, probably in the latter years of his life. He spent most of his time there working on the Gothic Town Hall, for which he supplied the sculptural ornamentation for both floors. He carved a large number of beam ends and corbels, most of which remain *in situ*, and some of which have been restored. Together with the relief discussed here these form an extraordinary ensemble that can be dated from archival sources, thus providing a very useful point of reference for undated and individual pieces.

Willem Ards appears to have sculpted his reliefs after drawings provided by the city artist Hubert Stuerbout. We know for certain that the latter supplied models for the decoration of the Gothic chamber on the second floor and for the Town Hall's ornate facade. The beam ends on the first floor portray episodes from the Old Testament and those on the second floor from the New Testament. The present one narrates Christ's Entry into Jerusalem in Ards's customary popular and somewhat rudimentary style, suggesting the biblical event through a few key elements. The coarse facial features are typical of his approach, and might almost be viewed as the master's signature.

Crab 1977, 126, 131 ("Joes Beyaert?, ca. 1468"); Smeyers 1977, 264–278 (convincingly associated with Ards, 1450–1); Leuven 1979, no. 1.4 (with extensive bibliography); Deutsch 1985, 175–176; Engelen 1993, 174–176 (unacceptable argument in favor of a nineteenth-century origin).

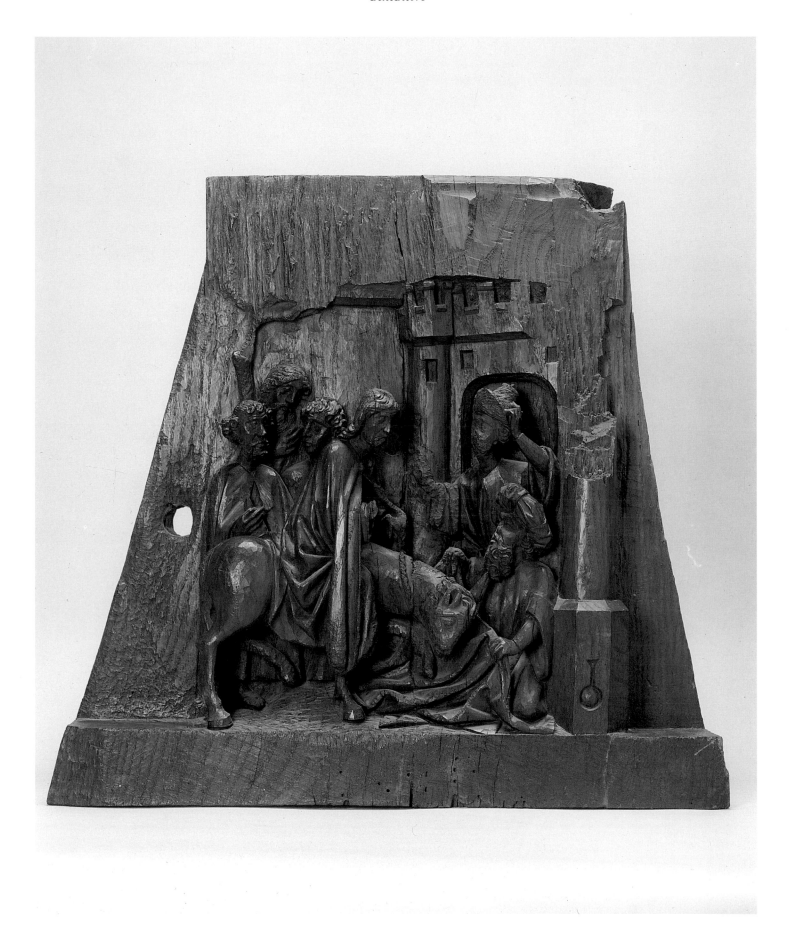

25A–B Two Retable Fragments: Visitation and Nativity

Atelier of Joes Beyaert (?)

Leuven, c. 1460–70

Walnut, 50 x 40 (Visitation); 50 x 62 (Nativity)

Worm damage; several elements missing

Antwerp, Kunsthistorische Musea, Museum Vleeshuis, inv. AV 853 A, B

These two fragments of an altarpiece belong to an iconographical and stylistic tradition of which the Ramerupt fragment (cat. 22) is an early expression. The latter fragment has been dated here to around 1420–25.

The Vleeshuis fragments are linked stylistically with the archaizing work produced by Joes Beyaert in the 1460s for Leuven Town Hall (see Smeyers 1977, 278–286). The two Vleeshuis fragments are also backward-looking. They illustrate the way in which popular representations and formal schemas could be repeated for decades, doubtlessly reflecting the immense demand that existed for altarpieces of this kind. A retable group representing the Adoration of the Magi in the Musée Curtius, Liège (de Borchgrave d'Altena 1965, 28, pl. II), can be attributed to the same atelier.

Van Herck 1948, no. 25C21 ("Zuidnederlands, omstreeks 1500").

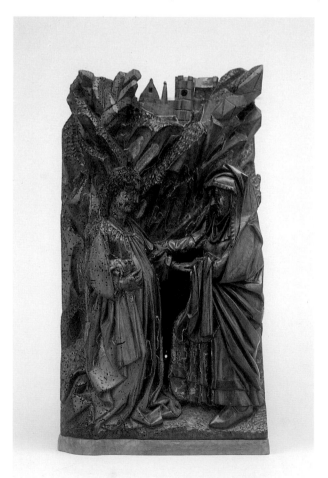

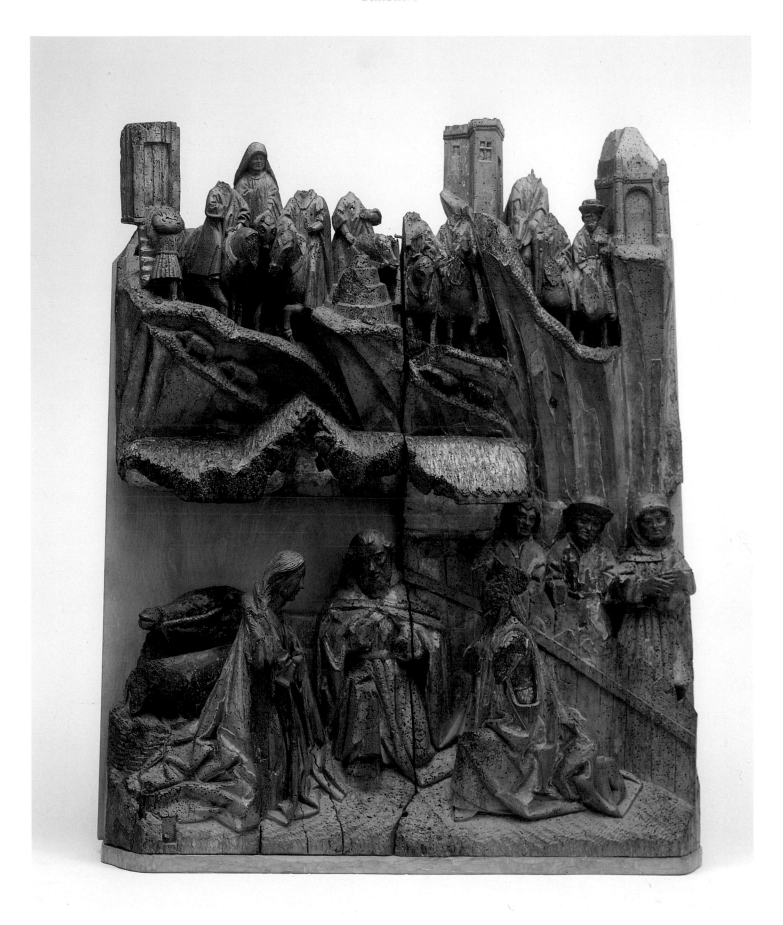

26 Standing Male Figure (Nicodemus or Joseph of Arimathea)

Brussels, c. 1470–1500

Oak, traces of polychromy, h. 81.5

Principal losses: both hands, right foot, bits of turban; back left partly uncarved

Ghent, Museum voor Schone Kunsten, inv. 1952–AN

This practically unknown but exceptionally fine figure once formed part of a composition dedicated to Christ's Passion, most likely a Lamentation or Entombment, comparable in size to the ensembles in the Detroit and Brussels Museums (see *Brussels*, figs. 36, 38). The expressive contrast between the subtly rendered, quiet melancholy of the facial features and the hard, sharply broken drapery rhythms reveals the hand of an important sculptor, probably active in Brussels during the closing decades of the fifteenth century. For a further study of this work a similarity of head type to two masterpieces of the Brussels School may be noted: a St. John the Baptist (fig. 26a; Boccador and Bresset 1972, 2 : fig. 314) and the Christ on the Cold Stone in the Hôtel-Dieu, Beaune (see Dijon 1971, no. 1).

Hoozee 1988, 24 ("Zuidelijke Nederlanden, 15de eeuw").

Cat. 26, profile view

Fig. 26a St. John the Baptist. Whereabouts unknown

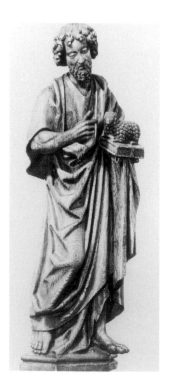

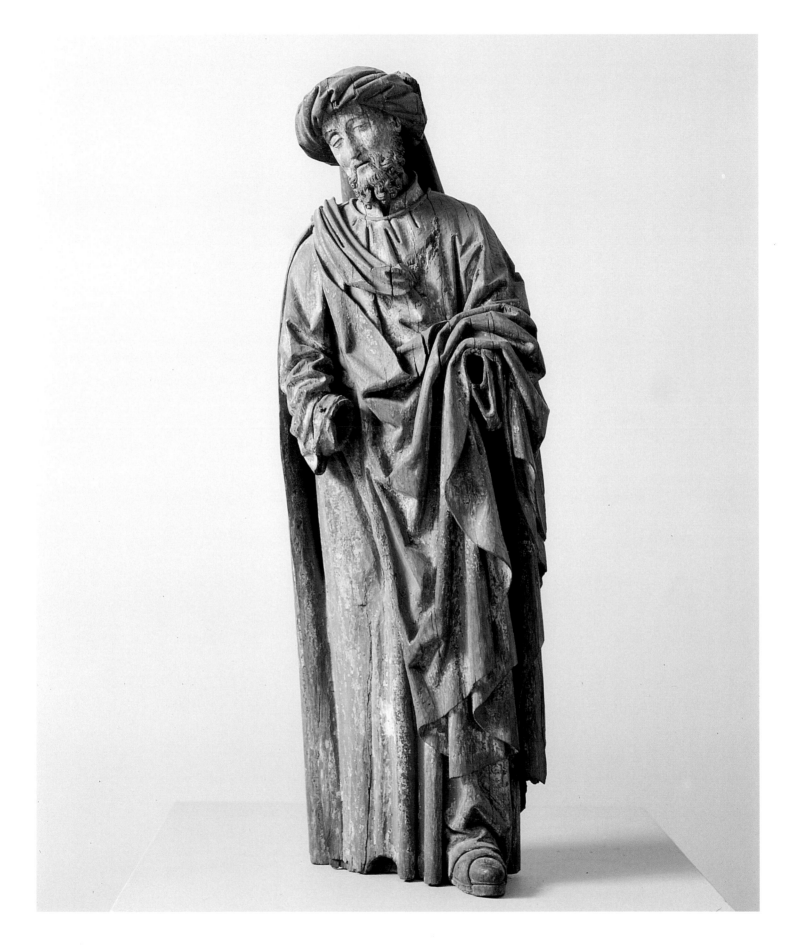

27 Retable Fragment: Nativity

Master of the Rouen Altarpiece

Brussels, c. 1470

Oak with remains of polychromy, 52 x 33

Principal losses: Joseph's left hand, parts of his right; head of ox behind Mary

Private collection

1 Sale catalogue Collections du
Major Lambert d'Audenarde, 1926,
no. 89, pl. 36.

Fig. 27a Retable fragment with the
Circumcision. Former Lambert
Collection

Fig. 27b Nativity group from the
Rouen Altarpiece. Rouen, Musée des
Beaux-Arts

Fig. 27c Retable fragment with the
Circumcision. Former Brabant
Collection

Like most of his Brussels contemporaries active in the third quarter of the fifteenth century, the sculptor of this retable fragment is dependent on earlier models developed in sculpture and painting during the years c. 1420–50. At the same time, he has a sufficiently distinctive manner to allow an attribution of other works to his atelier.

This is one of the finest known works of a sculptor active c. 1460–80 who may be called the Master of the Rouen Altarpiece after his only known complete retable (fig. 27b). The Rouen Master himself was probably a pupil of the Brussels sculptor responsible for two groups of the Circumcision, one formerly in the Lambert Collection (fig. 27a),[1] the other in the former collection A. Brabant (fig. 27c; see Liège 1973, no. 23), both probably dating c. 1460. The Nativity exhibited here differs from these earlier works in its greater refinement of detail and in the sharp linearization of surfaces.

Jansen and Van Herck 1948, no. 110 ("Brabants atelier, einde xvde eeuw"); Antwerp 1954, no. 182 ("Limburg?, 15de eeuw"); Antwerp 1959, no. 114 ("15de eeuw, Brabant").

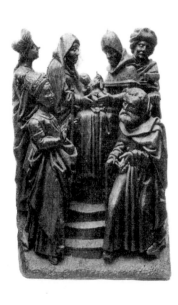

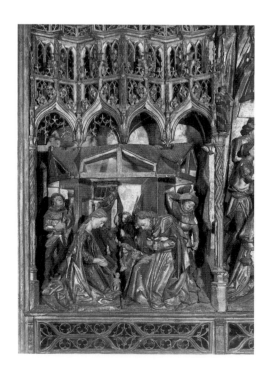

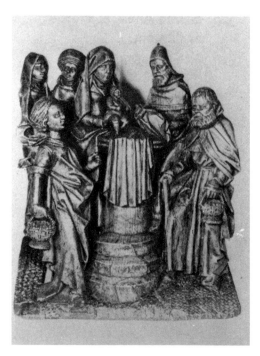

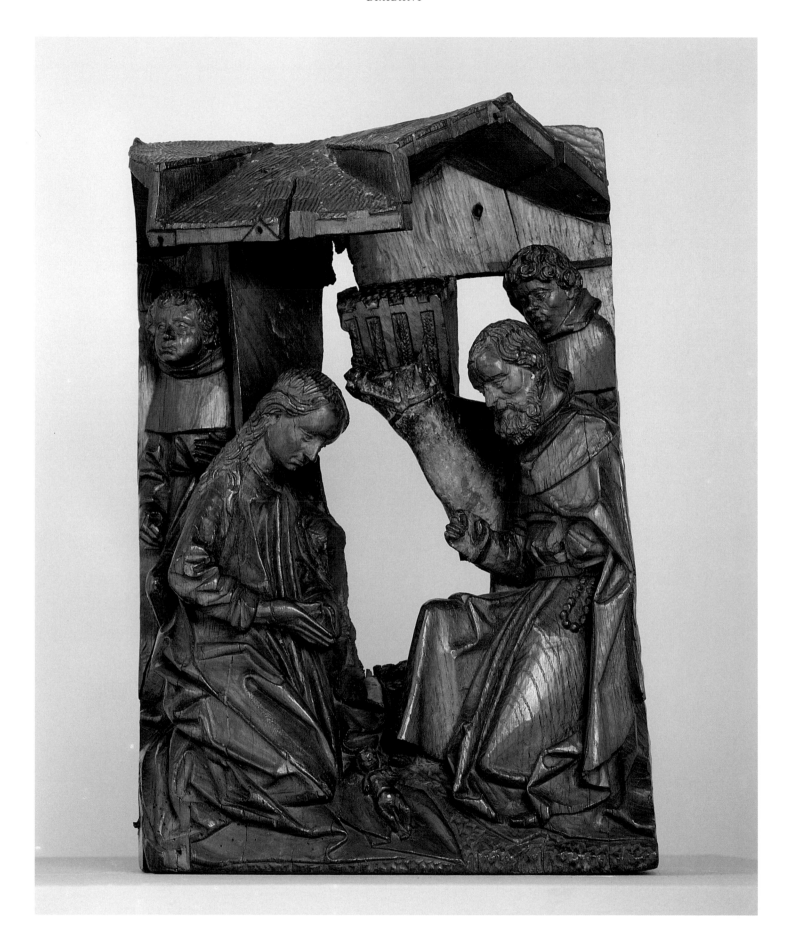

28 Retable Fragment: Swooning Virgin

Circle of the Master of the Vienna Votivkirche Calvary

Brussels, c. 1470–80

Walnut with extensive remains of polychromy and gilding, 56.5 x 23 x 12

Worm damage. Principal losses: Mary's left hand; right hand of Longinus; head and leg of latter's horse

Lille, Musée des Beaux-Arts, inv. A478

This fragment is representative of the better retables produced in great numbers in Brussels ateliers during the second half of the fifteenth century. Originally the lower left of a "Crowded Calvary," it includes a foreground group of St. John supporting the swooning Virgin; behind and above two mourning Maries; and at the top two horsemen, one of whom (at right) is identifiable as the blind Longinus.

The fragment belongs to what is probably the largest group of stylistically related Brussels altarpieces best known through the Altarpiece of Claudio de Villa (Brussels, Musées Royaux d'Art et d'Histoire) and which can be dated to the years c. 1460–80 (some of which have recently been studied by Becker 1989). In view of the exceptionally large number of examples and varied hands encountered in this series, they may well have been produced not in a single but in a large cluster of interdependent Brussels shops active at about the same time.

For the study of these works, a Brussels Calvary that forms the center of a Passion altarpiece from the Votivkirche, Vienna (c. 1470; now Dom- und Diözesan-Museum; see Zykan 1966, fig. 152), can serve as a reference point due to its high quality. Although the group in Lille was carved by a different hand, certain details, most notably the figure of Longinus, appear closely to reflect those in the Vienna ensemble, suggesting that the sculptor was perhaps an associate or follower of this artist.

Oursel 1984, fig. 3 ("Bruxelles, XVᵉ siècle").

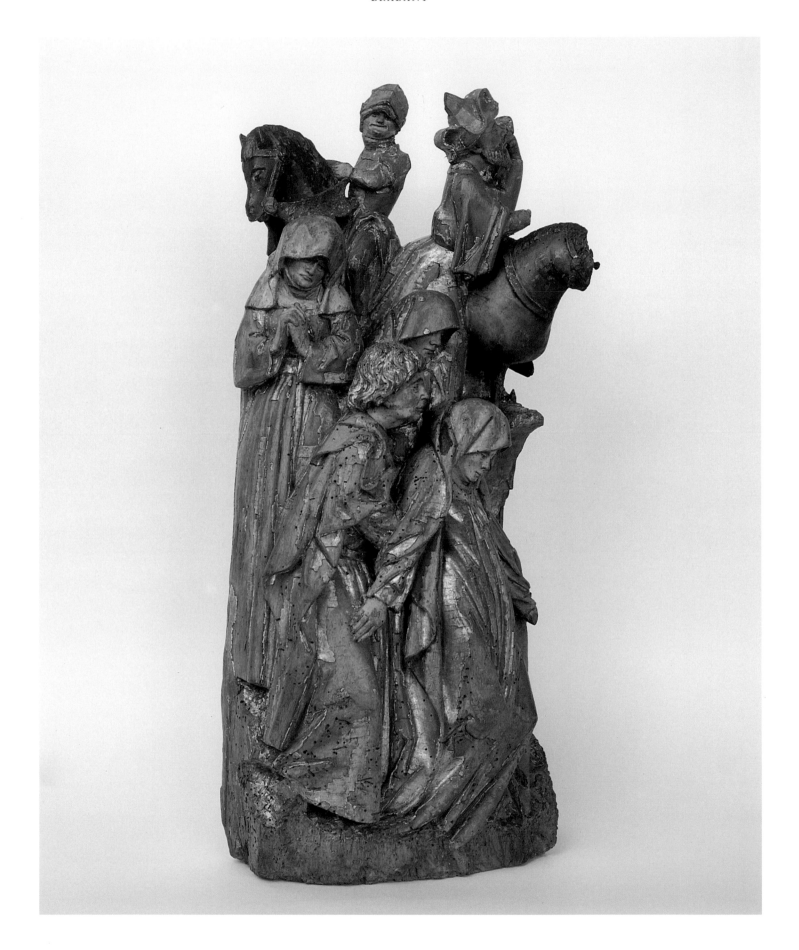

29A–B Two Groups from a Passion Altarpiece: Entombment and Lamentation

Brussels, c. 1480–5

Oak, 67.4 x 37 x 20.5 (Entombment); 69.5 x 37.7 x 10.3 (Lamentation)

Brussels marks (mallet)

Barnard Castle (County Durham), The Bowes Museum, inv. w 123.1018.1023

This little-known altarpiece, represented in the exhibition by two narrative groups, is of special interest for the study of the Brussels School, since it marks the transition between two important stages in the local development of sculpture: the years c. 1450–75, heavily indebted to the painter Van der Weyden, and the years c. 1500, dominated by the Borman family. Stylistically it closely and quite directly reflects the style of the Arenberg Lamentation (c. 1460–70; *Brussels*, fig. 36), albeit at an obvious qualitative distance. The Barnard Castle Lamentation group follows this important model in both its unusual iconography (Carrying of Christ to the Tomb) and individual detail, in spite of the more formulaic interpretation of the figures as well as the composition's more conventional verticalized and more compact grouping.

In view of this close dependence and the fact that the groups retain to some degree a crisp, linear definition of facial features and drapery forms, they may well date toward or shortly after 1480 – and certainly no later (the painted shutters have been placed c. 1475). Dated works tend to support this conclusion: for instance, a brass statuette of St. Leonard from Zoutleeuw, cast by Renier van Tienen in 1483 (Rotterdam, Museum Boymans-van Beuningen; see Brussels 1951, 147; Engelen 1993, 147) is very close in head type to the figures of St. John in Barnard Castle.

This question of chronology is of some importance, since the Barnard Castle Altarpiece is among the very earliest altarpieces in the Borman style. As such, it is contiguous with the beginnings of an evolution that can be traced through the two well-known Passion retables in the Cathedral of Strängnäs (Sweden), ordered by Bishop Cordt Rogge (1479–1501), one no doubt purchased during the early years of his episcopacy (Strängnäs I, c. 1480–90; *Brussels*, fig. 39), the other toward the end (Strängnäs II, c. 1490–1500),[1] and the retable in the church of Sint-Dymphna in Geel (c. 1500–10; *Brussels*, fig. 40). This sequence shows a remarkably consistent continuity of figure types and poses that extend back to the Van der Weyden-inspired Arenberg Lamentation (in spite of qualitative variation). But

Fig. 29a Barnard Castle Passion Altarpiece

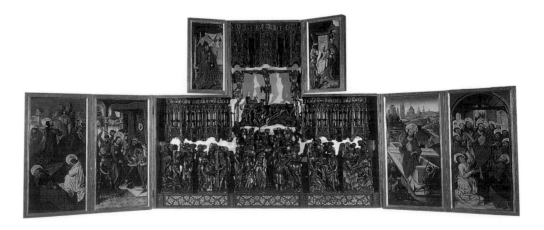

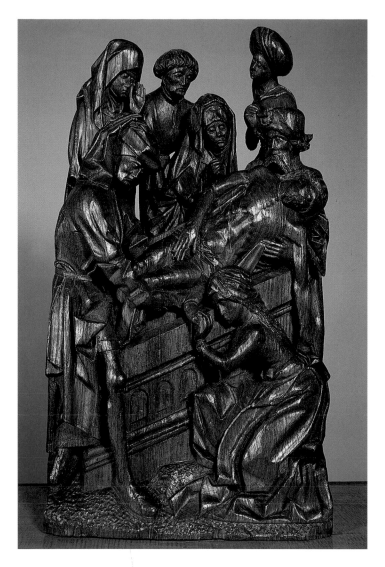 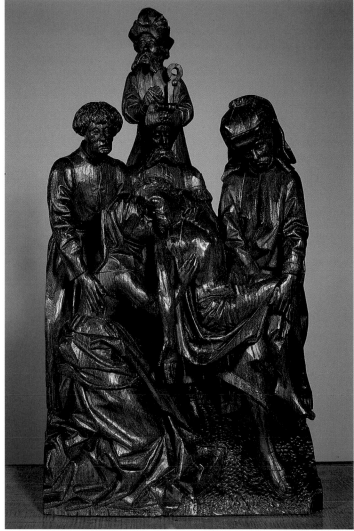

precisely for this reason it also makes especially clear the gradual change away from the taut, nervous asceticism and linearity of this latter work toward increasingly ample, pictorial forms and a sense of calm restraint that represents a reassertion of an indigenous Brussels preference and thus a concomitant attenuation of the Tournaisian current.

The painted shutters of this retable (see fig. 29a) have been attributed to the atelier of the anonymous Master of St. Goedele, perhaps the most original painter active in Brussels in the late fifteenth century. His expressive, mannered poses and facial types have led Sterling (1974–80) to propose the hypothesis of the artist's Tournai origin and training. This viewpoint would help explain the close parallels of this master's extraordinary facial types (see here the Blessing God the Father, St. Anthony, Pilate) to those current in Tournai sculpture, most evidently the grisly face of God the Father in the Lille Trinity (see cat. 5). It is interesting to note that two of the retables discussed above (Strängnäs II and Geel) have shutters that were painted in the same shop.[2]

1 For these, see Roosval 1903, 12–19; Andersson 1979, 2:185–191.

2 For these and for the relationship of painted and carved parts of Brussels retables, see Périer-D'Ieteren 1984.

Dubois 1989, 44, no. 6 (attribution of painted shutters to the atelier of the Master of St. Goedele); Grössinger 1992 ("Brussels work, c. 1475"); Massing, in Cambridge 1993, 35–36.

30 Standing Virgin and Child

Antwerp, c. 1470–80 (?)
Wood with polychromy, h. 108
Brussels, Carmelite Convent

Fig. 30a Standing Virgin and Child.
Madrid, Museo del Prado

The Madonna of the Carmelites is an exceptionally fine Brabantine treatment of this theme and one of the few fifteenth-century examples extant in the Belgian capital. In some basic respects, it is similar to and probably ultimately dependent on Brussels models of the second quarter of the fifteenth century such as the Vadstena Madonna (*Brussels*, fig. 50).

But such comparisons may be more a matter of influence than of common origin, since the Madonna of the Carmelites exhibits specific style features that, insofar as I can see, have no direct counterpart in the Brussels School. The Virgin's symmetrical drapery – her mantle drawn up at the sides, the lower half of her tunic articulated by a series of nested V-forms that extend to a point between her feet – represents a formulation which, although it is not unknown in Brussels (see cat. 15, fig. 15b), becomes especially common in Antwerp during the later fifteenth and early sixteenth century, for instance in a Madonna in the Altarpiece of Årsunda (fig. 30e) and in the work of Jan Crocq (cat. 32, fig. 32b; see also Hofmann 1966, figs. 13–14). More importantly, the somewhat dry, brittle, more linear interpretation of these forms can be recognized as a typically Antwerp style feature. The same is true of the pert facial type of the Virgin, differing from her Brussels sisters in its more elongated oval form and more pointed, sharply defined features. In fact, we can in this way identify other Antwerp works that share one or more of the above characteristics, including a Calvary group in Beerse (cat. 31; cf. Mourning Virgin); as well as "expatriate" works such as the exceptional Madonna in the Cathedral of Granada (fig. 30b; "Nuestra Señora de la Antigua," Weise 1927, 2:53, pls. 117–118), a younger sister of the Carmelite Madonna; and probably also the splendid Virgin and Child in the Prado (c. 1480?; fig. 30a), the latter a variant with typically Antwerp "crumpled" drapery forms. Some of these sculptures are also linked by analogous head types. For instance, the exuberant, joyous expression and wig-like corkscrew tresses of the Child in the Carmelite group, so different from the more sedate, reserved types common in contemporary Brussels examples, has a "twin" in the Granada example (differing mainly in the "make-up" of Spanish polychromy) and is also encountered in a Madonna in Geel (fig. 30c; Brussels 1961, no. 27), the latter almost certainly also by an Antwerp sculptor. If the examples differ among themselves, they nonetheless represent an "extended family" resemblance that allows a hypothetical attribution of all to the Scheldt city.

Given our very limited understanding of the early development of Antwerp statuary, a precise chronology of these works presents difficulties. Our best evidence in this sense is provided by the Granada Madonna, said to have been carried into battle against the Moors by the archdukes Ferdinand and Isabella and presented by them to the Cathedral, presumably in 1492. Taking into account that the campaign against the Moors began in 1482, an origin in the 1480s appears plausible, not least since it seems to be consistent with the group's style features. In view of the direct formal correspondence of this Madonna to that

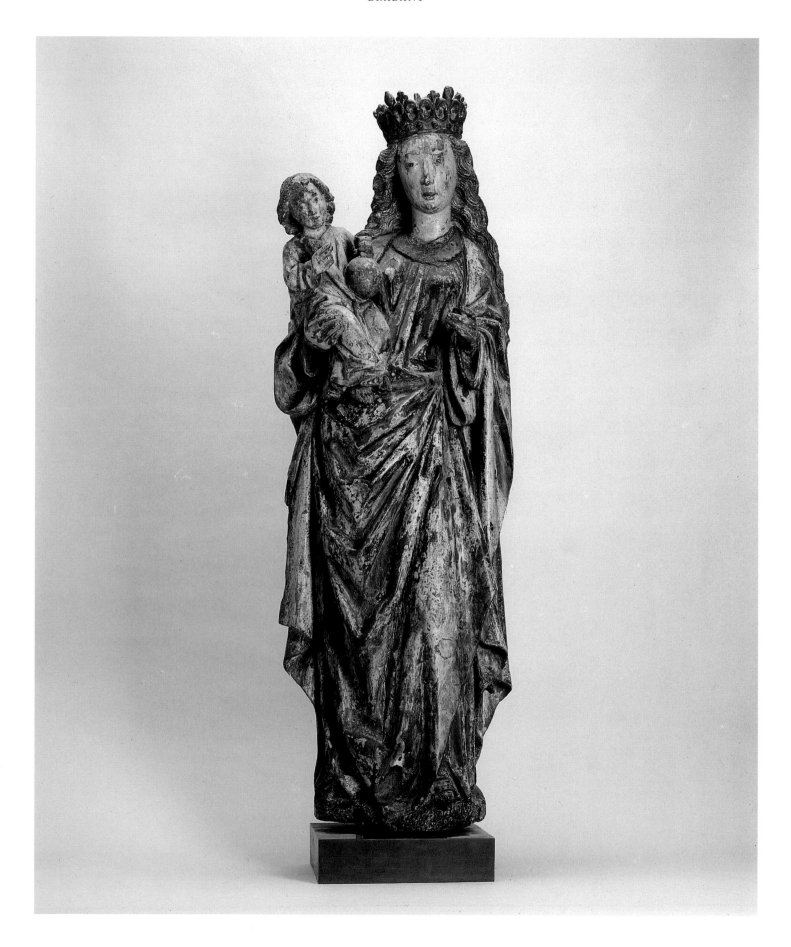

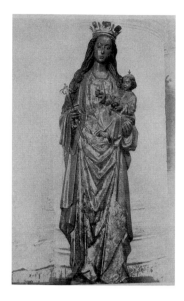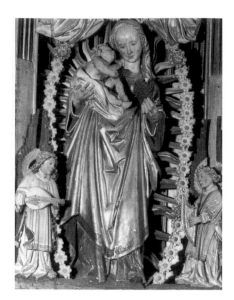

Fig. 30b Standing Virgin and Child. Granada, Cathedral

Fig. 30c Standing Virgin and Child. Geel, OCMW

Fig. 30d Mary from the Savigny Altarpiece. Trier, Diözesanmuseum

Fig. 30e Standing Virgin and Child from the Årsunda Altarpiece. Church of Årsunda

of the Carmelites, which is clearly earlier in time, an origin for the latter in the 1470s can be proposed by approximation. The relation of the two sculptures appears in any case meaningful in a relative chronological sense, and as such can provide some insight into the as yet only dimly perceived development of later fifteenth-century Antwerp sculpture.

Similar to the Carmelite Madonna in formal type, the Granada example exhibits a more strictly symmetrical drapery composition consisting of more flattened, stiffened, and regularized linear folds – all features that announce a characteristic Antwerp stylization of the years c. 1500 and beyond. Equally typical are modifications of physiognomy: the fresh naturalism of the Carmelite Virgin is altered to a slightly more stylized, more perfectly ovoid form with a high, markedly bombé forehead and framed by string-like hairstrands. The head of the Granada Virgin, and even more clearly that of the Prado example with its typically Antwerp pointed hairline in the shape of an inverted "V," directly announce those in early-sixteenth-century local retable production, where this type is reduced to a stereotyped though charming doll-like appearance with minute, pointed features.[1]

Didier, cited in Schmidt 1986 ("Brüsseler Arbeit um 1450"); Schmidt 1986, 322.

[1] An early example is the Virgin statuette in the Savigny Altarpiece, Trier, 1499 (fig. 30d); de Smedt, in Antwerp 1993, 27.

31 Calvary

Antwerp, c. 1460–80 (?)

Oak, h. 130 (Mary); h. 136 (St. John); 248 x 240 (Cross)

Extensively restored

Beerse, Sint-Lambertuskerk

Calvary groups represent a considerable proportion of extant Late Gothic Netherlandish statuary not only due to the ubiquity of this theme but also as a result of their usual high placement in church interiors, out of easy reach of the iconoclasts. In part, this also explains why they have not been studied systematically. In discussions of such ensembles, art historians have traditionally emphasized their close dependence on paintings, particularly by Van der Weyden – although this usually involves more of a parallelism or free adaptation, actual "copies" being extremely rare.[1]

These comments apply at least in part to the present group, clearly "in the spirit of Van der Weyden" in its intense though ultimately sublimated sense of suffering, as well as in certain details such as the motif of Christ's expressive, fluttering loincloth, but by no means a copy after this artist (e.g. the "stretched" pose of Christ, his legs in a frontal, parallel position, differs fundamentally from Rogier's more "neo-Gothic," angular treatment of this subject; on this, see Ohnmacht 1973). Among Calvary groups in the province of Antwerp the Beerse example is rather special both in its quality and in its surprisingly Tournaisian character evident in the dynamic stepping pose and broad-jawed, ascetic head of St. John,

1 Among the few exceptions are the Calvary Christs in Bierghes near Halle, based on Rogier's Calvary Triptych in Vienna, and in Boussu-lez-Mons, closely inspired by a lost work by Hubert van Eyck, known through a copy by Gerard David (Friedländer 1971, 6b: pl. 197).

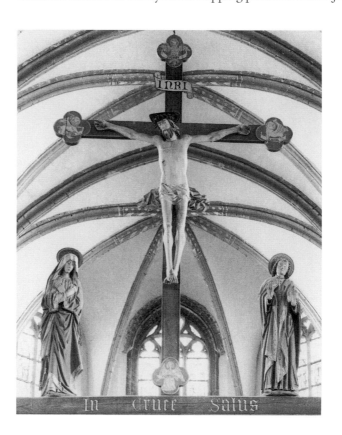

Fig. 31a Calvary.
Geel, Sint-Dymphnakerk

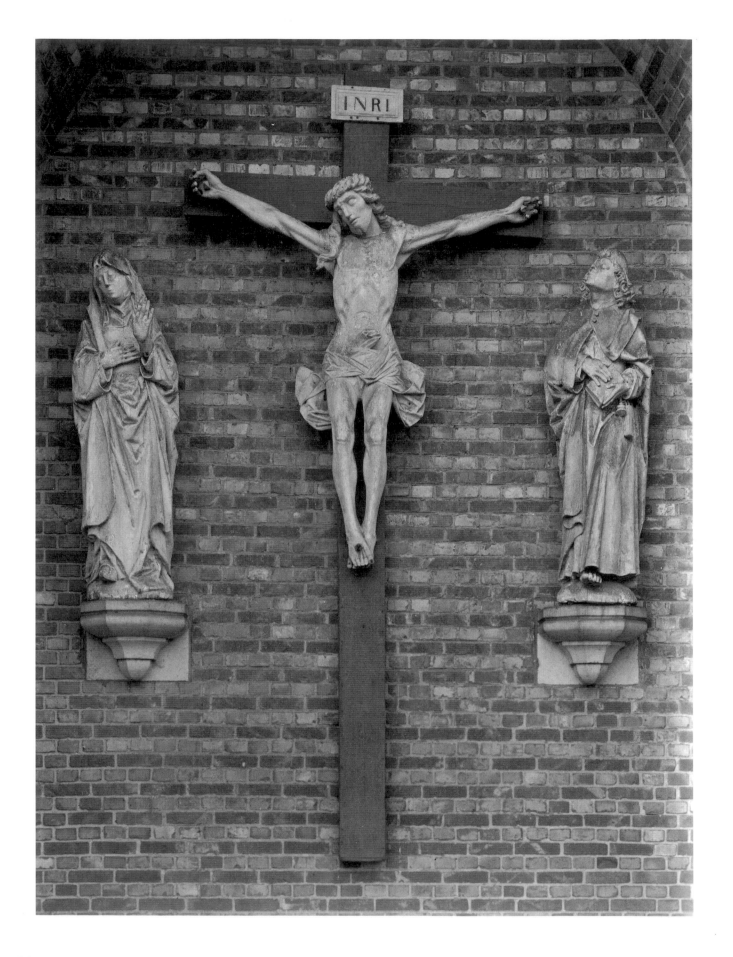

166

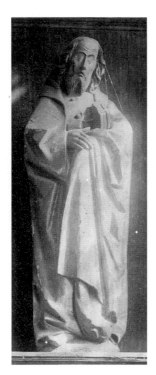 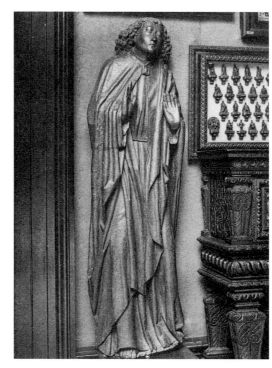

Fig. 31b St. James Minor. Zoutleeuw, Sint-Leonarduskerk

Fig. 31c St. John from a Calvary. Paris, Musée de Cluny, deposited in Arras, Musée des Beaux-Arts

and in the garment motifs, including the Tournai "false sleeves" of Mary's mantle and the cloak thrown over the shoulder of St. John. This infiltration of the Tournaisian manner into the Kempen region probably has its immediate explanation in Brussels works by or in the manner of Jean Delemer.

The underlying stylistic vocabulary is of Tournai–Brussels derivation, the syntax is Antwerpian in character. The Virgin's symmetrical drapery composition has its closest analogy in a series of Madonnas here localized to the Scheldt city (see cat. 30) and the long V-shaped passages with their sharply broken triangles – a hardened version of those encountered in the latest of a series of Antwerp retables (see Vielsalm Deposition, cat. 35) – are nearly identical to the drapery of a St. James Minor that can be attributed to an Antwerp sculptor (fig. 31b; Leuven 1971, z/3; see also a Madonna in Madrid, cat. 30, fig. 30a). Typologically related but stylistically more advanced works of probable Antwerp origin are the Calvary in Sint-Dymphna, Geel (fig. 31a; cf. Mourning Virgins) and two assistant Calvary figures from the collection of the Musée de Cluny, Paris (fig. 31c).

Antwerp 1930, 2:no. A6 (Virgin and St. John) ("xvᵉ siècle").

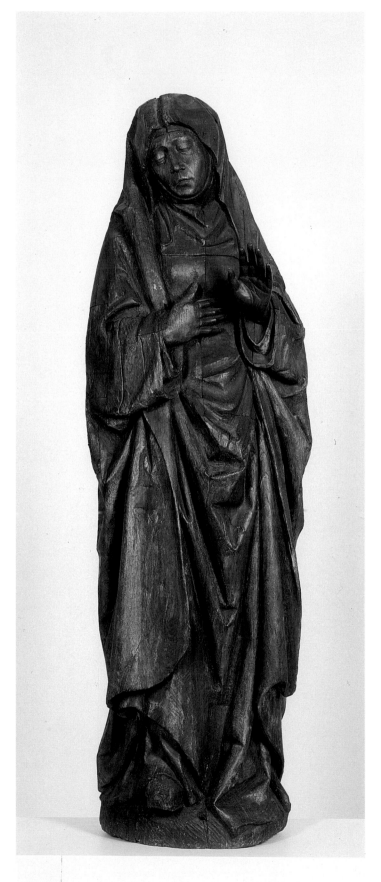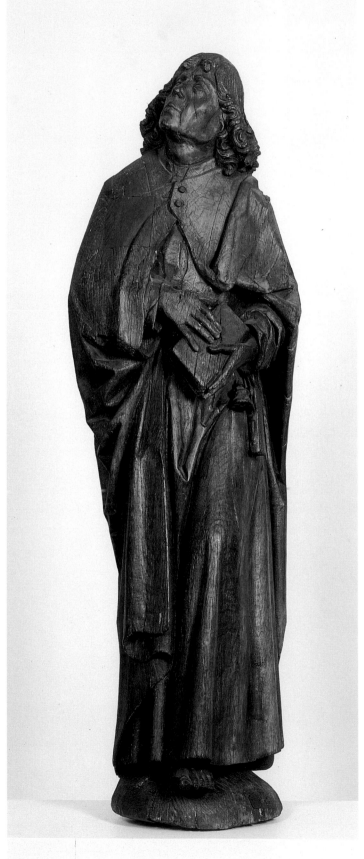

168

32 Saint John from a Calvary

Jan Crocq (active in Lorraine c. 1486–1510)
Wood, h. 97
Nancy, Musée Historique Lorrain, inv. 77-3-16

This exceptionally fine work has been convincingly attributed to Jan Crocq, active in Lorraine (Bar-le-Duc, Nancy), where he is cited in documents between the years 1486 and 1510, and who may be counted among the most important sculptors of the Antwerp School. There is little doubt that he can be identified with a "Jan Croeck" listed as *"regeerder"* in the Antwerp *Liggeren* (records of the painters' guild) in 1458, 1463 and 1466, and who, significantly, was cited as living abroad in 1472 (Rombouts and Van Lerius 1872, II, 15, 19; Asaert 1972, 67).

The artist's most important work, the tomb of Duke Charles the Bold in Nancy, is unfortunately lost. But his extant *œuvre* in Lorraine, gathered on the basis of style and associated with the documents by Hofmann (1962, 254–271; 1966) includes an impressive range of wood and stone sculptures, to which may be added a damaged stone Madonna in New York (fig. 32b), clearly one of his masterpieces. As Hofmann has observed, the style of these works, which differ markedly from the local tradition, is distinctly Netherlandish in character. Scholars who have concerned themselves with the artist's origin have hesitated between Antwerp and Bruges (see e.g. entry in Thieme-Becker 8:143, and a résumé with further literature in Beaulieu and Beyer 1992, 107–109), but both documentary (above) and stylistic evidence definitely favor the former city.

In fact, the style of his works provides a better insight into still little understood developments of the Antwerp School of the second half of the fifteenth century than any

Fig. 32a Passion Altarpiece of Schwäbisch Hall. Schwäbisch Hall, Michaelskirche

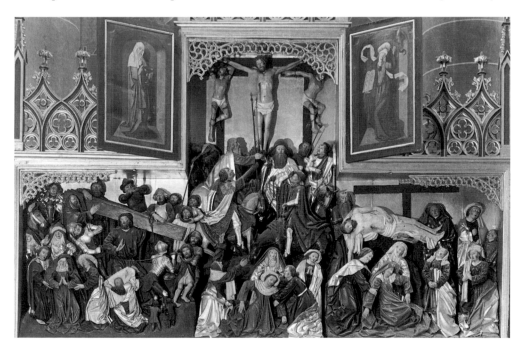

33 Mourning Virgin from a Calvary

Antwerp, c. 1520 (?)

Wood with remains of polychromy, h. 140

Principal losses: hands

Antwerp, Kunsthistorische Musea, Museum Vleeshuis, inv. 5566

The virtual identity of this statue to a Calvary Virgin surmounting the Antwerp Passion Altarpiece in the Church of San Lesmes in Burgos, Spain (c. 1510; fig. 33a; Dumortier, in Antwerp 1993, 1 : no. 42) assures its origin in the Scheldt city. It differs from the example in Spain in its less refined but more expressive, austere face, and a slightly more formulaic, less subtle drapery modeling, suggesting a somewhat later date, perhaps as late as the 1520s. Such a relatively advanced origin is not inconsistent with the face of the Vleeshuis Mary, which constitutes a characteristically Antwerp stylized "mask" (which has a pendant in and may have been influenced by Brussels Bormanesque works).

It is also of interest to observe that, as is typical of most Antwerp sculptures of the early sixteenth century, in their basic stylistic premises both of these figures reach back to creations of the previous century, and probably to the work of the Master of the Pfalzel Altarpiece (c. 1473–80; fig. 33b), a work of extraordinary importance (Zykan 1966; de Smedt, in Antwerp 1993, 2:24–25 and fig. 3). The head of Mary, covered by a veil, half-hidden by the mantle edge, as well as her gesture can serve as points of comparison. Other typically Antwerp motifs, notably the mantle edge drawn from the Virgin's right shoulder to a point just below her forearm, have a similarly early origin (cf. female mourners in Klausen Calvary Altarpiece, c. 1480).

Jansen and Van Herck 1949, 55, no. 39 ("Brabants atelier, omstreeks 1500").

Fig. 33a Virgin from a Calvary. Burgos, San Lesmes

Fig. 33b Pfalzel Passion Altarpiece, detail. Vienna, Dom- und Diözesan-museum

Fig. 33c Calvary Altarpiece, detail. Church of Klausen

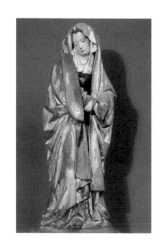

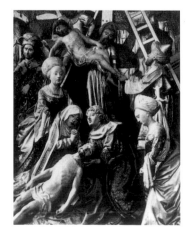

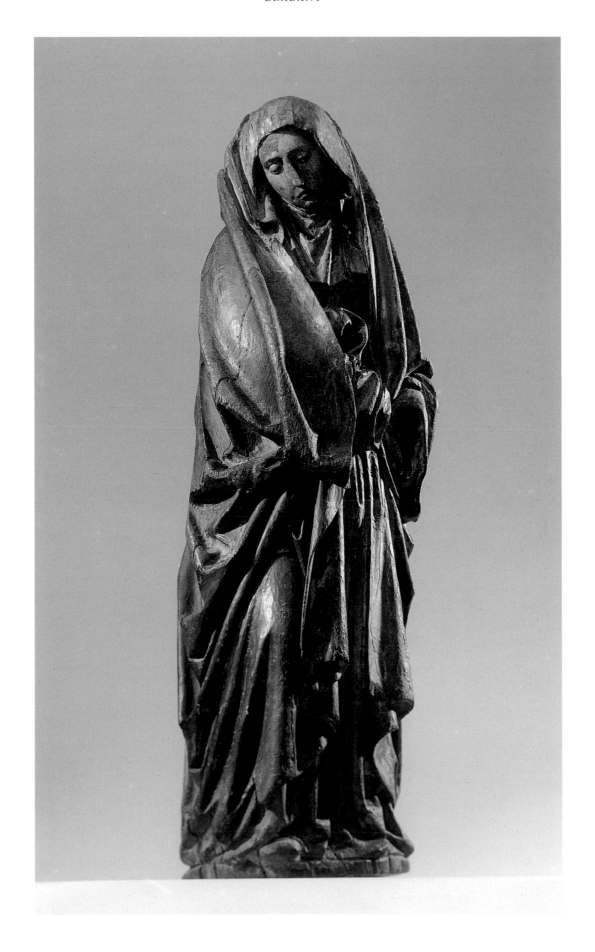

34 Christ on the Cold Stone

Antwerp, c. 1500

Oak, h. 155

Principal losses: Christ's right hand, part of rope

Antwerp marks (two hands)

Binche, Collégiale Saint-Ursmer

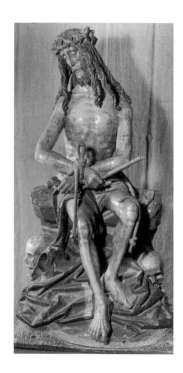

The patiently suffering Christ seated on Golgotha awaiting his death is one of the most typical themes of Netherlandish sculpture in the years c. 1500. Among the small number of examples that can be localized to Antwerp, the Binche Christ is perhaps the most obviously indebted to Brussels models, as Didier has noted. This influence is especially evident in the head type and hair treatment of Christ, familiar from the c. 1500 Brussels tradition associated with the Borman style. Besides the documentary evidence of the hallmarks, the Antwerp character of this work is perhaps most clear in the overtly emotive interpretation of the face of the Savior, representative of an expressive emphasis also encountered in a number of more distinctive Antwerp sculptures such as a Christ on the Cold Stone in Burgos (fig. 34a) and the two statues in Beauvais exhibited here under cat. 36.

Didier 1963 ("1470–80"; pioneering study of monumental sculpture in Antwerp, with earlier literature); de Borchgrave d'Altena and Mambour 1971, 43–45 ("début du XVI⁰ siècle"); De Smedt, in Leuven 1971, no. AB/7 ("begin 16de eeuw?").

Fig. 34a Christ on the Cold Stone. Burgos, Cathedral

Cat. 34, detail

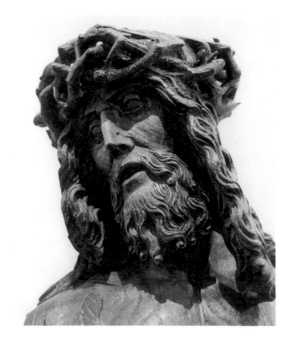

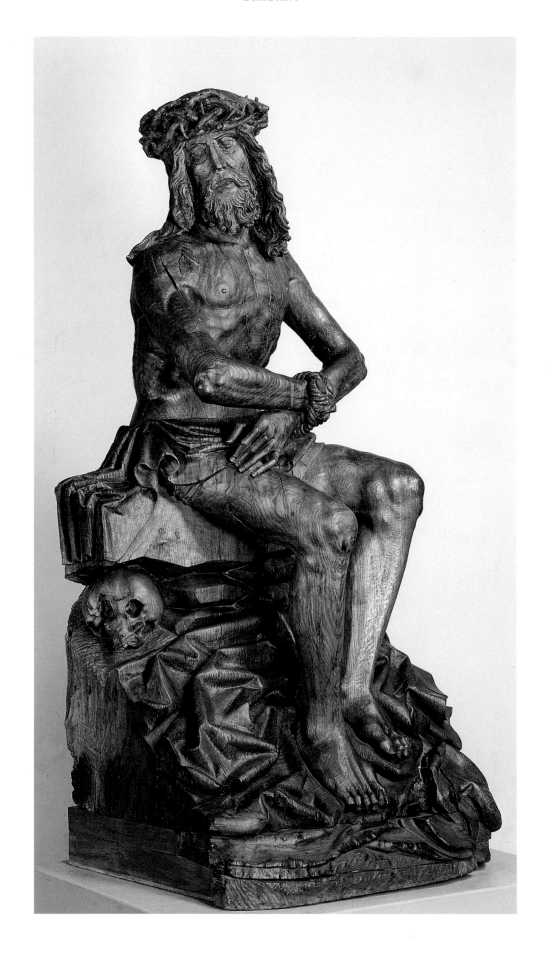

35 Retable Fragment: Deposition

Antwerp, c. 1460–70

Oak, 110 x 73

Minor losses; surface waxed

Vielsalm, Saint-Gengoul

This unusually large retable fragment belongs to a very important and distinctive but as yet little studied retable series dating from the years c. 1430–70. The earliest of these is a Calvary group in Cologne (c. 1430–40; fig. 35a); later examples include Passion retables in Segovia (c. 1450–60; fig. 35g) and in Schwäbisch Hall (c. 1470; St. Michaelskirche; see cat. 32, fig. 32a), as well as a large number of individual fragments (Didier 1989, 63–64). As von Euw (1965) has shown in a masterful analysis, the Cologne group is closely dependent on painting: for its overall *mise-en-scène*, on Jan van Eyck; for certain details, on Robert Campin. This formulation remains determining for the later examples, although these exhibit a growing assimilation of influences from Campin and Van der Weyden, without however abandoning their Eyckian "vantage point" and penchant for narrative elaboration. It is precisely this latter feature that most clearly differentiates these retables from the more usual Netherlandish altarpiece type. In the latter, as first developed in the Brussels tradition (see cat. 21, fig. 21d), isolated narrative groups housed in separate compartments are ranged in a linear narrative sequence; in the works under discussion, by contrast, these scenes are fused into a continuous narrative integrated into a single, panoramic, painterly whole.

The Vielsalm group, carved by a talented artist, represents a fascinating instance of eclectic borrowings from painting: the upper group is quoted from Rogier's Prado

Fig. 35a Calvary from a retable. Cologne, Schnütgen-Museum, and private collection

Fig. 35b Copy after Jan van Eyck's Carrying of the Cross, detail. Budapest, Szépmüvészeti Muzeum

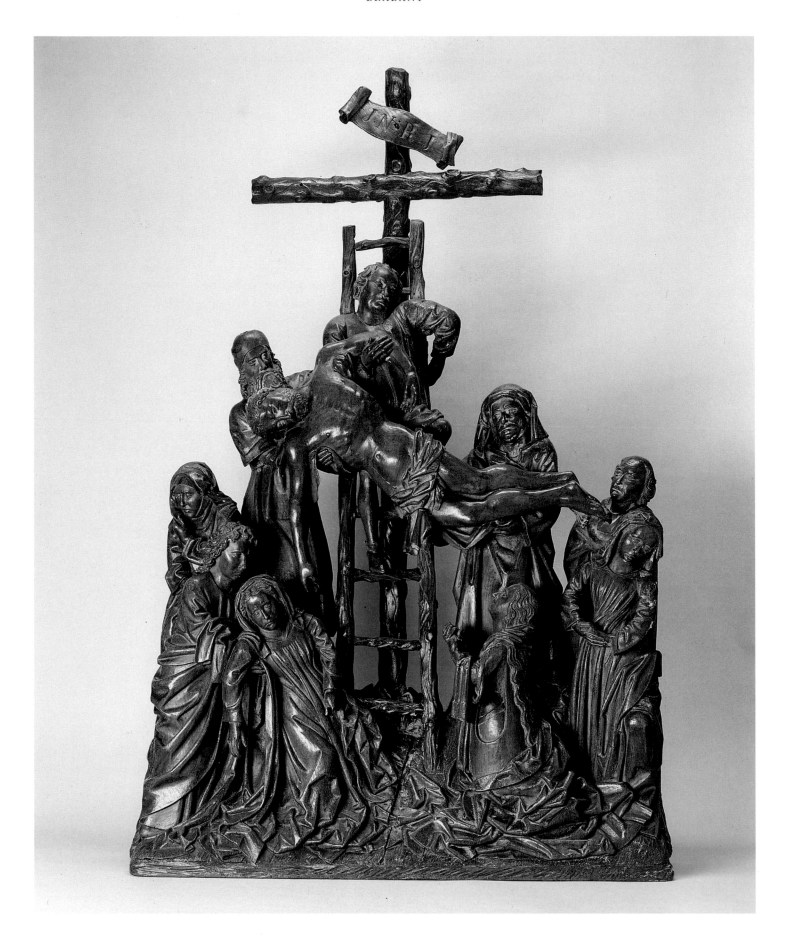

1 Interestingly, these copies include a
mural painting recently discovered in
Antwerp Cathedral (in mirror-
reverse).

Deposition (*Tournai*, fig. 26), reintegrated here into a more conventional verticalized narrative composition (cf. the print by the Master of the Banderoles, Lehrs 22), but also cites elements from Campin such as the Swooning Virgin group at lower left (cf. copy after Campin's lost Deposition Triptych; see Friedländer 1967, 2:pl. 86). Among directly related works are retable fragments of Christ carried to the Sepulchre in Baltimore (fig. 35c) and formerly in a Belgian private collection (fig. 35d). All three are by different hands but along with the other works cited above were surely carved in the same center.

In discussions of one or another of these works, art historians have suggested various places of origin (Bruges, Ghent). Recently a Brussels localization has been proposed (Didier 1989). However, an Antwerp provenance for this series appears more likely, as suggested as early as 1923 by Voegelen in her study of the Schwäbisch Hall Altarpiece. As this author observed, certain groups in this work exhibit a strong degree of typological/stylistic continuity with works of the well-known Antwerp production of the years around and after 1500. Voegelen's observations can be supplemented by other significant survivals of this sort. For instance, the pair of horsemen in dialogue beneath the Cross that appear in all Calvaries of the group – derived from Jan van Eyck's lost *Carrying of the Cross,* known through several copies (Budapest, fig. 35b),[1] – recur in later retables carved in the Scheldt city such as the "Grosser Ferber-Altar" in Gdansk (c. 1481–3; fig. 35e; see Drost 1963, 123) and make a full-fledged reappearance in the Petrikirche Altarpiece, Dortmund (1521, fig. 35f). And the (ultimately Campinesque) Swooning Virgin supported by St. John in Vielsalm can be considered as an antecedent of the same figures in a hallmarked masterpiece of the Antwerp School, the altarpiece in Klausen near Trier (see de Smedt, in Antwerp 1993, 2:fig. 6), in spite of obvious stylistic differences.

Didier 1989, 64 ("Maître bruxellois, vers 1450").

Fig. 35c Entombment.
Baltimore, Walters Art Gallery

Fig. 35d Entombment.
Private collection

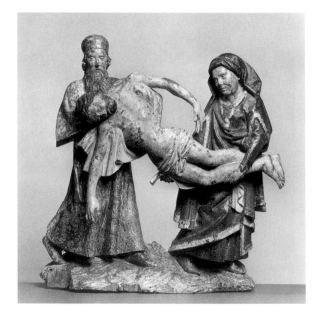

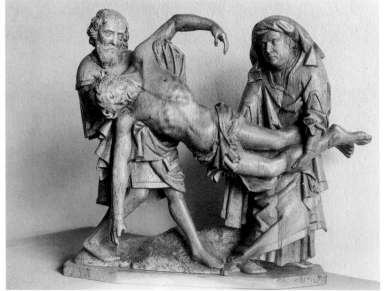

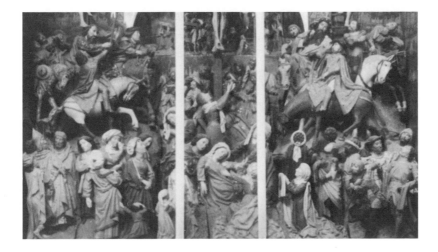

Fig. 35e "Grosser Ferber-Altar."
Gdansk, Marienkirche

Fig. 35f Passion Altarpiece, central
part. Dortmund, Petrikirche

Fig. 35g Passion Altarpiece, central
part, detail. Segovia, San Antonio el
Real Monastery

36A–B Two Figures from a Passion Group

Antwerp, c. 1500–10 (?)

Wood with original polychromy and gilding, h. 96 (bearded figure); h. 94 (clean-shaven)

Worm damage; principal losses: both hands of bearded figure, part of hand and attribute
(ointment jar and cover?) of clean-shaven figure

Beauvais, Musée départemental de l'Oise, inv. 843–174, 843–175

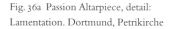

1 Quite similar to the Beauvais
bearded figure in head type.

Often identified as SS. Cosmas and Damian, these figures probably represent Joseph of
Arimathea and Nicodemus and undoubtedly formed part of a narrative ensemble from
Christ's Passion, most likely a Lamentation composed of several mourners surrounding a
central Pietà.

Their boldly expressive, realistically molded facial features, perhaps influenced by
prints of Martin Schongauer, and the drapery formulation, especially that of the bearded
figure whose mantle is drawn up at his waist and descends to the base in a long, irregular
V-pattern of jagged folds, can be recognized as typical of the Antwerp tradition of the later
fifteenth and early sixteenth centuries. That such expressive head types are not at all
unusual, and in fact appear to be typical of much of Antwerp's production in these years,
can be seen in the hallmarked Christs on the Cold Stone in Burgos Cathedral[1] and in
Binche (cat. 34; cf. Didier 1963) as well as in the recently exhibited John the Baptist in
Valladolid (Nieuwdorp, in Antwerp 1993, 2 : fig. 187).

In their extraordinary quality and size they far surpass the norm of similar figures in
contemporary Antwerp retables. This can be gaged by a comparison to the personages in a
Lamentation in the Petrikirche Altarpiece in Dortmund (by Master Gielisz, 1521; fig. 36a)
which includes a very similar elegantly garbed, "walking" man with an ointment jar. This
comparison can perhaps provide some idea of the original iconographic/compositional

Fig. 36a Passion Altarpiece, detail:
Lamentation. Dortmund, Petrikirche

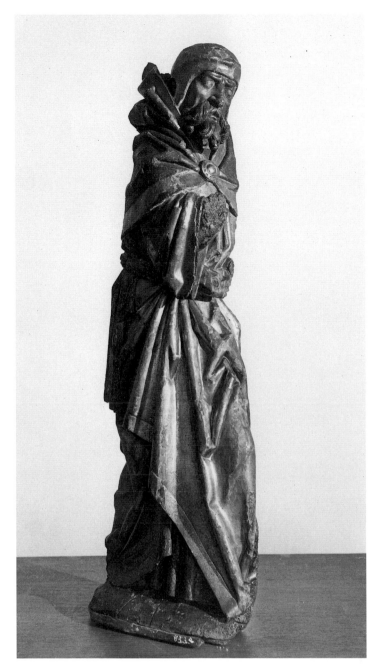
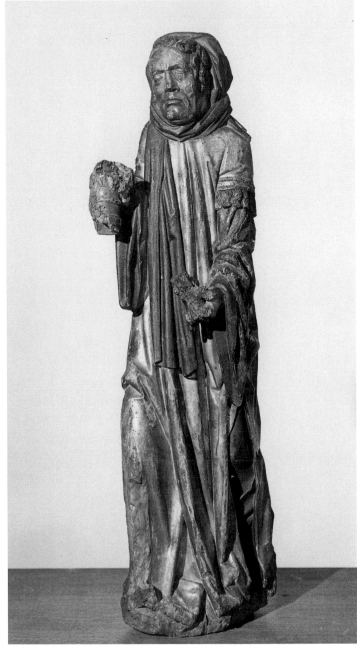

context of these sculptures which, although carved in the round, were undoubtedly intended to be seen primarily in a profile view, as indicated by the shallowness of the wood blocks from which they are carved. It also provides a *terminus ante quem* of 1521 for the sculptures in Beauvais, although a more precise date remains difficult to determine. Since there is no reason to think that they are later than the figure of the Baptist in Valladolid, dated 1504 by inscription, an origin in the opening years of the sixteenth century may be proposed by way of hypothesis.

Salmon 1975, 21–22 ("fin XVᵉ siècle").

Flanders

37 Brass of Gilles of Namain

Bruges, c. 1370–5

Brass, 238 x 134 (A); 71 x 64 (B)

Palimpsest of eight remaining fragments that were later re-used (reverse) for the funerary
and commemorative brasses of Pieter van Valencia (d. 1559) and his wife. Contained in
modern wooden frame

Bruges, Sint-Jacobskerk

Fig. 37a Console with Zachariah and
the Angel (?). Bruges, Gruuthuse-
museum

There exists a tendency to study works in an "internal" sense according to medium, which
is certainly logical. However, much can be gained in working "across" the varied media in
an attempt to gain a more complete idea of a given artistic region or center. So for instance
our understanding of painting in the Flanders–Tournai–Artois area in the early fifteenth
century could be greatly enhanced by a stylistic study of tapestries produced there. These
are after all among the few monumental ensembles of two-dimensional art to survive from
this time, and might, for instance, help us gain a clearer understanding of the very important
but at present isolated manner of Broederlam (cf. e.g. style of St. Eleuthère and St. Piat
tapestries, Tournai Cathedral). In this sense, a recent comparative study of Bruges tomb
plaques in relation to contemporary miniature painting is especially meaningful: it helps
to anchor these works in the local Scheldt School–Flanders tradition and to reinforce our
understanding of both media (see Dennison 1986).

It should be noted first of all that the evidence in favor of a Bruges origin for these
important brasses, distributed throughout Europe, is incontrovertible. These works have
now been studied in detail by Norris (1978) and Cameron (series of articles 1979–86 in
Transactions of the Monumental Brass Society), who however still favor a Tournai origin for
these works, in spite of the fact that written documentation gathered by these authors clearly
contradicts these localizations (see references to: "sepulcrum unum Flamingicum aurical-
cium", Lübeck, 1360s; "Lapis iam paratur in Brugis", Gniezno, 1426; see Norris 1978).

These monuments provide a remarkable profile, based on approximately dated
examples, of the development of the Bruges School from c. 1320 to c. 1370 and beyond;
subsequent examples of the years c. 1400 appear more derivative and thus less interesting
from this point of view.

This evolution stretches from the Pucelle style of the earliest example in Denmark
(King Eric Menved and Queen Ingeborg, Ringsted, c. 1320) over a mid-fourteenth-
century style (Lübeck, Plaque of Bishops Serken and von Mul, c. 1350) that closely parallels
the manner of the Jean de Grise manuscript (Oxford), to a lively narrative tendency carried
by rhythmic movement that appears to announce the style of Jean Bondol of Bruges and
related "Boqueteaux" manuscripts and their antecedents (overview of manuscripts in
Sterling 1987, 1:150ff).

The brass of Gilles of Namain is part of a series of Bruges examples, most of which
have been destroyed (e.g. in the church of Sint-Walburga; see Vermeersch 1976, 2:75–77,
83–86; Cameron 1981). It stylistically represents a relatively late stage within the series, that
exhibits links to the style of Beauneveu but also incipient and, given the time of origin,
precocious Soft Style tendencies (cf. the late style of Bondol as we know it through the
Angers Apocalypse tapestry series, 1380s). In this respect it is comparable to the earliest
sculptural decoration of the Bruges City Hall (c. 1376–9).[1]

1 Cf. also a series of stylistically
related, probably Bruges, leather
reliefs; the most important example
in Lucca, see Baracchini and Caleca
1973, 155–156.

2 A "generic" Scheldt-School feature
familiar in Beauneveu but appearing
as early as the miniature of the *Vœux
du Paon* manuscript in New York;
see Paris 1981–2, fig. 302.

Cat. 37, reconstruction, rubbing

The theme of gesticulating pairs of prophets and apostles in dialogue seen here, with lively secular themes underfoot typical of these Bruges brasses (lost in our example; cf. fragment formerly in Bruges Cathedral; see Devliegher 1979, 102–105, fig. 68), corresponds quite precisely to elements of the façade decoration.

This link can be reinforced by comparisons of detail: the head of the St. Paul with his bald pate and full beard flowing opposite to the direction of the turn of the head to suggest movement seen in the brass,[2] has a direct counterpart in the masterly head of "Zachariah" in one of the City Hall consoles (Didier and Steyaert, in Cologne 1978, 1:81–82; cf. "Angel"

3 The fact that very similar figures appear in a brass tomb plaque in Heers (see most recently Didier in Sint-Truiden 1991, 3:65) has led to an attribution of this work to Bruges; but a close analysis of the style indicates the derivative nature of this work, which may well be a Bruges-influenced work of Mosan origin.

with flying curls in the same console to those in the plaque; fig. 37a). And the faces in general, in this and earlier such plaques, share somewhat rude but expressive features (prominent noses with broad ridge and slightly bulbous tip) that are a constant of the Bruges School.[3]

Cameron 1970, 69 ("certainly not earlier than 1370"); Vermeersch 1976, 2:no.44 ("c.1350–75"; with complete earlier bibliography).

Cat. 37, details

38 Corbel with Lovers and Woman Washing a Man's Hair

Atelier of Jan van Valenciennes

Bruges, c. 1376–9

Limestone, 27 x 47 x 43

Principal losses: in the lovers' scene the right arm of the woman and left arm of the man

are missing and the man's face is heavily damaged; the hair-washing woman's head is also missing

Bruges, Gruuthusemuseum, inv. 0.119.VI

Although the precise subject of this corbel has not been identified, the two elements of the composition, a woman washing the hair of a presumably cuckolded man at the right, alongside a lively pair of embracing and obviously enthusiastic lovers is clear enough in its human meaning.

This corbel forms part of a series of historiated corbels, secular as well as religious, from the facade of the Bruges City Hall, known to have been completed by a team of sculptors working under the direction of Jan van Valenciennes between 1376 and 1379 (see also cat. 37, fig. 37a).[1] Since these have been extensively studied, primarily in their relation to written sources, some comments on style and the wider European context may be presented here.

The much debated possible origin of the leading sculptor in Valenciennes versus Bruges is important but remains unresolved. It is of course tempting to think that he was formed in the Scheldt city in the circle of Beauneveu. That he was an outsider as perhaps indicated by his surname is certainly a distinct possibility. His later successor in work on the same facade (1423–4), Colarde de Cats, was called in from the outside; he is almost certainly the same as the Tournai sculptor (of Mons origin?) "Colart le Cat" (Cloquet and de la Grange 1887, 233; Descamps 1905–6; Soil de Moriamé 1912, 24–26), who died c. 1426/7,[2] which undoubtedly explains why his statues for the facade needed to be brought up to par and placed by Jan Hoosebrugghe in 1426–7 (Gilliodts-van Severen 1876, 5:336).

Perhaps more important than the origins of Jan van Valenciennes, however, is his impact: his work appears to have laid the foundation for the Bruges School of the years c. 1400 and even, to an extent, for that of the regional Late Gothic.

These consoles form part of a European style current stretching over the years 1340–80 encountered in both sculpture and painting. This manner is characterized by figures in modish garb (notably the revolutionary new male fashion of tight-fitting, short, buttoned and padded garments), shown in lively movement with a particular preference for chiastic crossing movement of limbs (involving aerated sculpturally differentiated compositions), and an overall narrative with discreet touches of realism.[3]

In Netherlandish sculpture, this style is known to us, probably due to accidents of preservation, primarily in small-scale works, the most notable examples besides those in Bruges being the historiated corbels from the Schepenhuis, Mechelen, and in the sculptural decoration of Onze-Lieve-Vrouw-ten-Poel, Tienen (principally west facade). In Bruges itself, this manner can be seen to emerge gradually from the tradition of incised tomb plaques.

This stylistic tendency, of crucial significance for an understanding of the emergence of the new realism around 1400, has been considered as having been developed in and radiating out from the Parisian milieu (Didier and Steyaert, in Cologne 1978, 1:81–82;

1 Variation in quality and stylistic interpretation within the series confirms the participation of several hands.

2 See *Annales de la Société Historique et Littéraire de Tournai* 10 [1906], 94, 171.

3 This style is best known to us far from its western homeland in Bohemian and Austrian examples (see Schmidt 1977–8, 179–206; more recently, Schwarz 1986, chapters V-VII).

Didier and Recht 1980), so that the pervasive presence of this style in Flanders with its political and artistic links to France is not surprising. Insofar as the term "Franco-Flemish" retains some art-historical validity, it is surely apt in defining the lively artistic interaction between Flanders and France during these years, when it was further strengthened by the Burgondo-Flemish marriage alliance. However, the possibility of a Netherlandish, or even Flemish origin of this style can certainly not be dismissed if we take into account that the principal representative of this style in Paris was Jean Bondol ("de Bruges").

The corbel with the lovers and hair-washing, possibly the finest of the Bruges facade series, is a relatively late and progressive example of this style. Perhaps owing to its small size, profane theme, and damaged condition its importance has not been fully recognized. In its sculpturally developed forms and simplified drapery with diagonally sweeping, depth-creating fold lines, this work might be characterized as "Sluterian" (insofar as this overused term still holds some meaning) or at least as proto-Sluterian in style, as suggested by a comparison to Sluter's portal Madonna at the Chartreuse de Champmol (fig. 38a). Although an attribution of this or any of the other consoles to the young Sluter cannot be seriously considered, these works were carved precisely during the years of the master's South-Netherlandish (Brussels) activity; they may be seen as representative of an important – though now fragmentarily extant – local tradition that may have influenced this sculptor of genius before his arrival in Dijon (via Paris?).

It is not impossible that this association involves another Franco-Flemish link. The Champmol portal Madonna, acknowledged as Sluter's earliest work, may, at least to an extent, be indebted to the work of his recently deceased predecessor as *chef d'atelier*, Jean de Marville (d. 1389; see also Schmidt 1992, 299), to whom this group was once (unconvincingly) attributed, himself probably of (South-?) Flemish origin and head of a Champmol team hailing from the Flanders–Tournai area.[4] Furthermore, as noted by Janssens de Bisthoven (1944, 40–41) in his study of the consoles, it may not be entirely coincidental that Jean de Marville is known to have resided in Bruges for 172 days[5] during the year 1376,

Fig. 38a Claus Sluter, Standing Virgin and Child. Dijon, Chartreuse de Champmol

Fig. 38b Virgin of an Annunciation, fireplace corbel. Bruges, Beguinage

Fig. 38c Sint-Donaas Madonna, detail. Antwerp, Museum Mayer van den Bergh

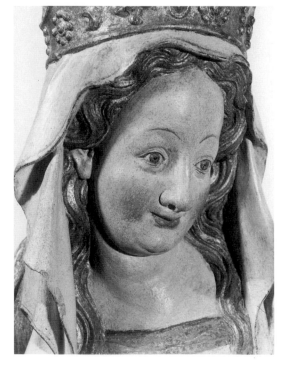

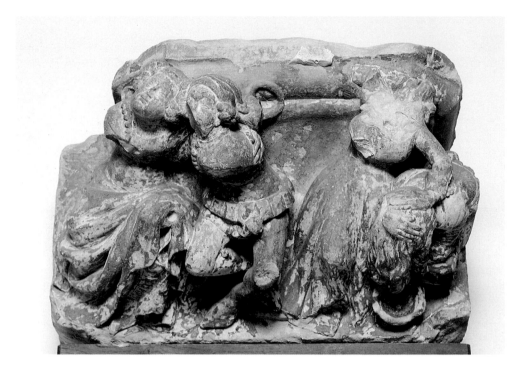

precisely at the time when the Bruges facade sculpture was in the planning phase and when work may already have begun.[6]

Whether the style of this and the other consoles was indigenous or not, these works introduce or at least represent a number of constant features typical of the Bruges School c. 1400, most obviously in a work such as the Madonna from Sint-Donaas (figs. 38b–c; see Didier and Steyaert, in Cologne 1978, 1:82). This is especially evident in head types with full, rounded cheeks (cf. female head in lovers' console; cf. also *Introduction*, figs. 11–12) and prominent features which stand out for their boldly expressive character (the somewhat earthy, healthy "joie de vivre" of the Sint-Donaas Madonna) rather than for the refined idealization commonly found in the Parisian version of this style.

Janssens de Bisthoven 1944, 7–81, esp. 49–50; Vanroose 1970–1, 57–65; Didier and Steyaert, in Cologne 1978, 1:81–82; Didier and Recht 1980, 185–186.

4 With the notable exception of Sluter; see Roggen 1934.

5 Apparently at the request of Duchess Margaret of Male, who may often have acted as go-between for Flemish artists from her native region.

6 See the verdict of the Bruges municipality regarding the conviction of the city of Sluis: Van de Walle, in Bruges 1976, 9.

39 Window Gable

Atelier of Jan van Valenciennes (?)
Bruges, c. 1380?
Oak, 102 x 92 x 15
Ghent, Sint-Lucasklooster

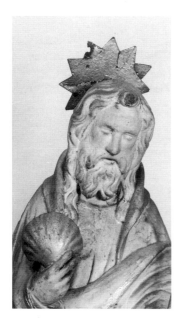

Fig. 39a St. James. Bruges, Cathedral

Said to come from a dormer window of the City Hall in Bruges, this triangular gable with an inscribed pointed arch set with trefoil tracery elements terminating in human heads, belongs to a much favored solution in Flanders during the later Middle Ages.

Its provenance can be confirmed by the near-identity to another complete window gable from the same building now in the Gruuthusemuseum, Bruges (Vermeersch 1969, no. 134), as well as to two left halves in the same collection.

It is known that the principal part of the building was completed over the years 1376–1421 (excellent résumé by Van de Walle, in Bruges 1976, 8–18) but published documents contain no reference to the execution of these windows.

Given their close similarity to the 1376–9 facade consoles from the same building (esp. the one showing Tristan and Iseult; see Detroit 1960, no. 68),[1] an origin around or immediately after may be tentatively suggested. In fact, it seems possible that these works can be associated with the earliest sculpture campaign: for instance, similarly derivative head types can be seen in the consoles decorating the vault over the staircase leading to the Aldermen's Hall, "Gotische zaal," which may have been carved in the atelier of Jan van Valenciennes in 1379–80.

These ornamental heads provide a repertory of characteristically Bruges types of the 1400 style, that can help link local architectural stone sculpture to wooden retable figures, thus supporting the Bruges origin of the latter. For instance, the bearded male head in the gable in Ghent with its rather heavy, somewhat coarse features and regular hairwaves exhibits a family kinship to statuettes of SS. James and Philip in Bruges Cathedral (c. 1370–90?; fig. 39a; Devliegher 1979, 88–89, figs. 134–135).

Heins 1904, 2:362.

1 Cf. esp. the broad, shield-shaped face of "Brangien" there.

Cat. 39, detail

40 Pietà

Bruges, c. 1430–40

Oak with remains of polychromy and gilding, h. 67

Principal losses: Christ's left hip and thigh, most of left arm; Mary's left forearm

Bruges, Sint-Janshospitaal, inv. 0.sj216v

The restrained, interiorized suffering of the Virgin, Christ's fluid pose and tranquil expression, suggesting deep sleep rather than anguish (his small wounds are barely noticeable), and the softly flowing drapery, combine to make this one of the most poetic and moving interpretations of the Pietà theme.

Unlike the example in Leusden (cat. 79), the Bruges group follows an indigenous Netherlandish, and ultimately Italian compositional format (cf. the much earlier example in Leuven, Stedelijke Musea; Ziegler 1992, no. 107). Both in its overall appearance, including Mary's Petrus Christus-like Eyckian facial type (youthful, idealized face with perfectly circular eye sockets and small pointed chin), and in its expression this group is a late masterpiece of the Soft Style as it survives into the beginning years of the Late Gothic. It can be dated, primarily on the basis of drapery forms, to the 1430s (cf. St. Catherine, cat. 44).

Steyaert, in Bruges 1976, 2:no. B13 ("Vlaanderen, c. 1430–50"); Lobelle, in Bruges 1992, no. 14 ("Vlaanderen, 1430–50"); Ziegler 1992, 260–261, no. 114.

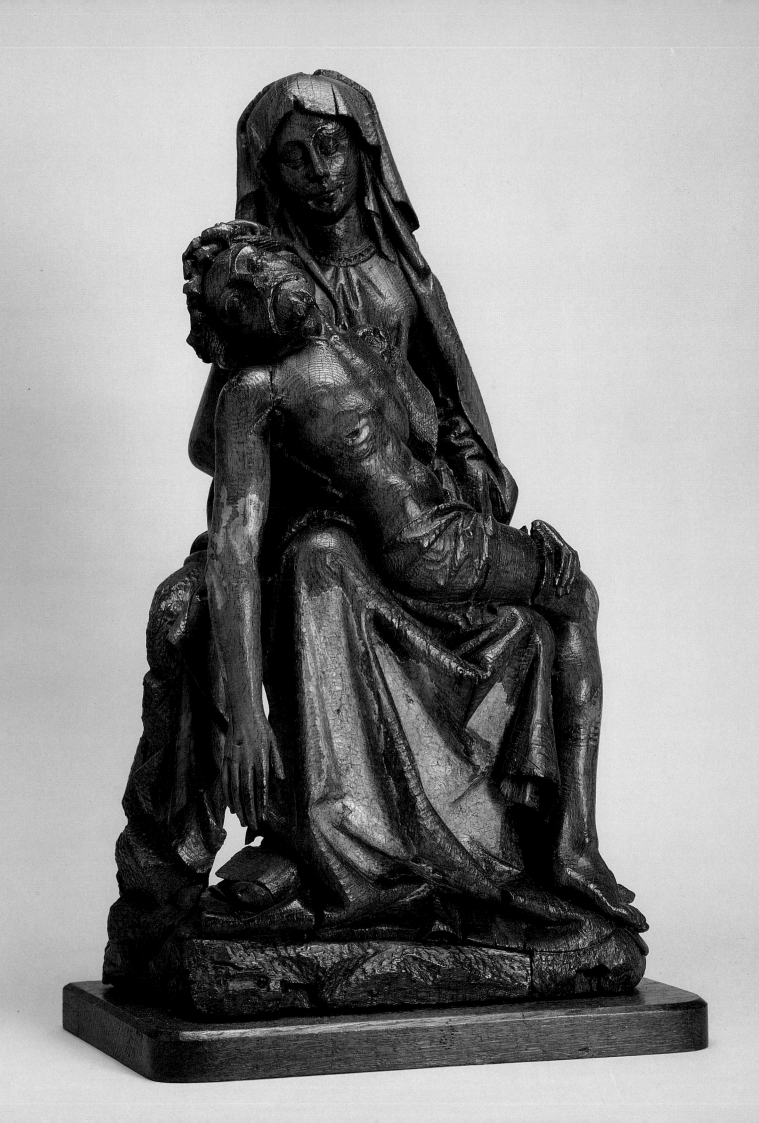

41A–B Two Angels with Passion Instruments

Tydeman Maes

Bruges, c. 1425–35

Walnut (?) with polychromy and gilding, h. 96 (A); h. 97 (B)

Carved intaglio inscriptions on backs of both statues: TYDEMAN
MAES/BRUGGIA, and a mark in the form of a hammer

Madrid, Museo del Prado, inv. E 493a, E 493b

The exceptional interest of this Angel pair is due not only to their unusual subject matter and high quality but also results from the fact that they are among the very few signed examples of Netherlandish medieval sculpture. Significantly, the Prado Angels were carved by an artist active in the same city as two painters who consistently signed their works, Jan van Eyck and Petrus Christus. Dressed in liturgical garb and supporting respectively the Cross and the column of the Flagellation, they are shown drawing aside sections of brocade cloth, presumably curtains, to reveal a now lost central representation of Christ's Passion, as indicated by the attributes and mournful expressions.[1] Several possible subjects could have served as the central part, including a Pietà group,[2] Christ in the Sepulchre, or perhaps a "Trinity Pietà"[3] (see cat. 5). The approximately rectangular silhouette and relief-like character of the Prado Angels, along with the fact that their backs are left uncarved, suggest that they were laterally placed in an architectural frame, possibly a retable, or alternatively beneath the altar mensa as part of a Holy Sepulchre.[4]

 The name of Tydeman Maes has been known to art historians for some time (see Vanroose 1970–1, 34–36, 99–102). He is cited in a series of texts that document his activity in Bruges during the years 1429 to 1452, although most mentions refer to his work as stone-cutter and merchant rather than as sculptor. Only one sculpture commission is recorded, but that suffices to reveal his importance: in 1442–3 he was called on to complete the alabaster tomb of Michelle de France, first wife of Duke Philip the Good, begun but left incomplete by Gilles le Blackere and intended for the abbey of Sint-Baafs in Ghent (de Laborde 1849, 1:385–387; de Busscher 1848–59).

 Unfortunately, no trace of this tomb remains, so that the Madrid Angels are the sole works that can be ascribed to the artist with certitude. Discovered in a church in Northern Spain during the 1960s, they were first brought to the attention of scholars through a lecture presented by Steppe in 1970.

 The provenance along with the inscription testify to the fact that the statues were exported, and their presence in Spain is not surprising given the active trade connections with the Netherlands through the Bruges port. More puzzling, however, is the use of the

1 Such curtain-drawing figures probably derive from Italian secular tombs; see Bauch 1976, figs. 238–239.

2 Cf. Spanish ensemble in Barcelona, see *Catalogo del Museo Marés* 1979, no. 1.956.

3 Cf. painted triptych in the Marienkirche, Gdansk; see Drost 1963, figs. 150–151.

4 Such arrangements for Entombment groups are found in the Netherlandish area, as e.g. in Arc (prov. Hainaut; see Didier 1970), and in Courtrai (see Debrabandere 1968, fig. 59). For column- and Cross-bearing Angels in Entombment groups, see e.g. the ensemble in Pont-à-Mousson (see Forsyth 1970, fig. 14–16).

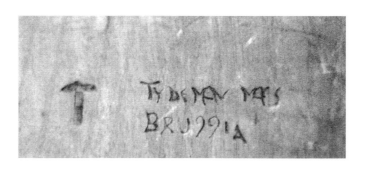

Cat. 41A, mark and inscription

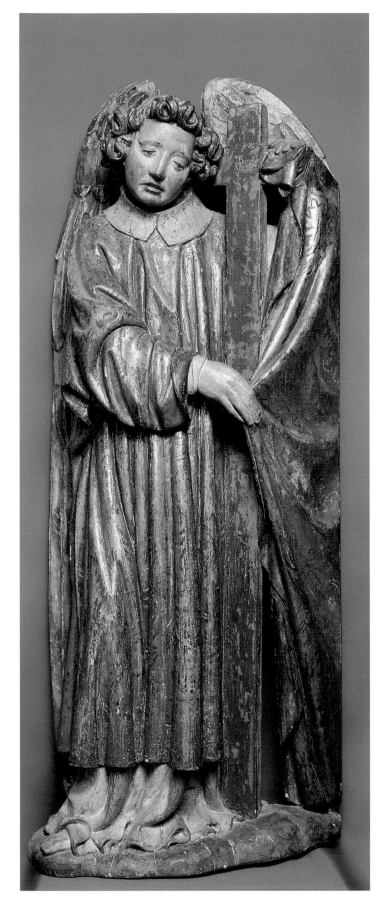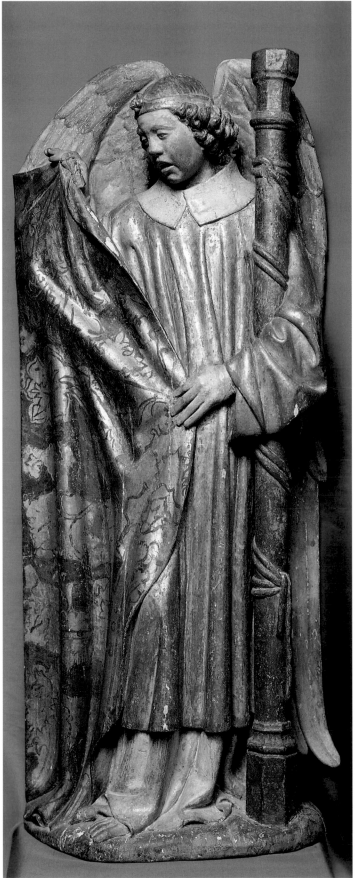

Italian form "Bruggia" of the inscription rather than the Spanish "Brujas", perhaps to be explained by the fact that the sculptures were commissioned by an Italian patron but that, due to unknown circumstances, they never reached their intended destination (as suggested by Steppe), as happened in the case of Memling's *Last Judgment* altarpiece, intended for Italy but ending up in Gdansk (Danzig) (Bialostocki 1966, 80–81).

In spite of the fact that both Angels carry Maes's name, de Salas believes that they were carved by two different sculptors active in the same shop, the Angel with the Cross being the finer and therefore presumably by the master's own hand. The fact that the Angel with the column does indeed appear somewhat more planar, schematic and stiff, more elongated (traditional) in proportions, and somewhat more summary in the handling of detail (note left hand), tends to support this observation. But the qualitative difference between the two is not great: the della Robbia-like youthful-idealized face of the column-bearing Angel, different from his counterpart in its more slender and angular definition, is certainly not inferior.

In view of our still very limited understanding of Bruges Late Gothic sculpture, the Maes Angels (for they are surely due at least to the creative conception of the same master) offer an important documented point of reference. In an overall sense, they retain the International Style tradition of softly modeled, flowing surfaces and decoratively undulating edges, although they clearly represent the very end of that style as is witnessed by the discontinuous, irregular, fluid triangular passages at the sleeves, and the general stiffening of forms. All this suggests a date at the latest sometime around 1430 and probably no later than 1435, thus making the inscriptions on the statues among the earliest texts citing the artist and documenting his whereabouts.

Fig. 41a Angel of an Annunciation, fireplace corbel. Bruges, Gruuthuse-museum

In their overall appearance, the Angels differ from the Bruges tradition around 1400 as we know it, though a general stylistic antecedent may be seen in a small Madonna in Sint-Janshospitaal (Steyaert, in Bruges 1976, 2:no. B6). The rather elongated proportions, emphasized by tubular parallel vertical folds, are somewhat reminiscent of the work of the Tournai sculptor Janin Lomme (see Janke 1977, e.g. figs. 26, 64–65), and in certain drapery details the Maes Angels are not unlike Angel figures by Claus de Werve in Dijon.[5] But these analogies are quite general and are probably due to typological and general period style features.

A link with the earlier Bruges tradition is most evident in the head types, which have been compared to those in the Ghent Altarpiece (Steppe; cf. similar grave, straining expression in Singing Angels panel). But their ancestry, especially that of the column-bearing Angel's full face with rounded cheeks, can also be traced in local tradition beginning with the historiated consoles from the City Hall (see cat. 37, fig. 37a; and cat. 38) and related examples, to become ubiquitous from c. 1400 on.

Directly similar and probably contemporary are two (unpublished?) fireplace corbels representing an Annunciation in the Gruuthusemuseum, exceptionally fine examples of a plentiful Bruges production of works of this kind (c. 1430; see fig. 41a). The head of the Annunciation Angel with his "speaking" mouth (slightly parted lips, corners drawn downward) and "flying" corkscrew locks are quite similar to our works, as are the draperies that flow against the base in softly curving S-forms, suggesting that they may have come from the Maes atelier.

Among works of later date that seem to reflect the sculptor's style is a group of St. Michael slaying the Dragon in the church of Sint-Jacob (cat. 42), quite close though less fine in head type (unfortunately difficult to evaluate owing to the thick layer of modern

5 Notably the Kneeling Angels from the tomb of Philip the Bold, which probably served as model for the tomb of Michelle de France, judging by the wording of the contract.

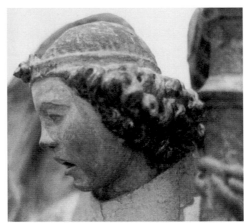

Cat. 41A–B, details

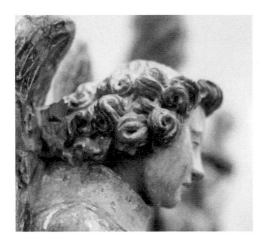
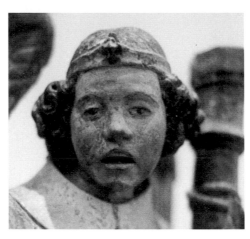

polychromy) and later in date (c. 1440–50?) as indicated by more heavy-set (Eyckian) proportions and hooked drapery forms. Two other works in the same church, representing SS. John the Baptist and Francis, can be attributed to the same sculptor, probably a follower of Tydeman Maes.

Steppe (Lecture "XLIste Congres van de Federatie van de Kringen voor Oudheidkunde en Geschiedenis van België," Mechelen, 3–6 Sept. 1970, 42 (résumé); Vanroose 1970–1, 36; de Salas 1978, 88–89 ("mediados siglo XV").

42 Saint Michael Slaying the Dragon

Bruges, c. 1440–50 (?)

Wood, modern polychromy, h. 80

Bruges, Sint-Jacobskerk

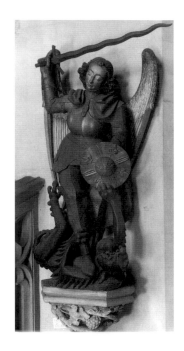

Fig. 42a St. Michael. Bruges,
Gruuthusemuseum

This image of St. Michael slaying the Dragon appears to have been influenced by Tydeman Maes (see cat. 41). Although the work has not previously been subjected to detailed study, the recent identification of the two signed pieces in Madrid helps us identify a characteristic Tydeman physiognomy beneath the disfiguring, modern polychromy. Two other statues in the same Bruges church, one of John the Baptist and the other of St. Francis, are probably by the same hand.

Comparison of the St. Michael with the Madrid Cross-bearing Angel (cat. 41A) reveals a striking facial resemblance, although the overpainting makes it difficult to judge the subtlety of the Saint's modeling. The sculpture from Sint-Jacobskerk in Bruges is squatter by comparison, and the treatment of the drapery more broken.

A very similar group is to be found in the Gruuthusemuseum in Bruges, although its proportions are more elegant and its face more subtle (fig. 42a). This piece is dated 1553 on the back, but this cannot be the year of its creation as the work is clearly fifteenth-century in character.

Cat. 42, detail

Cat. 41A, detail

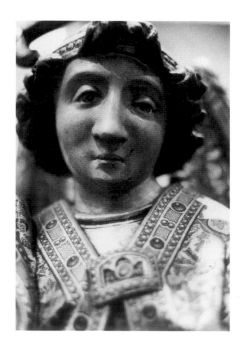

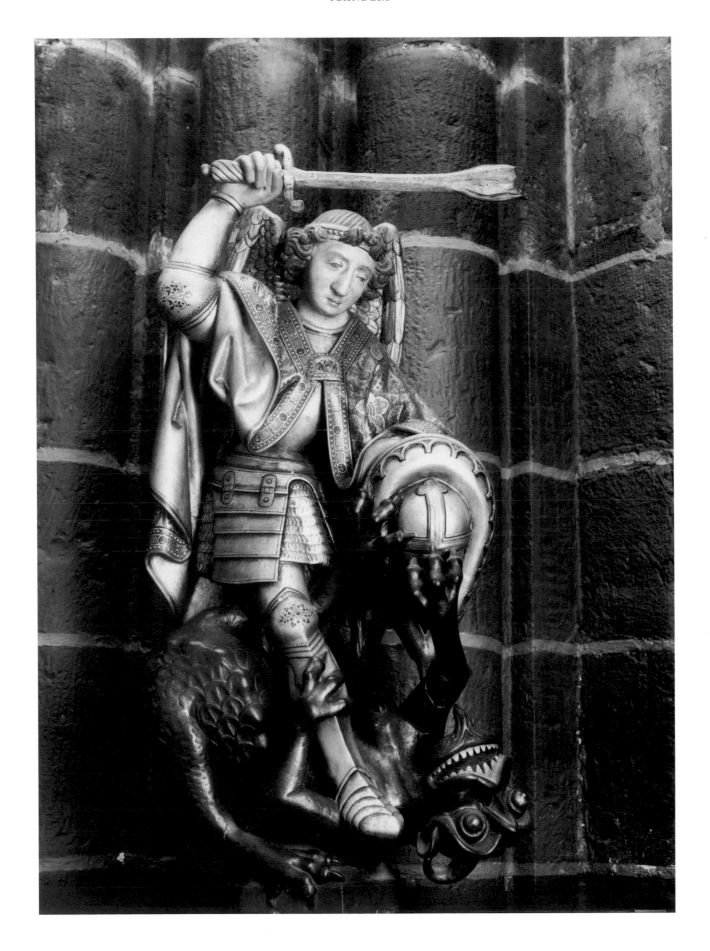

43 Saint Anthony Abbot

Bruges, c. 1430–40

Wood with polychromy, h. 105

Principal losses: right hand and forefinger of the left hand

Bruges, Gruuthusemuseum, inv. 076.v

This statue of St. Anthony Abbot, accompanied by his picturesque attributes of the pig and fire ("St. Anthony's fire") forms a perfect and roughly contemporary counterpart in both its high quality and period style to the statue of the same Saint in the Centre Publique d'Aide Sociale in Liège (see cat. 73). As the latter is characteristically Mosan, the Gruuthuse statue represents a Bruges idiom.

Its local origin and relatively early date are indicated by its similarity to a series of works in Bruges dating from the second quarter of the fifteenth century, especially a St. Catherine in the Cathedral (see cat. 44; especially clear in a comparison of profile views). The typically Bruges arrangement of folds below the Saint's left arm, which still echoes a schema of the Soft Style tradition, is interpreted here in terms of a more modern, angular, Eyckian design, somewhat reminiscent of the grisaille SS. Johns on the outside of the Ghent Altarpiece (*Introduction*, fig. 2).

A relatively early date is also suggested by the rather soft, pictorial treatment of the Saint's facial features which, in certain details (mouth with slightly everted, parted lips), is not unlike that of the Cross-bearing Angel by Tydeman Maes (cat. 41B).

Vermeersch 1969, no. 137 ("Nederlands werk, 15de eeuw").

Fig. 43a Choir stalls, detail: Misericord with the Sacrifice of Abraham. Bruges, Sint-Salvatorskathedraal

Cat. 43, detail and profile view

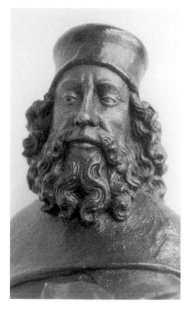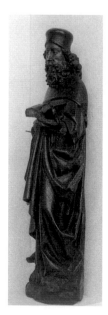

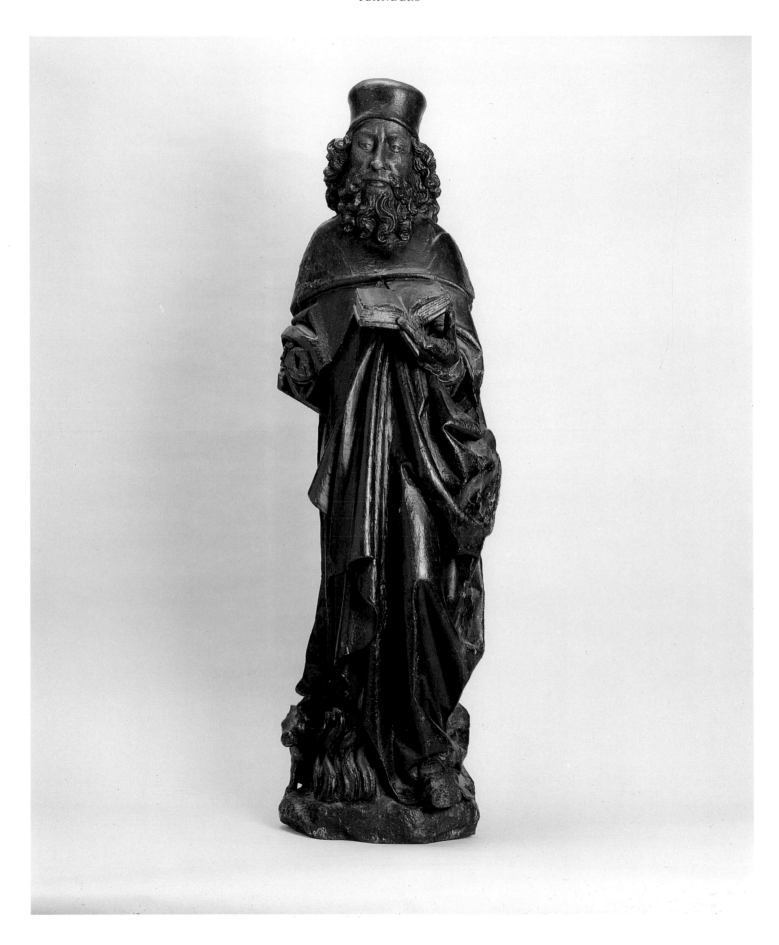

44 Saint Catherine of Alexandria

Bruges, c. 1430–40

Wood (oak?), h. 110.5

Hands, crown, wheel, palm, and sword are renewed; base is damaged

Bruges, Sint-Salvatorskathedraal

In contrast to most other Netherlandish centers, the city of Bruges preserves a large number of later medieval sculptures, whereas relatively few examples survive in its immediate artistic hinterland of Western Flanders. A comprehensive study of the production of this important port city will no doubt require a thorough consideration of Bruges work exported to other parts of Europe. As a first step, it is important to attempt to isolate characteristic types and elements in locally preserved examples.

This female Saint who was given the attributes of St. Catherine during restoration is especially useful in this regard as a relatively early and typically Late Gothic Bruges work. The formulation of drapery consisting of concentric hairpin folds that reach to the base is based on types encountered in the local tradition of the years c. 1400, as seen in a vault boss of the Annunciation in the "Schepenzaal" (aldermen's room) of the City Hall, carved in 1401 by Cornelis van Aeltre and Gillis van den Houtmeersch (fig. 44a; see Louis 1939), clearly in turn indebted to Parisian (rather than German–Bohemian) works of the "Beautiful Style" (cf. especially the Annunciation Virgin in Ecouis; for Parisian examples of this tendency, see Didier and Recht 1980). While not unknown in other parts of the Netherlands (cf. cat. 80), the Bruges version of this formal type is notable for its unusual longevity.

Cat. 44, before restoration and profile view

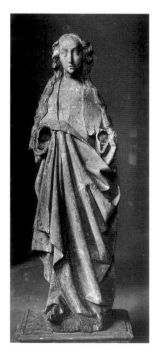

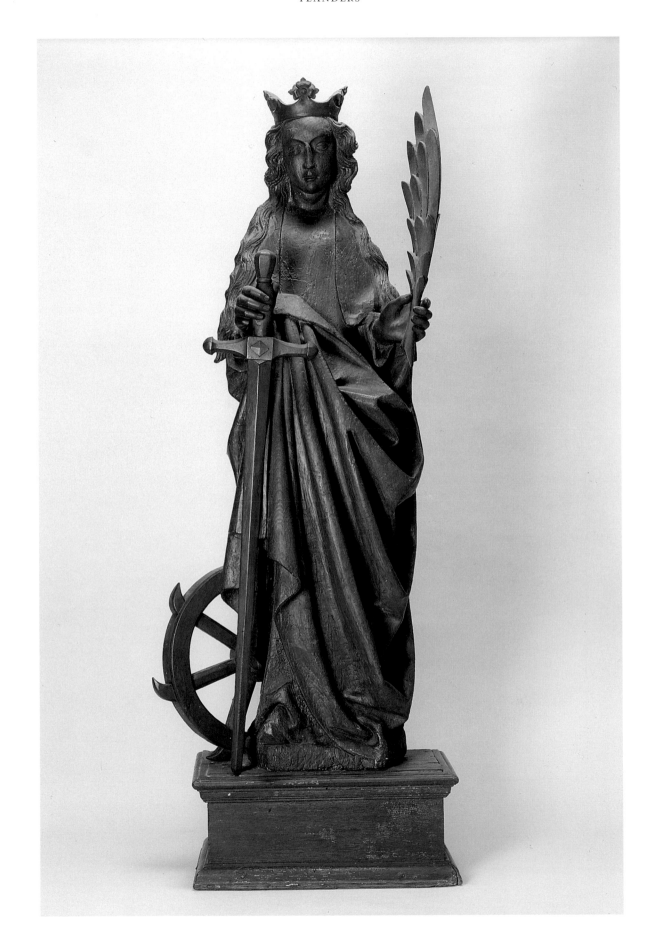

Fig. 44a Vault boss with Annunciation. Bruges, City Hall

1 Cf. e.g. Parisian Madonna in Vassar College, Poughkeepsie, and related examples; see Didier and Recht 1980. This interesting motif is probably of classical and specifically Roman origin (see sarcophagus from Acilia, Museo Nazionale Romano).

In the local tradition our Female Saint appears to be among the earliest Late Gothic interpretations of this type, distinguished primarily by slightly more irregular, angular surface lines, justifying a date not long after c. 1430 and probably antedating the choir stalls of Bruges Cathedral (c. 1440; see cat. 43, fig. 43a; Steppe, Smeyers, and Lauwerys 1973, 57–92).

A later stage of development is represented by an especially fine "Late Gothic Beautiful Madonna" in the Gruuthusemuseum (c. 1440–60?; fig. 44c), with its expressive face and characteristically Bruges "splinter" folds. Remarkably, this work retains the Parisian motif of the Virgin's right hand drawing up the mantle edge.[1]

To these works may be added examples outside the city, including a silver Madonna statuette in the Cathedral of Chieri (Italy), datable in or shortly before 1492, bearing a Bruges hallmark (see Bonenfant-Feytmans 1954, 95–103, ill. p. 97) – an origin confirmed by the typically full Bruges facial types. Among other related examples outside the city, a Madonna in the church of Notre-Dame-Finistère in Brussels (c. 1430–40; fig. 44b) is certainly among the most remarkable in its peregrinations. Although it was apparently brought to Brabant's capital from Aberdeen (Scotland) in 1625 (des Marez 1958, 311), the ultimate origin of this Madonna appears to be Bruges, as suggested by its overall type (essentially mirror-reverse of the Gruuthuse Madonna) and style (cf. profile view of cat. 44) as well as a number of details (Mary's fleshy face, drapery motifs).

It should be observed that the export of Bruges sculpture to Scotland would by no means be unusual: the choir stalls for the important abbey of Melrose were commissioned from Cornelis van Aeltre in 1441 (see Delepierre 1841; Vanroose 1970–1, 55).

Devliegher 1979, 89 ("einde 15de eeuw"); Vandenberghe, in Bruges 1992, no. 35 ("Brugge?, einde 15de eeuw").

Fig. 44b Standing Virgin and Child. Brussels, Notre-Dame-Finistère

Fig. 44c Standing Virgin and Child. Bruges, Gruuthusemuseum

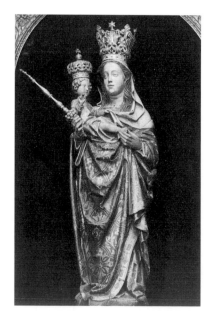

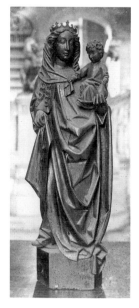

45 Brass of Kateline Daut

Bruges, c. 1461

Brass, 151.5 x 90; in ten sections

Inscribed around the edge: *Hier leghet begraven joncvrouwe Kateline f[ilia] Colaert Daut die hij*
hadde bij joncfr[ouwe] Kateline Sgroote[n] zinen wive wijlen was die versciet van deser werelt int jaer
m cccc ende lx op den vi sten dach in Sporkele. Bid Gode over de ziele

Bruges, Sint-Jacobskerk

This brass is unusual because of its striking and original iconography which treats the departure of the deceased woman very sensitively. Kateline Daut, who died at an early age in 1460, is shown in the middle, richly dressed and wearing a crown on her head. She is accompanied by two figures, identified by the texts on their clothes as "her brother" and "her guardian angel". The trio stand on a tile floor before a cloth of honor held up by angels. Their posthumous conversation is recorded in the verses above their heads, which are labelled A (brother), B (Kateline), and C (Angel) to show the order of the exchange:

> A *Ghy waert ter weerelt gheordineirt*
> *een bruud te wezen gheexalteirt*
> *zustre nu hevet de dood belet*
>
> B *Broeder in rusten hii avizeirt*
> *gods wete die al dat leift passeirt*
> *die wist vorwaer te voughene het*
>
> C *Vrienden ten baet gheargrieirt*
> *bij die in gloryen jubileirt*
> *verkiest haer als bruud ter hoochster wet.*[1]

1 A: "You were called into the world / to be a joyful bride / sister, now death has put an end to that"; B: "[My] brother who passed on before has this advice: / God's knowledge which transcends all that lives / has decreed that it be so"; C: "Friends, you who have the great fortune to be taken unto Him in Heaven / have her chosen as bride before the highest law."

Like the other brasses in this exhibition, that of Kateline Daut clearly belongs to the Bruges tradition. The expressive but unrefined facial features of the angels draw strongly on the city's formal vocabulary, lending continuity to the different types in spite of Late Gothic stylistic developments (fig. 45a).

Ghent 1961, 78–79, pl. XXX; Vermeersch 1976, 2:227–230, pls. 104–105 (with bibliography).

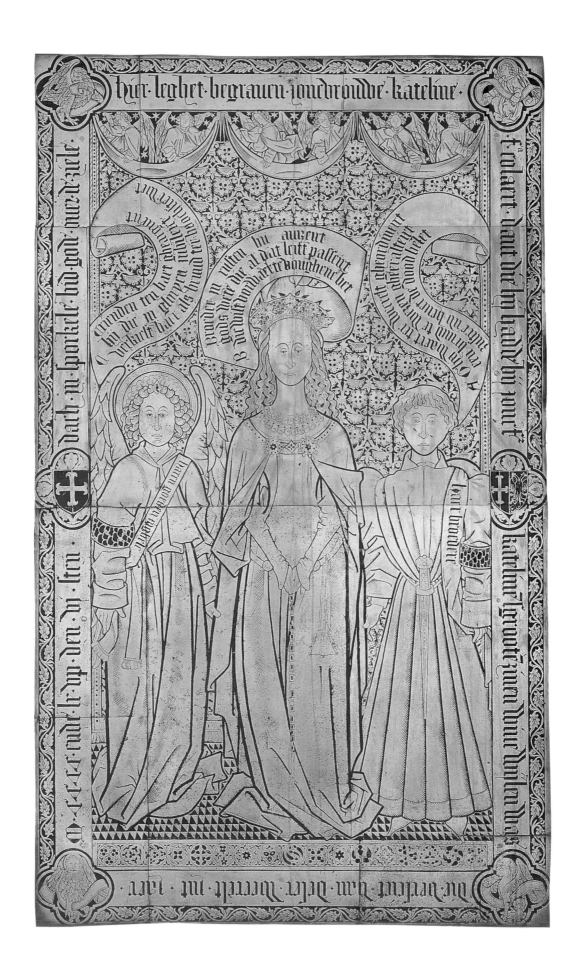

Cat. 45, details

Fig. 45a Angel holding a coat of arms,
detail of a beam from a house in
Bruges. Private collection

46 Angel Holding a Shield with a Coat of Arms

Bruges (?), mid-fifteenth century

Brass, 69 x 54

Brussels, Musées Royaux d'Art et d'Histoire, inv. 9163

Fig. 46a Beam end with an Angel holding a coat of arms. Bruges, Oud-Sint-Janshospitaal

This incised relief shows a seated Angel in liturgical dress supporting a coat of arms. As in contemporary engraving – and in contrast to fourteenth-century brasses – forms are modeled by means of parallel hatching and cross-hatching to create a range of tonality with rich textural contrast yielding a credible illusion of three-dimensional form. Such details of design as the grave aristocratic calm of the facial features that vitalize the image through asymmetrical contrasts, as well as the elegantly defined hands, testify to an execution by an especially skillful artist.

On the basis of a rubbing preserved in the Gruuthusemuseum, Bruges, this relief has been identified as having formed the central element of the tomb plaque of Jan Clays (d. 1445) and Catharina de Hond (d. 1463), formerly in the church of Onze-Lieve-Vrouw, Nieuwpoort, which also included a brass border (Vermeersch).

A Bruges origin appears likely in view of the original location as well as the fact that such works represent a long-standing tradition and production of funerary monuments in the city. This localization is also consistent with both figure type and style. Similar seated or kneeling Angels with musical instruments or, as here, holding shields with coats of arms, commonly appear in three-dimensional high-relief ceiling beam carvings in Bruges architecture (see Devliegher 1968, 2–3, *passim*). Among the closest in style and approximate date are examples in the "Memlingkamer" (attic) of Sint-Janshospitaal, datable 1459–78 (fig. 46a; see Steyaert, in Bruges 1976, 1:298, and 2:no. B18).

Vermeersch 1975, 173–176.

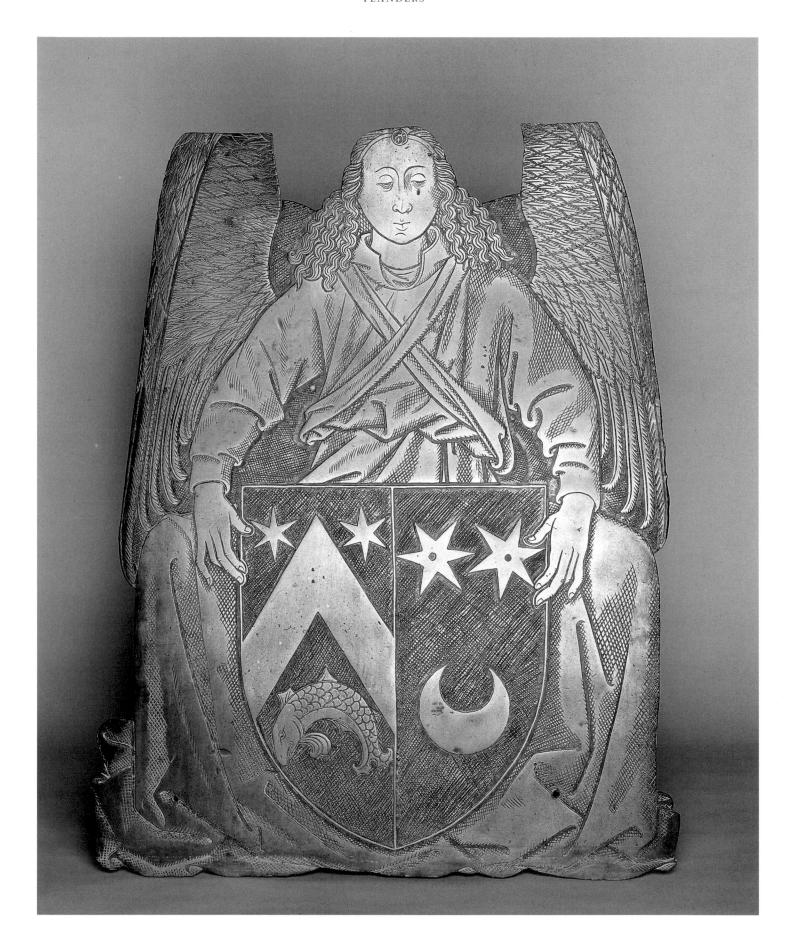

47 Seated Virgin and Child

Bruges, c. 1500–20

Oak, h. 45

Principal loss: right hand of Child

Bruges, Gruuthusemuseum, inv. 04VS

The peacefully meditative group of the seated Virgin and the Christ Child paging through a book represents a theme already familiar in Bruges tradition through the work of Jan van Eyck in the 1430s (Ince Hall Madonna). However, the Gruuthuse Madonna appears to be more directly inspired by the formulation of this subject in the Brussels School c. 1500.[1] That it was carved by a Bruges sculptor is evident in the head types, particularly that of Mary with its fine, somewhat fleshy face, and a coiffure consisting of relief striations at the top, defined at the forehead by an accolade that extends into thick serpentine waves to either side of the face (cf. the head of the Virgin in a Nativity also in the Gruuthuse-museum, Vermeersch 1969, ill. p. 38, or a similar physical type in a St. Ursula, fig. 47a, Sint-Janshospitaal; Steyaert, in Bruges 1976, 1 : ill. p. 208).

Also typical of Bruges is the drapery treatment, with its rather stiff Eyckian wedge and splinter folds found in the local tradition from the 1430s (see cat. 44) through the very end of the Gothic style in the sixteenth century (for a late example, see the St. John in Sint-Janshospitaal, Bruges 1976, 2 : B27).

Vandenberghe, in Bruges 1992, no. 36 ("Brugge?, einde 15de eeuw").

1 See examples discussed by Rademacher-Chorus 1972; also in the detail of the "nude" Child with slit shirt, cf. the Laredo Madonna; see *Brussels*, fig. 29.

Fig. 47a St. Ursula. Bruges, Oud-Sint-Janshospitaal

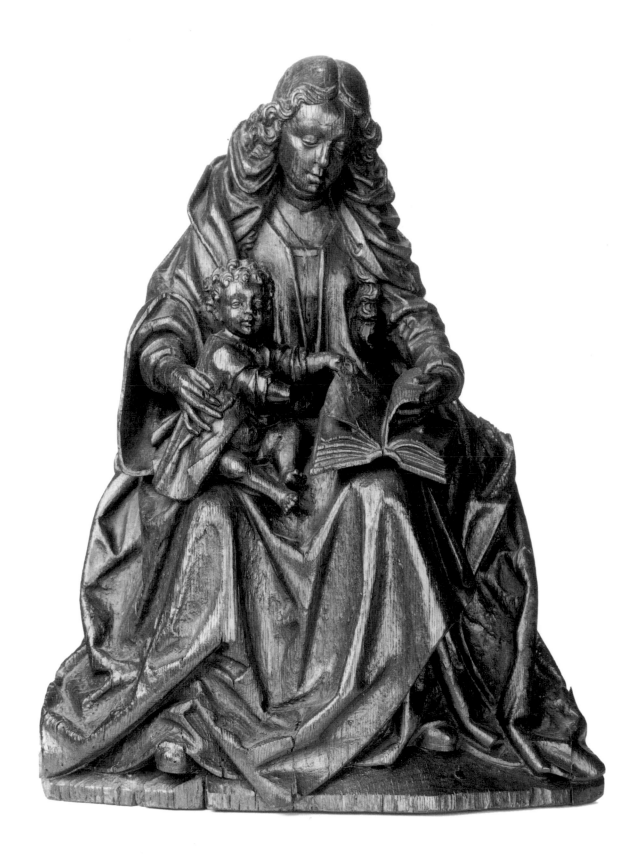

48 Brass of Gillis de Zuttere and Lisbette van de Dylis

Ghent, early fifteenth century

Brass, 40.7 x 31

Lower left corner lost; inscription defaced and damaged; reverse of the brass

reused in the sixteenth century

Ghent, Bijlokemuseum, inv. 335

This modest brass shows Gillis de Zuttere (d. 1410) and his wife Lisbette van de Dylis (d. 1391) at prayer. They appear in matching Gothic niches with inset trefoils and an architectural framework, and they each have a dog at their feet as a symbol of marital fidelity. As often happened, the brass was reused in the sixteenth century, the rear serving as a commemorative plaque for Segher van Diepenbeeke.

On stylistic grounds two similar brasses have been related to this one: the plaque of two unidentified men (c. 1368), also from the Wenemaere hospice in Ghent and now in the Bijlokemuseum, and that of Griele van Ruwescuere (d. 1410) in the Prinselijk Begijnhof (Beguinage), Bruges. It has even been suggested that the three of them were produced by the same Ghent workshop (Van Molle 1961, 125).

Indeed, this small group was not produced in Bruges. Their style is inferior and formulaic, and they have an air of routine craftsmanship. Despite these weaknesses, the pieces serve as evidence of the connection that existed between Ghent and Bruges. The style depends on Bruges examples, but these are simplified versions which lack the rich narrative development in the framing of the figures. Few examples of Ghent's once prolific output survive, making it difficult to discern how representative these brasses might be.

Van Duyse 1886, no. 1904; Anderson 1913, 332; Collon-Gevaert 1951, 297; Eichler 1933, 33–35; Deurne–Brussels 1957, no. 337; Ghent 1961, 73–74, no. 80; Ghent 1975, 3 : nos. 588, 594.

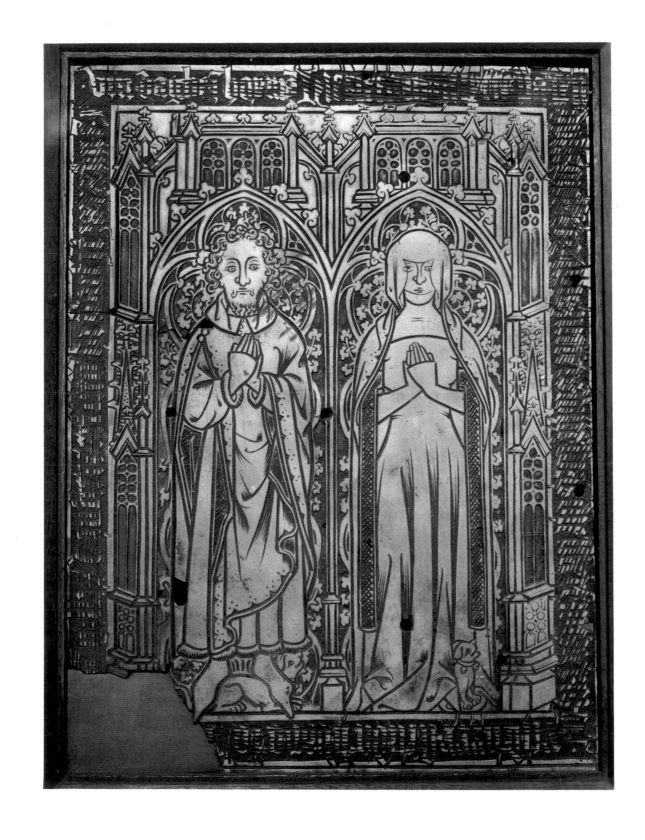

49 Pietà ("De Zoete Nood Gods")

Ghent, c. 1430–40

Wood with polychromy and gilding, 76.5 x 50 x 21

Lede, Sint-Martinuskerk

Examples of this theme in the Netherlands have only recently been considered in detail (Ziegler 1992).[1] The Lede example, among the earliest in Flanders, is representative of a "Calvary Pietà" type which shows Mary seated on a rocky outcropping – as opposed to enthroned types first introduced in the German area (see cat. 71) – and includes as a further "personification" of place (Golgotha) the skull of Adam (here beneath Christ's feet; a typological association between Adam, the sinner, and Christ, the "new Adam," the Redeemer of mankind).

The group forms the devotional focus of an important local cult that can be traced back at least to the year 1415. However, the style indicates that the work was carved about two decades later, at the very start of the Late Gothic, which appears here only in certain motifs such as the angular mantle folds of Mary's upper arms, although the overall composition remains representative of the International Gothic. A characteristic aspect of the treatment of this subject during these years is the way in which Christ's body is turned forward, out to the viewer, best known through Eyckian painted examples (*Lamentation* in Turin–Milan Hours; Friedländer 1967, 1:pl. 41).

1 The excellent study by Ziegler includes an inventory and consideration of the psychological and devotional functions of such groups.

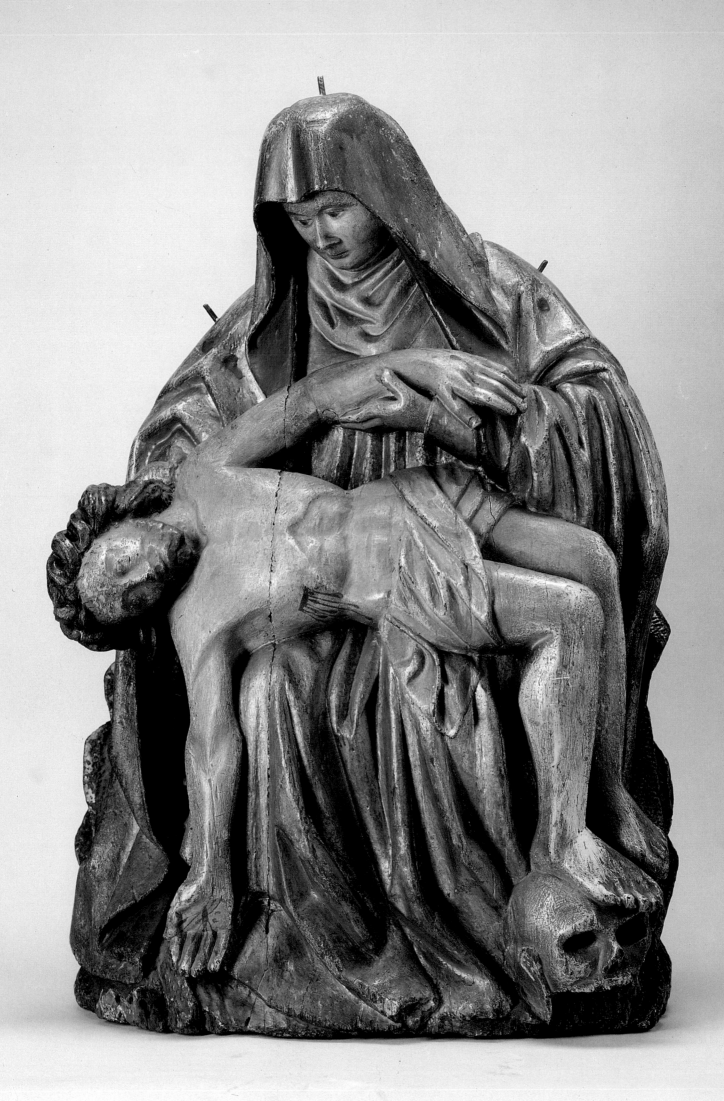

50 Relief: Madonna with Censing Angels

Oudenaarde (?), c. 1430–40

Limestone with traces of polychromy, 35 x 42.5

Ghent, Museum voor Schone Kunsten, inv. 1913–T

The typological and stylistic similarity of this relief, formerly in a private collection in Oudenaarde, to the Tournai School has rightly been noted (Didier), and is further clarified by a comparison of the central Madonna to the same theme in the damaged bluestone epitaph of Pierre Duquesnoy (d. 1457) and his family in Saint-Martin, Roubaix. An additional indication in this regard is the Virgin's head with its full, oval face, framed by thick hairwaves that swing out to the side (cf. cat. 4 and *Tournai*, figs. 20–23). But in spite of his dependence on Tournaisian models, the sculptor was probably active in Flanders. His rather heavy-set figures, swathed in ample garments, and the kneeling Angels particularly, are not unlike those in the Adoration of the Lamb panel in the Ghent Altarpiece (fig. 50a). This apparent mix of influences might be seen as consistent with an origin in the city of Oudenaarde, located roughly midway between Ghent and Tournai. Some support for this assumption is provided by reliefs still preserved there, most notably the epitaph of the priest Robrecht Boen in the church of Sint-Walburga, similar in a number of motifs to our work but later in date. Together with the yet later funerary monument of Zegher van Marke and his family in the same church, these three works might then provide points of reference for a study of the regional Late Gothic development in Oudenaarde.

Casier and Bergmans 1914, 1:63–64; Didier, in Ghent 1975, 1:no. 54 ("Doornik, c. 1430–40"); Hoozee 1988, 24 ("Zuidelijke Nederlanden, 15de eeuw").

Fig. 50a Hubert and Jan van Eyck, Ghent Altarpiece, detail of central panel: Adoration of the Lamb. Ghent, Sint-Baafskathedraal

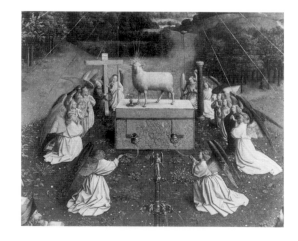

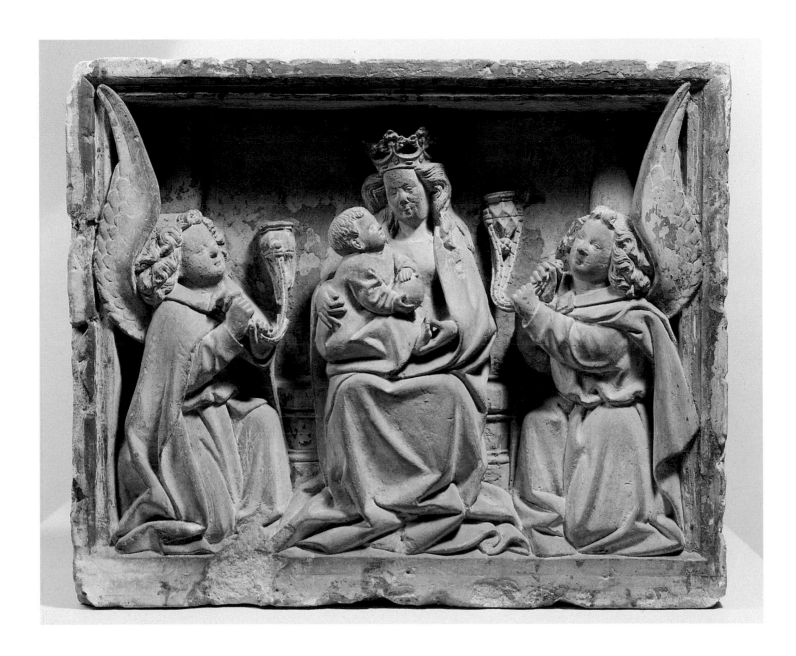

51 Bracket for a Ceiling Beam: Saint Peter

Ghent, soon after 1451

Oak, 130 x 39 x 12

Damaged in several places

Ghent, Bijlokemuseum, inv. 855

Fig. 51a Beam bracket with
St. Augustine. Ghent, Muziek-
conservatorium

This relief showing a standing St. Peter in an architectural framework dominated by a projecting baldachin, is important as a rare remnant of the initial phase of the Ghent Late Gothic of known local provenance and of more or less assured date. It is the only fully intact bracket from the tanners' guildhouse (Het Toreken) on the Vrijdagmarkt, the construction of which was apparently undertaken c. 1451.

Less well known are three other such wooden figures of the same series still preserved *in situ* in the main hall of the building (first floor), all restored to some extent, two representing bishops, a third a St. Michael battling the Dragon (see cat. 3, fig. 3c), along with small stone corbels with prophets (the latter mainly modern copies presumably based on the lost originals).

Were it not for the documented date, one might easily place these works as early as the 1430s; under the circumstances, they must be understood as representing a remarkably archaizing character. In spite of the clearcut Late Gothic appearance of his garments, the expressive but rude face of St. Peter is still basically reminiscent of a much earlier tradition as represented by Broeder-lam's St. Joseph, although possibly overlaid with an influence of later types, such as those in the Soignies Entombment (see *Tournai*, fig. 25).

For an integration of these works into a wider artistic context, the damaged figure of St. Michael is perhaps the most important, since it is clearly dependent on a model by the Tournai sculptor Jean Delemer (cf. cat. 3). This link is of some interest, since it serves to suggest that the long-established artistic connection between these two Scheldt cities retains a validity until at least the mid-fifteenth century. It is also in harmony with the limited evidence available from the immediately preceding tradition: several dated tombs in Tournai bluestone that can be attributed to members of the de Meyere family (see Roggen 1938), such as that of Margareta van Gistel (c. 1431; Ghent, Sint-Baafskathedraal) in which the new graphic and angular style makes a remarkably precocious appearance (cf. a slightly later and finer relief in Kloosterzande), exhibit the unmistakable impact of Tournaisian funerary monuments (cf. epitaph of Livinus Blecker, *Tournai*, fig. 24).

For a further study of the Ghent Late Gothic, the Toreken series are of great significance, since they are unmistakably related in type as well as style to the better-known and much finer brackets in the "Achtersikkel" (now Muziekconservatorium), the single most important group of fifteenth-century local sculptures (c. 1450–60?; fig. 51a; see Didier, in Ghent 1975, 1:no. 545).

Detroit 1960, no. 71 ("Flanders, Ghent?, middle of the 15th century"); Didier, in Ghent 1975, 1:no. 544 ("Gent, 1451-2").

52A–B Two Beam Ends:
Samson and the Lion and King David

Ghent (?), 1450–75

Oak, 65 x 24 x 8.7 (Samson); 69.5 x 25.8 x 9.5 (King David)

Ghent, Bijlokemuseum, inv. 907–908

The collection of Ghent's Bijlokemuseum includes a number of interesting items that shed light on the city's history. Many relics from demolished Ghent buildings have found their way into the museum, including these two beam ends which belonged to the 1902 bequest of a Ghent citizen.

The reliefs show two figures from the Old Testament: Samson and the Lion, and King David playing his harp. They appear to be later than the St. Peter from the tanners' house (cat. 51), and are rather stiff with coarsely carved faces and cursory anatomy. The maker has, however, attempted to create some movement in the drapery, especially in Samson and the Lion.

53 Relief: Last Supper

Ghent, fifteenth century

Stone with polychromy, 32 x 37

Ghent, Bijlokemuseum, inv. 2113

The composition of this relief, in which the twelve Disciples are grouped around Christ to eat the Passover lamb, is typical for the Last Supper theme. It shows the dramatic moment when Jesus identifies Judas as his betrayer by handing him a piece of bread. The presentation is conventional. Jesus presides in the middle, with John resting his head against his chest (although he seems to be reclining more on the table in this case). Peter sits at his right hand, with James on the other side, wearing the pilgrim's shell on his hat.

Judas is shown in the foreground of this animated gathering in the customary manner. He rises from his chair holding the purse with the thirty pieces of silver – the reward for his betrayal – in his right hand. The figures are arranged in a closed circle, so that two Apostles are seen from behind in addition to Judas, a rather unusual feature for this type of presentation. The work also stands out for the particular attention paid by the anonymous sculptor to details like the different types of seat.

The relief might originally have formed part of a wall tabernacle. It shows stylistic similarities with Brabantine sculpture.

Brussels 1968, 85, no. 93.

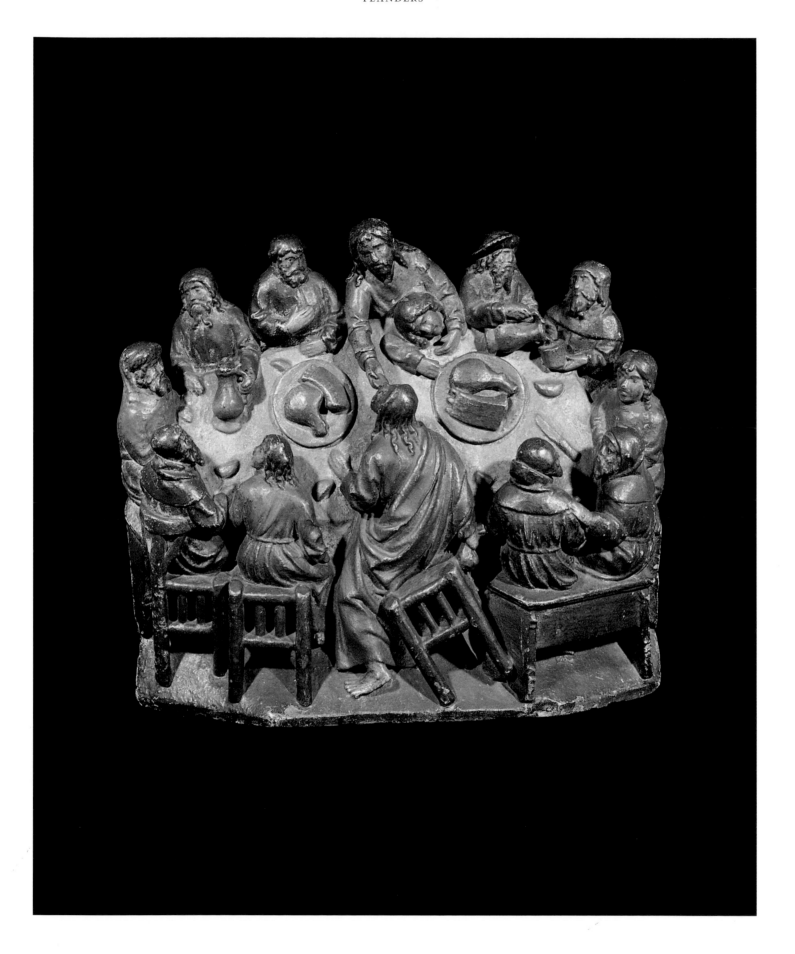

Northern France

BELGIUM

FRANCE

- CALAIS
- ROESELARE
- ARNÈKE
- YPRES
- KORTRIJK
- BOULOGNE
- SAINT-OMER
- ROUBAIX
- LILLE
- TOURNAI
- AIRE-SUR-LA-LYS
- HAM-EN-ARTOIS
- BOMY
- FLÉCHIN
- BÉTHUNE
- TENEUR
- DUISANS
- ARRAS
- CAMBRAI

54 Angel of the Annunciation

Arras or Tournai (?), c. 1430–40

Oak, h. 53

Heavily damaged and worm-eaten

Arras, Trésor de la Cathédrale d'Arras

In spite of its poor condition, this statuette of an Angel with a scroll, almost certainly part of an Annunciation group – although the presence of a base element suggests that it was probably not part of a retable ensemble – remains a work of great interest. It testifies, along with numerous other treatments of this theme (cat. 64), to the artistic influences of the Tournai School, and more specifically of Jean Delemer's well-known group (*Tournai*, figs. 1 and 2).

Although the progeny of Delemer's Angel is extensive, this figure is exceptionally close in style and therefore presumably in time to this important prototype. The Angel's dynamic and organically rendered "running" pose, his garment with its interlocking hairpin and broken folds and his broad, full-cheeked face framed by intricate, tightly wound cork-screw locks,[1] appear directly to reflect the sculptor's style and closely parallel other Tournaisian works such as the slightly later Angel in the Louvre (*Tournai*, fig. 17).

In view of this close dependence, the possibility of a Tournaisian origin cannot be excluded *a priori*. At the same time, the Tournaisian style was quite familiar in the Arras milieu; this is attested to by both documentary and monumental evidence, as for instance the well-known bluestone epitaph of the Walois family – almost certainly an import – where we find Angel figures that closely anticipate the style of Delemer (fig. 54a; for this work, see Oursel 1980; the style of the Walois epitaph suggests an origin in the second decade of the fifteenth century).

1 Cf. also Delemer's console Angels and the St. Michael in the Ponche epitaph (*Tournai*, figs. 13 and 20).

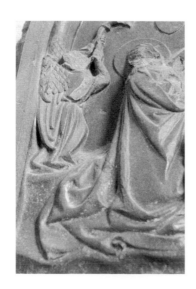

Fig. 54a Epitaph of the Walois family, detail. Arras, Musée des Beaux-Arts

55A–B Apostles Peter and Paul

Arras (?), c. 1440–60 (?)

Alabaster, h. 109 (Peter); h. 110 (Paul)

Principal losses: upper right part of St. Peter's head, part of his book, grip of key;

most of hilt and blade of St. Paul's sword; general surface abrasion

Arras, Trésor de la Cathédrale d'Arras

Fig. 55a Head of St. Peter as Pope.
Arras, Musée Diocésain

In these dark ("dunkle Zeit") descendants of the alabaster Apostles from Arneke (*Tournai*, fig. 6) the new realism takes an expressionistic turn. While relatively conventional in an overall sense (the drapery composition of St. Peter recalls a Tournaisian formula), the realistic interpretation of the carefully detailed, sensitively modeled hands, the materialization of cloth surfaces that yield to the pull of buttons, and above all the heads attest to the hand of a very talented sculptor. This is particularly true of the face of St. Paul, a haggard ascetic with moulded, prominent features marked by a distinctly saturnine air.

Our very limited knowledge of sculpture in this area makes it difficult to integrate or date these large alabaster statues from the church of Dainville, surely among the masterpieces of Late Gothic sculpture known in Arras, and so very different from the tempered character of the series attributed here to Saint-Omer (cat. 56 and 58). One would like to consider them as an Arras version of a Picard expressive "dialect" of Northern France that extends into the Tournai–Hainaut region of present-day Belgium, and was no doubt reinforced between these two cities by a shared tradition of tapestry production.[1] It is in Arras after all that we find the extraordinary, anguished pathetic head of Christ, probably the masterpiece of Northern French sculpture around 1300 (Wintrebert and Heckmann, in Arras 1986, no. 27).

Far more study is needed to clarify this question. Several related works from the city's environs do tend at least to support a regional origin for the Apostle pair, the most important of which is a stone head of St. Peter as Pope from the church of Sauchy-Cauchy (fig. 55a) which due to damage survives to us only as a wonderfully evocative mask (for this work, see *Ibid.*, no. 34). However, similar facial types are found elsewhere in Northern France, as in the head types in a wooden group of the Enthroned Virgin with Male Saints in the Boulogne area (*Ibid.*, no. 44).

1 For a discussion of the Picard manner in painting, see the important article by Sterling 1979.

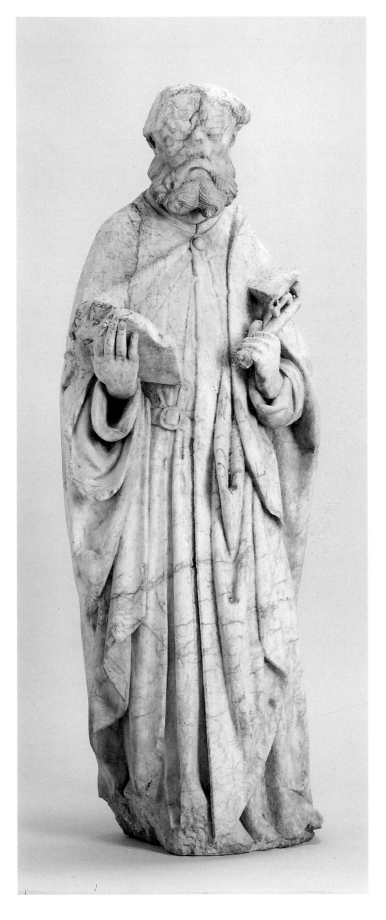

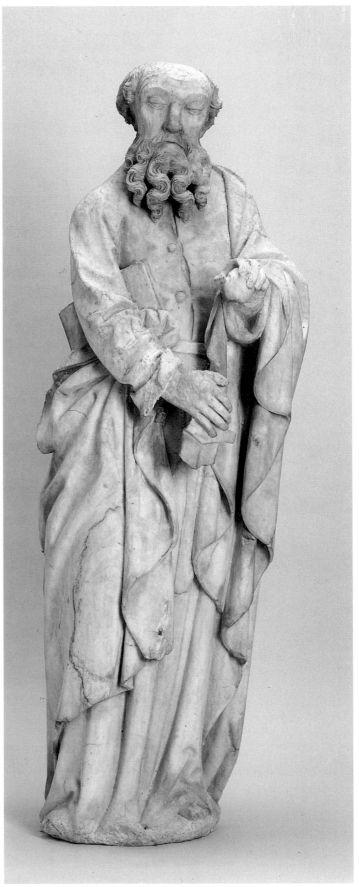

56 Funerary Monument of Gérard Didebecque

Saint-Omer, c. 1464

Stone with traces of polychromy, 105 x 70

Epitaph text: CY DEVANT GIST ENTERRE VENERABLE ET DISCRETE PERSONNE MAISTRE GUERARD DIDEBECQUE LICENCIES ES LOIS A SON TRESPAS CONSEILLER DE LA VILLE DE SAINT-OMER QUI TRESPASSA LE XXVI JOUR DE MARS L'AN M CCCC LXIIII. PRIIES DIEU POUR LUI

Stone damaged and flaking; several parts missing, including the donor's head

Saint-Omer, Musée Sandelin, inv. 7228

The numerous picture epitaphs extant in the city of Saint-Omer and vicinity offer an exceptionally rich series of dated sculptures which, beyond their intrinsic historical and iconographic interest, also provide important evidence for the emergence and development of an as yet little understood regional style.

The earliest of these monuments appear to have been influenced by Tournaisian models or, in some instances, imported from Tournai, as is probably true of the epitaph of Michel Ponche (1437, Saint-Omer Cathedral; see *Tournai*, fig. 20). Subsequent works dating soon after the mid-fifteenth century, such as the monument of Gérard Didebecque (d. 1464), while still clearly influenced by the Tournaisian as well as surely by now the Brussels School, nonetheless exhibit the emergence of a distinctive local character. The present monument (originally in the church of Saint-Denis, Saint-Omer), which retains the familiar theme of the nude Child held in Mary's lap and reaching out to a kneeling donor,[1] is among the earliest dated examples of a distinctive Saint-Omer production. Stylistically it occupies a transitional place. The overall drapery design follows South-Netherlandish precedents (donor's mantle flung over his shoulder; broken "Rogierian" S-curve configuration at the Virgin's lower right side). Yet at the same time it reveals an unmistakable local "accent" that becomes especially evident when compared to later local works (see cat. 58); drapery forms tend toward a broader, more planar character, articulated by more strictly vertical, parallel folds and sharp V's.

Representative of precisely the same style and therefore attributable to an Artois sculptor is the magnificent alabaster Annunciation in a church in the Saint-Omer *arrondissement* (c. 1460; fig. 56a; see Wintrebert, in Saint-Omer 1992, no. 63; cf. Steyaert, in Gillerman 1989, no. 39). This latter group is one of the few Continental alabasters that can be plausibly localized. While clearly inspired by the Tournai–Brussels tradition (cf. Van der Weyden's Louvre *Annunciation;* see *Tournai,* fig. 16), it is nevertheless clearly of Artois origin, judging by the near-identity of its drapery forms to the Didebecque epitaph (cf. also Mary's head type with its high forehead and long ornamentally striated hairwaves).

An equally instructive comparison is provided by a later work of lesser quality, the epitaph of Jehan de la Carouwe (c. 1497?; fig. 56b) in Saint-Omer Cathedral. This epitaph is clearly modeled after the Didebecque relief, but its regional, central-Artois characteristics are more conspicuous, as for instance in the head type of Mary and in the St. John the Baptist – the latter a "twin brother" of the same Saint in Camblain-Chatelain near Béthune (see Troescher 1940, pl. LXV, fig. 254).

1 Here the Child holds a scroll which undoubtedly once contained a painted text.

Epigraphie du département du Pas-de-Calais, 5:61.

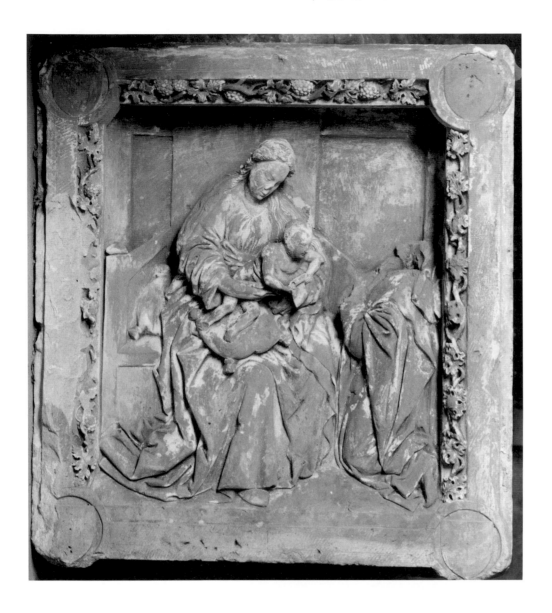

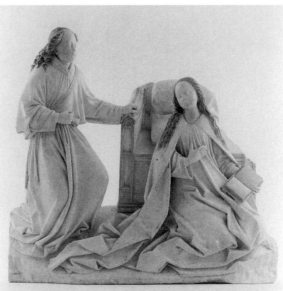

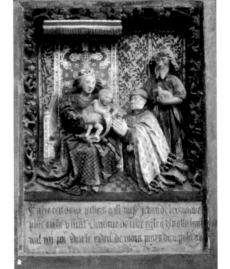

Fig. 56a Annunciation. Church in the
Saint-Omer *arrondissement*

Fig. 56b Epitaph of Jehan de la Carouwe.
Saint-Omer, Cathedral

57 Retable Fragment: Deposition

Northern France (Arras?), c. 1500 (?)

Wood with polychromy, 53 x 44.5 x 13.5

Arras, Musée des Beaux-Arts

This charming though secondary Deposition fragment is interesting as one of the few examples of Late Gothic retable sculpture preserved in the Artois region, especially since it can be linked in terms of style to a group of the same theme in the Metropolitan Museum, New York (fig. 57a), superior in quality but sufficiently close to suggest that both were carved in the same center or at least the same region. In the present state of research, the localization of these works can only be proposed by way of hypothesis and by exclusion. While almost certainly influenced by Brabantine models, these fragments clearly differ from any known South-Netherlandish works and are therefore presumably of local origin.

This tentative conclusion receives some support from the fact that certain details, such as the bearded head of the man on the ladder in the Arras Museum relief, exhibit some affinity to characteristically Picard works (cf. cat. 59). Were these works and others in the region, such as a Calvary fragment with Christ Carrying the Cross from Teneur (see Heckman, in Arras 1986, no. 37), carved in Artois ateliers under a combination of Brabantine and Picard influences? For a further study of this question, it might be noted that the peculiar head types of the Virgin and St. John with their rounded, rather blunt features in the Arras group are not unlike those of the statue of St. George in the same museum.

Fig. 57a Deposition. New York, The Metropolitan Museum of Art, Gift of J. Pierpont Morgan, 1916

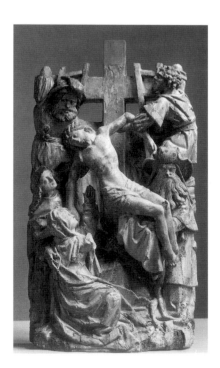

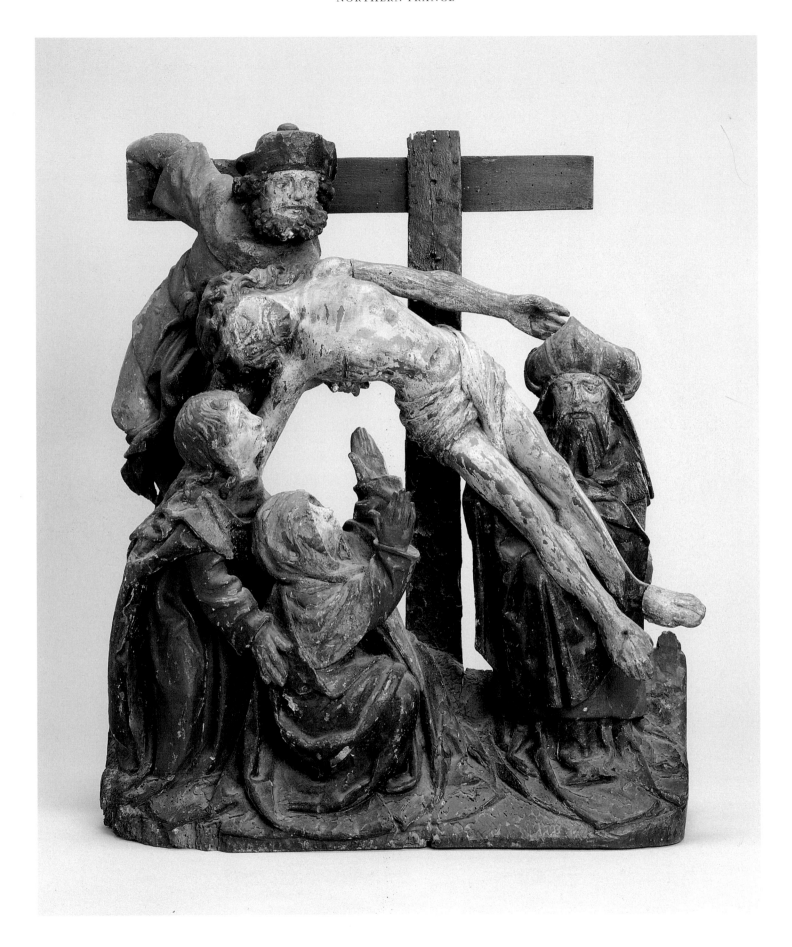

58 Calvary

Saint-Omer, late fifteenth or early sixteenth century

Wood with polychromy, h. 130 (Mary); h. 131 (John); 271 x 250 (Cross)

Saint-Omer, Musée Sandelin, inv. 8117

Although of relatively late date and by a lesser sculptor, this Calvary group is important as one of the rare complete ensembles of this theme to survive in the Artois region. Moreover, it can be recognized as a highly representative example of a distinctive regional style, as primarily evident in the figures of the Virgin and St. John.

Both exhibit a characteristically closed, simplified silhouette and drapery composition, the latter consisting of an unusually stiff "armature" of parallel vertical lines, relieved only by regularly undulating edges and an occasional splintered, sharp V-shaped wedge. Equally typical are the head types, particularly that of St. John with its emphatic underlying bone structure: a square jaw, flat chin, marked cheekbones, and a wig of hair low on the forehead that develops out from the crown in striated relief strands rolled into thick, circular curls at the ends. A variant of this type can be seen in the head of Christ, with his short, forked beard and hair in an aerated pattern of lively, loosely intertwining serpentine undulations. Finally, this regional style exhibits a predilection for ornamental, especially pearled, garment edges, as seen here in a modest form in the neckline of St. John's tunic.

Numerous comparable statues as well as retable fragments representative of this style survive. Since all of the examples known to me are concentrated in the central-Artois region between Saint-Omer and Béthune (the largest and finest ensemble in the church of

Fig. 58a Calvary Virgin. Bruges, Gruuthusemuseum

Fig. 58b Calvary Virgin (sale New York, Sotheby's, 28 November 1980, no. 27)

Fig. 58c St. Catherine. Church of Ham-en-Artois

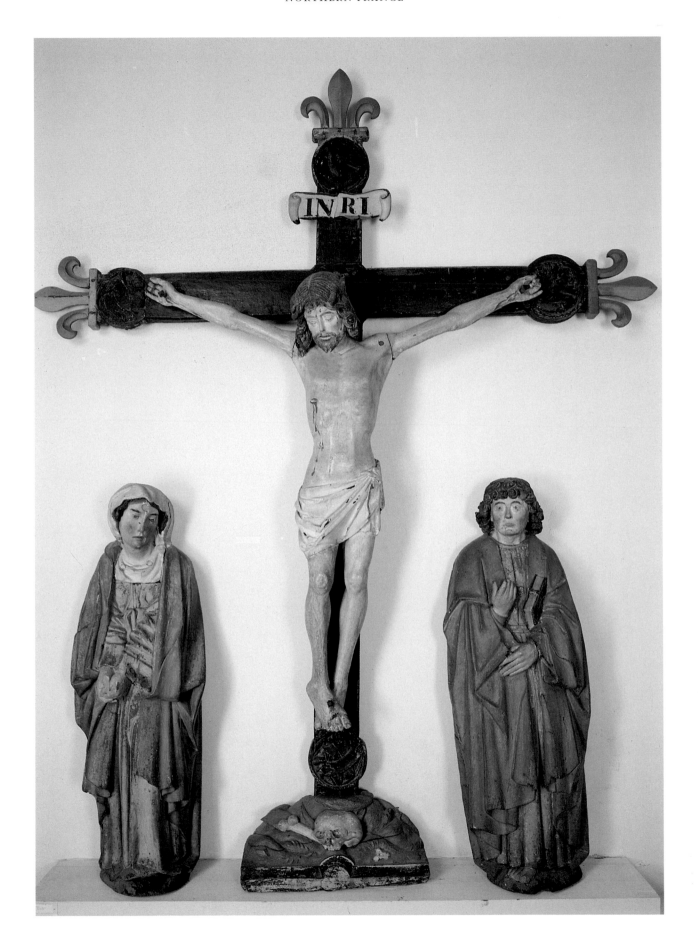

Ham-en-Artois; see Arras 1986, fig. 52, and our figs. 58c and 63a), a local artistic origin, most probably in Saint-Omer, appears likely. Among the most important comparable examples of this Saint-Omer style, which appears soon after the mid-fifteenth century (cf. cat. 56), are a St. John the Baptist in Bomy, whose head is a finer version of that of Christ in the exhibition (see Wintrebert, in Saint-Omer 1992, no. 72)[1] and a Calvary Virgin now in a private collection (fig. 58b). The style of these sculptures exhibits such constant features that related examples outside the region can be identified with relative ease – so, for example, an enthroned male figure (an Evangelist?) in the Musée des Beaux-Arts in Lille (fig. 58d).

 Although the broader context of this style in its relation to other schools remains to be defined, it appears to reflect influences both from the region of Picardy and the Southern Netherlands, possibly via Flanders, as suggested by a related Calvary Virgin in the Gruut-husemuseum, Bruges (by a sculptor active in Bruges or in south-west Flanders?, c. 1500–20; fig. 58a).

1 Wintrebert was the first author to identify this regional style.

Fig. 58d Seated Saint. Lille, Musée des Beaux-Arts

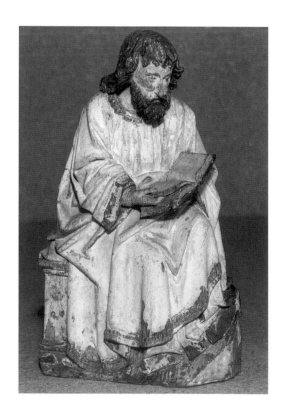

59 Retable Fragment: Entombment

Picardy, early sixteenth century

Wood, 37 x 33 x 7

Principal losses: left forearm of the man on the left (Joseph of Arimathea?);

right arm, part of the head of Nicodemus (?) and arms and left knee of Christ

Lille, Musée des Beaux-Arts, inv. A266

This damaged retable fragment is the only example of the School of Picardy in the exhibition. This area appears to have become particularly important during the later phase of the Late Gothic style, in terms of both numbers and quality of preserved works.[1] Our work forms part of a stylistically related series of retable fragments dating around 1500 and soon after which includes a Deposition in Budapest (fig. 59c; Szmodis-Eszláry, in Utrecht 1990, no. 44) and an Entombment group in Berlin (fig. 59b; Demmler 1930, 360–361, no. 8068). While influenced by South-Netherlandish examples, they exhibit a clearly distinctive character, notably in their interest in ornamental enrichment of the garments, textural differentiation of surfaces, and a very marked "family" of expressive head types. In this latter regard, a magnificent stone head of Christ from the church of Saint-Sauveur, Beauvais (fig. 59a; Bonnet-Laborderie, in Beauvais 1975, no. 19) can serve as an anchor for localization. This emotive head with its slightly open mouth, heavy-lidded eyes, and a short, compact beard, defined in a painterly, tightly massed series of small curls, is a recurrent feature in all of these works (cf. the figure at Christ's feet in the Lille Entombment).

The significance of these works is considerable, since they in turn can serve as a basis for identification and association of other Picard works. For instance, the Christ in the

Fig. 59a Head of Christ. Beauvais, Musée départemental de l'Oise

Fig. 59b Entombment, retable fragment. Berlin, Staatliche Museen

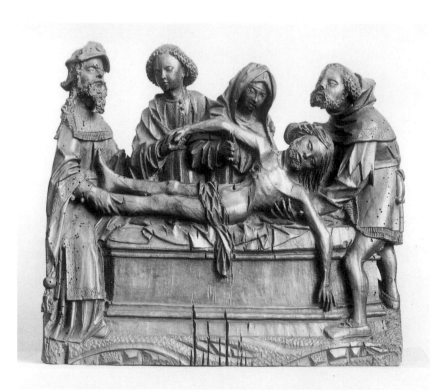

Budapest Deposition is virtually identical to a damaged Crucified Christ and a Christ in a small Calvary relief, both in private collections, that have been convincingly identified as Picard works (see Boccador and Bresset 1972; Boccador 1974, 2 : fig. 162). And the poses and facial types seen in all three retable fragments have direct counterparts in the lively misericord reliefs in the choir stalls from Saint-Lucien near Beauvais in the Musée de Cluny, Paris (1492–1500; Haraucourt 1925, nos. 344ff, pls. XIV–XV).

Taken together with other extensive ensembles of Picard sculpture, such as the choir reliefs and stalls in Amiens Cathedral (Zanettacci 1954, 195–212) and isolated masterpieces such as the Seated Virgin in the Musée de Picardie (Lernout 1992, no. 17), the importance of this school is impressive indeed. There is good reason to think that it may have exercised a degree of influence in the adjoining Artois region and possibly as far as French Flanders, where one occasionally encounters a related style and a preference for ornamental detail (see cat. 58 and 63).

1 See the basic study by Zanettacci 1954.

Szmodis-Eszláry 1986, 46, fig. 31; Utrecht 1990, 59.

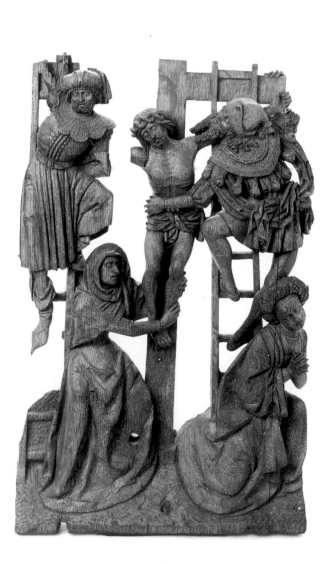

Fig. 59c Deposition, retable fragment. Budapest, Szépmüvészeti Muzeum

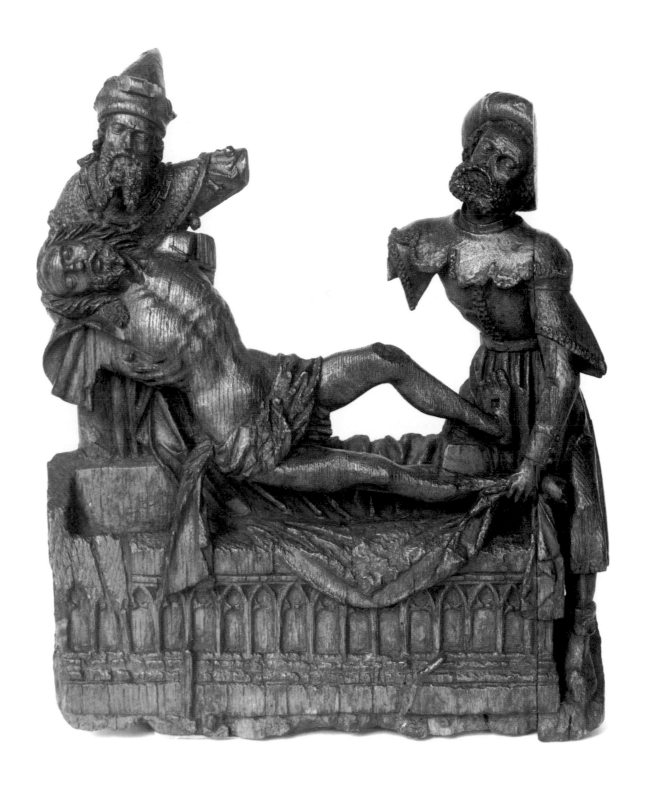

60A–B Two Angels

Lille (?), c. 1430–50

White stone with traces of polychromy, h. 114

Extensive surface damage. Principal losses: Angel A (at left):

both hands, lower parts of mantle; Angel B: both hands

Lille, Musée des Beaux-Arts, inv. LAP 14–1, 14–2

The complementary poses of these two Angels – among the foremost examples of the Late Gothic style in Lille – suggest that they were once placed to either side of a central figure or group; judging by their gestures, they also probably held censers.

In general formal type (cf. cat. 54) they strongly recall similar figures in Tournaisian works – the organic "running" pose and drapery forms (mantle edge folded over and swept back over right arm) have a direct counterpart in Van der Weyden's paintings of the 1430s (St. John in the Prado *Deposition*; see *Tournai*, fig. 26). This also applies to the head types with their flowing tresses wound in lively curls and rather broad oval faces representative of types like those in Campin and the young Rogier. Even minor details point in the same direction: the casually creased folded-over stole of the right figure represents a much favored element in Tournaisian sculpture and painting, and its decoration in the form of S-shaped design with spiralling ends appears in near-identical form in Jacques Daret's *Adoration of the Magi* of 1435 in Berlin (hem of Virgin's mantle).

A study of these works alongside other sculptures will perhaps provide a better idea of their artistic context. The similarity of the Angels' poses and head types to works from the circle of Jean Delemer (cf. head of Angel in Ponche epitaph, *Tournai*, fig. 20) on the one hand and to characteristically later Lille works on the other (e.g. cat. 62) appears especially promising.

Vandenberghe, in Bruges 1992, no. 61 (cat. 60B only) ("Noord-Frankrijk, tweede tot derde kwart 15de eeuw?").

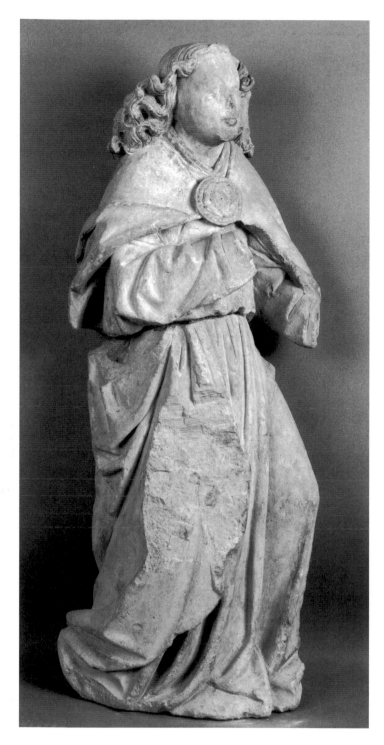

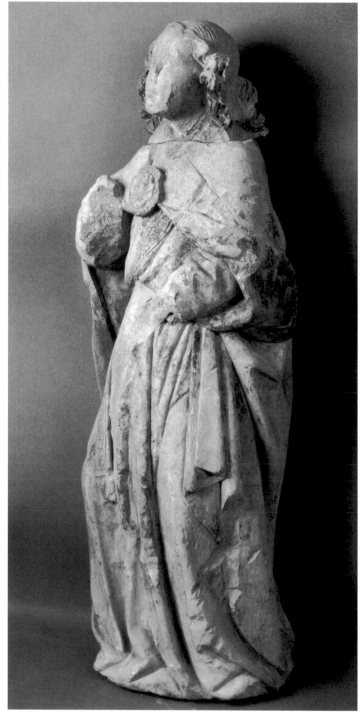

61 Group of Donors

Lille, c. 1450

Stone with traces of polychromy, 61 x 53 x 18

Extensive damage, especially at upper center; fragments indicate that

additional figures were originally present at both sides

Lille, Musée des Beaux-Arts, inv. LAP 27/1

This unfortunately damaged group undoubtedly formed the left part of a funerary
monument of unusual quality. (An even more poorly preserved pendant group of female
donors is also in the museum.) Along with numerous other examples of this type preserved
in Lille it testifies to the important Tournaisian artistic influence in this city. This phenom-
enon extends at least to the mid-fifteenth century and is also documented in written sources
(Oursel 1980). But here, as in other Northern French cities such as Arras and Saint-Omer,
Tournaisian imports were increasingly replaced at this time by locally carved examples at
first closely based on those of Tournai but soon developing distinctive regional features.
(This evolution is documented with unusual clarity in the picture epitaphs of Saint-Omer,
see cat. 56.)

Our work appears to be representative of this transition. The realistic, striking heads
of the donors, their faces marked by a solemn sense of piety, remind one quite directly of the
splendid head of Jean du Clercq, abbot of Saint-Vaast, Arras, in the Visitation panel by the
Tournaisian painter Jacques Daret (1435; Berlin, Staatliche Museen) whose own career
testifies to the Tournaisian artistic influences in the Northern French region (Lestocquoy
1937b).

However, it is possible that the group was carved by a Lille sculptor, as suggested by
Oursel; the heads of these personages appear to represent a local interpretation of Tour-
naisian models that recur in local works of later date such as a figure of St. Augustine and a
retable fragment of Christ in the House of Simon, both preserved in the same museum.

Oursel, in Lille 1978–9, no. 77 ("milieu du xvᵉ siècle, Lille?").

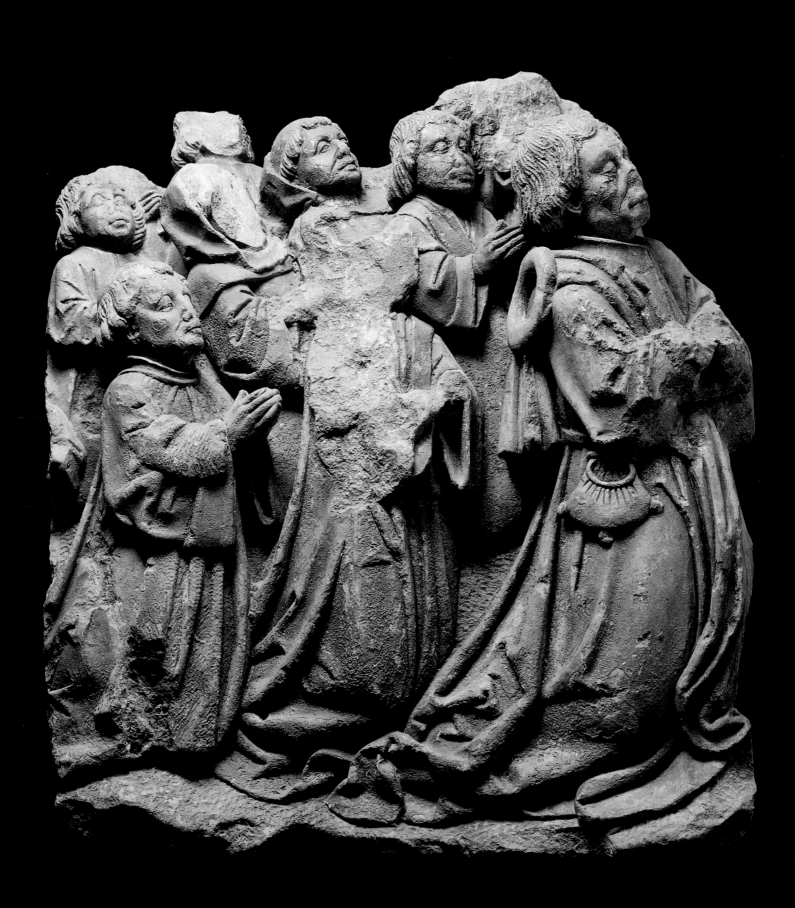

62A–C Three Angels with Passion Instruments

Lille, c. 1450–75

Oak with remains of polychromy, h. 90 (Angel with nails); h. 90

(Angel with column of the Flagellation); h. 89 (Angel with Cross)

Lille, Musée des Beaux-Arts, inv. A152

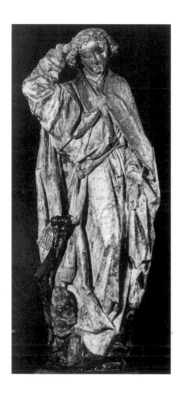

Fig. 62a St. Michael. Norfolk
(Virginia), The Chrysler Museum

These dignified, svelte altar Angels with their fresh, juvenile faces and long-legged striding
poses, are shown holding elements related to Christ's Passion, respectively the column of the
Flagellation, the three nails, and the (broken) Cross.

Of unknown provenance, they are traditionally assumed to be of Northern French
origin. Although our knowledge of later medieval sculpture in this area remains very
limited, evidence in favor of a Lille origin might be seen in the ovoid facial types with their
high convex forehead, heavy-lidded eyes beneath highly arched brows, precious mouth,
and sharp jutting chin, comparable to other works preserved in the city, most notably the
masterly stone Madonna believed to come from the church of Saint-Sauveur (see cat. 103,
fig. 103a). As this latter work, they exhibit a silhouette with narrow, sloping shoulders, as
well as drapery articulated in a series of V's squared off at the bottom.

The Angels have served as point of reference for a localization of comparable sculp-
tures of presumed Northern French origin, including a splendid St. Michael in Budapest
(see recently Szmodis-Eszláry, in Utrecht 1990, no. 32), to which may be added an equally
fine figure of the same Saint in Norfolk, Virginia (fig. 62a; see Brooklyn 1936, no. 53).
The tall proportions shared by all of these Angels and the elegantly gliding, eurhythmic
movement of the St. Michael statues suggest an origin in the third quarter of the fifteenth
century, corresponding to the late style of Van der Weyden's paintings.

But in spite of their kinship, it is not at all certain that all of these figures were carved
in the same center. For a further study of this question, an investigation of their relationship
to the School of Tournai would undoubtedly provide further insights. The indebtedness
of the Virginia St. Michael to the style of Jean Delemer is in any case obvious (cf. the
St. Michael in Ellezelles, cat. 3).

Oursel, in Lille 1978–9, no. 74 ("première moitié du xvᵉ siècle"); Vandenberghe, in
Bruges 1992, no. 18 ("Noord-Frankrijk, midden of derde kwart 15de eeuw?").

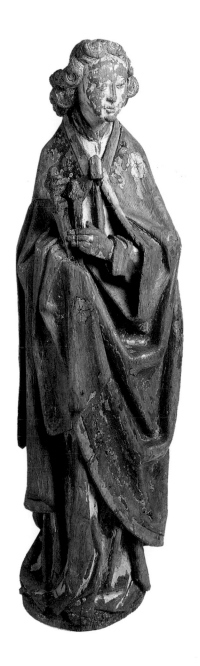
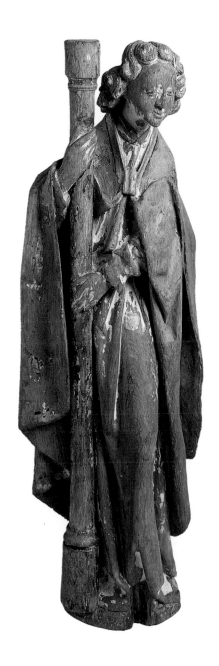
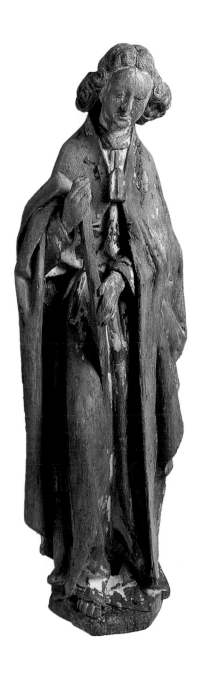

63 Seated Virgin and Child

Lille (?), c. 1520

Oak with traces of polychromy and gilding, h. 93

Principal losses: left arm and right hand of the Child; a few fingers of Mary

Lille, Musée des Beaux-Arts, inv. 987.61

Fig. 63a Virgin and Child Enthroned.
Church of Ham-en-Artois

This imposingly monumental enthroned Virgin supporting a long-legged, briskly stepping nude Christ Child, wearing a (coral?) necklace and bracelet, and reaching to grasp a now lost object once in Mary's left hand, is known to have come from the priory of Fiefves immediately outside the city and presently part of greater Lille. As is true of so many works in this area, it can be more easily dated than localized: the Virgin's blunt, wide-tipped shoes, and her square neckline with its encurved lower edge, exposing a high-necked pleated shirt, suggest a date toward 1520, which is also consistent with the contemporary ideal aesthetic of an exceptionally high (plucked) forehead.

In principle, given the provenance, the work should be of Lille origin; but this remains unfortunately difficult to establish in terms of other examples preserved in the city. It shows no evident association with early-sixteenth-century sculptures of nearby Tournai. Oursel has noted its similarity to a fragmentary donor statuette in Arras, and indeed the Madonna reveals certain parallels to sculptures in the Artois region. It is tempting to consider the Fiefves Madonna as a typological and stylistic counterpart to the Artois Virgin and Child Enthroned in the church of Ham-en-Artois (fig. 63a), where we also find a somewhat analogous stiff drapery (e.g. pendant sleeve-like mantle at arm). Other works, including the splendid St. Catherine in Duisans (Oursel, in Lille 1978–9, no. 91) exhibit a similar system of fold-lines that break forward in an angular succession to crack hard against the base. But the works cited differ fundamentally from ours in other respects, so that this relationship may simply point to certain shared common traits of the Northern French area, and possibly an influence from the Artois region on our work.

Oursel, in Lille 1978–9, no. 92 ("début du xve siècle"; with bibliography).

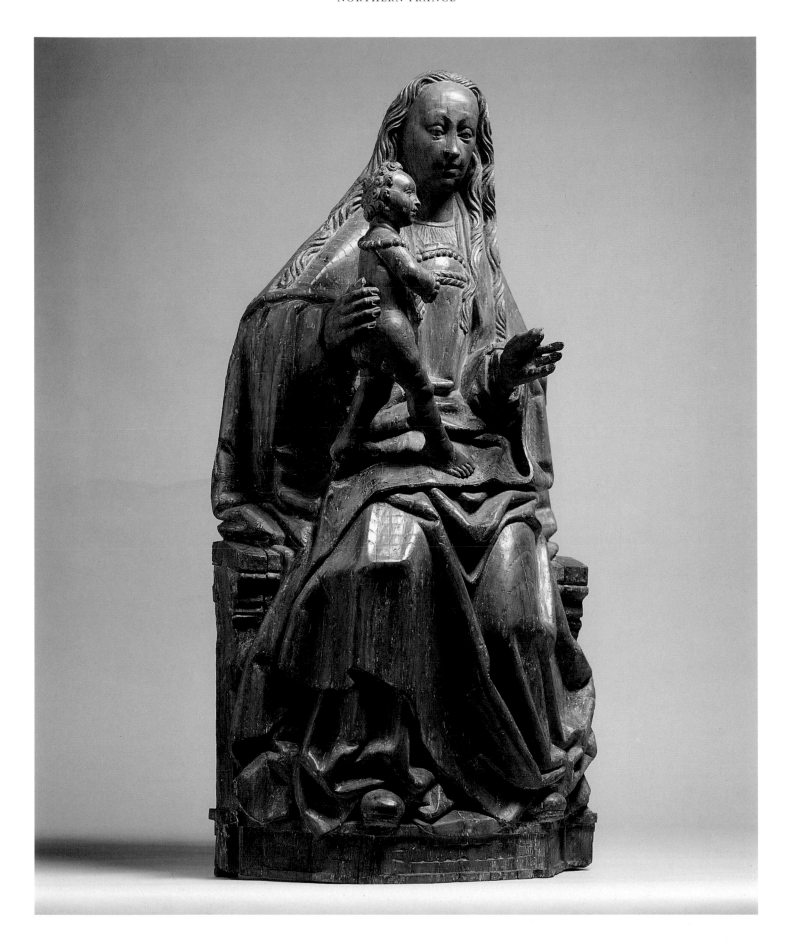

64 Angel of the Annunciation

Southern Hainaut, c. 1450–1500

Wood with traces of color, h. 108.5

Both hands missing[1]

Valenciennes, Musée des Beaux-Arts, inv. s.9117

1 The Angel once served as a replacement for a St. John (!) in a Calvary group formerly in Bavisiaux near Obies. The Calvary Virgin from this ensemble is also preserved in the Musée des Beaux-Arts, Valenciennes.

The overall style indicates an origin for this work sometime in the second half and probably in the third quarter of the fifteenth century (tall proportions, linearized drapery). If its ultimate ancestry in the Tournai–Brussels tradition is sufficiently clear, the Angel's eventual integration into a Hainaut tradition is problematic.

A possible local antecedent for the Angel's rather sharp, dry surface forms, arranged in stiff vertical lines that break hard against the base, alternating with interconnected triangles, might be seen in Madonnas in the churches of Bermeries and Liessies, located in the same region, possibly dating toward the mid-fifteenth century (cf. also elongated oval faces common in this area). On the other hand, two small altar Angels in the church of Obies (now transformed into SS. James and Philip), much inferior in quality, seem to reflect the style of our work (draperies).

However tentative, these comparisons do bring out the exceptional quality of the Angel in Valenciennes and provide some context for a possible indigenous origin.

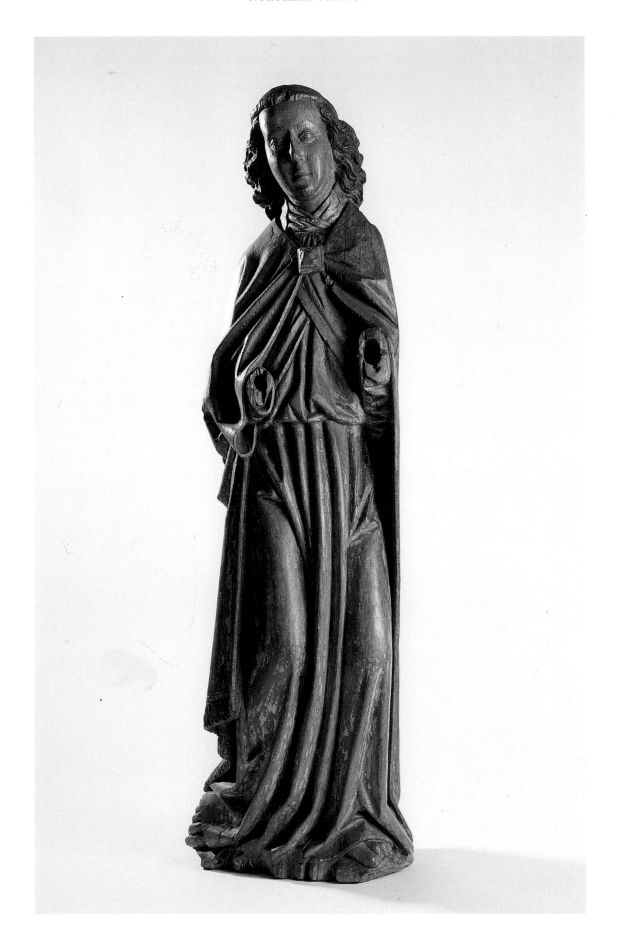

65 Calvary

Southern Hainaut (Avesnes?), early sixteenth century

Wood with polychromy, h. 120 (Mary); h. 120 (John); 315 x 280 (Cross);

ensemble with rocky base: 353 x 280

Marpent, Parish church

The Marpent Calvary marks the intrusion of Brussels influence into the Southern Hainaut region in the early sixteenth century. This derivation is evident in the overall figure types. Most notable are the Virgin's characteristic sideward fainting pose with her left arm vertically suspended, and her drapery (mantle drawn across her lower body, end thrown over her left forearm), best known through a statuette on the Paschal Candelabrum, Zoutleeuw (1482–3; but much earlier in origin), and through a number of variants. This Brussels influence can also be seen in certain details, such as the expressive Bormanesque head of St. John.

There is good reason to think that this ensemble was carved in a local workshop, since specifics of interpretation (tall proportions, drapery surfaces reduced to a stiff linear network) appear to represent a later extension of the style of the Angel of Valenciennes (cat. 64).

Moreover, the Marpent ensemble stands at the head of a "family" of stylistically related but slightly later works in the Avesnes region, characterized by proportions elongated to a mannered extreme and the recurrent motif of the sharply "cracked" fold

Figs. 65a–b Virgin and St. John from a Calvary. Church of Eccles

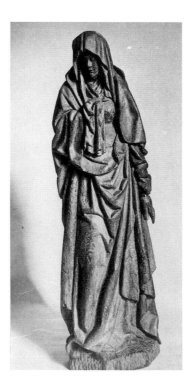 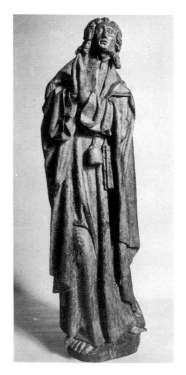

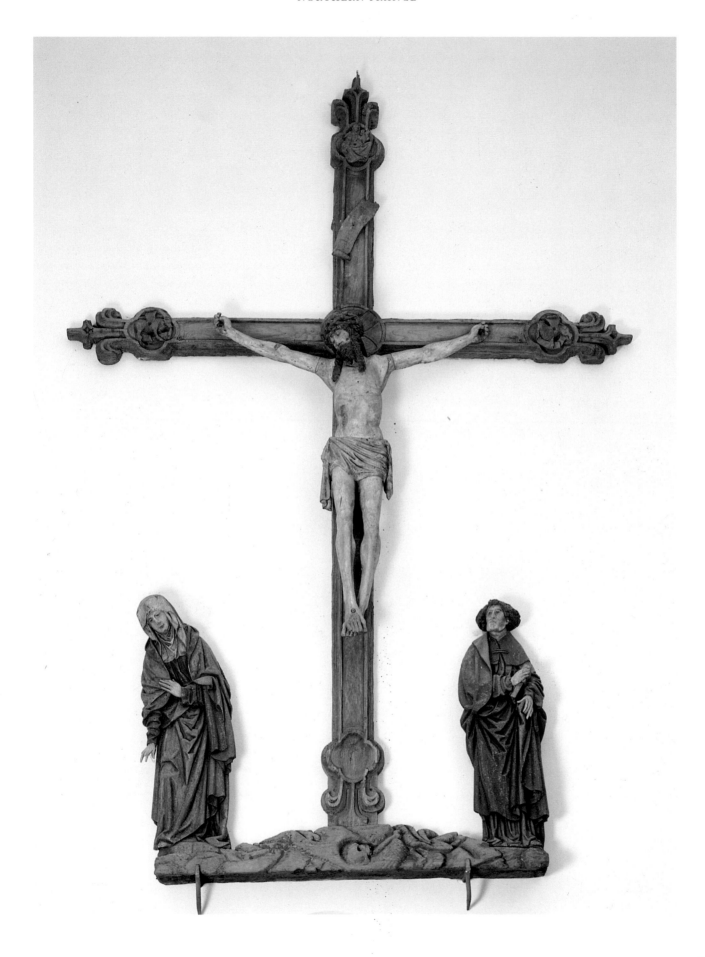

above the knee of the advanced leg. This series includes a Calvary group in the church of Eccles (figs. 65a–b) and four Apostle figures until recently in Eppe-Sauvage (stolen in 1993; fig. 65c) possibly carved in the same shop, as well as the later, derivative Calvary group in Mecquignies (for the latter, see Douai 1969, ill. p. 144). The characteristic features of these works can also be identified in examples *ex situ* such as two assistant Calvary figures that recently appeared on the art market (figs. 65d–e).[1] As elsewhere in this frontier region, these works can only be meaningfully studied across modern national boundaries. Closely related works have survived in the directly adjoining area of the "botte du Hainaut" in Belgium; for example: Calvary groups in Epinois, Leval-Trahegnies (St. John of later date), Croix-lez-Rouveroy (Christ later), Christ on the Cross in Peissant (for these works, see de Borchgrave d'Altena and Mambour 1972, *passim*).

In view of the difficulty of studying these works at close range, their stylistic versus typological relationship can only be suggested here. It may be hoped that a study of the Marpent Calvary in the context of the exhibition will provide the possibility of more precise conclusions. But the presence of comparable examples in the Thuin region of Belgium suggests that parallels and influences from the Mosan area can further clarify the artistic context of these works, as also suggested by a comparison of the Marpent St. John with the same figure from a Calvary, supposedly from Ciney, by a Dinant sculptor (Namur, Musée des Arts anciens du Namurois).

1 Sale London, Sotheby's, 12 Dec. 1985, no. 63; the Christ (no. 64 in the same catalogue) probably formed part of the same ensemble, in spite of its different attribution.

Fig. 65c Apostle.
Church of Eppe-Sauvage

Figs. 65d–e Virgin and St. John from a Calvary (sale London, Sotheby's, 12 December 1985, no. 63)

252

66 Virgin and Child with Saint Anne

Mons, early sixteenth century

Oak, h. 100

Avesnes-sur-Helpe, Collégiale

In function of a tendency toward humanization of religious subjects, the Gothic period exhibited a particular interest in themes of the family of Christ. During the later Gothic times, the theme of the generational group of the Virgin and Child with St. Anne ("Sint-Anna ten-Drieën") which also implies the notion of the Immaculate Conception, became extremely popular (see Uden 1992). This theme gave rise to a great variety of formal and/or iconographic types, often associated with important regional prototypes or preferences.

The present group represents a composition common in the Netherlands in which the large figure of St. Anne is foremost, and indeed is identifiable by the presence of a smaller Madonna group alongside that serves an "attribute function." In style, it is a fine example of a large group of sculptures known to us principally in the eastern part of the Belgian Hainaut and of probable Mons origin (see cat. 13). Since many of these works were carved in stone quarried in Avesnes, it appears likely that related works were carved in this city and region, formerly the southern part of the county. Besides, other examples of this style survive here, including two Apostles in the church of Avesnelles, a Christ in Bousig-nies-sur-Roc (see Douai 1969, no. 12), and a St. Roch formerly in a Valenciennes private collection, now in the Musée des Beaux-Arts (fig. 66b; see Ghent 1913, no. 1077, and

Fig. 66a Virgin and Child with St. Anne from the Altarpiece of the Chapelle des Féries. Mons, Collégiale Sainte-Waudru

Cat. 66

253

Hardy 1972, 259; a near-identical figure is in the Bayerisches Nationalmuseum, Munich; fig. 66c).

Our limited knowledge of artistic developments in this area makes it difficult to decide which of these works are of local origin or possible imports from Mons. The latter alternative is suggested for our work, given its close correspondence to a group in the retable in Sainte-Waudru, Mons (fig. 66a; cf. also the funerary monument of Jehan Salmon and Gille Bourgoix, Chapelle Saint-André, Binche). A stylistically related group in Wattignies-la-Victoire (fig. 66d; see Douai 1969, no. 38) might represent a Southern Hainaut (Avesnes? Maubeuge?) variant of this style.

Oursel, in Lille 1978–9, 169 ("début du XVIᵉ siècle").

Fig. 66b St. Roch. Valenciennes, Musée des Beaux-Arts

Fig. 66c St. Roch. Munich, Bayerisches Nationalmuseum

Fig. 66d Virgin and Child with St. Anne. Wattignies-la-Victoire, Saint-Ghislain

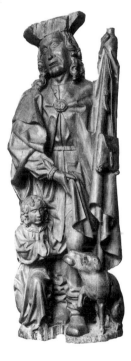

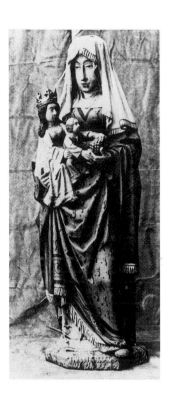

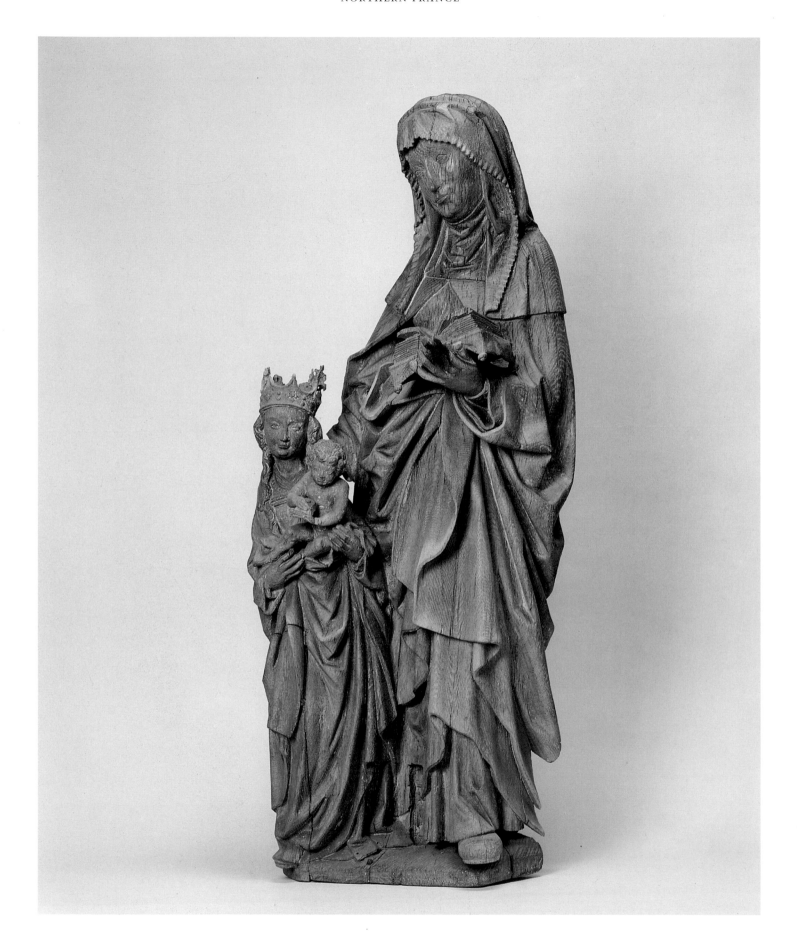

Meuse Valley

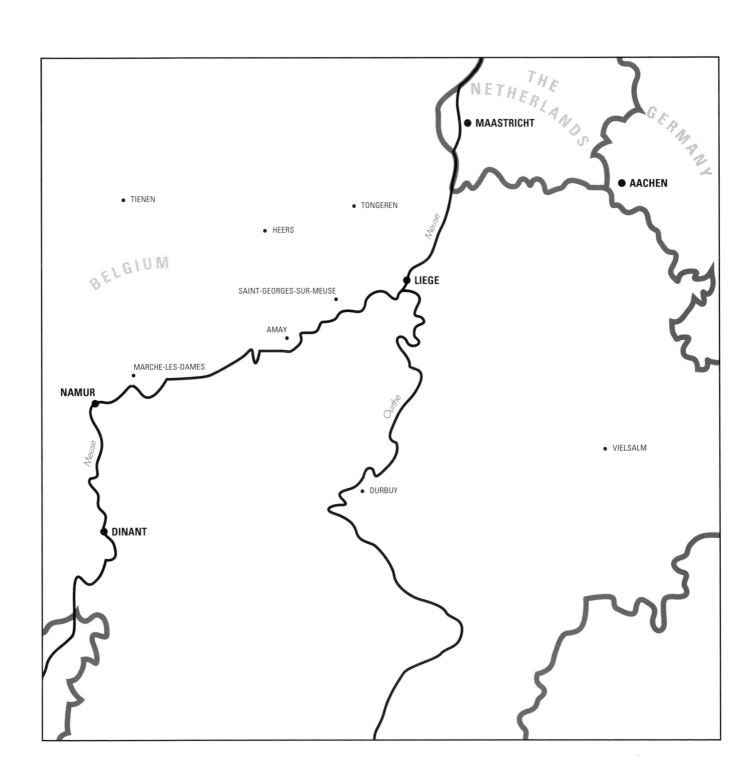

67A–B Apostles Peter and Paul

Master of the Heers Peter and Paul

Liège, c. 1370

Wood, h. 38 (Peter); h. 39 (Paul)

Heers, Sint-Martinuskerk

Fig. 67a St. Peter. London,
Victoria and Albert Museum

Fig. 67b Two heads.
Liège, Musée Curtius

The wooden winged altarpiece (*Flügelaltar*) inset with narrative groups and statuettes represents perhaps the best-known and is among the most characteristic forms of late-medieval Netherlandish sculpture. Although the earliest intact examples survive in the work of the Flemish sculptor Jacob de Baerze (1390s), the most complete known series of fourteenth-century retable figures can be associated with the Mosan area. Given the relative scarcity of examples from this early time, at least in the Low Countries (they subsist in far greater number in the German and Scandinavian region), these works are of special interest. These two statuettes were almost certainly part of a wooden retable that would have included a complete Apostle series as well as a central group of the Coronation of the Virgin or a Calvary.

The distinctive features of the Heers statuettes also appear in a number of other works in nearby Tongeren and in a complete Apostle series with a Coronation of the Virgin in the Victoria and Albert Museum (see fig. 67a), where they were until recently classified as of English origin.[1]

In view of the concentration of examples in Tongeren (where a somewhat related Christ on the Cross survives in the church of Sint-Jan de Doper) and vicinity, one might be tempted to consider them local works carved under Liège influence. But evidence supporting an origin in the Mosan artistic capital itself can be seen in the similarity of St. Peter's features to several small sandstone heads from the church of Sainte-Croix, now in the Musée Curtius (for these, see Lemeunier, in Liège 1980, 36, no. B26). At least two of these charming miniature heads may – due to their close similarity – be attributed to the Master of the Heers Peter and Paul (fig. 67b, head at right; cf. squarish face; thin, elongated eyes; tiny mouth with slightly everted lips; small wedge-shaped nose; ears sticking out; hair in separate curly locks). They undoubtedly reflect more important large statues carved in Liège, obviously an artistic center of great significance during these years.

The head types of the Heers Peter and Paul still recall, at least distantly, those found in the later works of the Master of the Marble Madonnas and his immediate followers

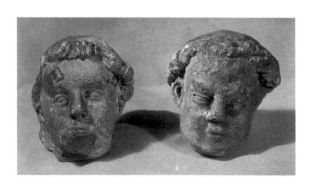

258

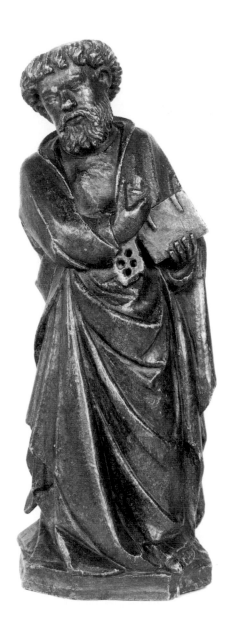

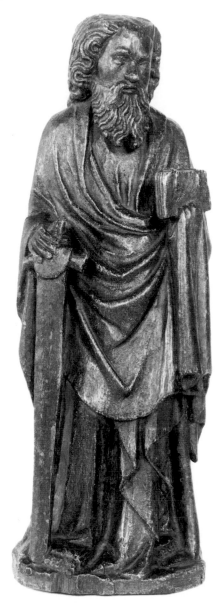

(active c. 1330–50),[2] as does the drapery typology of the St. Peter (cf. Annunciation Virgin, Dayton, Ohio; Forsyth 1968), so that a relatively early origin toward 1370 appears plausible. The important issue of the wider artistic connections of these statuettes remains to be solved. In my view, these should probably be sought in an east-north-easterly direction, in the works of Master Bertram and related altarpieces in the Baltic region.

Smets, in Sint-Truiden 1985, nos. 13–14 ("Onbekend atelier, Maaslands?, 1ste helft 15de eeuw"; with earlier bibliography); Steyaert and Didier, in Sint-Truiden 1990, no. 4 ("Maasland, Luik, c. 1370–80").

1 See Williamson 1988, nos. 28–33; cf. also a related characteristically Mosan Madonna with St. Anne of c. 1350–70 in the same collection (no. 14); for the Mosan attribution of the series, see Sint-Truiden 1990, nos. 1–2, 4.

2 For the ornamental serpentine hair of St. Paul, cf. Coronation Virgin, Walcourt.

68 Morse: Virgin and Child with Canon Johannes Cleinjans

Godfried Gufkens

Tongeren, 1396–8, after a model of c. 1370

Silver, partly gilded; translucent enamel; 16.5 x 14.5

Scepter in Mary's right hand broken off

Tongeren, Onze-Lieve-Vrouw-Geboortekerk, Basilica Museum

The treasury of Tongeren is exceptionally rich in examples of medieval goldsmiths' work. It is also among the best-known such collections, repeatedly exhibited and studied from varied viewpoints. These small metalwork items can also prove helpful to students of monumental works of the same period, as the three examples in the exhibition can help demonstrate. The present morse can be dated precisely to the years 1396–8, an origin consistent with the exceptionally fine lateral enamels showing the kneeling donor, Canon Johannes Cleinjans (d. 1402), and an Angel with his coat of arms. The Madonna statuette at the center, however, is representative of an earlier tradition (cf. Didier) and not surprisingly so, since the molds used in casting these miniature sculptures were often used over more than one generation. In fact, a nearly identical Madonna cast from the same mold (Child's head updated or replaced) survives in a slightly later morse in the same treasury. The arching, decorative stance of Mary is familiar to us from a famous series of Liège marble Madonnas of the years c. 1330–50, among which the example now in Antwerp Cathedral is perhaps the finest. But the figure in the morse lacks the elegance and refinement of these works; the garment is rendered simply, the heads with prominent expressive features are quite different from Parisian courtly types as well as from later local works inspired by Beauneveu (see cat. 69).

No directly comparable wood or stone sculptures appear to survive in the Mosan region. An explanation for this Madonna's style may perhaps be sought in Rhenish–Mosan artistic contacts (Cologne?). It is quite similar to a wooden Madonna statuette decorating the choir stalls of the Cathedral in Bamberg (c. 1370–80; see Schmidt 1978, 69 and fig. 3), itself reflecting the works of the important German architect-sculptor Peter Parler, whose style is in part rooted in the Netherlands.

Didier, in Cologne 1978, 1:103.

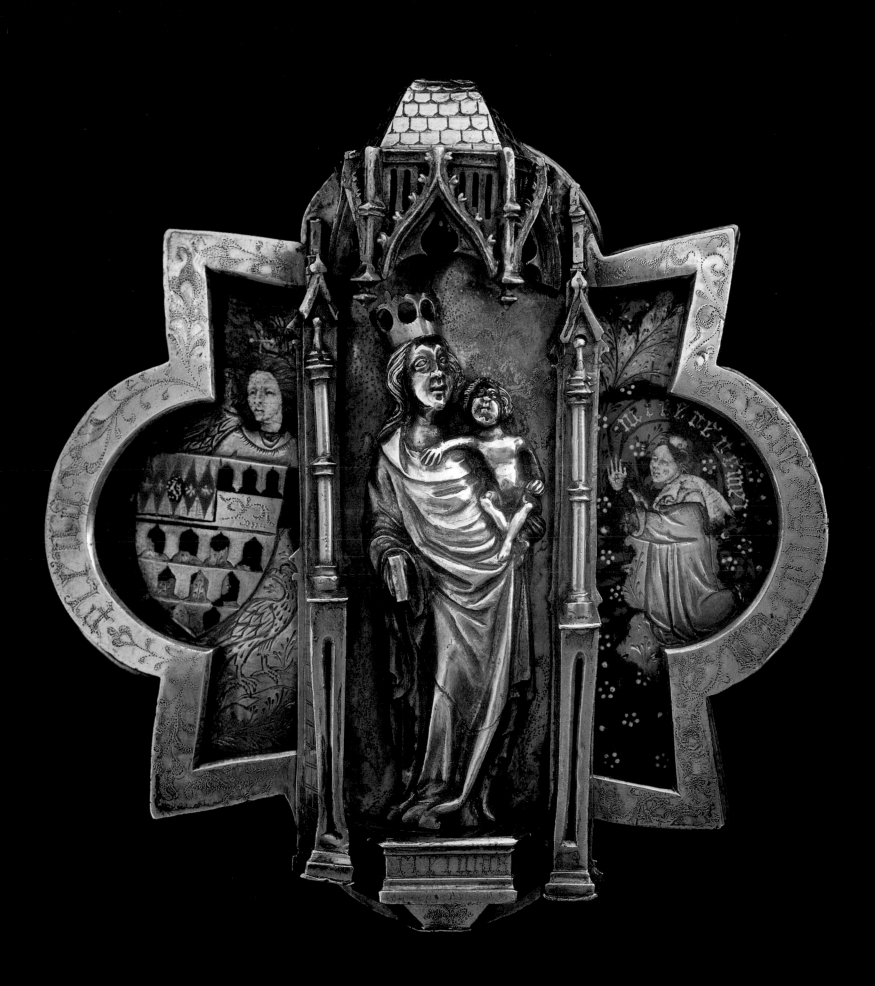

69 Standing Virgin and Child

Master Hendrik and the Gufkens Brothers

Tongeren, c. 1400

Silver, partly gilded; pearls, precious stones, h. 36.8

Tongeren, Onze-Lieve-Vrouw-Geboortekerk, Basilica Museum

Fig. 69a Virgin and Child from the Shrine of the Martyrs of Trier. Tongeren, Onze-Lieve-Vrouw-Geboortekerk, Basilica Museum

Fig. 69b Standing Virgin and Child. Private collection

This superb reliquary statuette is documented as having been executed by Master Hendrik and the Gufkens of Tongeren in the year 1400. It is of special interest as a dated example of a characteristically Mosan (in the ban of Liège) Madonna of the "c. 1400" style. In its basic style features, it has rightly been compared to the work of Beauneveu (Lüdke 1983, 121) whose influence is evident in the Virgin's overall appearance and particularly in the drapery composition (cf. *Tournai*, fig. 3). But here as elsewhere during this aptly named period of the "International Style," this important sculptor's influence is "colored" by regional nuances and motifs that, although minor, are sufficiently distinctive to indicate a regional "accent." It has apparently gone unnoticed that the work has a very close counterpart in a small wooden statuette attached to the ends of the Shrine of the Martyrs of Trier in the same treasury (c. 1370–90; fig. 69a). Virtually identical in drapery detail, although more traditional in its elongated proportions, this humble but important figurine is either an immediate forerunner, or perhaps a copy of our work by a more conservative master.

Whichever the case, these two statuettes share certain features in their interpretation of Beauneveu's style, including the more regular, horizontal low-relief folds drawn across the upper part of Mary's mantle, and motifs such as the edge that undulates to a point above her left foot, typical regional Mosan features. A formal antecedent may be seen in a small Madonna in a Belgian private collection (c. 1360–70; fig. 69b; Laarne 1969, no. 3; Didier, Henss, and Schmoll gen. Eisenwerth 1970, 109), apparently a Mosan version of a wide-ranging European style that extends to Cologne and Westphalia (see Palm, in Cologne 1978, 1:169). The artistic provenance and date of this latter statuette is supported by the presence of an identical limply layered drapery design of "butterfly edges" in two historiated consoles in Mosan bluestone at the central facade entrance to the church of Onze-Lieve-Vrouw-ten-Poel, Tienen, dated on the basis of documents to c. 1360, and probably carved by a certain Lambert Maes (see de Borchgrave d'Altena 1941, 234; for the documents, see Roggen and Withof 1944, 197). These three Madonnas constitute a distinctive "family" group that can serve as a basis for an identification of certain constant features in the later local tradition (see cat. 74), providing further evidence for the fact that Late Gothic regional styles can only be fully understood by an examination of the preceding c. 1400 style.

Ceulemans and Didier, in Sint-Truiden 1990, no. 580B (with comprehensive bibliography).

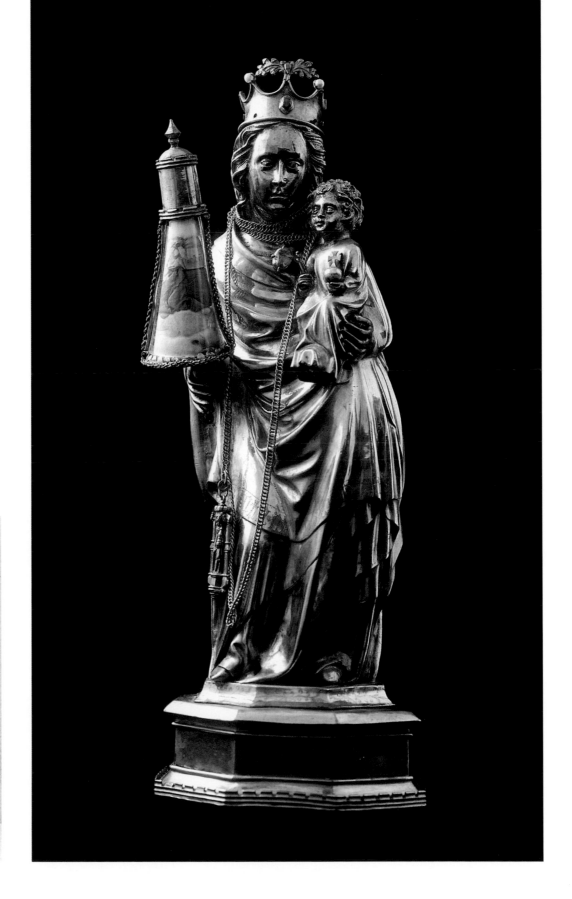

70 Morse: Arrestation of Christ

Tongeren or Liège (?), c. 1410–20 (?)

Silver, partly gilded, diam. 12.5; frame of later date (sixteenth century?)

Tongeren, Onze-Lieve-Vrouw-Geboortekerk, Basilica Museum

This circular relief is among the less well-known but most fascinating of the late-medieval objects in the Tongeren treasury. It depicts Christ's Arrestation with a central group of Judas' kiss of betrayal and in the right foreground St. Peter raising his sword against the fallen Malchus. At the top and sides, we see a menacing, closely packed group of soldiers, including a black man directly above Christ decked out in armor and a varied series of helmets (reminding us of the Mosan area's importance in the manufacture of arms and armor).

The composition and the characterization of individual figures is especially interesting since it is one of several related treatments of this subject in the Rhine-Meuse area that can help confirm the artistic background of the Van Eycks. These include a drawing in the British Museum associated with the style of the Limbourg brothers (c. 1415–20?; Ring 1979, no. 69, fig. 35), in which Christ is threatened by a group of exotic grasping soldiers worthy of Jerome Bosch, and a related scene in the "Roermond Passietafel" in the Rijksmuseum, Amsterdam (c. 1420–30; Venner 1989, 72). Recurrent details in both these works and our relief, notably the Malchus with his lantern, collapsed with one outstretched leg, may be seen as an indication that they belong to the same regional tradition. In addition, the head of St. Peter in the Tongeren relief can be recognized as a distinctive Liège type encountered from the Master of the Heers Peter and Paul (cat. 67) through the Rheinberg Altarpiece (see Achter 1960, 228, fig. 222). Most interesting, however, are the links of the composition to the early Van Eyck style: the pose and drapery of St. Peter, the striding advance of Judas, and the grim anonymity of the helmeted soldiers offer a parallel to the Arrestation miniature in the Turin-Milan Hours attributed to Jan (Friedländer 1967, 1 : pl. 29). Along with the pipeclay relief in this exhibition (cat. 93; where the centurion is similar in type to the St. Peter), this work thus belongs to that small but important group of pre-Eyckian works that confirm the importance of studying the origins of the *ars nova* across varied media. The Tongeren relief has been rightly compared to the same subject as treated by the Master of the Parement de Narbonne, active in Paris (see ill. in Meiss 1967, fig. 22), though such an analogy may tell us more about the Netherlandish artistic background of this artist than about the eventual Parisian sources of our Mosan work.

Trésor 1890, 31; Paquay 1911, 156–157; Didier, in Cologne 1978, 1:105; Sint-Truiden 1990, 60 ("Maasland, Luik of Tongeren, c. 1420?").

71 Pietà

Liège (?), c. 1400–10
Wood with polychromy, 62 x 42 x 23
Beringen, Sint-Pietersbandenkerk

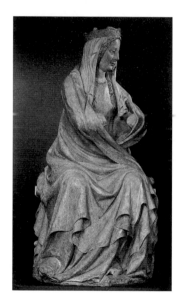

Fig. 71a Pietà. Diest, Onze-Lieve-
Vrouwekerk

Fig. 71b Coronation of the Virgin.
Liège, Saint-Jacques

In the Mosan area, we can trace the development of the Pietà in sculpture from as early as the opening years of the fourteenth century through the end of the Late Gothic in the early sixteenth. The Pietà in Beringen is a most interesting work by a lesser sculptor probably active in the Liège School or at least within its influence range, as most works of the years c. 1400 in the Limburg region. The Beringen work is dependent on Central European Pietàs in its iconography (Virgin seated on throne; see Kutal 1969) and even in formal type – not surprisingly since Liège formed part of the German Empire at the time. Nevertheless, its specific traits are distinctly Mosan, as can be demonstrated by a dual comparison, principally based on the drapery schema.

The arrangement of Mary's garment in symmetrically arranged pendant "butterfly" undulations and in a fold that travels diagonally from one knee to "bounce" against the opposite base is a characteristically Netherlandish (Beauneveu) schema of this time interpreted here in a Mosan vernacular known to us through the crucial monumental Coronation of the Virgin group in Saint-Jacques, Liège (c. 1390–1400?; see fig. 71b and cat. 21, fig. 21a). Basically the same formal arrangement can also be seen in the impressive Liège (?) "Beautiful Pietà" in Diest (fig. 71a), which is however of later date (c. 1420). In the important Diest Pietà, the same forms acquire a plenitude which, along with the more dynamically treated diagonal "bouncing" folds, represent an immediate antecedent to the emergence of the Late Gothic, especially as we know it in the late work of the Master of the Hakendover Altarpiece (cf. Apostles in Prayer, *Brussels*, fig. 11).

The shared features of these sculptures are of interest from the point of view of our still limited knowledge concerning the evidently very significant Mosan School c. 1400, but equally because they tend to strengthen the hypothesis of a Mosan background for the important Master of the Hakendover Altarpiece (see cat. 21 for this sculptor's God the Father, closely related in formal type to the Beringen Pietà).

De Borchgrave d'Altena 1942–3, 268, fig. 13 ("xvᵉ siècle"); Ceulemans and Didier, in Sint-Truiden 1990, no. 12 ("Maasland, Luik (?), c. 1400–10"); Ziegler 1992, 210–211, pls. 5–6.

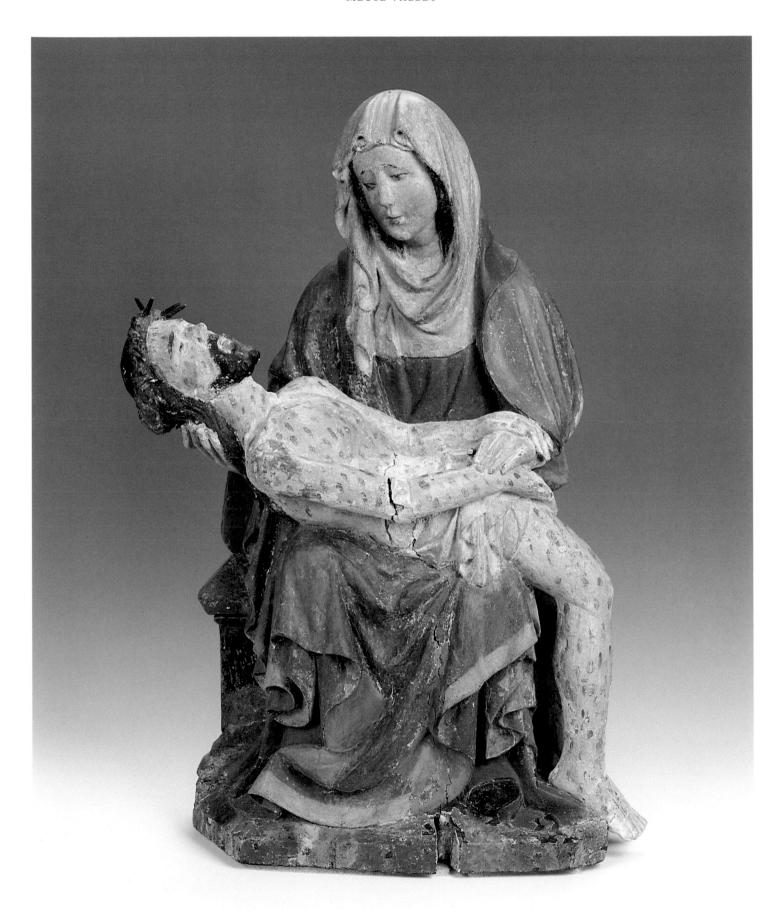

72 Saint Agnes

Liège, c. 1435–40

Oak, h. 81

Worm damage

Tongeren, Collection OCMW

This extremely fine statue of St. Agnes with her attribute, the lamb, may be considered as the masterpiece of a group of sculptures that have been ascribed to the anonymous Master of the Eyckian Female Figures (Didier). Among the works in the exhibition, the Saint's face with its delicate, subtly nuanced, "melting" expression can be compared and contrasted to the Madonna in Lille (cat. 74), a confrontation that brings out at once a common origin as well as the superior quality of the St. Agnes.

As a superb example of the initial formation of the Late Gothic in Liège, this work can provide some insight into the local origins of this style. The distinctive, rather fleshy facial type may be partly indebted to the (Cologne? Liège?) "Beautiful Madonna" in a private collection in Liège (see cat. 86, fig. 86b). On the other hand, the drapery schema reveals a parallel to and may have been influenced by the work of Delemer (motif of mantle edge below right hand; see *Tournai,* fig. 19). But the Liège interpretation of such motifs is sufficiently distinctive to serve as a basis for the attribution of other works to the same center: directly analogous forms (mantle edge folded over below right hand and formed into a thick V, calligraphic undulations descending to a point) can be seen in the figures of the Rheinberg Altarpiece, for example the St. Peter (Achter 1960, fig. 229), which can be attributed to a Liège atelier on this basis.

De Borchgrave d'Altena 1926, 101–103 ("Tongres?, xveˢ siècle"), and 1930, 16; Devigne 1932, 253 ("commencement du xvieˢ siècle, Art Rhénan"); Derveaux-Van Ussel 1972, 193 ("Limburgs atelier, 2de helft 15de eeuw"); Didier 1982, 162 ("vers 1440"); Didier, in Sint-Truiden 1990, no. 12 ("Meester van de Eyckiaanse Vrouwenfiguren, 1435–40").

73 Saint Anthony Abbot

Liège, c. 1430–40

Oak with traces of polychromy, h. 98

Liège, Centre Public d'Aide Sociale, Volière, inv. xv/2

Fig. 73a St. Paul. Lawrence (Kansas),
Spencer Museum of Art

Among the many statues of St. Anthony, invoked against various illnesses, this impressive, spirited example is notable for its grave, dignified "presence" and the wide-eyed, piercing intensity of his gaze (originally heightened by the partially preserved painted definition of the Saint's pupils). Along with several related works including a St. Maurus in Holsbeek near Leuven (see de Borchgrave d'Altena 1941, pl. 39, located in an area that was formerly part of the Liège diocese and within the sphere of Liège artistic influence well into the first half of the fifteenth century) and four very impressive Apostles in the Spencer Museum, Lawrence, Kansas (c. 1420–30; Schrader, in Lawrence 1969, nos. 54–55; Steyaert, in Gillerman II), it forms part of a group of works whose style might be characterized as half Brussels, half Liégeois. These examples share the somber, expressive head type so typical of a period which has been characterized by the German art historian Wilhelm Pinder as the "Dunkle Zeit."

All of the above were probably carved by Liège sculptors possibly indebted to Brussels models without abandoning their indigenous artistic heritage. The Liège origin of the St. Anthony is certainly unmistakable: the drapery schema of this figure reaches back to a Mosan tradition and is approximately related to that of the less fine, derivative Madonna in the retable from the Beguinage Church in Tongeren (Brussels, Musées Royaux d'Art et d'Histoire; Didier 1982, fig. 21). Typologically it appears closely dependent on the St. Paul, the most progressive statue of the Kansas group, with his characteristically broad, flat, symmetrically undulating Mosan beard ending in small "button" curls (fig. 73a) and in the mantle, drawn out by the movement of the Saint's left arm and pulled across the lower body (cf. a later St. Barbara in Saint-Georges-sur-Meuse; de Borchgrave d'Altena 1930, 18, ill.). Though inevitably differing in detail from this schema owing to iconographic exigencies, the Holsbeek St. Maurus with his characteristic drapery *enroulements* at the Saint's lower right side (perhaps not coincidentally reminiscent in terms of origin of the statuettes in the Hakendover Altarpiece; see cat. 15, fig. 15a, and cat. 21, fig. 21b) also may be seen as a formal forerunner of our work.

Didier 1982, 155–156 ("Liège, vers 1420–30"; with bibliography).

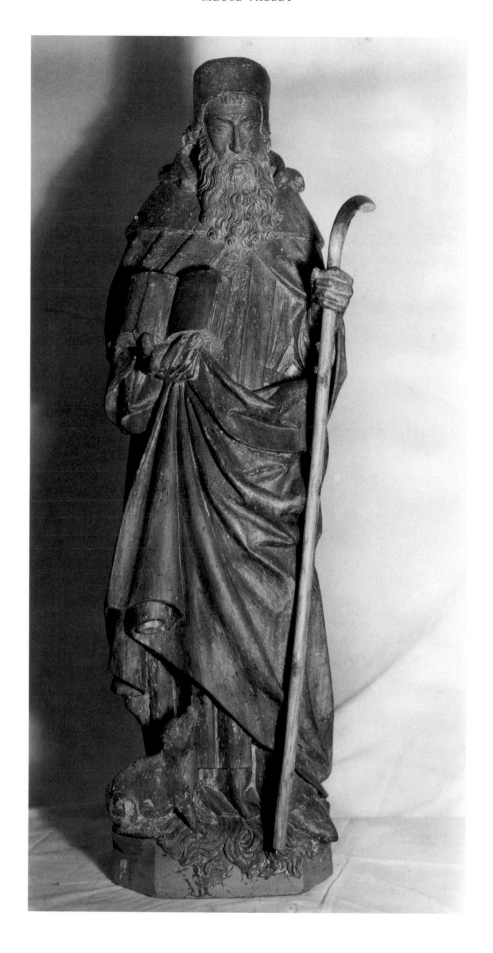

74 Standing Virgin and Child

Liège, c. 1430–5

Wood with polychromy, h. 69

Worm damage; left hand, feet, and lower drapery of Mary lost

Lille, Musée Diocésain, inv. 183

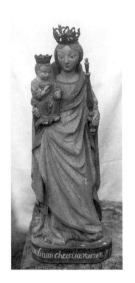

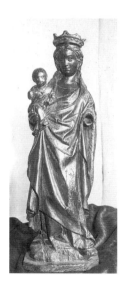

This Virgin with the Writing Christ Child, seemingly unpublished and of unknown provenance, is of considerable art-historical interest. Its presence in Lille and a degree of similarity to Tournaisian works (see cat. 4) may at first sight suggest the possibility of an origin in that center. Closer analysis, however, indicates that it was probably carved by a Liège sculptor during the initial years of the Late Gothic style. Evidence for this conclusion is provided by the disposition of Mary's mantle, a late variant of the c. 1400 style tradition, quite similar to that of two Mosan Madonnas: one in Soy-lez-Durbuy (c. 1420; fig. 74a), the other formerly in Charleroi (c. 1420–30; fig. 74b; for these works, see Didier 1982, 148–149). Together, these works constitute a chronological series that clearly demonstrates the local transition to the Late Gothic: drapery forms are gradually modified from a sharpened flowing system of broad hairpin folds to one of fragmented, fluid triangles, and finally stiffen into a more angular nascent Late Gothic schema. The Mosan (Liège) character of our work is most evident in the head and hair treatment of Mary (quite different from that of the still Beauneveu-inspired types of the two earlier Madonnas) which directly announces those of the sculptures grouped under the name of the Master of the Eyckian Female Figures (see Didier, in Sint-Truiden 1990, no. 12; cf. e.g. head and crown type of both the Virgin and Child to the Madonna in the church of Haasrode; see Derveaux-Van Ussel 1968–70, fig. 44).

Directly related to the Madonna in Lille is a damaged statue of an Angel (or Female Saint?) in the collection of the University Library, Leuven (fig. 74c), that may be attributed to the same hand. Both figures share a highly characteristic Liégeois drapery formulation: the mantle is formed into a series of nested sack folds at the front, drawn up on one side, and trailing to the opposite foot (cf. fig. 74a). It is interesting to observe that this same formula also occurs in the important retable in Rheinberg, traditionally considered as a Brussels production (fig. 74d; Achter 1960; Marijnissen and Van Liefferinge 1967) but almost certainly of Liège origin. Even more interesting, however, is the fact that a damaged sandstone figure of St. Michael recently discovered in the excavations of the Cathedral of Saint-Lambert, Liège, exhibits nearly identical drapery forms, and may thus also be dated to the 1430s.

Fig. 74a Standing Virgin and Child. Soy-lez-Durbuy, Chapelle Notre-Dame

Fig. 74b Standing Virgin and Child. Whereabouts unknown

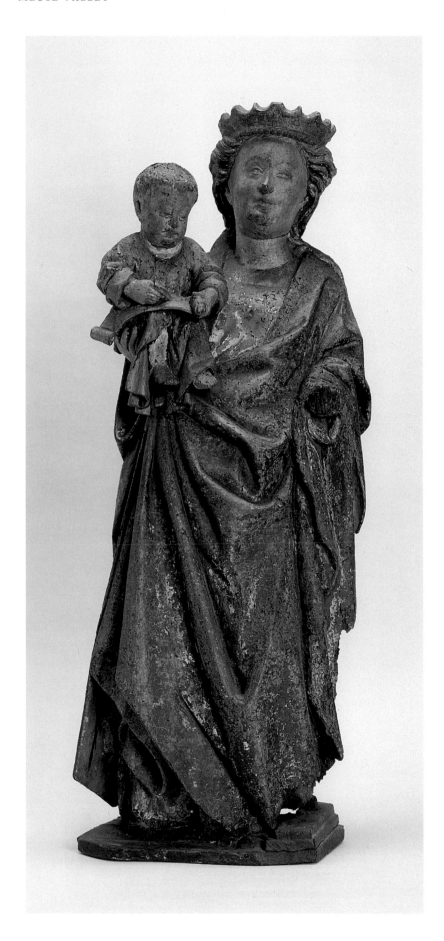

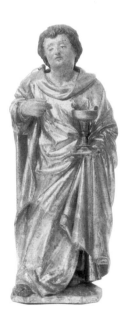

Fig. 74c Angel or Female Saint.
Leuven, Universiteitsbibliotheek

Fig. 74d St. John the Baptist from the
Rheinberg Altarpiece. Rheinberg,
Katholische Pfarrkirche

75 Retable Fragment: Adoration of the Magi

Liège, c. 1440

Wood with polychromy and gilding, 50 x 55 x 17

Marche-les-Dames, Notre-Dame du Vivier

In this delightful Adoration group, the Magi are represented as usual in varied poses, costumes, and ages, and here also races (the Moorish magus seems to make his appearance in Netherlandish art of the second quarter of the fifteenth century). Presumably once part of an altarpiece with narrative scenes and as such especially precious since no complete contemporary ensembles of Mosan origin are known, the fragment has been rightly associated with an unknown Liège sculptor nicknamed the Master of the Eyckian Female Figures, and with related works.

The association of the Adoration with this important series of works, consisting mainly of standing female figures (see cat. 72, 74), is evident primarily in the head type of the Virgin and in certain constant drapery motifs such as the scoop-like mantle edge with a thick V-fold suspended below Mary's right arm, as well as other formulae.

In spite of the artist's *Notname*, the Eyckian character of our group has never been defined, nor is it immediately apparent in either the composition or the head types. But this may be due to our lack of thorough understanding of the earlier developments of the Mosan School, which brings us to the chronology of this work.

The Adoration has been dated to the years c. 1440 in the context of directly related examples in the Meuse area, a chronological position supported by a comparison with the statuettes in the Rheinberg Altarpiece (see cat. 74, fig. 74d and fig. 75a; for this work, see Achter 1960; Marijnissen and Van Liefferinge 1967). Traditionally dated c. 1430–40, the retable can be attributed to a Liège atelier on account of its similarity to the works under discussion. An anchor to link this entire series to earlier Liégeois sculptures is the Pietà in the church of Saint-Jacques (c. 1430; fig. 75b; Didier 1982, 154), very similar in drapery composition to the Marche-les-Dames Madonna (cat. 75) but absolutely identical to the Rheinberg figures with which it shares a heavier and thicker consistency of garments. This

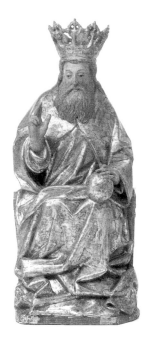

Fig. 75a God the Father from the Rheinberg Altarpiece. Rheinberg, Katholische Pfarrkirche

Fig. 75b Pietà. Liège, Saint-Jacques

Fig. 75c Copy after Jan van Eyck, *Fons Vitae*, detail. Madrid, Museo del Prado

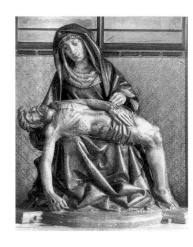

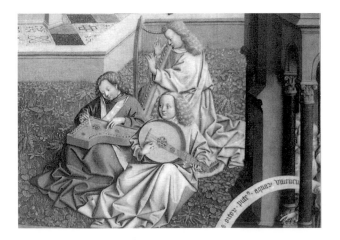

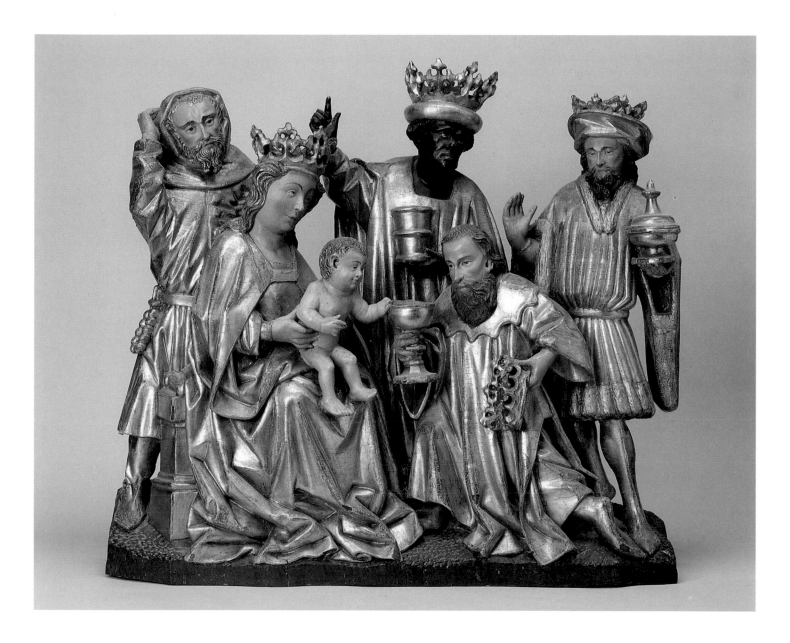

formal solution appears to represent an indigenous Liège tradition, since the Saint-Jacques Pietà seems to be a Late Gothic version evolving from earlier local sculptures (see the Pietà in Diest, cat. 71, fig. 71a), which has retained, albeit in a modified stiffened form, certain basic earlier motifs, most notably the trailing diagonals that swing out from Mary's right knee against the base, where they now break, hook, and twist into a richly complicated series of curvilinear triangles.

Although the question needs further study, this development is not only important for our understanding of Liège sculpture, but has broader implications, since the drapery style of these works is literally the same as that found in the contemporary paintings of the Van Eycks (fig. 75c).

Devigne 1932, 180 ("atelier namurois"); Didier 1982, 158–159 ("sculpteur liègeois, vers 1440").

76　Retable Fragment: Carrying of the Cross

Liège (?), c. 1430–40 (?)

Wood (walnut?), 40 x 24 x 11

Principal losses: part of Cross, left hands of all three foreground figures

Namur, Musée des Arts Anciens du Namurois

No identifiable Mosan narrative retables survive from the fifteenth century. But a number of fragments, such as this group of Christ Carrying the Cross from a Passion retable, can be identified as local products on the basis of both their presence in the area and their style. Especially telling in our example are the "wide-eyed" faces of Christ's tormentors (cf. cat. 73). To a certain extent comparable to our group is a fragment in the Musée Diocésain, Liège, putatively relating to the Arrestation of Christ but more probably part of the Discovery of the True Cross. Directly related but stylistically more advanced are: two groups that recently appeared on the art market (c. 1440; figs. 76a–b); a fragment from a Gethsemane scene closely similar in style, possibly from the same altarpiece as the former and certainly the same atelier; and a figure of St. James (both Liège, Musée Curtius; de Borchgrave d'Altena 1965, 57, pl. XXV, and 61, pl. XXVIII). In spite of their Mosan character, these works mark the unmistakable influence of Brussels models – known to us for instance through the work of Willem Ards (see cat. 24).

Figs. 76a–b Retable fragments with Carrying of the Cross and Flagellation (sale London, Sotheby's, 12 December 1985, no. 83)

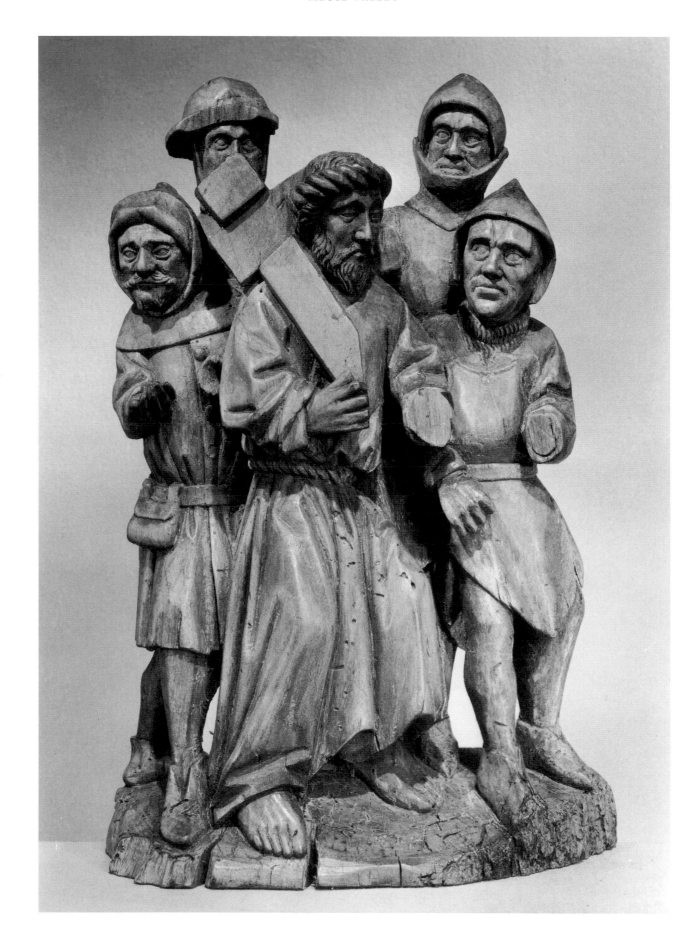

78 Altarpiece of Ollomont

Liège (or Ardennes region?), early sixteenth century

Oak, 138 x 185 x 15

Brussels, Musées Royaux d'Art et d'Histoire, inv. 1454

Fig. 78a Retable group with the Carrying of the Cross. Lokeren, Private collection

Fig. 78b Retable group with the Swooning Virgin. Oslo, Nasjonalgalleriet

Only from the very end of the Late Gothic period in the early sixteenth century do we have preserved to us a group of intact Mosan retables. The Mosan character of this Passion altarpiece, originally in the Chapel of Sainte-Marguerite, Ollomont (province of Luxembourg) has been convincingly identified by Didier, who has attributed it to a local Ardennes atelier. In support of this conclusion can be cited a closely related retable in the church of Bleialf (Kreis Prüm: see Clemen 1927, 35, fig. 17), located north of Trier near the Belgian frontier and therefore in the same general geographic area. To these two should be added a small Passion retable formerly in the W. R. Hearst Collection and now in the Nelson Atkins Museum, Kansas City (see Steyaert, in Gillerman II).

These complete ensembles allow an identification of three stylistically related fragments: an Entombment (Boccador 1974, 2 : fig. 336) and a Christ Carrying the Cross (fig. 78a; Lokeren *s.d.*, 51–52), both in private collections; and an Entombment on the art market (sale London, Sotheby's, 12 Dec. 1985, no. 69), the latter an indifferent atelier work. The style of this series, carved by a number of different hands active in the same or directly associated ateliers in the same center, indicates that they were produced in a *retardataire* workshop in the early sixteenth century. The architectural frame and figure grouping ultimately derive from Brabantine retables of the third quarter of the previous century, although the presence of Borman-inspired, expressive, caricatural male facial types as well as vestimentary detail confirm a late date.

Even though an Ardennes origin appears possible, these works may also have been carved in Liège or at the very least by sculptors trained in this city, where closely related retable groups are known (Mocking of Christ, Centre Public d'Aide Sociale; Martyrdom of St. Erasmus in Herstal, see Lemeunier, in Herstal 1985, no. 11). In addition, they exhibit the unmistakable influence of the Master of the Liège St. Bernard (name work in the Musée d'Art religieux et d'Art mosan; see Didier and Krohm 1977, no. 9) who in spite of his Lower Rhenish roots was surely established in Liège. The numerous works attributable to or influenced by this important sculptor cannot be fully discussed here (see Steyaert, in Gillerman II; Didier, in Sint-Truiden 1990, no. 23). But it is clear that a more complete study of his *œuvre* holds the key to an understanding of the Ollomont retable series. Three enthroned figures in the Martin d'Arcy Museum, Chicago (see Steyaert, *op. cit.*), intermediary between the St. Bernard in Liège and the retables under discussion, in terms of both size and stylistic nuance, can serve as a useful reference point for such a study. For the ultimate stylistic sources of the retables, a group of the Swooning Virgin in the National Gallery, Oslo (fig. 78b; Oslo 1952, 75) by an important Brabantine (Antwerp) or Liège sculptor appears especially interesting.

Didier, in Houffalize 1985, 182–183 ("Début XVIᵉ siècle, Ardennes"; with bibliography).

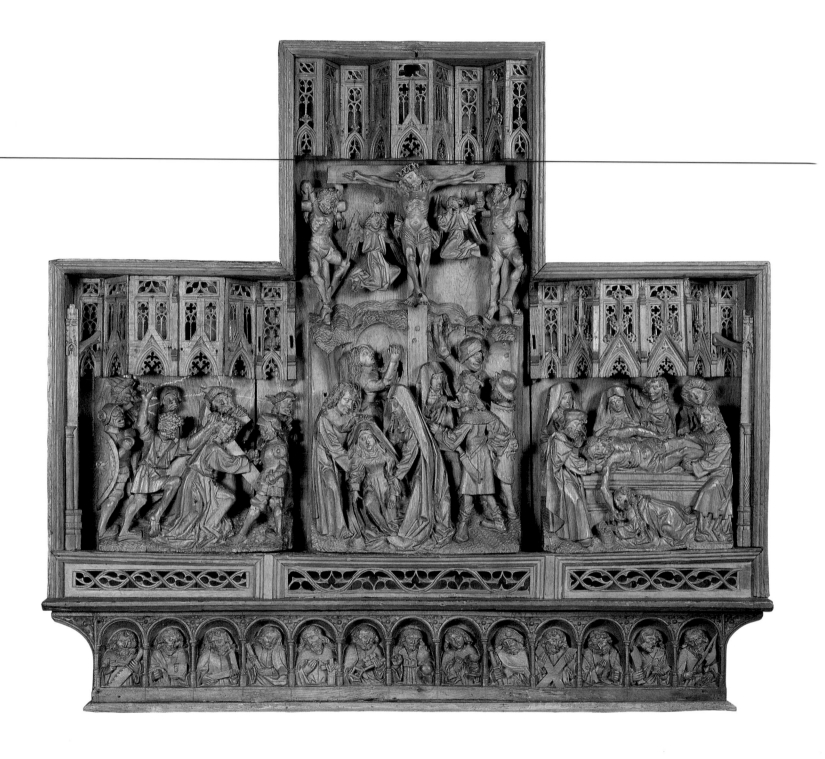

79 Pietà

Utrecht, c. 1430

Oak, h. 40.5

Leusden, Sint-Jozefkerk

Among Netherlandish examples of the Pietà theme, this group holds a special place that parallels the approximately contemporary Madonna from Ankeveen (cat. 81), since it represents a local interpretation of the "Beautiful Pietà," influenced by Central European examples (for these works, see Clasen 1974, *passim*, and Schmidt 1977). Characteristic in this regard are the horizontal position of Christ's upper body, Mary's ample garment, asymmetrically arranged in the lower half in rotating V's at her left leg and pendant vertical undulating edges at her right – a disposition echoed in simplified form in her veil – as well as the poignant conjunction of crossed arms at the right side of the composition. Among German examples, the stone Pietà in Grefrath (Kreis Bergenheim; Krönig 1967, nos. 32–33) offers a reference point for comparison, at least with regard to the drapery (the placement of the arms derives from other German examples). Compared to such models, the Leusden group reveals a stiffer, more frontal and simplified appearance, marked by a greater calm and a degree of reserve. But more importantly and unlike German "Beautiful Pietàs" in which Mary is shown enthroned, she is here seated on a rocky mound symbolizing the historical setting of Golgotha, a typically Western European iconographic solution of Italian origin apparently first developed in sculpture in the Southern Netherlands (see Kutal 1969; Steyaert 1981).

The physiognomic type of Mary and the concentric pattern of thick, interlocking sack-like folds of her garment, while not identical to those of the Ankeveen Madonna, are nonetheless sufficiently similar to propose an Utrecht origin for our group. This localization is of some importance because together with several other examples the Leusden Pietà can be recognized as a distinctive regional Netherlandish type known to us through other small

Fig. 79a Pietà. Leuven, Stedelijke Musea

Fig. 79b Pietà. Aachen, Suermondt-Ludwig-Museum

Fig. 79c Pietà. Church of Hulsel

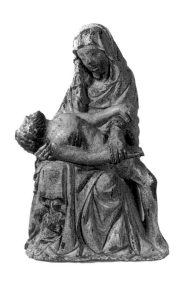

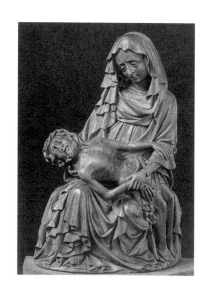

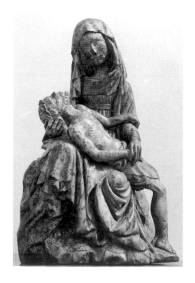

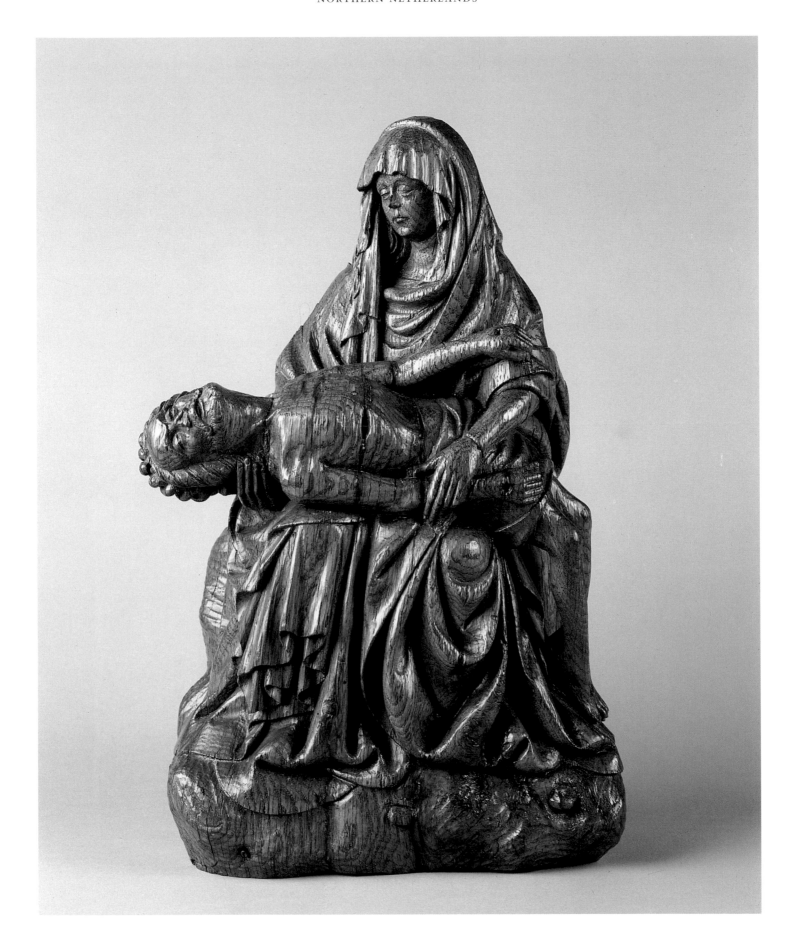

wooden groups. A more compact, simplified example, also of possible Utrecht origin, is in the Stedelijke Musea, Leuven (c. 1430–5; fig. 79a; *Museumstrip Leuven* [1974], no. 20). Of slightly later date is the Pietà in Hulsel (c. 1435?; fig. 79c), in which Mary's knees are placed at different heights, supporting Christ in a diagonal position, probably by a North Brabantine sculptor influenced by Utrecht (relation first observed by Lemmens and de Werdt, in 's-Hertogenbosch 1971, no. 44).

These works can in turn serve to associate other examples outside the Netherlandish area. An interesting case that survives in a region with close trade connections to the Northern Netherlands (see Leeuwenberg 1959) is the provincial and clearly derivative Pietà in the church of Hasvik, Norway (Engelstad 1936, no. 151, pl. 6), no doubt by a local sculptor after an Utrecht model. Also related to some extent is the superb boxwood group in the Suermondt-Ludwig-Museum, Aachen (c. 1420–30?; fig. 79b; Grimme 1977, no. 258), that has sometimes been assigned a Netherlandish origin. It is interesting to note that the facial features of Mary in this group (heavy-lidded eyes set aslant beneath sharply angled brows, a formula related to that of German "Beautiful Pietàs") is quite similar to those of the youthful St. John in the pipeclay relief exhibited here (cat. 91).

More problematic but of great interest is the very fine group in a Paris private collection, attributed to a Lorraine sculptor, presumably on account of its provenance (Boccador 1974, 2 : fig. 207), and clearly related to our series (except that Christ is turned out to the viewer, a solution also common in Netherlandish art). It is difficult to decide whether this work is to be considered as Netherlandish, or rather as an indigenous Lorraine parallel based on the same trans-Rhenish sources.

Bouvy 1947, 155 ("Stichtsch-Hollandsch, betrekkelijk kort na 1500 ontstaan");
Timmers 1949, 55–79 ("tussen Holland en het Sticht, einde der 15de eeuw").

80 Retable Fragment: Adoration of the Magi

Utrecht, c. 1460–5

Oak, 75.5 x 72

Principal losses: both hands of the king standing in the center, and part of the back of the
head of the servant behind him to the right; left hand and several fingers of the right hand
of the page in the foreground to the right

Utrecht, Rijksmuseum Het Catharijneconvent, inv. BMH 144

Of the numerous treatments of this theme so frequently encountered in Netherlandish
retables, this group is surely among the most original in its lively interweaving of the action
as well as in the contrasting psychological characterization of the protagonists. The Christ
Child reaches with obvious delight and enthusiasm to grasp the coins in the cup proferred
by the eldest Magus; Mary retains a sense of restrained, maternal patience and calm, while
the crusty old St. Joseph, his elbow propped up on the back of her throne and his face
drawn into a scowl, appears rather annoyed at the proceedings. The eldest kings approach
with dignified respect; the Moorish magus pauses and gazes off into space, as he intently
listens to the words whispered by a servant. Four other richly garbed assistants also prom-
inently partake in the event: one gently removes a crown; another, represented as a young
black teenager, presents a (lost) cup to his master; a third, who casts a world-weary glance
toward the Child, carries a pair of hooded falcons on his wrist. Throughout, we find a
differentiation of textures in garments and in such details as the woven straw mat (a *"baker-
mat"*?), the latter a detail frequently encountered in Utrecht works (de Jaeger; also in manu-
script miniatures: see New York 1990, no. 16). However, this peculiar detail, probably
symbolizing the Virgin's humility, appears to derive from the art of the German area, where
it appears as early as the fourteenth century (see Stange 1936, 2 : figs. 112, 225; an early-
fifteenth-century instance is the Middle Rhenish painted altarpiece wings in the Utrecht
Museum).

 The Adoration is well known and has long been linked with three stylistically related
retable groups from the Chartreuse of Strasbourg (discussed by Zimmerman, in Karlsruhe
nos. 6–7). As a result, it was at times assigned to an Upper Rhenish sculptor; at present,
however, its local, probably Utrecht origin is no longer seriously contested and has recently

Cat. 80, St. Joseph and two Magi

been buttressed further by comparison with a fragmentary Adoration in a stone retable in the Buurkerk, Utrecht, remarkably similar in its motifs (see Lemmens and de Werd, in Amsterdam 1980, 26–27, no. 35).

The evolution of the Utrecht School after 1450 exhibits a growing, increasingly important assimilation of influences from the Brussels School (rather than late Sluterian, Burgundian impulses as has been suggested), although it should be emphasized that as in contemporary Northern Netherlandish painting, this involves a creative use and not in any respect simply a copying of Brussels models, as often encountered elsewhere.

The Adoration group can be integrated into a formal sequence of Utrecht Epiphanies (influenced by South Netherlandish works - e.g. the same theme in the Laredo Altarpiece, see *Brussels*, fig. 26) which include the earlier Buurkerk fragment (above) and a stylistically related group in Vert-Saint-Denis (Guillot de Suduiraut; cf. dependent Utrecht pipeclay groups, see de Jaeger), both dating in my opinion to the 1450s considering their stylistic equivalence to the works attributed to Jan Nude (Lemmens and de Werd, in Amsterdam 1980, 20–22, no. 31). At the same time, our work seems closely to anticipate the manner of Adriaen van Wesel as seen in his retable formerly in 's-Hertogenbosch (dated 1475–7; cf. cat. 85). It seems reasonable therefore to accept a date in or immediately after 1460.

This question of date is of course of great importance given the close association with the groups in Strasbourg, which appear to represent a direct stylistic extension of our work.[1] This relationship appears far too close to be explained by the intermediary of a graphic model, but is almost certainly due to an execution by the same Utrecht sculptor at a later stage in his career (c. 1470?), who by that time perhaps had settled in Strasbourg. This is not to deny the evident differences between them – the group in Utrecht has rightly been recognized as more traditional (Recht) – but rather to characterize those differences as part of a normal evolutionary process (the work in the exhibition, which has lost its original color, being by no means inferior in quality to the others). Changes seen in the Strasbourg sculptures *vis-à-vis* the work in Utrecht (more restlessly crinkled pictorial drapery surface, more incisive realism and "molded" facial features), which do not, however, represent a fundamental alteration of style, may perhaps be explained by influences of the Strasbourg milieu, and possibly even of his more brilliant compatriot Nicolaus Gerhaert, active in the same city during this time (cf. especially figures in the Nördlingen Altarpiece; Recht 1987, figs. 46–53). It is in any case beyond doubt that the Strasbourg groups, given their extensive influence in the Upper Rhine region and elsewhere in the German area,[2] testify further to the important European significance of the Utrecht School alongside Brabantine centers.

1 An association strengthened further by two presumably Utrecht groups; see sale London, Sotheby's, 21 April 1988, no. 70.

2 Possibly including a St. Barbara in Sitten dated 1474; see Reiners 1943, figs. 153, 155; cf. a beturbaned female at the back of a Circumcision group, in which Didier (1989, 72) sees links with Mosan sculpture.

Leeuwenberg, in Amsterdam 1958, no. 267 ("Noordelijke Nederlanden, derde kwart 15de eeuw"); Zimmerman, in Karlsruhe 1970, 83; Halsema-Kubes, Lemmens, and de Werd, in Amsterdam 1980, no. 35 ("Utrecht? omstreeks 1460–70"; with earlier bibliography); Recht 1987, 201; Guillot de Suduiraut, in Paris 1988, no. 76; Didier 1989, 70; de Jaeger, in Brussels 1992, 71.

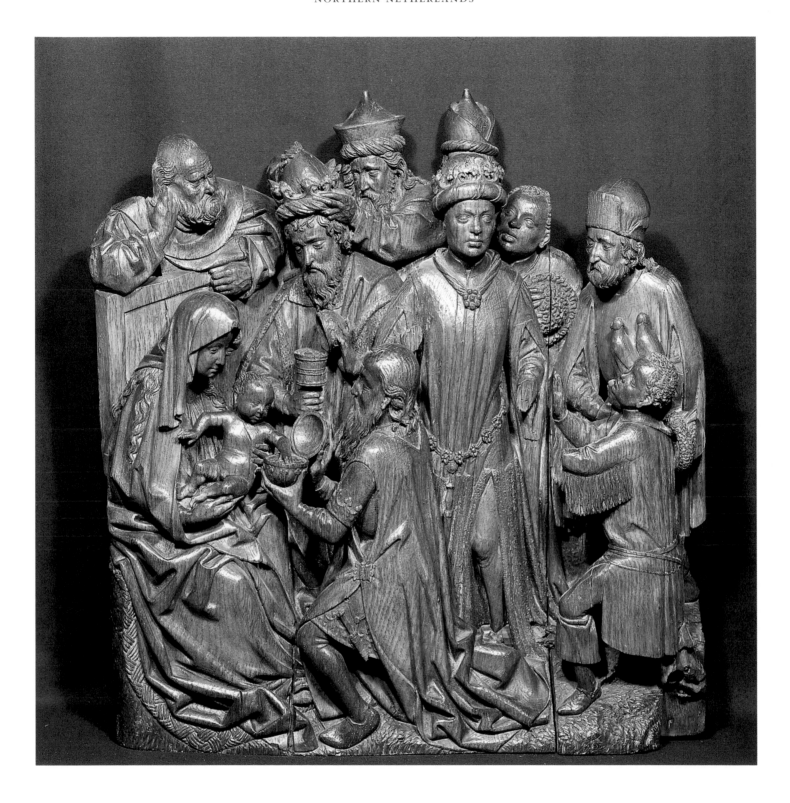

81 Standing Virgin and Child from Ankeveen

Utrecht, c. 1430

Oak with traces of polychromy, h. 130

Principal losses: Mary's crown, right hand and a few fingers of her left hand;

the Child's forearms and left foot

Utrecht, Rijksmuseum Het Catharijneconvent, inv. ABM494

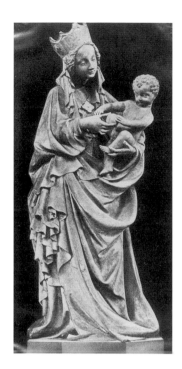

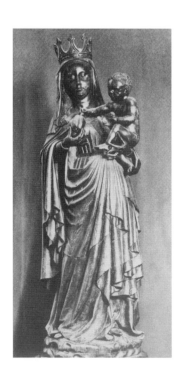

It is safe to say that this Madonna is of seminal significance for an understanding of the Late Gothic School of Utrecht. Its similarity to German works of the Soft Style has often been noted. In effect, it represents a regional North-Netherlandish, almost certainly Utrecht, offshoot of the Bohemian–German "Beautiful Madonna" theme.

The ample asymmetrical drapery composition with its rich deployment of concentric hairpin folds, the cross-legged nude Christ Child reaching for a (lost) object presented by his Mother, along with the treatment of detail such as the way the soft flesh of the Child's leg yields to the pressure of the thumb and forefinger of Mary's (damaged) left hand and the scissor-like way her fingers touch his heel, clearly establish the sculptor's familiarity with Central European models of the Torún (Thorn) Madonna type (fig. 81a; for this type, see Schmidt 1978, 75ff; followed here in mirror-reverse). Evidence that this type was known in the Netherlandish area is provided by a group in Maastricht (see Schürmann, in Cologne 1978, 1:119), variously assigned to a Cologne or Netherlandish origin. Perhaps the closest stylistic antecedent (drapery, veil) for the Ankeveen example is the well-known "Beautiful Madonna" in Gdansk (Danzig) (Schmidt 1978, 85ff; Didier and Recht 1980, 190) which has been attributed to an artist from the Netherlands active in the Baltic region.

The work in the exhibition differs from these in the strictly upright and frontal presentation of Mary's upper body (whereas the lower retains the traditional arching drapery movement) and in its more compact, closed silhouette – aspects that tend to support the relatively late date of c. 1430 traditionally associated with the group. More importantly however, the Ankeveen Madonna introduces a distinctive formulation of this theme followed by a series of later Utrecht Madonnas that enjoyed a widespread European expansion by way of export and influence. The earliest instance is the "Virgen del pimiento" in the Museo Marés, Barcelona (fig. 81b; *Catalogo del Museo Marés*, Barcelona 1979, no. 1.899) which Leeuwenberg (1965a, 242–243) recognized as a Spanish copy after ours or a similar Utrecht example. Although substantially restored, especially in the lower half, the essentially original upper part of this group is so close to ours that it allows a plausible reconstruction of missing elements here, such as the artificial, mannered elegance of the Virgin's hands. The Barcelona group is also interesting in another respect: it was formerly in the convent of Calabazos near Palencia and is said to have been presented to that institution by Constable Alvaro de Luna on the occasion of his marriage to Juana Pimentel, shortly before 1435 (*Catalogo del Museo Marés*, no. 1.899). Since this time of origin is entirely consistent with the style of these Madonnas, this tends further to support an origin immediately around 1430 for both works.

Geisler 1957, 31 ("möglicherweise im Moselgebiet entstanden"); Bouvy 1962, no. 24 ("Middelrijns, omstreeks 1430"); Leeuwenberg 1965a, 242–243 ("stellig Nederlands en waarschijnlijk Noordnederlands werk van omstreeks het midden der 15de eeuw"); Clasen 1974, 214 ("Niederländish, 1. Viertel 15.Jahrhundert"); de Werd, in Cologne 1978, 1:115 ("Nordniederländish, Utrecht?, um 1430").

Fig. 81a Standing Virgin and Child.
Torún, Marienkirche

Fig. 81b Standing Virgin and Child.
Barcelona, Museo Marés

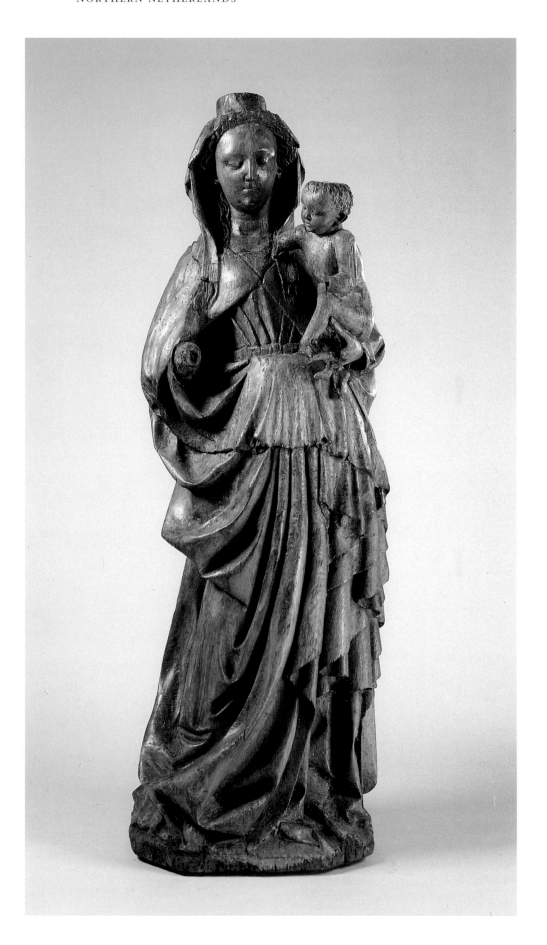

82 Standing Virgin and Child

Utrecht, c. 1440–50

Oak with polychromy, h. 94.5

The part from Mary's knees down to the base is not original

Kortrijk-Dutsel, Sint-Catharinakerk

The Utrecht origin of this work is indicated by its close formal correspondence to a pipe-clay statuette almost certainly produced in that city (see cat. 88). To some extent and at a distance in time it retains certain features of the Ankeveen Madonna (cat. 81): the hollow framing the Virgin's right arm; the prominent sack-like fold directly below; Mary's face (albeit in a fuller, more fleshy variant); and her hair, developed as a dense, flat pattern of regular undulating waves to either side of the face (leaving the ears exposed) and flowing over her shoulders. But whereas the Ankeveen Madonna is indebted to the Central European "Beautiful Style," the present example reveals the impact of the *ars nova* of the Southern Netherlands.

This work has consistently been compared to the paintings of Van der Weyden, but it more closely reminds of the work of his master Campin ("Flémalle Madonna," Frankfurt; see *Tournai*, fig. 27[1]) and of the Van Eycks.[2] Although a specific time of origin is difficult to determine, such comparisons suggest that the group is of earlier date than traditionally assumed, and may be placed c. 1440–50 by way of hypothesis.

It is interesting to note that Recht (1987) has called attention to the Kortrijk-Dutsel Madonna as a possible antecedent for the style of the important Dutch sculptor Nicolaus Gerhaert (active 1462–73). The fact that this work can be shown to be of Utrecht rather than Brabantine origin and probably of relatively early date confirms the soundness of this author's observation and underlines the great interest of this Madonna.

1 The motif of the veil looped over on one side of Mary's head, common in later Utrecht tradition, may have its origin here.

2 Cf. e.g. the drapery forms in the Annunciation Angel in the Ghent Altarpiece, including the loosely pendant calligraphic loop of the mantle edge.

Leuven 1962, no. B45 ("Brabant, 1470–80"); Tournai 1964, no. 45 ("Atelier du Brabant 1470–80"); Smeyers, in Leuven 1979, no. I.9 ("Brabant, ca. 1480–90"); Recht 1987, 21.

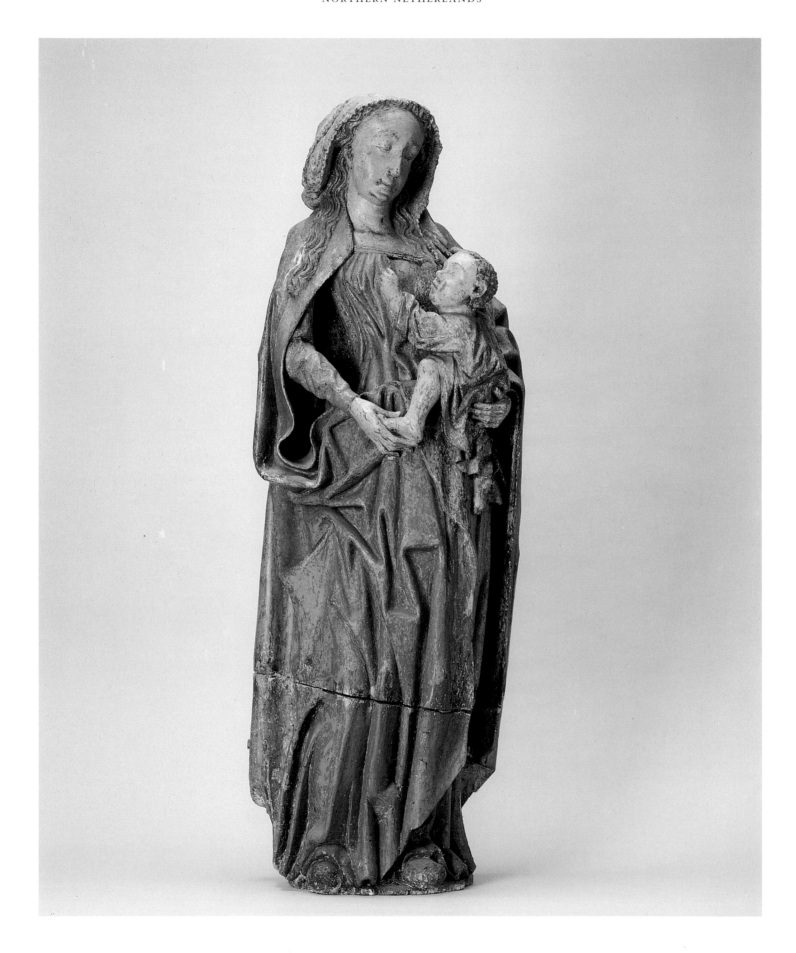

83 Standing Virgin and Child

Utrecht, c. 1450–60 (?)

Wood with polychromy, h. 132

The Child's head, hands and his orb attribute are modern restorations as are (in part) the fingers of
Mary's left hand and the grape cluster (cf. earlier condition in Clemen, fig. 196). The rather intense
polychromy is also of modern date, although based on extensive original remains

Trier, Basilika St. Matthias

Cat. 83, profile view

1 Compare the advancing pose,
armor, and general niche-like spatial
treatment of the cup-bearing Magus
as well as the drapery below the
arm of the beardless king, to the
St. Adrian statue in the Musées
Royaux d'Art et d'Histoire, Brussels;
for the latter, see Didier and Krohm
1977, no. 25.

This Madonna has been called a "hervorragendes Werk der späten Trierer Gotik" ("an
outstanding example of later Trier Gothic"; Clemen 1938). It is all the more significant
therefore that it is probably an import from the Northern Netherlandish School which
exercised such a strong influence in the formation of this style in the Middle and Upper
Rhenish area. Although representative of the Late Gothic style, this Madonna remains a
linear descendant of the group from Ankeveen (cat. 81); compare for instance the Virgin's
facial type, the outspread mannered fingers of her left hand, and the drapery arrangement
with the arching movement of folds from the center to Mary's right foot.

An intermediary stage of development between these two works survives in a
Madonna in the Suermondt-Ludwig-Museum in Aachen (fig. 83a; for this work, which has
been restored yet left intact in its main parts, see Grimme 1977, no. 150) which is therefore
probably also of Utrecht origin and possibly dating c. 1450.

Stylistically, the crinkled pattern of the St. Matthias Madonna's folds is quite close to
those seen in the Kortrijk-Dutsel Madonna (cat. 82), although somewhat sharper and more
complex in character, suggesting a somewhat later date, soon after 1450. While its Utrecht
origin is evident solely on the basis of typological and stylistic evidence, it is reassuring that
this localization can also be supported by historical circumstances. The abbey of St. Matthias
is known to have maintained close contacts with the Northern Netherlands; and from 1451
until 1519, the abbey was administered by abbots from the Northern provinces (Clemen
1938).

Additional monumental evidence in this regard is provided by stone statues of the
Magi preserved in the same church, recognized as of North-Netherlandish origin c. 1455
by Lücker (1924, 41ff). Although the author's attribution of these sculptures to the youthful
Nicolaus Gerhaert has been rightly rejected, their "proto-Gerhaertian" character is indeed
evident.[1] It appears likely that this early "Dutch connection" best known through the
Netherlandish-Moselle area activities of Nicholas Cusanus (1401–1464), can also help
explain Gerhaert's commission of the tomb of Archbishop Jakob von Sierck (1462; for this
question, see Schmoll gen. Eisenwerth 1967, 215; for the tomb, see Schommers 1990).

Clemen 1938, 254 ("Trier um 1480").

Fig. 83a Standing Virgin and Child.
Aachen, Suermondt-Ludwig-
Museum

84 Female Saint

's-Hertogenbosch c. 1450–60
Wood with polychromy, h. 82
Principal losses: upper part of right thumb and part of the base
Antwerp, Kunsthistorische Musea, Museum Vleeshuis, inv. AV 5501

This Female Saint, who cannot be identified for lack of a specific attribute, is almost certainly of North Brabant origin. By no means an innovative work, it is nonetheless an interesting example of Netherlandish production at a more provincial level. In view of its overall style and motifs (head type with high bombé forehead, broadly undulating hair-waves, pearled headband) it is akin to the works of the Master of Koudewater, active c. 1460–70/80 in 's-Hertogenbosch (whose *œuvre* was first defined by de Werd, in 's-Hertogenbosch 1971).

Among the many works associated with the circle of this anonymous and delightful artist, our work comes closest to sculptures such as a Female Saint and an Annunciation Angel in the Rijksmuseum, Amsterdam (de Werd 1971, nos. 22, 53), which are generally associated with followers active toward the end of the century, but which are probably among the earlier examples of this group. This appears in any case to be true of the Vlees-huis Saint in which the influences of Utrecht models (ultimately determining for the entire Koudewater series) are (still) quite strong: in the drapery composition, head type, and the overall pictorial surface treatment it more closely recalls Utrecht works from the mid-century (see cat. 82).[1] As such, it differs from the presumably later "core" works of this series such as the St. Catherine in Amsterdam (see de Werd 1971, no. 1) which shows a crisp, graphic character that is indicative of a more advanced stylistic development.

Van Herck 1948, no. C13 ("einde der 15de eeuw").

1 For a possible "missing link," see a Female Saint (c. 1450?; sale Cologne, Lempertz, May 1986, no. 1214), probably the direct model for our statue.

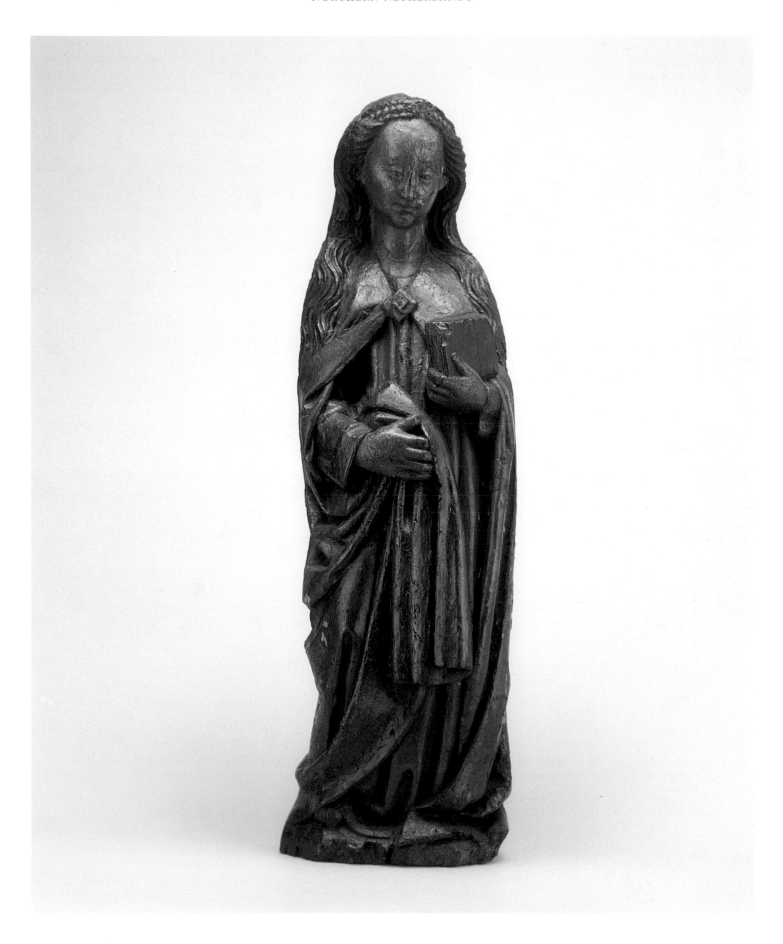

85 Retable Fragment: Virgin in Prayer from an Annunciation

Adriaen van Wesel (Utrecht c. 1417–c. 1490)

Oak, 46 x 40 x 13

The drapery at the lower left from the knee down is renewed;

the mantle edge at the Virgin's left arm is possibly recarved

Bruges, Gruuthusemuseum, inv. 0.154.v

That Adriaen van Wesel played a dominant role in the Utrecht milieu of the second half of the fifteenth century is testified to by both written and monumental evidence.[1]

The varied aspects of this important sculptor's art cover a considerable thematic and expressive range, including simple but profoundly human (characteristically "Dutch"?) genre scenes of a charmingly intimate and homespun character (Holy Family group in Utrecht; Amsterdam 1980–1, no. 13). Within the evolution of the Utrecht School, this master's work also represents the impact of the rhythmic, linear, neo-courtly style developed in the Tournai–Brussels milieu, as evident in his well-known Visitation group (*Ibid.*, fig. 7) where the broken S-curve of the Virgin's pose is clearly based on types introduced in paintings by Van der Weyden. He also appears to have been familiar with Brussels sculpture of the mid-fifteenth century (the time of his youth) as suggested by a comparison of his idealized female head types with the Brussels Madonna in this exhibition (cat. 19) as well as by confrontation of the latter work with the St. Barbara statuette in 's-Hertogenbosch (*Ibid.*, fig. 12), probably carved in the master's atelier, which exhibits a similarly elegant stance and long diagonally flowing drapery lines.

The Bruges Virgin in Prayer, presumably once part of an Annunciation group of which the Angel is lost, is believed to come from the retable of the Onze-Lieve-Vrouw Broederschap in 's-Hertogenbosch, Van Wesel's only (partially) surviving documented work (1475–7). It is perhaps significant that within the *œuvre* of this very original artist as we know it, this very fine figure appears to be the only one that can be traced with absolute certitude to a previous prototype. As has always been recognized, the Virgin, shown seated on the ground in a position emphasizing her humility, is based on the work of the Tournai painter Robert Campin (either the Mérode Triptych or a variant by the same painter known to us through a copy in the Prado; cf. fig. 85a, and *Tournai*, fig. 15).

That the author chose a model which by then was a half-century old is interesting *per se*: Mary's pose, absorbed in reading, as yet entirely unaware of the Angel's presence, represents a most unusual iconographic solution rarely if ever followed in later Southern Netherlandish works (significantly, the well-known copy in the Brussels Museum [Friedländer 1967, 2:pl. 80] differs mainly in the changed pose of Mary). However, it does appear in earlier Northern Netherlandish art, in the work of the illuminator the Master of Catherine of Cleves (Hours of Catharina van Lochhorst, c. 1440–50; New York 1990, no. 47), another Utrecht artist who was thoroughly acquainted with Southern sources which he incorporated into a highly personal style.

1 Our present understanding of the artist and the identification of his works was made possible by years of detective work on the part of a series of scholars, culminating in the important 1980 Van Wesel exhibition in Amsterdam.

Leeuwenberg 1967, 54–56; Vermeersch 1969, 164–165; Lemmens and de Werd 1971, 171; Amsterdam 1980, no. 6; Vandenberghe 1984, 154; Koldeweij 1990, no. 133; Halsema-Kubes 1992, 150; Bruges 1992, no. 32.

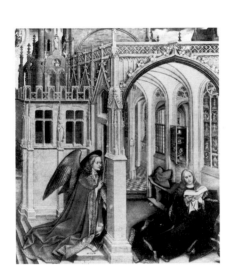

Fig. 85a After Robert Campin,
Annunciation. Madrid, Museo
del Prado

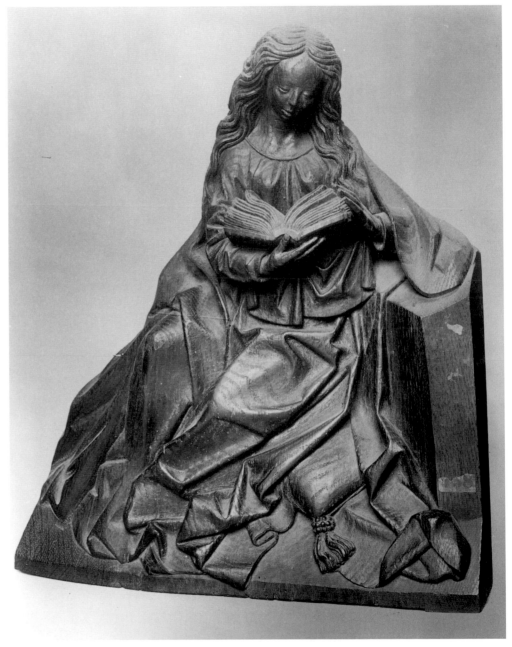

86 Standing Virgin and Child

Cleves–Guelders (?), c. 1430

Oak, h. 62

Right arm and both feet of the Child are missing; base damaged

Utrecht, Rijksmuseum Het Catharijneconvent, inv. ABM BH 262

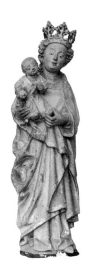

Fig. 86a Standing Virgin and Child from the Tongeren Beguinage Altarpiece. Brussels, Musées Royaux d'Art et d'Histoire

Fig. 86b Standing Virgin and Child. Private collection

The Cleves–Guelders region is represented in the exhibition by only two works dating from the beginning and the end of the fifteenth century. This small group appears to be the north-eastern Netherlandish counterpart to the Utrecht Madonna from Ankeveen (see cat. 81). As has been observed (Bouvy), it exhibits an association with Bohemian–German "Beautiful Madonnas." For an understanding of the genesis of this type, it can be meaningfully compared to examples in St. Foillan, Aachen (c. 1411?; see Schürmann, in Cologne 1978, 1:126–127) and in St. Maria Lyskirchen, Aachen (c. 1420; Clasen 1978, fig. 74) in that order.

Within this filiation our work occupies a somewhat later stage: it maintains the frontalized character of the Madonna in Cologne, but renders the drapery in a more reduced, simplified format. While still closely dependent on Cologne models (facial type and hair treatment of Mary, cf. Madonnas in Cologne Cathedral and in the Gruuthusemuseum, Bruges; see Cologne 1978, 1:85, 188–189), it appears to represent a regional Cleves–Guelders variant. Possible evidence for this assumption is the typological similarity of the work under discussion to a yet more simplified version of this type in a Madonna from a church in Roermond, now in a private collection (c. 1430).[1] As is true of the Madonna from Ankeveen, this statuette presents some intriguing links to other versions of this theme that require further study. The pose and head of the Child appear related to the well-known and much finer Darsow Madonna, formerly in Lübeck Cathedral, a work that has always been recognized as indebted to "Western" tradition (Hasse 1983).

Equally interesting are certain points of similarity ("wrapped in" left arm, drapery edges at base) to a "Beautiful Madonna" in a Liège private collection which has been plausibly localized to Cologne (fig. 86b; Didier and Krohm 1977, no. 11) and which thus provides further evidence of the "background" of our work. But it is interesting to note that this important work has a local provenance (it was formerly in a church in Huy; see Devigne 1932, 57) and is representative of a Cologne style (or perhaps a Cologne-based Liège style?) that may have contributed to the formation of the so-called Master of the Eyckian Female Figures (fig. 86a; cf. facial types, e.g. cat. 72, exceptionally bald [!] Child; cf. Madonna in retable from Tongeren Beguinage, in Musées Royaux d'Art et d'Histoire, Brussels).

Vogelsang 1911, 1:no. 9 ("Niederrheinische Arbeit, um 1430"); Bouvy 1962, no. 46 ("Gelders-Kleefs, omstreeks 1430").

1 De Werd (in Cologne 1978, 1:116–117) favors a Mosan origin.

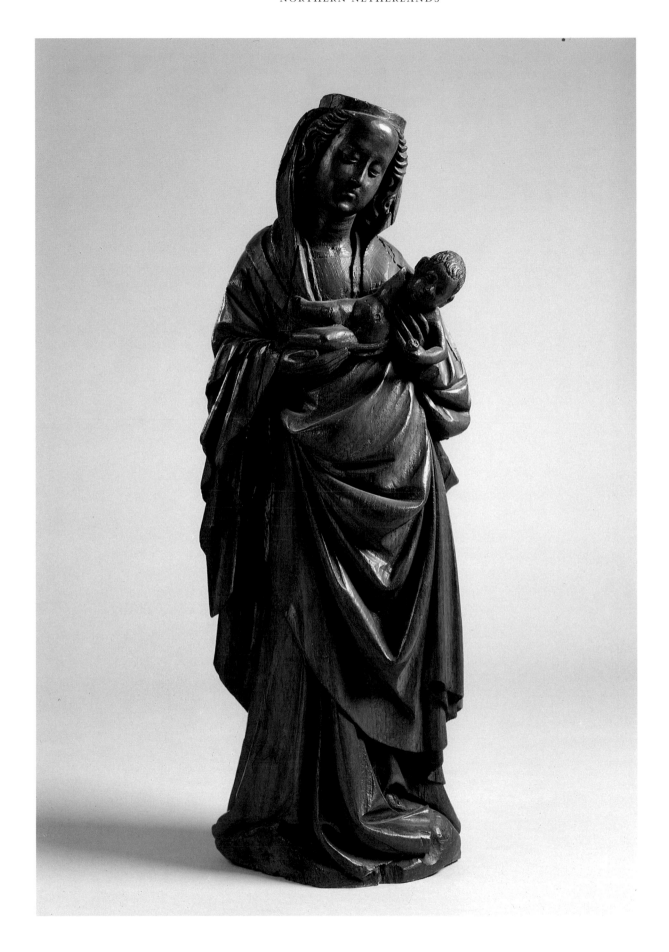

87 Saint Sebastian

Master Arnt (van Zwolle)
Northern Netherlands, c. 1480–5
Oak, h. 125
Surface heavily cracked; arrows missing
Ghent, Museum voor Schone Kunsten, inv. 1903–L

Fig. 87a Christ on the Cross, detail.
Mons, Couvent des Filles de Sœur
Marie-Vianney

Fig. 87b *Schmerzensmann*, detail.
Oostrum, Rooms-katholieke
parochiekerk

This lively and expressive St. Sebastian, tied to a tree and pierced by arrows (now missing), who in spite of the horrors of his martyrdom maintains an elegantly chiastic, cross-stepping pose, is a fine representative of the Late Gothic style of Cleves-Guelders. In the artistic domain, this region in the north-eastern part of the Burgundian Netherlands occupied a place of considerable significance, especially in the years c. 1400.

The formation of the Late Gothic style appears to have been dependent on both the Brussels and Utrecht Schools, although the developments here always exhibit an original and unmistakably local character. A modest series of statuettes of Apostles and Christ from a choir screen or retable in St. Nicolai, Kalkar, dating toward the mid-fifteenth century are important as early manifestations of the new style, especially since at least two of these figures are clearly inspired by Utrecht pipeclay models (SS. Peter and Andrew; see Meurer 1970, fig. 254; for the comparable pipeclay figures, see Leeuwenberg 1965, figs. 2–3). A number of later works in the same area also appear to reflect Utrecht influences, or can be recognized as imports from this city, most notably the exquisite SS. Agnes and Catharine in Emmerich (Halsema-Kubes, Lemmens and de Werd, in Amsterdam 1980, no. 43). Meurer has detected Brabantine influence in two statuettes of SS. Cosmas and Damian in Cleves (c. 1460, Museum Haus Koekkoek), which may depend on the work of the Master of the Arenberg Lamentation.

But it is in the work of Master Arnt, active in Kalkar and Zwolle (1460–92), that these influences are combined into a highly personal style that was to have a determining artistic impact in the Lower Rhine region and beyond.[1] The Ghent St. Sebastian has long been recognized as among the foremost works by this fascinating sculptor. The Saint's rhythmic, expressive ornamental pose, also known in the *œuvre* of Nicolaus Gerhaert and in Master E.S.'s engravings, may have its origin in the Tournai–Brussels milieu in the second quarter of the fifteenth century (see the Christ in the Lille Trinity, cat. 5).

Further evidence in this regard is provided by a comparison of a Christ in Mons (fig. 87a; de Borchgrave and Mambour 1972, 40), probably by a Brussels sculptor and perhaps dating as early as the years c. 1450–70, to one of Master Arnt's masterpieces, a *Schmerzensmann* in Oostrum (fig. 87b; see Meurer 1970, 59ff). The head of this Christ, based on Van der Weyden's style but softening this painter's taut asceticism by a more refined, ornamental treatment of detail, appears to provide an immediate source for Master Arnt, suggesting an initial training of the sculptor in the Brussels milieu (cf. Gorissen 1965, 28: "One might be inclined to think that he learned the trade in Brussels").

Meurer 1970, 59 ("c. 1483–90"); Didier and Krohm 1977, no. 36 ("vers 1480–5").

1 His range of influence extends into the Meuse area by the years c. 1500, notably in the works of the Master of the Liège St. Bernard.

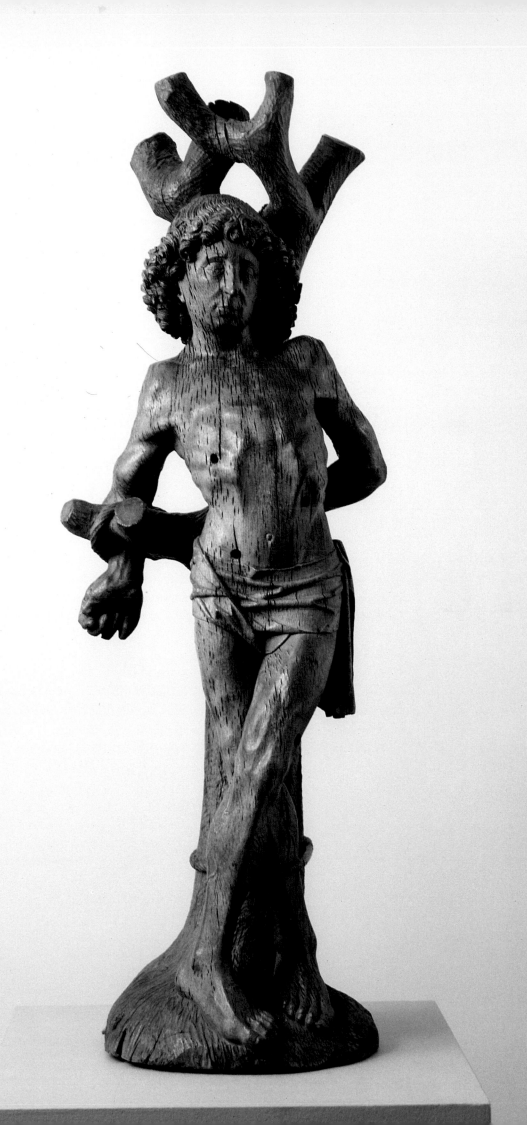

88 Standing Virgin and Child

Utrecht, or after an Utrecht model of c. 1450

Pipeclay with traces of polychromy, h. 38.3

Antwerp, Museum Mayer van den Bergh, inv. 2165

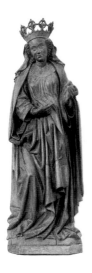

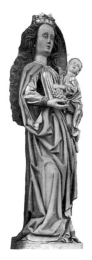

This exquisite statuette represents one of the most influential types of the Utrecht School. The existence of very similar much larger works in wood (see especially cat. 82 and 83) tends to support the idea that such pipeclay statuettes were inspired by more monumental sculptures. At the same time, the very fine quality of this example, with its elegant S-curving stance, lively drapery edges, and intricate detail is by no means inferior to that of its larger sisters. As in the case of thirteenth-century Madonna sculptures of Northern France, where similar parallels and differences of formal types exist between monumental portal figures in stone and statuettes in ivory, we seem to be dealing here with two different stylistic modes related to a more public cult function versus a more intimate private use.

The question of the origins and influence of this Madonna type requires a great deal more study. For instance, it has close parallels in works in the Mosan area, where comparable pipeclay figures were also produced in a Liège atelier (examples in Musée Curtius). Among the most notable is a wooden statue of the Virgin or Female Saint in Heusden-Zolder (fig. 88a; see Didier, in Sint-Truiden 1990, no. 14). Given the importance of the Mosan School and the features of this work, one might be tempted to see it as a possible source of the Utrecht tradition. But a close analysis indicates otherwise, suggesting that the Heusden-Zolder statue is in fact a fascinating hybrid work, carved by a Liège sculptor as evident in the upper body and especially the head (cf. cat. 72) and based on Utrecht models for the rest (cf. also the Utrecht Madonnas in Kortrijk-Dutsel and Trier, cat. 82 and 83).

No single other Utrecht Madonna type appears to have been more influential; besides numerous other pipeclay examples, a small wooden copy from Möja (Stockholm, Statens Historiska Museet; Rydbeck 1975, 4 : fig. 86), a version in cast iron in the Boston Museum of Fine Arts (Netzer 1991, no. 45) may also be cited. Large-scale examples, inspired either by pipeclay models or by larger Utrecht works, are common throughout Europe, for example in the Lower Rhine region (see e.g. fig. 88b, a free copy in Sonsbeck; Essen 1974, 2 : no. 142).

De Coo 1969 ("Luik naar Utrechts voorbeeld, omstreeks 1460/70"; with bibliography).

Fig. 88a Female Saint. Heusden-Zolder, Sint-Willibrorduskerk

Fig. 88b Standing Virgin and Child. Church of Sonsbeck

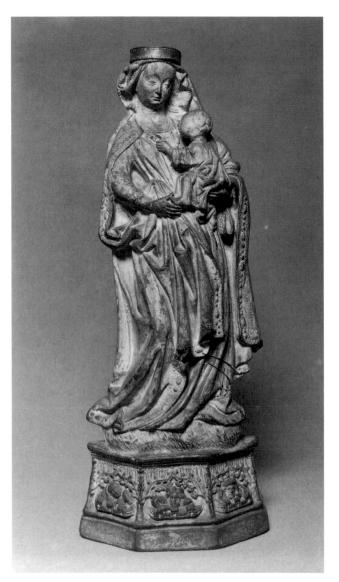

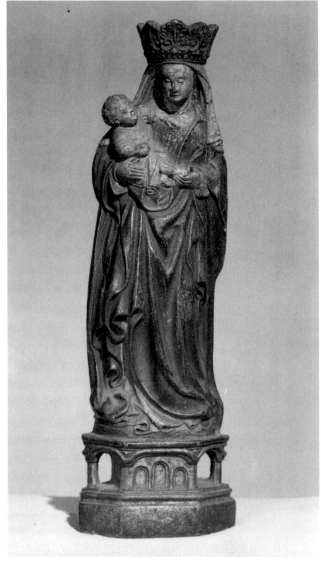

Cat. 88

Cat. 89

89 Standing Virgin and Child ("Notre-Dame de Foy")

Utrecht, seventeenth century, after an Utrecht model of c. 1420–30

Pipeclay with polychromy, h. 22.1

Antwerp, Museum Mayer van den Bergh, inv. 2312

This very modest statuette, although probably made as late as the seventeenth century (de Coo) is of great interest to the student of fifteenth-century Netherlandish sculpture. Along with numerous other identical works in pipeclay, it follows a model produced by Utrecht *"beeldenbakkers"* making use of molds sometime in the years c. 1420–30 and exported as objects of popular devotion to all parts of Europe (see Van Vlijmen and Caron, in Utrecht 1982, 12–21; for pipeclay retables, see Brussels 1992).

These sculptures provide an interesting insight into the artistic situation in Utrecht during the 1430s. The emergence of the Late Gothic in this city combines the local c. 1400 style tradition, linked with Lower Rhenish developments (Cologne?), but already colored by Eyckian influences since the 1420s, with important artistic stimuli from the Southern Netherlands (Campin; transmitted by way of sculpture?) into a distinctly Utrecht synthesis.[3]

Although Utrecht pipeclay products were known in Bruges as elsewhere in the Southern Netherlands (see cat. 91), few examples appear to survive in the city.[4] However, an important documentary reference concerning pipeclay export by way of Flanders survives in a text apparently unnoticed by specialists of this subject. On July 21, 1445, the aldermen of Bruges fined a certain Pieter of Dordrecht "because he had had five baskets and two crates with 'baked stone' statues shipped from Holland to the Zwin [Bruges' seaport], subsequently transshipped them to Saint-Omer and thus circumvented the Bruges staple."[5] This appears to represent the earliest known mention of the Northern Netherlandish trade in these works.

3 This observation also seems valid for the *œuvre* of the illuminator, the Master of the Hours of Catherine of Cleves.

4 A fine Madonna relief said to have come from Bruges is preserved in the Liebighaus, Frankfurt; see Maek-Gérard 1981, no. 98.

5 "... dat hij vijf manden ende twee kisten van ghebakenen steenine beelden die hij ute Holland hadde ghedaen commen tote int Zwin, aldaer versceipt hadde in een scip van Sint Omaers, zonder ten stapele ghebracht te zine." Published by Gilliodts-van Severen 1873, 207.

Fig. 90a Standing Virgin and Child. Former Arens Collection

Fig. 90b Standing Virgin and Child. Leuven, Stedelijke Musea

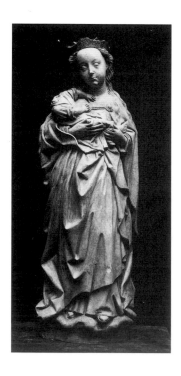
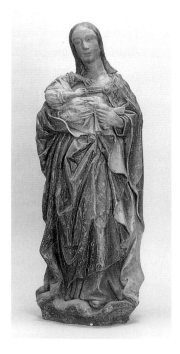

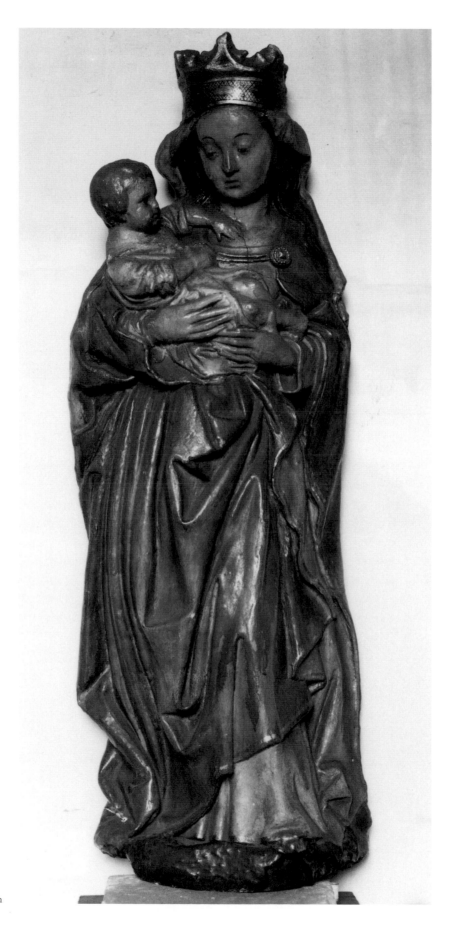

Cat. 90, before the 1994 restoration

91 Fragment of a Calvary Relief with Saint John

Liège, after an Utrecht model of c. 1430–40

Pipeclay, 23 x 15

Liège, Musée Curtius, inv. 24/176

This fragment of a Calvary scene showing a mourning St. John, two Angels and the legs of a Crucified Christ is an exceptionally crisp and therefore presumably early version of a composition known through several complete reliefs of various quality in pipeclay and one in papier mâché (Leeuwenberg 1965, 159–160; Ohnmacht 1973, 52–55). A relief in the Württembergisches Landesmuseum, Stuttgart (Baum 1917, no. 368) appears to represent the earliest state of this series, closely followed by our fragment, which is more simplified in detail (e.g. the Latin inscription in the halo is eliminated). Other examples, including a late, more summary relief in the Museum in Schwerin (Hegner 1983, no. 128) and an apparently unrecognized variant in Bruges (inset in the facade of a private house, 14–16 Westmeers; see Devliegher 1968, 384, fig. 806), testify to the wide-ranging distribution of these interesting works.

In view of its provenance this relief is almost certainly of Liège origin, where such works are known to have been produced (see Leeuwenberg 1965). But there is strong evidence to suggest that these Mosan examples closely follow Utrecht models. The head type of St. John with his rounded cheeks is familiar from pipeclay figures as well as other sculptures produced in that city (e.g. a stone St. Martin from Utrecht Cathedral, now attributed to Jan Nude; see Haslinghuis and Peeters 1965, 2). The figure style of these reliefs appears closely related to that encountered in Utrecht miniature painting by early followers of Van Eyck, notably the masters of Zweder van Culemborg, active c. 1415–40 (especially the Egmont Breviary; see New York 1990, 97–116). Circumstantial evidence for the time of origin is provided by the fact that the mourning Virgin in these Calvaries has an exact counterpart (copy?) in two missals produced for Delft use that have been dated c. 1440 (New York 1990, 185ff, fig. 93; see also Marrow 1978, figs. 46–48).

92 Relief: Saint George Slaying the Dragon

Liège, after an Utrecht model of c. 1430–40

Pipeclay, glazed, 31 x 20.5

Broken in several places; triangular fragment missing lower left

Liège, Musée Curtius, inv. 19/6

1 Cf. a mediocre echo in a manuscript sold in London, Sotheby's, 5 Dec. 1989, no. 119.

2 Comparable to the horses of the Just Judges and the Soldiers of Christ in the Ghent Altarpiece, but quite different from Campin and Van der Weyden's more stylized International Gothic horses.

3 For Van Eyck's St. George paintings, see Hand and Wolff 1986, 246–253.

The fact that this relief, discovered in the rue Entre Deux Ponts in Liège, is also known in a very similar but pictorially more elaborate miniature in a (Bruges?) Book of Hours in the Pierpont Morgan Library (fig. 92a; Detroit 1960, 383–384, no. 201)[1] indicates that both are based on a lost fifteenth-century panel painting.

The Eyckian character of this work is suggested by such details as the robust horse with pointed ears and ornamental trappings,[2] as well as the carefully detailed armor and the fine scimitar of the Saint. The miniature in New York, where the Saint's weapon is a less exotic, Western-style sword, includes other Eyckian details: fissured rocks, a flight of birds in a V-formation, shiny highlights in the Saint's armor. It is therefore tempting to see in this work a (partial?) reflection of the (lost) treatment of this subject by Jan van Eyck.[3]

It appears likely that the relief follows an Utrecht model, as suggested by its overall format and certain details (framework with rosettes; inscriptions, including inscribed halo), as well as by the Saint's facial type, known in other pipeclay figures produced there.

Gaier 1960–1; Philippe 1971, 76 ("Liège, xvᶜ siècle").

Fig. 92a St. George Slaying the Dragon from a Book of Hours. New York, Pierpont Morgan Library, Ms. M.421

312

93 Calvary Relief

Liège (?) after an Utrecht model of c. 1420 (?)

Pipeclay, glazed, 42 x 32

A few cracks

Amay, Musée communal d'Archéologie et d'Art religieux

This rather mediocre but fascinating relief of a Calvary scene reflects an exceptionally important, presumably lost composition, probably a painting, dating around the year 1420. The theme of Christ's death is rendered in terms of high-pitched drama: at right, a tightly crowded group of the centurion and two other figures, one of whom is the Jewish high priest (shown wearing a bishop's mitre) press menacingly close to Christ; opposite, Mary is shown in a pathetic collapsing pose comforted and bewailed by the three Maries and St. John.

In spite of the awkward rendering of detail (the stereotypical inexpressive faces, awkwardly joined hands of St. John), the vivid intensity of action and dramatic contrasts, as well as the macabre detail of the grinning skull of Adam at the base of the cross, provide some intimation of the importance of the original.

Although this relief, with its provenance in the abbey of Paix-Dieu, may well have been produced in Liège, its origin in or dependence on Utrecht models is likely. The head of St. John with its sharply angled brows and floating lateral haircurls is clearly a weaker version of that in the Calvary fragment in the exhibition (see cat. 91; as noted by Lemeunier), and also displays characteristic Utrecht details such as the molding with rosette motifs.

It is of course interesting to speculate on the source of this influential composition, also known in other works (see cat. 95), which exhibits a vaguely early Eyckian character without being directly based on any single known painting. The poignant contrast between the cruelty of Christ's tormentors and the huddling mourners reminds one in general spirit of Jan van Eyck's Calvary Diptych leaf in New York (Metropolitan Museum; see Friedländer 1967, 1 : pl. 36), a composition well known in the Utrecht School of painting, while certain figures such as the centurion represent Soft Style formal types that survive in early Eyckian miniatures (see cat. 70; pose and drapery of St. Peter in Arrestation miniature, Turin-Milan Hours, see Friedländer 1967, 1 : pl. 29).

Lemeunier, in Huy 1990, no. 125 ("Utrecht ou Liège?, seconde moitié du xvᵉ siècle").

Ivory and Alabaster

94 Standing Virgin and Child

Flanders (Bruges or Ghent?), late fourteenth century

Ivory, h. 27

Thin vertical cracks

Aalst, Hospitaal van de Zusters Augustinessen

Fig. 94a Relief on a church bell. Münster, Überwasserkirche

1 Written references are unfortunately scarce; for the years c. 1400, besides the expatriate Jean de Marville, we have a reference to Pierre Aubert, "tailleur d'ivoire," mentioned in Tournai in 1379 and 1389, whose brother was, significantly, active in Paris; see Cloquet and de la Grange 1887, 84.

The carving of ivory statuettes and reliefs during the Gothic period, normally produced in specialized workshops, was long associated almost exclusively with French, and particularly with Parisian ateliers. It has become increasingly clear, however, that such works were also produced elsewhere, including the Netherlandish area, especially during the closing Middle Ages.[1] This statuette is among the finest of these. Although its Netherlandish character appears evident from its general similarity to the work of Beauneveu, it remains relatively isolated in its specific appearance (except for a comparable work in the Staatliche Museen, Berlin) among ivories in the Netherlandish area. Certain details of this figure have parallels in the region of Flanders. The peculiar hair treatment of Mary, set out from the head in thick, twisted strands and forming a sharp semi-circular hairline at the forehead, is found in a number of Bruges sculptures (a chimney lintel with Annunciation relief, from a house in the Mariastraat; see Vermeersch 1969, no. 302, possibly c. 1350–70). Furthermore, the drapery forms are not unlike those encountered in (later) works in Ghent such as the alabaster statuette in Sint-Pieter's (cat. 98) and Jacob de Baerze's retables (oblique crossed "collar" folds at upper mantle, rolled-up "apron" fold edges; see cat. 98, fig. 98c).

Far more interesting, however, is the fact that this work can be linked to a late-fourteenth- or early-fifteenth-century Netherlandish style current (with links to Paris) that extends north-eastward into Westphalia and the Baltic area, so clearly defined by Paatz (1956, 42ff; 1967, *passim*). An especially important "relay" point for this influence can be seen in the Annunciation and Madonna reliefs decorating several church bells, including one in the Überwasserkirche, Münster (fig. 94a), and a partly identical example of Coesfeld, signed by a "Johan smit ut Henegaven" ("Johan blacksmith from Hainaut"; Pescatore 1918, 93–102; Hilger 1961, 106–111, who rightly associated these important reliefs with Tournai: the Annunciation seems a close antecedent to Delemer's). A wealth of statuary ranging from the Madonna and a Female Saint in Soest (Neu-Kock, in Cologne 1978, 1:219), numerous works in Münster and Lübeck (beginning there with the Wise and Foolish Virgins from the Burgkirche), and ranging to Ludgo, Sweden, form part of this style current (in brief, to a great extent the works studied by Paatz 1929) with its delicate, idealized faces. Further study of comparable Netherlandish works is needed, although it appears that the style of the Ghent ivory Madonna is especially "at home" in the Scheldt–Flanders region.

Casier and Bergmans 1914, 1:64, pl. XXXIV; Didier, in Ghent 1975, 1:no. 533 ("Doornik of Ghent?, c. 1370–80"); Didier and Steyaert, in Cologne 1978, 1:86 ("Ghent, um 1380").

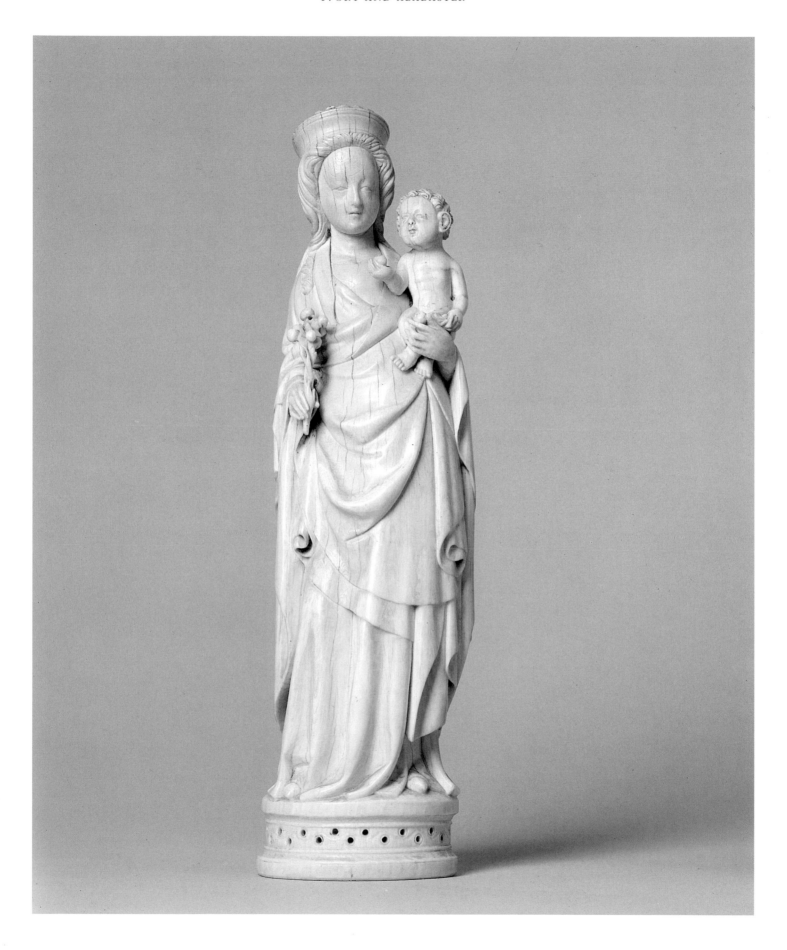

95 Relief: Swooning Virgin

Utrecht (?), c. 1420–30

Ivory with traces of polychromy, 10.6 x 6.7 x 0.6

Lille, Musée des Beaux-Arts, inv. A248

This excellent relief of the Swooning Virgin accompanied by the three Maries and St. John once formed the lower left corner of a Calvary scene. It is of great interest on two accounts. First of all because it is among the finest of an exceptionally large group of stylistically related bone and ivory carvings generally assumed to be of Netherlandish origin.

Characteristic features of this series as we see it here include distinctive female head types (round, full-cheeked, with an S-curve profile of the convex forehead extending into a turned-up nose; heavy-lidded eyes, as if swollen) as well as technical features involving textural differentiation (striation, cross-hatching).

Related reliefs survive in large numbers, though mostly of lesser quality; a close three-dimensional equivalent exists in a fine Pietà statuette in Angers (Koechlin 1924, no. 969, pl. CLXIX).

The precise localization of these works remains to be fully established. An important study by Koch (1958) introduced arguments in favor of a North-Netherlandish (Utrecht) origin; more recently, Randall has attributed these works to Flanders (Bruges) or Utrecht (1985, 1993). Although it is quite possible that, as in the fourteenth century, such works were carved in a number of different centers, the relief in Lille may be tentatively attributed to an Utrecht atelier on account of its close similarity to the pipeclay relief in Amay (cat. 93). Although our work reveals a more lyrical interpretation of the subject, it differs only in a number of minor details (haloes, bearded St. John). It appears likely that both derive from a single, presumably painted, prototype, which is also known through two additional works, both in the Metropolitan Museum, New York. A cruder and clearly derivative version is a relief that forms part of a gilt copper Calvary triptych (fig. 95a; Steingräber 1969, 30ff: "Frankreich–Niederlande, um 1425–30") and a work much finer in quality, a fragment of a

Fig. 95a Calvary Triptych, detail: Swooning Virgin. New York, Metropolitan Museum of Art

Fig. 95b Calvary. New York, Metropolitan Museum of Art

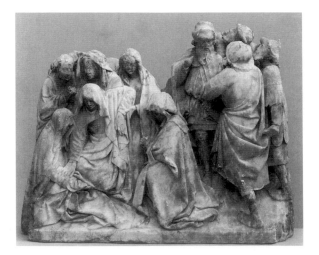

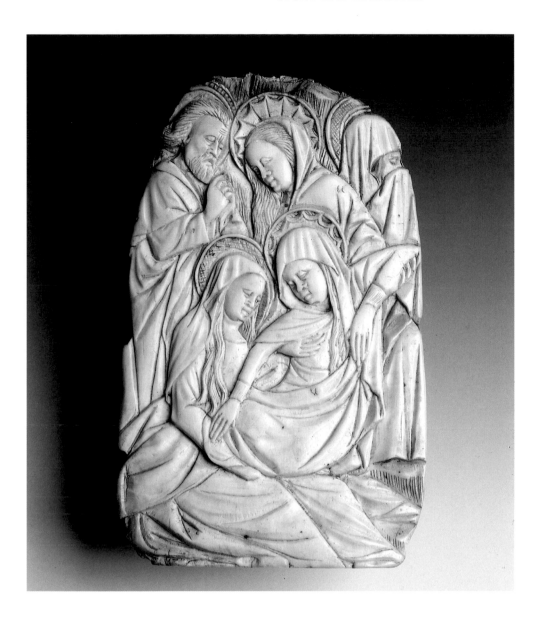

Calvary group in alabaster (c. 1440 or later; fig. 95b; Forsyth 1937, 66–69) which renders the same theme in high relief.

Interestingly enough, we face the remarkable situation that essentially the same group is known to us in four different media. Equally extraordinary is the fact that in the New York and Amay examples the pendant centurion groups placed to the right of the Cross vary completely from one another.

Although the intriguing question of the precise filiation and place of origin of all these works cannot be resolved here, it is interesting to note that, taken as a group, they reveal compositions indebted to the late style of the Limbourg Brothers[1] and early Eyckian painting.[2] As such, these works are representative of an important early moment of transition in the origins of the Netherlandish Late Gothic.

1 E.g. Swooning Virgin group in the *Très Riches Heures de Jean de Berry*, fol. 153; Meiss 1974, pl. 587.

2 For the alabaster ensemble in New York, cf. Jan van Eyck's *Calvary* in the Metropolitan Museum; Friedländer 1967, 1 : pl. 36.

96 Pax with Madonna Enthroned

Netherlands (Tournai?), c. 1430 (?)

Ivory, 13.3 x 7.6

Deux-Acren, Saint-Martin

This relief shows the Virgin enthroned in front of a summarily defined cloth of honor suspended vertically. At her left she supports the nude Child, who appears to draw aside the edge of her mantle; her right arm is extended out to the side, a large flower in her hand. The precise localization and date of these interesting industrially produced works remains problematic – a number have recently been attributed to various Netherlandish centers (Randall 1993). Possibly carved in nearby Tournai, the ultimate source of this Madonna relief should probably be sought in free-standing sculpture of the Parisian tradition, such as the Madonna in the Cleveland Museum of Art (fig. 96a). For a further study of this question, two additional works closely related in composition but different in style may be cited: a (Bruges?) pax in the Gruuthusemuseum (fig. 96b; Vandenberghe 1992, no. 87), and a relief in an "*image de chevet*," formerly in the Flannery Collection, Chicago, possibly of Paris or Liège origin (fig. 96c; compare drapery schema to Beringen Pietà, cat. 71).

Soil de Moriamé 1923–1941, 5: no. 290; de Borchgrave d'Altena, in Tournai 1960, no. 17 ("xvᵉ siècle").

97 Pax with Calvary

Netherlands (Bruges or Utrecht?), early fifteenth century

Ivory, 10.5 x 7.3

Crack running vertically from lower center to one third of height

Lille, Musée Diocésain, inv. 332

The other pax exhibited here, showing a compact Calvary scene, belongs to the same general stylistic group, although specifics of interpretation suggest a possible Bruges or Utrecht origin.

Comparable figure types can be seen in Calvary reliefs decorating caskets in Baltimore (Randall 1985, no. 359, "Flemish") and in the Victoria and Albert Museum (Longhurst 1927, 1:43).

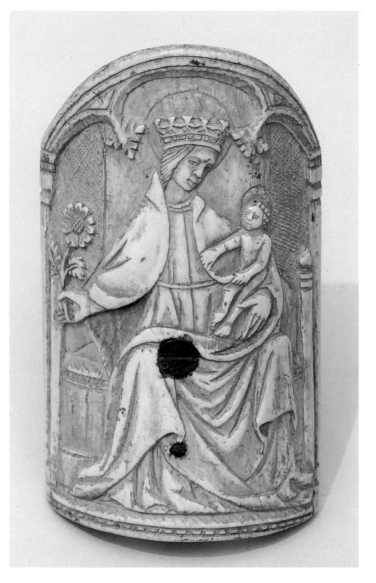

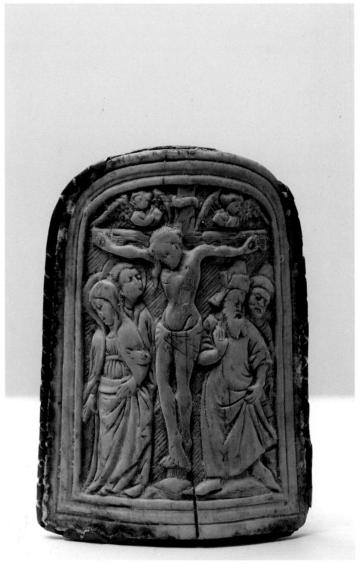

Cat. 96

Cat. 97

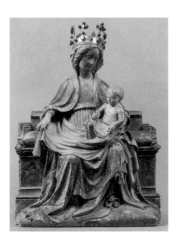

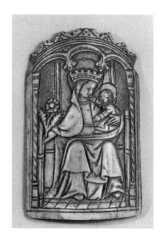

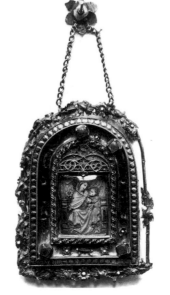

Fig. 96a Virgin and Child Enthroned. Cleveland Museum of Art

Fig. 96b Pax with Virgin and Child Enthroned. Bruges, Gruuthuse-museum

Fig. 96c *Image de chevet* with an ivory Virgin and Child Enthroned (sale London, Sotheby's, 1–2 December 1983, no. 26)

98 Standing Virgin and Child ("Onze-Lieve-Vrouw ter Rive")

Ghent, c. 1400–10 (?)

Alabaster with remains of polychromy and gilding, h. 51

Ghent, Onze-Lieve-Vrouw-Sint-Pieterskerk

From c. 1300 on, we witness a growing use of white alabaster (and marble) in Northern European sculpture, often combined with black marble as part of a "grisaille esthetic" that parallels contemporary developments in painting and stained glass, often without or with only a limited use of color (see Schoenberger 1937; Legner, in Cologne 1974, 140ff). This preference and interest in the beauty of the fine material (cf. earlier ivories) appears to have originated in the Parisian court milieu whence it spread to the rest of Europe. In the Netherlandish area as elsewhere we find frequent references to cult statues, especially Madonnas, such as the "Notre-Dame d'albastre" cited in 1370 in Cambrai Cathedral (Houdoy 1880, 39), significantly referred to as "Notre-Dame la Belle," which was placed in the choir screen *(sub pulpito)*, an arrangement visually documented by Jan van Eyck's painting of the *Madonna in the Church* in Berlin (Dhanens 1980, fig. 199).

The "Onze-Lieve-Vrouw ter Rive" is among the few surviving such works of the 1400 style in the Low Countries and especially interesting as a rare example of these years in the city of Ghent, so sadly depleted of religious statuary during the iconoclasm of the sixteenth century. The general formal relationship of this work to Tournaisian Madonnas and thus ultimately to the influence of Beauneveu (a "Scheldt School" artistic linkage of long standing) has been noted, as has the relation of Mary's roundish facial type to an important fragment of a Virgin from the abbey of Baudeloo, suggesting the possibility of a characteristically Ghent regional type (Didier). Both observations can be strengthened by

Fig. 98a Head of a Virgin from Baudeloo. Formerly Lokeren, Van Hooff Collection

Fig. 98b Standing Virgin and Child. Huesca, Museo Diocesano

Fig. 98c Jacob de Baerze, Magdalen from a Passion Altarpiece. Dijon, Musée des Beaux-Arts

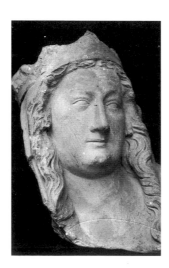
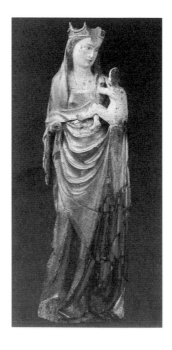
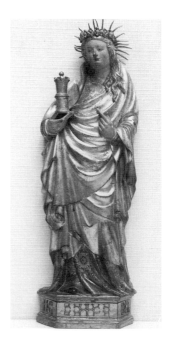

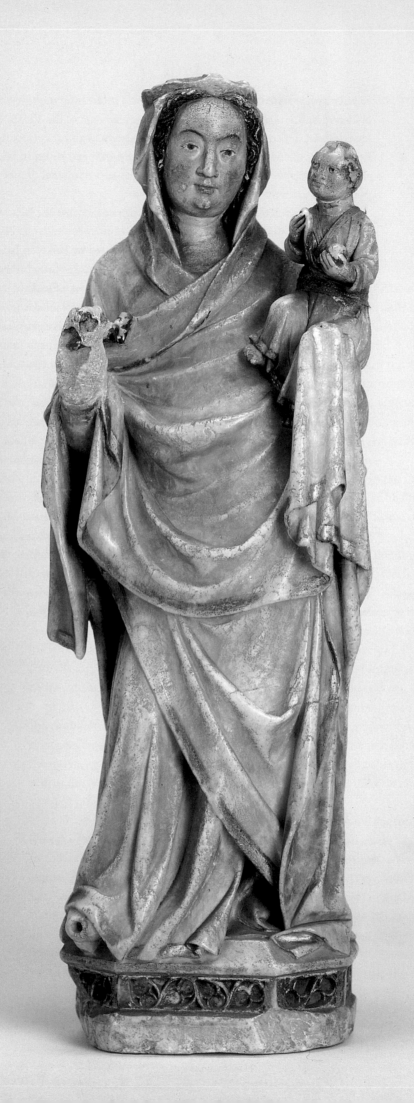

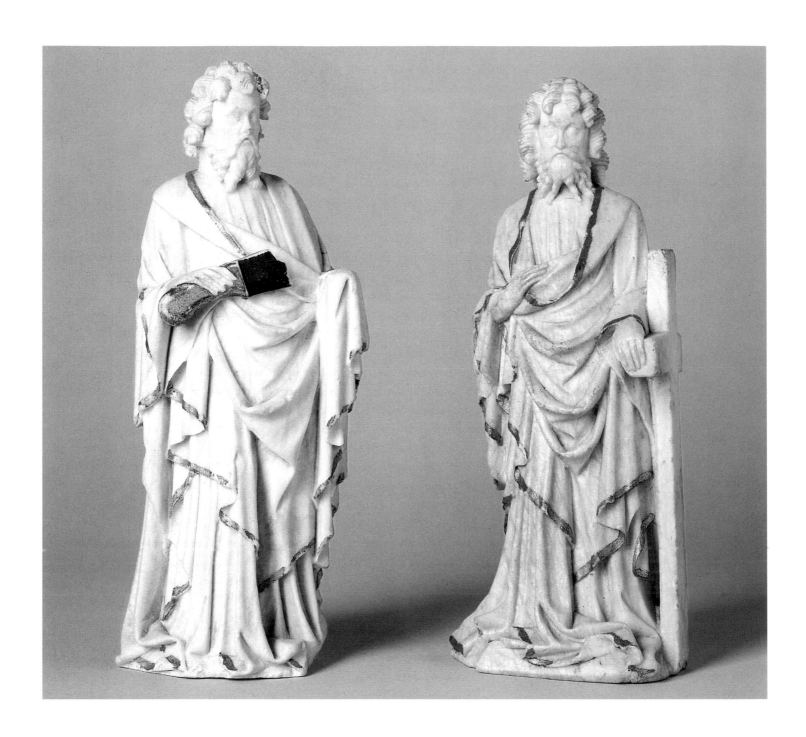

The localization of these works remains a thorny but fascinating problem to art historians. They have generally been assigned an origin in the Netherlandish or the adjoining Northern French areas, which explains their inclusion in the exhibition (Paatz 1956a and 1956b). Alabaster is often cited and was certainly carved in this region, where the stone was imported from England (as for the tomb of Michelle de France in Ghent).[3]

Nonetheless, most of these "Riminesque" works were probably carved in German ateliers, whence they were exported throughout Europe. This appears in any case to be true of the Saint-Omer Apostles, late derivatives of the Central European "Beautiful Style" as first developed in the Bohemian area, that are in every sense *Fremdkörper* in the Netherlandish artistic milieu, where they have no direct counterparts, save of course in other such alabaster sculptures.

3 Cf. "… une pièce de pierre d'allebaustre d'Engleterre," cited in a contract of 1415 for a tomb to be carved by the Mons sculptor Gilles le Cat; Descamps 1905–6, 19.

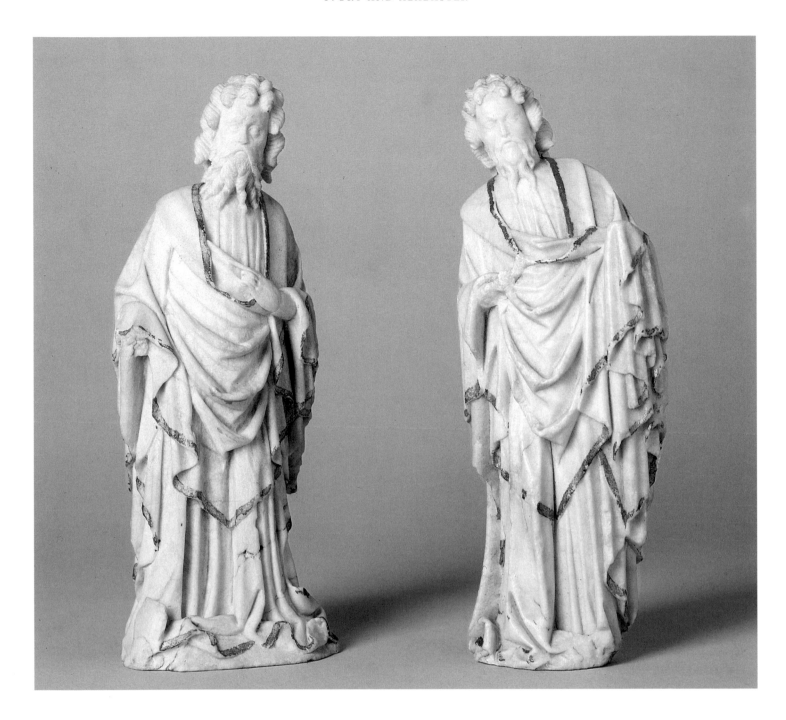

By way of hypothesis, an origin may be proposed in Central Germany, where alabaster was extensively quarried and carved, and where, more importantly, stylistically similar sculptures in other materials survive, including the stone Apostles in the choir of the Cathedral in Halberstadt (see Marchand 1925–26 and the sharpsighted observations of Pinder 1923, 2:262ff). This association is also evident in the interpretation of certain details, such as the "Bohemian knee" seen in our works (folds swinging down and outward from knee, bifurcating against the base) which is found in comparable form in "Beautiful Madonnas" of this region, as in Arnstadt (Clasen 1974, fig. 373; cf. also corkscrew locks of the Child) and in the Allendorf Altarpiece, Eisenach Museum (Kämpfer s.d., figs. 3–6).

100 Madonna on the Crescent Moon

Southern Netherlands or Germany, c. 1430–50

Alabaster, h. 29

Horizontal break at center; on the underside of the base are incised marks of
a crescent moon and a sketchily defined quadruped (a monkey?), presumably
personal or atelier marks

Ghent, Museum voor Schone Kunsten, inv. 1986–C

Small, intimately conceived statuettes of the Madonna, intended for private devotional use, constitute a large proportion of fifteenth-century alabaster production. The serene image in the Ghent Museum shows Mary holding her Son, who embraces his Mother while drawing the edge of her veil, a characteristically Gothic genre motif with symbolic religious significance in reference to Mary's virginity. The Virgin is also identified here as the Woman of the Apocalypse, as indicated by the crescent moon at her feet. The human face in the moon, here framed by a veil, is a detail quite common in the German tradition, only rarely encountered in Netherlandish works.

The stylistic premises of this work, and a number of motifs (e.g. the textured base and veil of Mary; the rounded, pendant apron-like mantle edge at the center; the mantle wrapped around the Virgin's right arm) are clearly reminiscent of the Rimini Altarpiece (Frankfurt, Liebighaus) of c. 1430. The fact that the drapery is restructured to a more simplified schema in which the richly undulating calligraphic edges are reduced to a more sober, symmetrical arrangement, is indicative of a somewhat later origin, which in turn also anticipates a subsequent "Eyckian" alabaster series (e.g. cat. 101, 102).

The stylistically transitional appearance of the Ghent statuette is of special interest since it is symptomatic of a continuity of development in terms of style, iconography, and motifs in Continental European alabaster sculpture c. 1420–50. These gradual alterations can be clearly followed in works exhibited and/or illustrated here from the graphic surfaces of the Saint-Omer Apostles (cat. 99) representing a late, mannered version of the Soft Style rooted in the years c. 1400, through an intermediate stage in the Ghent Madonna, in turn leading directly to the broken-fold style of the Late Gothic in the Dadizele (c. 1440; see cat. 101, fig. 101b) and the later Ghent Madonnas (cat. 101). If the chronology of these works remains largely hypothetical in an absolute sense, the relative evolutionary steps are clearcut, and provide support for the assumption that all of these alabasters were carved in the same region or at least in a series of closely linked workshops.

Cat. 100, underside of base

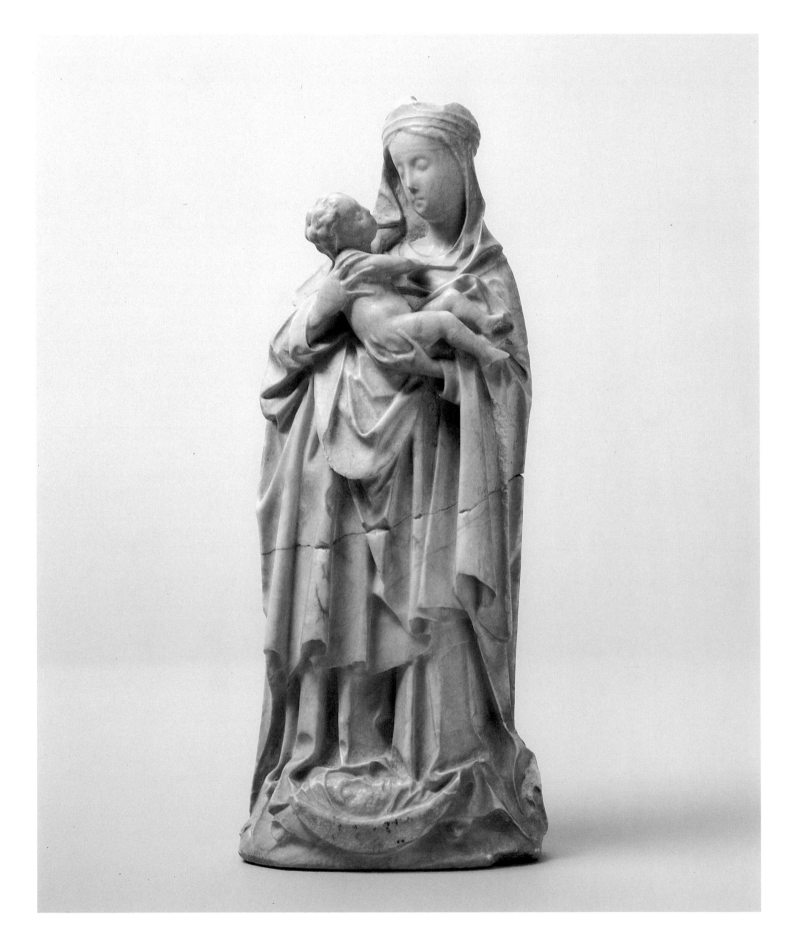

101 Standing Virgin and Child

Netherlands or Germany, c. 1440–50

Alabaster, traces of polychromy, h. 36.5

The statue is preserved as a half-length;[1] head and hands and right

kneecap of the Child missing, as well as several of Mary's fingers

and her crown; Mary's face is badly damaged

Ghent, Museum voor Schone Kunsten, inv. 1914–DN

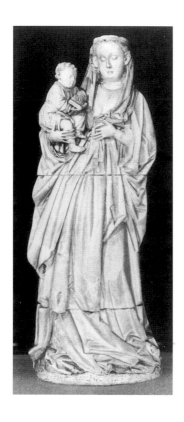

Fig. 101a Standing Virgin and Child.
Weinsberg, Kerner-Haus

1 As often encountered in such alabaster works, the original full-length statue probably consisted of more than one, probably three alabaster blocks, as is also true of the Madonnas in Bruges (Sint-Janshospitaal) and in Weinsberg (fig. 101a).

2 Cf. the grisaille Annunciation in Madrid, Fundación Colección Thyssen-Bornemisza, and a series of Apostle drawings in Vienna (Friedländer 1967, 1 : pls. 69, 99).

This impressive work is representative of a second widespread European group of alabasters, now distinctly Late Gothic and markedly "Eyckian" in style. Although it survives only as a heavily damaged fragment, its high quality remains evident. The full-bodied monumentality of Mary, her rather sensuous features, marked by an expression of grave restraint, and the vigorous rhythm of the abstract, craggy drapery forms, make this piece one of the finest alabasters of its kind.

A very large number of comparable examples survive in the Netherlandish, French, and especially the German areas, although only a handful attain the same high level of quality. In Flanders may be cited the more modest miraculous statue in the Basilica of Dadizele near Roeselare, smaller in size and somewhat earlier in date (c. 1440; fig. 101b).

Given the widespread distribution and the stylistic variations of this series, these works, as those of the earlier Rimini Master group, were probably produced in a number of closely interdependent specialized ateliers working for export. But as in the previous series, their origin remains difficult to determine, in spite of their obvious Netherlandish character. A Bruges origin has been proposed for our work and for several other particularly fine alabasters, notably a Madonna in the Budapest Museum, based on their obvious affinity with the work of Jan van Eyck[2] (Didier and Krohm 1977; Didier 1984, 31–32), although this hypothesis has not been convincingly corroborated by comparison to examples of Bruges sculpture. Perhaps our best evidence in this regard is provided by the figural decoration of the choir stall figures in Bruges Cathedral (cf. cat. 43, fig. 43a, and fig. 101c) where we encounter an Eyckian-inspired drapery consisting of bifurcating and splinter folds that recur in a number of later Bruges works (see Steyaert, in Bruges 1976, no. B27). Such comparisons allow for the possibility of a Bruges or at least a South-Netherlandish origin for these works, but this remains at best only a working hypothesis.

For a further study of this question, two examples related to the work in Ghent may be cited as important points of reference. A Madonna in Weinsberg, probably Swabian c. 1450–60 (fig. 101a; see Jopek 1988, 62–65, 121–122), is so similar to ours even in detail (Mary's left hand with spread fingers, elegantly proffering her veil; the Child's long shirt, drawn up over his right knee), that it allows for a reconstruction of its original appearance.

The "Eyckian" manner is of course also found elsewhere in sculpture, including in the northern part of the Netherlands, where Jan van Eyck was resident during the years 1422–5. It is interesting to note that Wentzel (1960, 73) in his discussion of the Weinsberg work rightly observed a degree of affinity to an Utrecht pipeclay Madonna (our cat. 88). A more explicit reference in this regard can be seen in a comparison of this pipeclay figure (along with the Madonna in Kortrijk-Dutsel, see cat. 82) with a superb alabaster Madonna in the Art Museum of St. Louis – a stylistic variant of the work in Ghent which may be attributed to either an Utrecht master or more likely an Utrecht-inspired Upper Rhenish

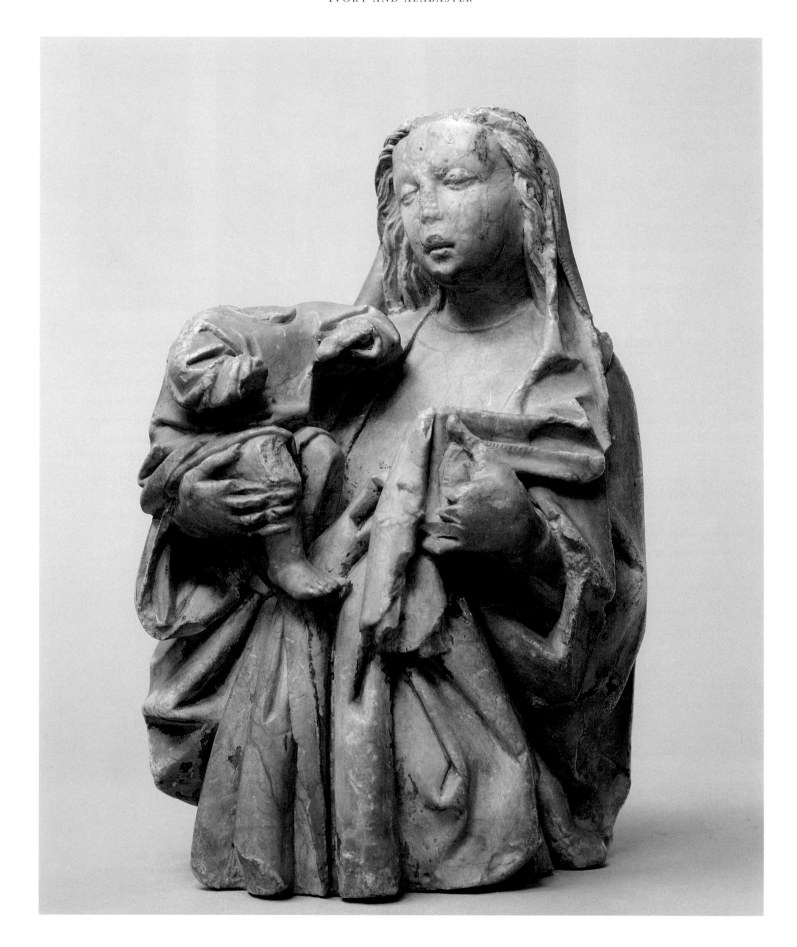

Fig. 102a Virgin and Child with
St. Anne. Munich, Bayerisches
Nationalmuseum

Fig. 102b Virgin and Child with
St. Anne. Nová Říše, Norbertine
Convent, St. Anne's Chapel

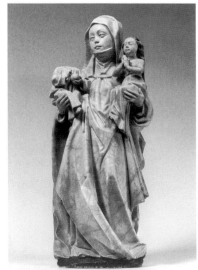

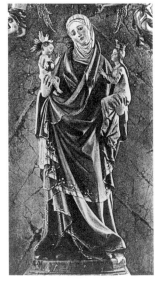

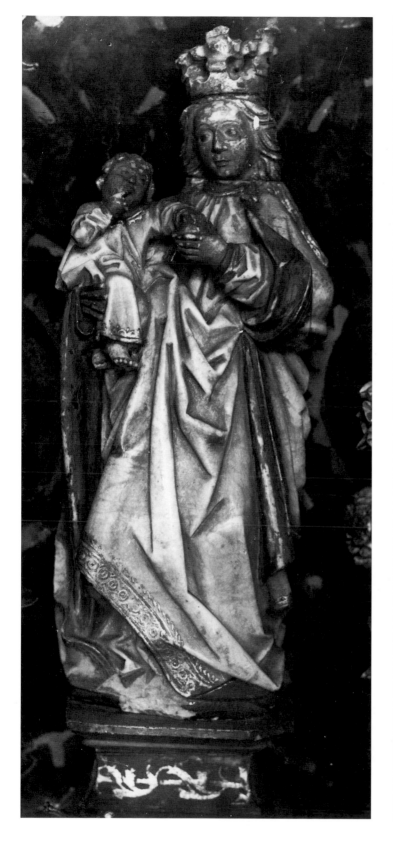

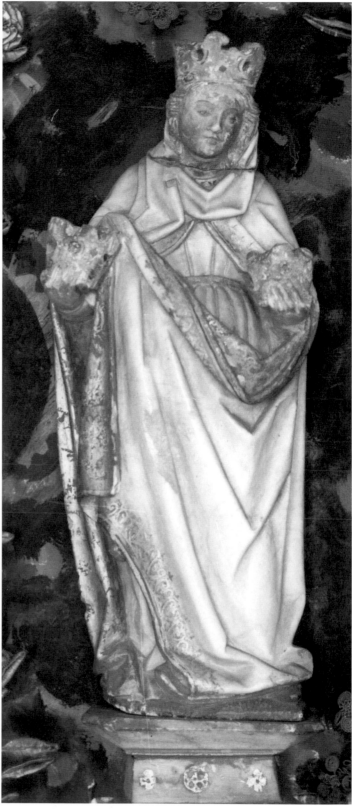

103 Standing Virgin and Child

Lille, c. 1450–60 (?)

Alabaster, recent polychromy, h. 27.5

Child's face reattached; Mary's left hand missing

Lille, Musée Diocésain

This delightful little group is among the few alabaster statuettes that can be associated with a specific center, at least by way of hypothesis. In formal type (the Virgin's open mantle with the lower garment drawn up on one side and descending in a series of connected V's) it belongs to a characteristic Netherlandish type probably introduced in Tournai toward or soon after c. 1430 (see cat. 20) and also known to us through works of presumable Lille origin such as a stone St. Barbara in the Musée des Beaux-Arts. A possible dependence on Tournaisian models may also be seen in the ovoid face of Mary (cf. e.g. cat. 7). At the same time, the more pointed oval shape with sharp jutting chin appears in other works found in the city, most notably in the large stone Madonna, the masterpiece of Lille sculpture from the mid-fifteenth century (fig. 103a; Weise 1925–30, 3, 1:38–39; Oursel, in Lille 1978–9, no. 73), so that it appears to represent a distinctly Lillois variant on Tournaisian models (cf. also a Madonna on the Crescent Moon in the Musée Diocésain, reputedly from a church near Lille).

Fig. 103a Standing Virgin and Child. Lille, Musée des Beaux-Arts

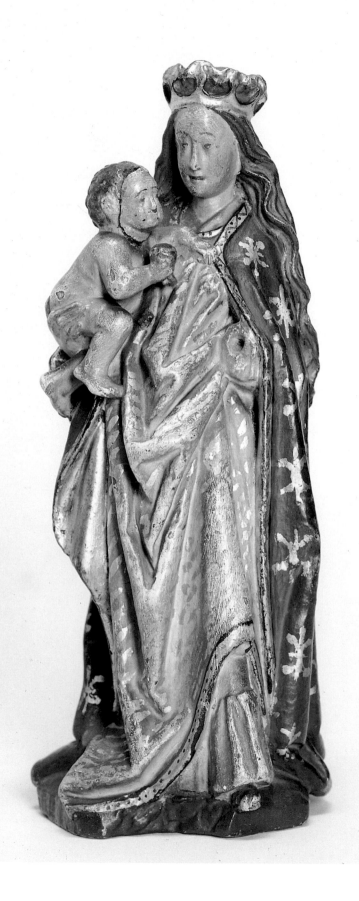

104 Calvary Fragment: Mary Embracing the Cross

Southern Netherlands or Northern France (?), mid-fifteenth century

Alabaster, h. 59.5

Joint below the head

Cambrai, Musée Diocésain d'Art Sacré

This practically unknown work is among the outstanding alabaster carvings extant in the Netherlandish–Northern French area. It shows the kneeling figure of Mary embracing the base of the Cross while her tearful, grieving visage turns to the Savior above. Comparable figures, though more usually representing the Magdalen with her free-flowing hair, are a constant feature of alabaster Calvaries beginning with the Rimini Altarpiece (for this iconography, see Panofsky 1953, 465–466). Based on the size of this figure, the original ensemble, perhaps set in a retable, must have formed an unusually large Calvary group.

It is also among the few examples of alabaster sculpture that can be shown to be directly based on Netherlandish painting: although best known through Van der Weyden's Calvary Triptych in Vienna, the figure appears closer to the Calvary painting in the manner of Campin (fig. 104a; see Friedländer 1967, 2:pls. 19, 95; note the specifics of the drapery design and the position of the hands).

Machelart, in Cambrai 1973, no. 97.

Fig. 104a After Robert Campin, Calvary, detail. Berlin, Staatliche Museen, Gemäldegalerie

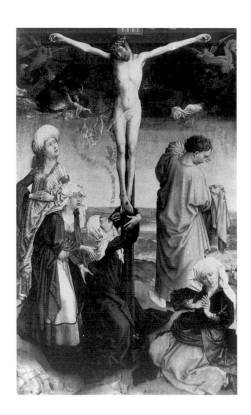

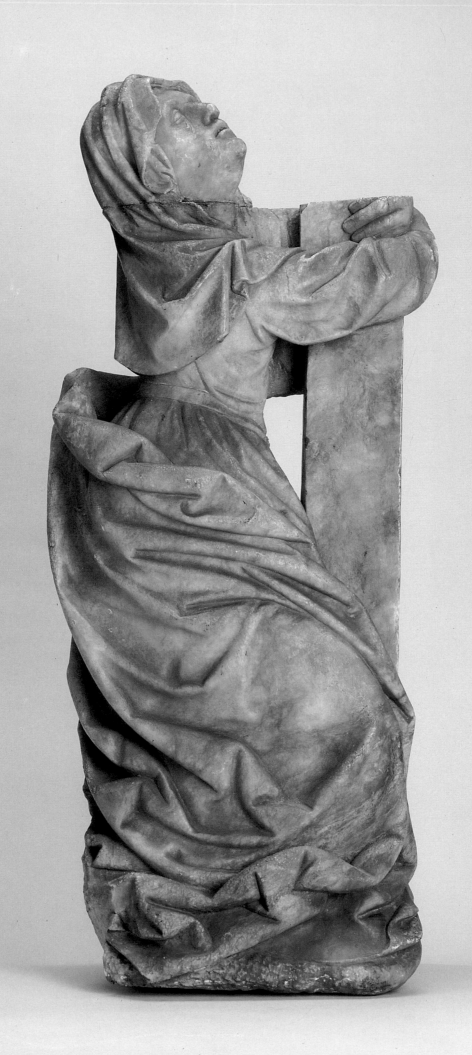

105 Man of Sorrows

Southern Netherlands or Germany (Upper Rhine?), c. 1450–60

Alabaster, traces of polychromy, h. 39.9[1]

Principal losses: right hand (with three nails?) of Angel to the right

of Christ's head; wingtips of Angel with crown of thorns; chips at base

Antwerp, Museum Mayer van den Bergh, inv. 2220

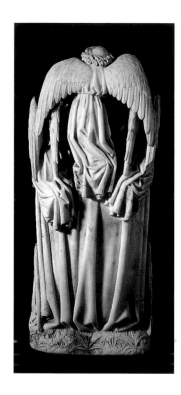

Cat. 105, reverse

This is unquestionably one of the preeminent works of fifteenth-century alabaster sculpture both in form and subject matter. Verdier has aptly characterized this extraordinary image of the *Schmerzensmann*: Christ is wearing a chasuble with a pelican morse; he is surrounded by Angels in liturgical garb carrying tapers, the *arma Christi*, and the crown of thorns, and thus represented as the priest-victim, celebrating his own sacrifice. Although acquired in Naples, there is no reason to think that this work was carved in Italy. Stylistically it exhibits a clear affinity to the art of the Southern Netherlands and particularly to the Tournaisian School as represented by the paintings of Campin and the Entombment group in Soignies (see *Tournai*, fig. 25). It should be noted, however, that this style also has antecedents in the later works of the Master of the Rimini Altarpiece, as we know it through a Carrying of Christ to the Sepulchre in St. Petersburg (see Liebmann 1988, nos. 67–69, ill.), itself reflecting Tournaisian influences.[2]

As several other alabaster carvings in the exhibition, this small masterpiece raises the difficult question of the localization of such works. If the sculptor's dependence and possible training in the Netherlands seems certain – the long trailing diagonal folds of the Angels' garments appear at least ultimately to derive from Jean Delemer – certain nuances of inter-pretation (drapery design) remind one of Netherlandish-inspired works in the Upper Rhine area, such as a Kneeling Magdalen from Baden-Baden (for this work, see Zimmerman 1985, no. 110). These subtle differences hint at a possible origin there, although for lack of further evidence this must remain a tentative suggestion. But whatever its place of origin, the style of the Antwerp group can probably help clarify the Netherlandish–Upper Rhenish sources of the "Alabaster Master of 1467" active in the Central German region.[3]

De Coo 1969, 178 ("omstreeks 1475/85, Zuidnederlands [?]"); Verdier 1973, 342, no. 46 ("œuvre néerlandaise de la fin du troisième quart du xvᵉ siècle"); Steyaert, in Minneapolis 1978 ("mid-fifteenth century"); Nieuwdorp 1992, 76 ("Zuidnederlands, ca. 1460").

1 Since the group is carved fully in the round, it must have been placed so as to be visible from the back.

2 As in the Campinesque motif of a lower border consisting of symbolic floral motifs, also seen in our group.

3 For this master, see Jopek 1988, 77–86; cf. this sculptor's Kneeling Angel decorating the stone baptismal font in the Severikirche, Erfurt; Rudolph 1930, pl. xxx.

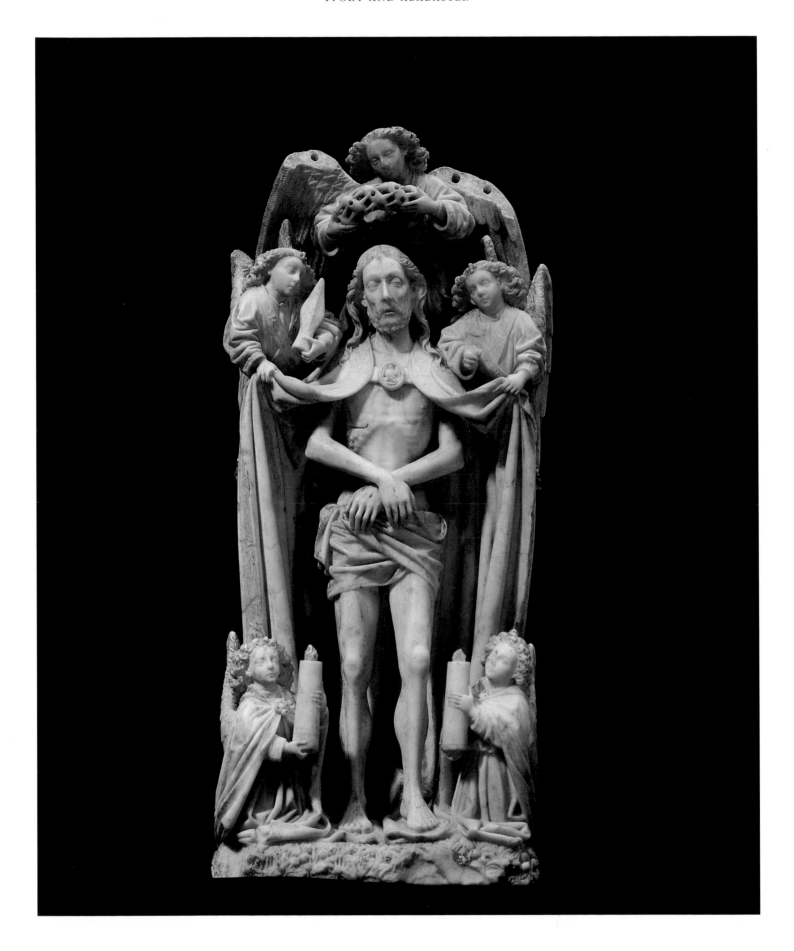

Bibliography

Aalst 1980 Stedelijk Museum, Oud Hospitaal. *500 jaar Sint-Martinuskerk Aalst.*

Achter 1960 I. Achter, Schrein und Flügelgemälde eines gotischen Altares, jetzt in der Kath. Pfarrkirche zu Rheinberg, in *Jahrbuch der Rheinischen Denkmalpflege. Berichte über die Tätigkeit der Restaurierungswerkstatt in den Jahren 1953–1959*, 23 (1960), 207–258.

Amiens 1992 Musée de Picardie. F. Lernout, *Le Moyen Age au Musée de Picardie.*

Amorison and De Reymaeker 1980 L. Amorison and M. de Reymaeker, Sculptures des xve et xvie siècles, in *Le patrimoine du pays d'Ath. Un premier bilan (Etudes et documents du Cercle Royal d'Histoire et d'Archéologie d'Ath et de la Région, 2)*, Ath 1980, 509–530.

Amsterdam 1958 Rijksmuseum. *Middeleeuwse Kunst der Noordelijke Nederlanden.*

Amsterdam 1980 Rijksmuseum. W. Halsema-Kubes, G. Lemmens and G. de Werd, *Adriaen van Wesel (ca. 1417/ca. 1490) een Utrechtse beeldhouwer uit de late middeleeuwen.*

Amsterdam 1986 Rijksmuseum. *Kunst voor de beelden-storm. Noordnederlandse kunst 1525–1580.*

Anderson 1913 G. Anderson, The Brasses of Ghent, in *The Antiquary* 9 (1913).

Andersson 1980 A. Andersson, *Medieval Wooden Sculpture in Sweden, 3, Late Medieval Sculpture*, Stockholm 1980.

Andersson 1983 A. Andersson, *Vadstena Klosterkyrka, 2, Inredning Östergötland*, Stockholm 1983.

Annaert 1982–3 M. Annaert, Selectie uit de werkzaam-heden van 1980 en 1981, H. Maagd met Kind … Tongerlo, Norbertijnenabdij, in *Bulletin van het Koninklijk Instituut voor het Kunstpatrimonium* 19 (1982–3), 194–195.

Antwerp 1930 *Exposition internationale coloniale, maritime et d'art flamand.*

Antwerp 1954 Koninklijk Museum voor Schone Kunsten. *De Madonna in de kunst.*

Antwerp 1959 Feestzaal Arthur Goemaerelei 18. *Derde eeuwfeest Sint-Laurentiusparochie 1659–1959.*

Antwerp 1993 Cathedral. *Antwerp Altarpieces 15th–16th Centuries*, 1, Catalogue; 2, Essays.

Arras 1986 Musée des Beaux-Arts, Palais Saint-Vaast. *Le trésor de la cathédrale d'Arras.*

Arte in Lombardia *Arte in Lombardia tra Gotico E Rinasci-mento*, Milan 1988.

Asaert 1972 G. Asaert, Documenten voor de geschiedenis van de beeldhouwkunst te Antwerpen in de xvde eeuw, in *Jaarboek Koninklijk Museum voor Schone Kunsten Antwerpen (1972)*, 43–85.

Asselberghs 1968 J.F. Asselberghs, *La tapisserie tournai-sienne au 16e siècle*, Tournai 1968.

Baltimore 1962 The Walters Art Gallery. *The International Style. The Arts in Europe around 1400.*

Baracchini and Caleca 1973 A. Baracchini and A. Caleca, *Il Duomo di Lucca*, Lucca 1973.

Baron 1990 F. Baron, Le décor du soubassement du tombeau d'Anne de Bourgogne, duchesse de Bedford († 1432), in *Bulletin de la Société Nationale des Antiquaires de France (1990)*, 262–274.

Bauch 1976 K. Bauch, *Das mittelalterliche Grabbild*, Berlin-New York 1976.

Baudoin 1990 J. Baudoin, *La sculpture flamboyante en Champagne Lorraine*, Nonette 1990.

Baum 1917 J. Baum, *Deutsche Bildwerke des 10. bis 18. Jahr-hunderts* (Kataloge der Kgl. Altertümersammlung in Stuttgart, 3), Stuttgart-Berlin 1917.

Beaulieu and Beyer 1992 M. Beaulieu and V. Beyer, *Dictionnaire des sculpteurs français du Moyen Age*, Paris 1992.

Beauvais 1975 M.J. Salmon, A. Erlande-Brandenburg and P. Bonnet Laborderie, *Pierres et bois sculptés du Musée Départemental de l'Oise du XIIe au XVIe siècle*, Beauvais 1975.

Becker 1989 U. Becker, Beobachtungen zum Hochaltar der Pfarrkirche St. Vincentius in Dinslaken und zu seiner Stellung in der flämischen Retabelproduktion des 15. Jahrhunderts, in *Wallraf-Richartz-Jahrbuch* 50 (1989), 115–140.

Becksmann 1988 R. Becksmann, *Deutsche Glasmalerei des Mittelalters. Eine exemplarische Auswahl*, Ausstellung des Instituts für Auslandsbeziehungen, Stuttgart 1988.

Bergius 1936 R. Bergius, *Französische und belgische Konsol- und Zwickelplastik im 14. bis 15. Jahrhundert*, Diss., Munich 1936.

Bergmann 1989 U. Bergmann, *Die Holzskulpturen des Mittelalters (1000–1400), Schnütgen-Museum Köln*, Cologne 1989.

Bialostocki 1966 J. Bialostocki, *Les musées de Pologne (Gdansk, Krakow, Warszawa)* (Les Primitifs flamands, 1, Corpus de la peinture des anciens Pays-Bas méridionaux au quinzième siècle, 9), Brussels 1966.

Bichler 1992 S. Bichler, Les retables de Jacques de Baerze, in *Actes des journées internationales Claus Sluter (sept. 1990)*, Dijon 1992, 23–35.

Bloch 1969 P. Bloch, *Kölner Madonnen, Die Muttergottes in der Kölner Bildnerei des Mittelalters*, Mönchengladbach 1961.

Bober 1953 H. Bober, André Beauneveu and Mehun-sur-Yèvre, in *Speculum* 28 (1953), 741–753.

Boccador 1974 J. Boccador, *Statuaire médiévale en France de 1400 à 1530*, Zoug 1974.

Boccador and Bresset 1972 J. Boccador and E. Bresset, *Statuaire médiévale de collection*, s.l. 1972.

Bonenfant-Feytmans 1954 A.M. Bonenfant-Feytmans, Une orfèvrerie brugeoise – et non bruxelloise – du xve siècle, in *Annales de la Société Royale d'Archéologie de Bruxelles* (1954), 95–103.

Boon 1978 K. Boon, *Netherlandish Drawings of the Fifteenth and Sixteenth Centuries*, Rijksmuseum, The Hague 1978.

Bouvy 1947 D. Bouvy, *Middeleeuwsche beeldhouwkunst in de Noordelijke Nederlanden*, Amsterdam 1947.

Bouvy 1962 D. Bouvy, *Beeldhouwkunst van de middeleeuwen tot heden uit het Aartsbisschoppelijk Museum te Utrecht*, Amsterdam–Brussels 1962.

Bozière 1860 Fr.J. Bozière, Les épitaphes rimées des églises et des couvents de Tournai, in *Bulletin de la Société Historique et Littéraire de Tournai* 6 (1860), 67–96.

Brooklyn 1936 Brooklyn Museum. *An Exhibit of European Art 1450–1500.*

Bruges 1973 Sint-Godelieve Abdij. *300 Jaar Sint-Godelieve Abdij.*

Bruges 1976 Sint-Janshospitaal. *Sint-Janshospitaal Brugge, 1188–1976.*

Bruges 1992 Gruuthusemuseum and O.-L.-Vrouwekerk. S. Vandenberghe, *Vlaamse Kunst in de 15de eeuw.*

Brussels 1951 Palais des Beaux-Arts. *De eeuw van Bourgondië.*

Brussels 1954 Musées Royaux d'Art et d'Histoire. *Kunst-schatten van Brabant.*

Brussels 1960 Musées Royaux d'Art et d'Histoire. *Moeder en Kind in de religieuze kunst.*

Brussels 1961 Palais des Beaux-Arts. *Verzamelingen van de Openbare Onderstand.*

Brussels 1968 Palais des Beaux-Arts. *Aanwinsten der provinciale en gemeentelijke musea 1945–1967.*

Brussels 1976 Musées Royaux d'Art et d'Histoire. *Brusselse wandtapijten van de pre-Renaissance.*

Brussels 1979 L. Hadermann-Misguich, De samenhang naar geest en vorm tussen de schilderijen van Van der Weyden en de beeldhouwkunst van zijn tijd, in *Rogier van der Weyden. Rogier de le Pasture. Officiële schilder van de stad Brussel. Portretschilder aan het Hof van Bourgondië*, 85–93.

Brussels 1992 *Retables en terre cuite des Pays-Bas (XVe–XVIe siècles). Etude stylistique et technologique.* C. Périer-D'Ieteren and A. Born (ed.), Université Libre de Bruxelles, Brussels 1992.

Cambrai 1973 *Musée Diocésain d'Art sacré de Cambrai*, Cambrai 1973.

Cambridge 1993 Fitzwilliam Museum. *Splendours of Flanders. Late Medieval Art in Cambridge Collections.*

Cameron 1970 H.K. Cameron, The Fourteenth Century School of Flemish Brasses, in *Transactions of the Monumental Brass Society* 11 (1970), no. 2, 50–81.

Cameron 1981 H.K. Cameron, Two lost Brasses of the Tournai School Formerly at Bruges, in *Transactions of the Monumental Brass Society* 13–2 (1981), no. 98, 119–131.

Campuzano-Ruíz 1985 E. Campuzano-Ruíz, *El Gótico en Cantabria*, Santander 1985.

Campuzano-Ruíz 1989 E. Campuzano-Ruíz, *Arte de Flandes en Cantabria*, Santillana del Mar 1989.

Campuzano-Ruíz 1992 E. Campuzano-Ruíz, El retablo de Belén, de la iglesia de Laredo, in J. Valles, *Comarcas de Cantabria, 8, Zona oriental*, Santillana del Mar 1992, 41–44.

Caron 1982 M. Caron, Pijpaarden beeldjes, individuele devotie en massacultuur, in *Vroomheid per Dozijn*, Utrecht, Rijksmuseum Het Catharijneconvent, 17–21.

Casier and Bergmans 1914–22 J. Casier and P. Berg-mans, *L'art ancien dans les Flandres (Région de l'Escaut), Mémorial de l'exposition rétrospective organisée à Gand en 1913*, Brussels-Paris 1914–22.

Châtelet 1990 A. Châtelet, Roger van der Weyden et le lobby Polinois, in *Revue de l'Art* (1989), no. 84, 9–21.

Clasen 1974 K.H. Clasen, *Der Meister der Schönen Madonnen, Herkunft-Entfaltung und Umkreis*, Berlin-New York 1974.

Clemen 1927 E. Wackenroder, *Die Kunstdenkmäler des Kreises Prüm* (Die Künstdenkmäler der Rheinprovinz, P. Clemen, ed., 12, no. 2), Düsseldorf 1927.

Clemen 1938 H. Bunjes et al., *Die Kirchlichen Denkmäler der Stadt Trier mit ausnahme des Domes* (Die Künstdenkmäler der Rheinprovinz, P. Clemen, ed., 13, no. 3), Düsseldorf 1938.

Cloquet and de la Grange 1887–8 L. Cloquet and A. de la Grange, Etudes sur l'art à Tournai et sur les anciens artistes de cette ville, in *Mémoires de la Société Historique et Littéraire de Tournai* 20 (1887); 21 (1888).

Coekelberghs 1975 D. Coekelberghs, *Répertoire photogra-phique du mobilier des sanctuaires de Belgique, Province de Brabant. Canton de Wavre*, Brussels 1975.

Coekelberghs and Lequeux 1980 D. Coekelberghs and J.M. Lequeux, *Répertoire photographique du mobilier des sanctuaires de Belgique, Province de Hainaut. Canton de Lessines*, Brussels 1980.

Collon-Gevaert 1951 S. Collon-Gevaert, *Histoire des arts du métal en Belgique* (Verhandelingen van de Koninklijke Belgische Academie, Klasse der Schone Kunsten. 2de serie, 7), Brussels 1951.

Cologne 1970 Kunsthalle. *Herbst des Mittelalters. Spätgotik in Köln und am Niederrhein.*

Cologne–Brussels 1972 Kunsthalle–Musées Royaux d'Art et d'Histoire. *Rijn en Maas. Kunst en cultuur 800–1400.*

Cologne 1978 Kunsthalle. *Die Parler und der Schöne Stil 1350–1400. Europäische Kunst unter den Luxemburgern, Ein Handbuch zur Ausstellung des Schnütgen-Museums in*

der Kunsthalle Köln, 1–3 (1978); 4 (1980); Resultatband (1980).

Cologne 1989 Schnütgen-Museum. U. Bergmann, *Die Holzskulpturen des Mittelalters (1000–1400)*.

Comblen-Sonkes and Van den Bergen-Pantens 1977 M. Comblen-Sonkes and C. van den Bergen-Pantens, *Memoriën van Anthonio de Succa* (Les Primitifs Flamands, 3, Corpus de la peinture des anciens Pays-Bas méridionaux au quinzième siècle, 7), Koninklijke Bibliotheek Albertina, Brussels 1977.

Cousin 1619–20 J. Cousin, *Histoire de Tournay*, Douai 1619–1620. Nouvelle édition, publiée par les soins de la Société Historique et Littéraire de Tournai, Tournai 1868.

Crab 1977 J. Crab, *Het Brabants beeldsnijcentrum Leuven*, Leuven 1977.

Davies 1954 M. Davies, *The National Gallery, London* (Les Primitifs Flamands, 1, Corpus de la peinture des anciens Pays-Bas méridionaux au quinzième siècle, 3), Antwerp 1954.

de Borchgrave d'Altena 1926 J. de Borchgrave d'Altena, *Sculptures conservées au pays mosan*, Verviers 1926.

de Borchgrave d'Altena 1930 J. de Borchgrave d'Altena, A propos de quelques sculptures provenant du Limbourg, in *Bulletin des Musées Royaux d'Art et d'Histoire* 1 (1930), 15–19.

de Borchgrave d'Altena 1932 J. de Borchgrave d'Altena, Les sculptures du portail sud de l'église à Huldenberg, in *Bulletin de la Société Royale d'Archéologie de Bruxelles* (1932), no. 6, 201–204.

de Borchgrave d'Altena 1934 J. de Borchgrave d'Altena, Des caractères de la sculpture brabançonne vers 1500, in *Annales de la Société Royale d'Archéologie de Bruxelles* 38 (1934), 188–214.

de Borchgrave d'Altena 1941 J. de Borchgrave d'Altena, *Notes pour servir à l'inventaire des œuvres d'art du Brabant. Arrondissement de Louvain*, Brussels 1941.

de Borchgrave d'Altena 1942–3 J. de Borchgrave d'Altena, Vierges de pitié de chez nous, in *Annales de la Société Royale d'Archéologie de Bruxelles* 46 (1942–3), 264–270.

de Borchgrave d'Altena 1945 J. de Borchgrave d'Altena, *Madones anciennes conservées en Belgique 1025–1425*, Brussels 1945.

de Borchgrave d'Altena 1946 J. de Borchgrave d'Altena, *La passion du Christ dans la sculpture en Belgique*, Paris–Brussels 1946.

de Borchgrave d'Altena 1947a J. de Borchgrave d'Altena, *Notes pour servir à l'inventaire des œuvres d'art du Brabant. Arrondissement de Bruxelles*, Brussels 1947.

de Borchgrave d'Altena 1947b J. de Borchgrave d'Altena, *Le retable de Saint-Georges de Jan Borman*, Brussels 1947.

de Borchgrave d'Altena 1948 J. de Borchgrave d'Altena, *Les retables brabançons conservés en Suède*, Brussels 1948.

de Borchgrave d'Altena 1962–6 J. de Borchgrave d'Altena, Trésor d'art, in *Annales de la Société Royale d'Archéologie de Bruxelles* (1962–6), 377–408.

de Borchgrave d'Altena 1963 J. de Borchgrave d'Altena, Notes pour servir à l'étude des œuvres d'art du Limbourg, 1, in *Bulletin de la Société d'Art et d'Histoire du Diocèse de Liège* 43 (1963), 67–181.

de Borchgrave d'Altena 1965 J. de Borchgrave d'Altena, Fragments de retables brabançons des XV᷐ et XVI᷐ siècles conservés au musée Curtius à Liège, in *Chronique Archéo-logique du Pays de Liège* 56 (1965), 55–113.

de Borchgrave d'Altena and Mambour 1968a J. de Borchgrave d'Altena and J. Mambour, *Fragments de retables en bois et retables en pierre du Hainaut*, Mons 1968.

de Borchgrave d'Altena and Mambour 1968b J. de Borchgrave d'Altena and J. Mambour, *Retables en bois du Hainaut*, Mons 1968.

de Borchgrave d'Altena and Mambour 1971 J. de Borchgrave d'Altena and J. Mambour, *La passion dans la sculpture en Hainaut de 1400 à 1700*, Mons 1971.

de Borchgrave d'Altena and Mambour 1972 J. de Borchgrave d'Altena and J. Mambour, *La passion dans la sculpture en Hainaut de 1400 à 1700*, Mons 1972.

de Borchgrave d'Altena and Mambour 1974 J. de Borchgrave d'Altena and J. Mambour, *La passion dans la sculpture en Hainaut de 1400 à 1700*, Mons 1974.

de Brabandere 1968 P. de Brabandere, *Geschiedenis van de beeldhouwkunst te Kortrijk*, Kortrijk 1968.

de Busscher 1848–59 Ed. de Busscher, Mausolée de Michelle de France, in *Annales de la Société Royale des Beaux-Arts et de la Littérature de Gand 1848–1850* (1848–59), 207–212.

de Coo 1969 J. de Coo, *Museum Mayer van den Bergh, 2, Beeldhouwkunst, plaketten, antiek*, Antwerp 1969.

de Laborde 1849 A. de Laborde, *Les ducs de Bourgogne. Etudes sur les lettres, les arts et l'industrie pendant le XV᷐ siècle…, seconde partie, 1, preuves*, Paris 1849.

de la Grange 1904 A. de la Grange, Choix de testaments tournaisiens antérieurs au XVI᷐ siècle, in *Annales de la Société Historique et Archéologique de Tournai* 8 (1904), 5–365.

Delepierre 1841 O. Delepierre, Stalles de l'abbaye de Melrose faits à Bruges, in *Annales de la Société d'Emulation de Bruges* 3 (1841), 402–431.

Demmler 1930 T. Demmler, *Die Bildwerke des Deutschen Museums. Die Bildwerke in Holz, Stein und Ton. Grossplastik, Staatliche Museen zu Berlin*, Berlin–Leipzig 1930.

Demuynck 1982 P. Demuynck, Vondst van een belangrijke partij architecturaal beeldhouwwerk in de voormalige Sint-Gertrudisabdij te qqLeuven, in *Jaarboek van de Geschied- en Oudheidkundige Kring voor Leuven en Omgeving* 22 (1982), 43–56.

Dennison 1986 L. Dennison, The Artistic Context of Fourteenth Century Flemish Brasses, in *Transactions of the Monumental Brass Society* 14 (1986), 1–38.

de Ridder 1988–9 P. de Ridder, *Sint-Goedele, het verhaal van een kathedraal*, Algemeen Rijksarchief, Brussels 1988–9.

de Ruette et al. 1988–9 M. de Ruette, M. Dupas, G. Genin, L. Maes, L. Masschelein-Kleiner, and I. Vandevivere, Etude technologique des dinanderies coulées. L'œuvre de Guillaume Lefèvre (Synthèse), in *Bulletin des Musées Royaux d'Art et d'Histoire* 22 (1988–9), 104–159.

Derveaux-Van Ussel 1968–70 Gh. Derveaux-Van Ussel, Het Apostelenretabel uit de voormalige Begijnhofkerk van Tongeren, in *Bulletin des Musées Royaux d'Art et d'Histoire* 40–42 (1968–70), 137–199.

de Salas 1978 X. de Salas, *Museo del Prado. Adquisiciones de 1969 a 1977*, Madrid 1978.

Descamps 1905–6 G. Descamps, Maître Gilles Le Cat, tailleur d'images et graveur de tombes, ses œuvres et sa famille, in *Annales du Cercle Archéologique de Mons* 35 (1905–6), 1–23.

Deschamps de Pas 1892–6 L. Deschamps de Pas, L'église Notre-Dame de Saint-Omer d'après les comptes de fabrique et les registres capitulaires, in *Mémoires de la Société des Antiquaires de la Morinie* 22 (1892), 147–228; 23 (1893–6), 3–126.

Des Marez 1958 G. Des Marez, *Guide illustré de Bruxelles. Monuments civils et religieux. Remis à jour et complété par A. Rousseau*, Brussels 1958.

de Smedt 1993 H. de Smedt, De Antwerpse retabels en hun iconografie: een overzicht van onderwerpen en veranderingen, in *Antwerpse retabels, 15de–16de eeuw*, Antwerp, Cathedral, 1993, 2: 23–46.

Destrée 1894–9 J. Destrée, Etude sur la sculpture brabançonne au Moyen Age, in *Annales de la Société Royale d'Archéologie de Bruxelles* 8 (1894), 5–113; 9 (1985), 363–405; 13 (1899), 273–330.

Destrée 1927 J. Destrée, Groupe de la Vierge et de l'Enfant provenant de l'ancienne abbaye de Saint-Ghislain, in *Annales de la Société Royale d'Archéologie de Bruxelles* 30 (1927), 207–213.

Detroit 1960 The Detroit Institute of Arts. *Flanders in the XVth Century: Art and Civilization*.

Deurne–Brussels 1957 Het Sterckshof–Musées Royaux d'Art et d'Histoire. *Koper en brons*.

Deutsch 1985 W. Deutsch, Der Hochaltar der Haller Katharinenkirche, Geschichte und Herkunft, in *Württembergische Franken Jahrbuch* (1985), 127–220.

de Valkeneer 1963 A. de Valkeneer, Inventaire des tombeaux et dalles à gisants en relief en Belgique. Epoques romane et gothique, in *Bulletin van de Koninklijke Commissie voor Monumenten en Landschappen* 14 (1963), 91–256.

Devigne 1932 M. Devigne, *La sculpture mosane du XII᷐ au XVI᷐ siècle*, Paris–Brussels 1932.

Devliegher 1968 L. Devliegher, *De huizen te Brugge* (Inventaris Kunstpatrimonium van West-Vlaanderen, 2–3), Tielt–The Hague 1968.

Devliegher 1979 L. Devliegher, *De Sint-Salvatorskathedraal te Brugge* (Inventaris Kunstpatrimonium van West-Vlaanderen, 8), Tielt–Amsterdam 1979.

de Winter 1987 P. de Winter, Art from the Duchy of Burgundy, in *The Bulletin of the Cleveland Museum of Art* 74 (1987), 406–449.

D'Hainaut-Zveny 1983 B. d'Hainaut-Zveny, La dynastie Borreman (XV᷐–XVI᷐ s.), Crayon généalogique et analyse comparative des personnalités artistiques, in *Annales d'Histoire de l'Art et d'Archéologie* 5 (1983), 47–66.

Dhanens 1961 E. Dhanens, *Dendermonde* (Inventaris van het Kunstpatrimonium van Oost-Vlaanderen, 4), Ghent 1961.

Dhanens 1980 E. Dhanens, *Hubert and Jan Van Eyck*, Antwerp 1980.

Didier 1963 R. Didier, Christ attendant la mort au Calvaire et Pietà, deux sculptures anversoises conservées à Binche, in *Bulletin van de Koninklijke Commissie voor Monumenten en Landschappen* 14 (1963), 53–75.

Didier 1970a R. Didier, Le Maître de la mise au tombeau d'Hautrage et du Calvaire d'Isières, in *Mélanges d'Archéologie et d'Histoire de l'Art offerts au professeur Jacques Lavalleye*, Leuven 1970, 53–73.

Didier 1970b R. Didier, La mise au tombeau d'Arc (Hainaut), in *Revue des Archéologues et Historiens d'Art de Louvain* 3 (1970), 73–90.

Didier 1972 R. Didier, Aspekten van de laatgotiek in Brabant … Leuven, Stedelijk Museum 1971, in *Pantheon* 30 (1972), no. 5, 405–408.

Didier 1973 R. Didier, Contribution à l'étude de la sculpture gothique tardive dans le Brabant méridional, in *Annales de la Société d'Archéologie d'Histoire et de Folklore de Nivelles et du Brabant-Wallon* 22 (1973), 89–209.

Didier 1977 R. Didier, L'art à Tournai et en Hainaut, la sculpture en Hainaut, in *La Wallonie. Le pays et les hommes. Lettres–arts–culture* 1 (1977), 385–404.

Didier 1982 R. Didier, Sculptures mosanes des années 1400–1450, in *Clio et son regard. Mélanges d'histoire, d'histoire de l'art et d'archéologie offerts à J. Stiennon*, Liège 1982, 143–171.

Didier 1983 R. Didier, Sculptures des années 1400–1450 en Hainaut, in *Recueil d'études d'histoire hainuyère offertes à Maurice A. Arnould* (Analectes d'histoire du Hainaut, 2), Mons 1983, 361–400.

Didier 1984 R. Didier, De H. Cornelis van het St. Jans-hospitaal en de Brugse beeldhouwkunst omstreeks 1400, in *Rond de restauratie van het 14de eeuwse Corneliusbeeld Brugge St. Janshospitaal*, Bruges 1984, 19–52.

Didier 1989 R. Didier, Sculptures et retables des anciens Pays-Bas méridionaux des années 1430–1460. Traditions et innovations pour le Haut-Rhin et l'Allemagne du Sud, in *Le retable d'Issenheim et la sculpture au nord des Alpes à la fin du Moyen-Age. Actes du colloque de Colmar (2–3 nov. 1987)*, Colmar 1989, 49–79.

Didier 1993 R. Didier, *Claus Sluter* (Monographies du Musée des Arts anciens du Namurois, 3), Namur 1993.

Didier, Henss and Schmoll gen. Eisenwerth 1970 R. Didier, M. Henss and J.A. Schmoll gen. Eisenwerth, Une Vierge tournaisienne à Arbois (Jura) et le problème des Vierges de Hal. Contribution à la chronologie et à la typologie, in *Bulletin Monumental* 128 (1970), 93–113.

Didier and Krohm 1977 R. Didier and H. Krohm, *Duitse middeleeuwse beeldhouwwerken in Belgische verzamelingen*, Generale Bankmaatschappij, Brussels 1977.

Didier and Recht 1980 Didier and R. Recht, Paris, Prague, Cologne et la sculpture de la seconde moitié du XIV᷐ siècle. A propos de l'exposition de Parler à Cologne, in *Bulletin Monumental* 138 (1980), 173–219.

Dijon 1972 Musée de Dijon. *Jean de la Huestre et la sculpture Bourguignonne au milieu du XV᷐ siècle*.

Dijon 1973 Musée de Dijon. *Antoine le Moiturier, le dernier des grands imagiers des ducs de Bourgogne*.

Douai (Section d'Archéologie) 1937 *Catalogue du Musée de Douai (Section d'Archéologie)*, Douai 1937.

Douai 1969 Musée de la Chartreuse. *Richesses artistiques méconnues du Nord*.

Doutrepont 1937 A. Doutrepont, Le cloître de l'ancienne abbaye de Sainte-Gertrude à Louvain, in *Belgisch Tijdschrift voor Oudheidkunde en Kunstgeschiedenis* 7 (1937), 103–133.

Drost 1963 W. Drost, *Die Marienkirche in Danzig und ihre Kunstschätze*, Stuttgart 1963.

Dubois 1987–8 H. Dubois, *Le Maître à la vue de Sainte-Gudule: contribution à l'étude de critique de son œuvre, Mémoire*, Université Libre de Bruxelles, Brussels 1987–8.

Durand 1989–90 G. Durand, Retables (flamands) et statuaire bretonne. La notion d'expansion artistique aux XV᷐ et XVI᷐ siècles, in *Le Serment des Horaces, Revue d'Art internationale* (1989–90), no. 3, 142–159.

Duverger 1933 J. Duverger, *De Brusselsche steenbickeleren. Beeldhouwers, bouwmeesters, metselaars enz. der XIVde en XVde eeuw met een aanhangsel over Klaas Sluter en zijn Brusselsche medewerkers te Dijon*, Ghent 1933.

Duverger 1935 J. Duverger, *Brussel als kunstcentrum in de 14de en 15de eeuw*, Antwerp–Ghent 1935.

Eichler 1933 H. Eichler, Fländrische gravierte Metallgrab-platten des XIV. Jahrhunderts, in *Jahrbuch der preussischen Kunstsammlungen* 54 (1933), 199–220.

Engelen 1993 C. Engelen, *Zoutleeuw. Jan Mertens en de laatgotiek. Confrontatie met Jan Borreman*, Leuven 1993.

Engelstad 1936 E. Engelstad, *Senmiddelalderens Kunst i Norge ca. 1400–1535*, Oslo 1936.

Epigraphie Pas de Calais *Epigraphie du département du Pas de Calais, ouvrage publié par la Commission départementale des monuments historiques, 8, 1883–1937.*

Essen 1974 *Die Gottesmutter, Marienbild in Rheinland und in Westfalen*, Recklinghausen 1974.

Forsyth 1937 W. Forsyth, Four Fifteenth-Century Sculptures Showing Flemish Influence, in *The Bulletin of the Metropolitan Museum of Art* 32 (1937), 66–69.

Forsyth 1968 W.H. Forsyth, A Group of Fourteenth Century Mosan Sculptures, in *The Metropolitan Museum Journal* 1 (1968), 41–59.

Forsyth 1970 W.H. Forsyth, The Entombment of Christ, *French Sculptures of the Fifteenth and Sixteenth Centuries*, Cambridge (Mass.) 1970.

Foster 1979 M.B. Foster, *The Iconography of St. Joseph in Netherlandish Art: 1400–1550*, Ph.D. Diss., University of Kansas, Lawrence 1979.

Friedländer 1967 M.J. Friedländer, *Early Netherlandish Painting*, 1, *The van Eycks-Petrus Christus*; 2, *Rogier van der Weyden and the Master of Flémalle*, Leiden–Brussels 1967.

Friedländer 1971 M.J. Friedländer, *Early Netherlandish Painting, Hans Memlinc and Gerard David*, Leiden–Brussels 1971.

Gaborit-Chopin 1978 D. Gaborit-Chopin, *Ivoires du Moyen-Age*, Freiburg 1978.

Gaier 1960–1 C. Gaier, Contribution à l'étude de l'armement au XVᵉ siècle: à propos d'un bas-relief en terre cuite du Musée Curtius, in *Chronique Archéologique du Pays de Liège (1960–1961)*, 37–55.

Geisler 1956 I. Geisler, Studien zur niederländischen Bildhauern des ausgehenden 14. und frühen 15. Jahrhunderts, in *Wallraf-Richartz-Jahrbuch* 18 (1956), 143–158.

Geisler 1957 I. Geisler, *Oberrheinische Plastik um 1400*, Berlin 1957.

Ghent 1961 Museum van de Bijloke. *Koperen kunstwerken uit kerken van noord en zuid.*

Ghent 1975 Museum voor Schone Kunsten–Museum van de Bijloke–Centrum voor Kunst en Cultuur. *Gent, 1000 jaar Kunst & Cultuur.*

Ghent 1976 Centrum voor Kunst en Cultuur. *Eenheid en scheiding in de Nederlanden 1555–1585.*

Gillerman 1989 D. Gillerman, *Gothic Sculpture in America, 1, The New England Museum*, New York–London 1989.

Gillerman II D. Gillerman, *Gothic Sculpture in America, 2, The Midwestern Museums* [forthcoming].

Gilliodts-van Severen 1871–85 L. Gilliodts-van Severen, *Inventaire des archives de la ville de Bruges. Inventaire des chartes*, Bruges 1873.

Godenne 1957 W. Godenne, Préliminaire à l'inventaire général des statuettes d'origine malinoise présumées des XVᵉ et XVIᵉ siècles, in *Handelingen van de Koninklijke Kring voor Oudheidkunde, Letteren en Kunsten van Mechelen* 61 (1957), 47–127.

Gohr 1974 S. Gohr, Anna Selbdritt, in *Die Gottesmutter, Marienbild in Rheinland und in Westfalen*, 1, Recklinghausen 1974, 243–254.

Gorissen 1965 F. Gorissen, *De Meester van Varsseveld en Kersken Woyers gen. Van Ringenberg*, s.l. 1965.

Gorissen 1973 F. Gorissen, *Das Stundenbuch der Katharina von Kleve. Analyse und Kommentar*, Berlin 1973.

Grams-Thieme 1988 M. Grams-Thieme, *Lebendige Steine. Studien zur niederländischen Grisaillemalerei des 15. und frühen 16. Jahrhunderts* (Böhlau Dissertationen zur Kunstgeschichte 27), Cologne–Vienna 1988.

Gravelines 1981–2 La Poudrière en l'Arsenal. *Bois sculptés du Musée de Saint-Omer XIIIᵉ–XVIIIᵉ siècle.*

Grimme 1977 E. Grimme, *Europäische Bildwerke vom Mittelalter zum Barock. Suermondt-Ludwig-Museum Aachen*, Cologne 1977.

Grössinger 1992 C. Grössinger, *North-European Panel Painting. A Catalogue of Netherlandish and German Paintings Before 1600 in English Churches and Colleges*, London 1992.

Halsema-Kubes 1992 W. Halsema-Kubes, Der Altar Adriaen van Wesels aus 's Hertogenbosch. Rekonstruktion und Kunstgeschichtliche Bedeutung, in H. Krohm and E. Oellermann, *Flügelaltäre des späten Mittelalters. Staatliche Museen zu Berlin. Preussischer Kulturbesitz. Skulpturensammlung*, Berlin 1992, 144–156.

Hamann 1923 R. Hamann, Spätgotische Skulpturen der Wallfahrtskirche in Hal, in *Belgische Kunstdenkmäler*, P. Clemen (ed.), 1, Munich 1923, 203–246.

Hand and Wolff 1986 J. Hand and M. Wolff, *Early Netherlandish Painting. The Collections of the National Gallery of Art*, Washington 1986.

Hardy 1972 A. Hardy, Musée des Beaux-Arts de Valenciennes, 1, Sculptures et objets d'art, in *La Revue du Louvre* 22 (1972), nos. 4–5, 259–260.

Haslinghuis and Peeters 1965 E. Haslinghuis and

C. Peeters, *De Nederlandse Monumenten van Geschiedenis en Kunst, 2, De provincie Utrecht. De Dom van Utrecht*, The Hague 1965.

Hasse 1961 M. Hasse, Bildwerke des Mittleren 15. Jahrhunderts in Lübeck und Vadstena, in *Niederdeutsche Beiträge zur Kunstgeschichte* 1 (1961), 187–200.

Hasse 1983 M. Hasse, *Marienkirche zu Lübeck*, Munich 1983.

Heinrichs-Schreiber 1991 U. Heinrichs-Schreiber, Die Konsolfiguren der Tour du Village in Vincennes. Ein unbekanntes Frühwerk Claus Sluters, in *Jahrbuch der Berliner Museen*, N.F. 33 (1991), 99–105.

Heins 1904 A. Heins, Tympan de lucarne brugeois, in *Inventaire Archéologique de Gand (1904)*, 362.

Hegner 1983 K. Hegner, *Mittelalterliche Kunst, 2, Kleinkunst, Kunsthandwerk, Staatliches Museum Schwerin*, Schwerin 1983.

Herstal 1985 Eglise Saint-Lambert. *Patrimoine historique et religieux.*

's-Hertogenbosch 1971 Noordbrabants Museum. G. Lemmens and G. de Werd, *Beelden uit Brabant. Laatgotische kunst uit het oude hertogdom 1400–1520.*

Hessig 1935 E. Hessig, *Die Kunst des Meister E.S. und die Plastik der Spätgotik*, Berlin 1935.

Hilger 1961 H. Hilger, *Der Skulpturenzyklus im Chor des Aachener Domes*, Essen 1961.

Hiller and Vey 1969 I. Hiller and H. Vey, *Katalog der Deutschen und Niederländischen Gemälde bis 1550 (mit ausnahme der Kölner Malerei) im Wallraf-Richartz-Museum und im Kunstgewerbe Museum der Stadt Köln*, Cologne 1969.

Hofmann 1962 H.D. Hofmann, *Die Lothringische Skulptur der Spätgotik*, Saarbrücken 1962.

Hofmann 1966 H. Hofmann, Die Niederländer Jan Crocq Hofbildhauer in Bar-le-Duc und Nancy, in *Aachener Kunstblätter* 32 (1966), 106–125.

Hoei 1990 Collégiale. *Filles de Cîteaux au pays mosan.*

Hoozee 1988 R. Hoozee, *Museum voor Schone Kunsten Gent* (Musea Nostra), Brussels 1988.

Houdoy 1880 J. Houdoy, *Histoire artistique de la cathédrale de Cambrai, ancienne église métropolitaine Notre-Dame*, Lille 1880.

Houffalize 1985 Salle Communale. *Art religieux, histoire et archéologie au pays de Houffalize.*

Jaca–Huesca 1993 Jaca, Catedral–Museo Diocesano, Huesca. *Signos. Arte y Cultura en el Alto Aragón Medieval.*

Jacobs 1986 L. Jacobs, *Aspects of Netherlandish Carved Altarpieces 1380–1530*, Ph. D. Diss., New York University, New York 1986.

Janke 1977 R. Janke, *Jehan Lome y la escultura gótica posterior en Navarra*, Pamplona 1977.

Jansen 1964 A. Jansen, *Christelijke kunst tot het einde der middeleeuwen*, Musées Royaux d'Art et d'Histoire, Brussels 1964.

Jansen and Van Herck 1949 A. Jansen and C. van Herck, *Kerkelijke kunstschatten*, Antwerp 1949.

Janssens-de Bisthoven 1944 A. Janssens-de Bisthoven, Het beeldhouwwerk van het Brugsche stadhuis, in *Gentse Bijdragen tot de Kunstgeschiedenis* 10 (1944) 7–81.

Jopek 1988 N. Jopek, *Studien zur deutschen Alabasterplastik des 15. Jahrhunderts* (Manuskripte zur Kunstwissenschaft in der Wernerschen Verlagsgesellschaft, 21), Worms 1988.

Kalf 1912 J. Kalf, *De Nederlandse monumenten van geschiedenis en kunst in de provincie Noord-Brabant, 1, De Baronie van Breda*, The Hague 1912.

Kämpfer s.a. F. Kämpfer, *Mittelalterliche Bildwerke aus Thüringer Dorfkirchen*, Dresden s.a.

Karlsruhe 1970 Badisches Landesmuseum. *Spätgotik am Oberrhein. Meisterwerke der Plastik und des Kunsthandwerks 1450–1530.*

Koch 1958 R. Koch, An Ivory Diptych from the Waning Middle Ages, in *Record of the Art Museum, Princeton University* 17 (1958), no. 2, 55–64.

Koechlin 1924 R. Koechlin, *Les ivoires gothiques français*, Paris 1924.

Koldeweij 1990 A. Koldeweij, *In Buscoducis 1450–1629. Kunst uit de Bourgondische tijd te 's Hertogenbosch. De cultuur van late middeleeuwen en renaissance*, Noordbrabants Museum, 's-Hertogenbosch 1990.

Körner 1965 G. Körner, *Museum für das Fürstentum Lüneburg*, Hamburg 1965.

Koyen and Van Dijck 1973 M. Koyen and L.C. van Dijck, *Tongerlo door de eeuwen heen*, Tongerlo 1973.

Krohm 1976 H. Krohm, *Spätmittelalterliche Bildwerke aus Brabant. Figuren heiliger Frauen von einer Grablegung Christi* (Studienhefte der Skulpturengalerie, 3) Berlin 1976.

Krönig 1967 W. Krönig, *Rheinische Vesperbilder*, Mönchengladbach 1967.

Kutal 1962 A. Kutal, *Ceské Gotické Socharstvi 1350–1450*, Prague 1962.

Kutal 1969 A. Kutal, Les problèmes limitrophes de la sculpture tchèque au tournant de 1400, in *Sbornik Praci Filosofické Fakulty Brnenské University* 19 (1969), 155–166.

Laarne 1969 Château. *Middeleeuwse beeldhouwkunst behorend tot Belgische privé-verzamelingen.*

Lane 1973 B. Lane, The Symbolic Crucifixion in the Hours of Catherine of Cleves, in *Oud Holland* 87 (1973), 4–26.

Lane 1984 B. Lane, *The Altar and the Altarpiece*, New York 1984.

Lawrence 1969 The University of Kansas Museum of Art, J. Schräder, *The Waning Middle Ages.*

Leeuwenberg 1951 J. Leeuwenberg, De tien bronzen "plorannen" in het Rijksmuseum te Amsterdam, hun herkomst en de voorbeelden waaraan zij zijn ontleend, in *Gentse Bijdragen tot de Kunstgeschiedenis* 13 (1951), 13–59.

Leeuwenberg 1959 J. Leeuwenberg, Een nieuw facet aan de Utrechtse Beeldhouwkunst, 3, Vijf Utrechtse Altaarkasten in Noorwegen, in *Oud Holland* 74 (1959), 79–102.

Leeuwenberg 1962 J. Leeuwenberg, Een nieuw facet aan de Utrechtse beeldhouwkunst, 5, in *Oud Holland* 77 (1962), 79–99.

Leeuwenberg 1965a J. Leeuwenberg, Sprokkelingen van een reis op het Iberisch schiereiland, in *Miscellanea pro Arte*. Festschrift für Hermann Schnitzler, Düsseldorf 1965, 239–243.

Leeuwenberg 1965b J. Leeuwenberg, Die Ausstrahlung Utrechter Tonplastik, in *Studien zur Geschichte der europäischen Plastik. Festschrift für Th. Müller*, Munich 1965.

Leeuwenberg and Halsema 1973 J. Leeuwenberg and W. Halsema-Kubes, *Beeldhouwwerk in het Rijksmuseum*, The Hague–Amsterdam 1973.

Lefèvre 1942 P. Lefèvre, *De Collegiale Kerk van Sint-Michiel en Sinte-Goedele te Brussel*, Brussels 1942.

Lefèvre 1956–7 P. Lefèvre, La collégiale des Saints-Michel et Gudule à Bruxelles. L'édifice, son ornementation et son mobilier à la lumière des textes d'archives, in *Annales de la Société Royale d'Archéologie de Bruxelles* 46 (1956–7), 16–72.

Legner 1974 A. Legner, Polychrome und monochrome Skulptur in der Realität und im Abbild, in *Vor Stefan Lochner. Die Kölner Maler von 1300–1430. Ergebnisse der Ausstellung und des Colloquiums*, Cologne 1974, 140–163.

Lehrs 1908–34 M. Lehrs, *Geschichte und kritischer Katalog des Deutschen, Niederländischen und Französischen Kupferstichs im XV. Jahrhundert*, Vienna 1908–34.

Lemmens and De Werd 1971 G. Lemmens and G. de Werd, Een onbekend fragment van Adriaen van Wesels Mariaaltaar van de Onze-Lieve-Vrouwe-Broederschap, in *Antiek* 6 (1971), no. 3, 170–178.

Lequeux 1979 J.M. Lequeux, *Répertoire photographique du mobilier des sanctuaires de Belgique. Province de Hainaut. Canton de Soignies*, Brussels 1979.

Lequeux 1980 J.M. Lequeux, *Répertoire photographique du mobilier des sanctuaires de Belgique. Province de Hainaut. Canton de Rœulx*, Brussels 1980.

Lequeux, Amand De Mendeta and Coeckelberghs 1982 J.M. Lequeux, J. Amand De Mendeta and D. Coeckelberghs, *Répertoire photographique du mobilier des sanctuaires de Belgique. Province de Hainaut. Canton de Tournai*, Brussels 1982.

Lestocquoy 1937a J. Lestocquoy, Sculptures d'origine ou d'influence brabançonne en Artois, in *Annales de la Société Royale d'Archéologie de Bruxelles* 61 (1937), 75–82.

Lestocquoy 1937b J. Lestocquoy, Le rôle des artistes tournaisiens à Arras au XVᵉ siècle Jacques Daret et Michel de Gand, in *Revue Belge d'Archéologie et d'Histoire de l'Art* 7 (1937), 211–227.

Leuven 1962 Stedelijk Museum. *Ars sacra antiqua.*

Leuven 1965 Stedelijk Museum. *Het werk van Rogier de le Pasture/Van der Weyden.*

Leuven 1971 Stedelijk Museum. *Aspekten van de laatgotiek in Brabant.*

Leuven 1975 St. Pieterskerk. *Dirk Bouts en zijn tijd.*

Leuven 1979 Stedelijk Museum. *Het laatgotisch beeldsnijcentrum Leuven.*

Leuven 1988 Stedelijk Museum. *Schatten der armen. Het artistiek en historisch bezit van het O.C.M.W.–Leuven.*

Liebmann 1988 M. Liebmann, *La sculpture d'Europe occidentale des XVᵉ et XVIᵉ siècles dans les musées de l'Union Soviétique*, Leningrad 1988.

Liège 1973 Institut St. Joseph. *Art ancien dans le patrimoine privé liégeois.*

Liège 1980 Basilique Saint-Martin. *Œuvres maîtresses du Musée d'art religieux et d'art mosan.*

Lier 1959 Musea Wuyts-Van Campen en Caroly. *Kerkelijke kunst stad Lier.*

Lille 1978–9 Musée des Beaux-Arts. H. Oursel, *Sculptures romanes et gothiques du Nord de la France.*

Lobelle 1985 H. Lobelle, *Memlingmuseum, Sint-Janshospitaal* (Musea Nostra), Bruges 1985.

Lokeren s.a. *Antieke houten beelden in Lokers bezit*, s.a.

Longhurst 1927 M. Longhurst, *Catalogue of Carvings in Ivory. Victoria and Albert Museum*, London, 1 (1927); 2 (1929).

Loriquet 1889 H. Loriquet, *Journal des travaux d'art exécutés dans l'abbaye de Saint-Vaast par l'abbé Jean du Clercq (1429–1461)*, Arras 1889.

Lotthé 1940 E. Lotthé, *Les églises de la Flandre française au Nord de la Lys*, Lille 1940.

Louis 1939 L. Louis, La petite sculpture à l'hôtel de ville de Bruges. Clés de voûte et quadrilobes, in *Belgisch Tijdschrift van Oudheidkunde en Kunstgeschiedenis* 9 (1939), 201–207.

Lücker 1924 H. Lücker, Zur gotischen Plastik in Trier, in *Wallraf-Richartz-Jahrbuch* 5 (1924), 27–46.

Lüdke 1983 D. Lüdke, *Die Statuetten der gotischen Goldschmiede*, Munich 1983.

Luxemburg 1966 G. Schmitt, *Madones au Luxembourg*, Luxemburg 1966.

Maek-Gérard 1981 M. Maek-Gérard, *Liebieghaus-Frankfurt am Main, Museum Alter Plastik. Nachantike Grossplastische Bildwerke, 2, Italien, Frankreich und Niederland, 1380–1530/40*, Melsungen 1981.

Maeterlinck 1901 L. Maeterlinck, Roger van der Weyden, sculpteur, in *Gazette des Beaux-Arts* 26 (1901), 265–284; 399–411.

Mambour 1981 J. Mambour, *La Vierge à l'Enfant dans la sculpture en Hainaut. La statuaire de 1200 à 1530*, Mons 1981.

Mann 1992 J. Mann, Medieval Art, in *The Saint Louis Art Museum, Bulletin* (Winter 1992), 1–68.

Marchand 1925–6 H. Marchand, Die Plastik des Halberstädter Doms im XV. Jahrhundert, in *Zeitschrift für Bildende Kunst* 59 (1925–6), 310–318.

Marijnissen and Van Liefferinge 1967 R. Marijnissen and H. van Liefferinge, Les retables de Rheinberg et de Haekendover, in *Jahrbuch der Rheinischen Denkmalpflege* 27 (1967), 75–89.

Marrow 1978 J. Marrow, A Book of Hours from the Circle of the Master of the Berlin Passion: Notes on the Relationship between Fifteenth Century Manuscript Illumination and Printmaking in the Rhenisch Lowlands, in *The Art Bulletin* (1978), 590–616.

Medding 1934 W. Medding, Herkunft und Jugendwerke des Claus Sluter, in *Zeitschrift für Kunstgeschichte* 3 (1934), 341–359.

Meiss 1967 M. Meiss, *French Painting in the Time of Jean de Berry. The late Fourteenth Century and the Patronage of the Duke*, London–New York 1967.

Meiss 1974 M. Meiss, *French Painting in the Time of Jean de Berry. The Limbourgs and their Contemporaries*, London 1974.

Meurer 1970 M. Meurer, *Das Klever Chorgestühl und Arnt Bildesnider* (Die Kunstdenkmäler des Rheinlandes, 15), Düsseldorf 1970.

Millin 1795 A.L. Millin, *Antiquités nationales, ou recueil de monuments* 5, Paris 1795.

Minneapolis 1978 University of Minnesota Gallery. A. Stones and J. Steyaert, *Medieval Illumination, Glass and Sculpture in Minnesota Collections.*

Morand 1984 K. Morand, Claus Sluter: The Early Years, in *Liber Amicorum H. Liebaers*, Brussels 1984, 561–584.

Morand 1991 K. Morand, *Claus Sluter. Artist at the Court of Burgundy*, London 1991.

Müller 1900 S. Müller, Nederlandse Heiligenbakkerijen, in *Bulletin Nederlandse Oudheidkundige Bond* (July 1900), 213.

Müller 1966 Th. Müller, *Sculpture in the Netherlands. Germany, France and Spain 1400 to 1500*, Harmondsworth-Baltimore (Maryland) 1966.

Netzer 1991 N. Netzer, *Catalogue of Medieval Objects, Metalwork, Museum of Fine Arts Boston*, Boston 1991.

Neu-Kock 1980 R. Neu-Kock, Überlegungen zur stilistischen Herkunft der Madonna der Überwasser Portales in Münster, in *Die Parler und der Schöne Stil 1350–1400. Europäische Kunst unter den Luxemburgern, 4, Das internationale Kolloquium vom 5. bis zum 12. März 1979, anlässlich der Ausstellung des Schnütgen-Museums in der Kunsthalle Köln*, Cologne 1980, 100–103.

New York 1990 Pierpont Morgan Library. *The Golden Age of Dutch Manuscript Painting.*

Nieuwdorp 1971 H. Nieuwdorp, Het huwelijk van de H. Maagd: een Brussels retabelfragment uit het midden van de 15de eeuw, in *Bulletin van de Musea voor Schone Kunsten* (1971), 7–23.

Nieuwdorp 1981 H. Nieuwdorp, De oorspronkelijke betekenis en interpretatie van de keurmerken op Brabantse retabels en beeldsnijwerk (15de–begin 16de eeuw), in *Archivum Artis Lovaniense. Bijdragen tot de geschiedenis van de kunst der Nederlanden. Opgedragen aan Prof. Em. Dr. J.K. Steppe*, Leuven 1981, 85–98.

Nieuwdorp 1992 H. Nieuwdorp, *Museum Mayer Van den Bergh Antwerpen* (Musea Nostra), Brussels 1992.

Nijs 1990 L. Nijs, *La production lapidaire des tombiers tournaisiens aux XIIIᵉ, XIVᵉ et XVᵉ siècles.* Diss. Université Catholique de Louvain, Louvain-la-Neuve 1990.

Norris 1978 M. Norris, *Monumental Brasses*, 1, London 1978.

Ohnmacht 1973 M. Ohnmacht, *Das Kruzifix des Niclaus Gerhaert von Leyden in Baden-Baden von 1467. Typus-Stil, Herkunft-Nachfolge*, Frankfurt 1973.

Oslo 1952 Nasjonalgalleriet. *Katalog over Skulptur og Kunstindustri*, Oslo 1952.

Otto 1954 G. Otto, Schwäbische Plastik in ausländischen Sammlungen, in *Schwäbische Heimat* 5 (1954), no. 6, 251–257.

Oursel 1980 H. Oursel, Monuments funéraires des XIIIᵉ, XIVᵉ, XVᵉ et XVIᵉ siècles à Lille et dans ses environs immédiats, in *Revue du Nord* 62 (1980), 345–370.

Oursel 1984 H. Oursel, *Le Musée des Beaux-Arts de Lille*, Paris 1984.

Paatz 1926 W. Paatz, Der Meister der Lübeckischer Steinmadonnen, in *Jahrbuch der preussischer Kunstsammlungen* 47 (1926), 168–183.

Paatz 1929 W. Paatz, *Die Lübeckische Steinskulptur der ersten Hälfte des 15. Jahrhunderts* (Veröffentlichungen zur Geschichte der Freien und Hansestadt Lübeck, 9), Lübeck 1929.

Paatz 1936 W. Paatz, Eine nordwestdeutsche Gruppe von frühen flandrischen Schnitzaltären aus der Zeit von 1360 bis 1450, in *Westfalen* 21 (1936), 49–68.

Paatz 1956a W. Paatz, *Prolegomena zu einer Geschichte der deutschen spätgotischen Skulptur im 15. Jahrhundert* (Abhandlungen der Heidelberger Akademie der Wisschenschaften: Philosophisch-Historische Klasse), Heidelberg 1956, 127–135.

Paatz 1956b W. Paatz, Stammbaum der gotischen Alabasterskulptur 1316–1442, in *Kunstgeschichtliche Studien für Hans Kauffmann* (1956), 127–135.

Paatz 1967 W. Paatz, *Verflechtungen in der Kunst der Spätgotik zwischen 1360 und 1530* (Abhandlungen der Heidelberger Akademie der Wissenschaften: Philosophisch-Historische Klasse), Heidelberg 1967.

Panofsky 1953 E. Panofsky, *Early Netherlandish Painting. Its Origins and Character*, Cambridge (Mass.) 1953.

Paquay 1911 J. Paquay, *Monographie illustrée de la collégiale Notre-Dame à Tongres*, Tongeren 1911.

Paris 1925 E. Haraucourt, F. de Montrémy and E. Maillard, *Musée des Thermes et de l'Hôtel de Cluny. Catalogue des bois sculptés et meubles*, Paris 1925.

Paris 1959 Musée de l'Orangerie, *L'Art en Champagne au Moyen Age.*

Paris 1981–2 Galeries Nationales du Grand Palais. *Les fastes du gothique. Le siècle de Charles V.*

Paris 1988 Musée du Luxembourg. *Trésors sacrés, Trésors cachés. Patrimoine des églises de Seine-et-Marne*, Paris 1988.

Paris 1991 Musée du Louvre. S. Guillot de Suduiraut, *Sculptures allemandes de la fin du Moyen Age dans les collections publiques françaises 1400–1530.*

Périer-D'Ieteren 1984 C. Périer-D'Ieteren, *Les volets peints des retables bruxellois conservés en Suède et le rayonnement de Colijn de Coter*, Stockholm 1984.

Pescatore 1918 A. Pescatore, *Der Meister der Bemalten Kreuzigungsreliefs. Ein Beitrag zur Geschichte der Niederdeutschen Plastik im fünfzehnten Jahrhundert* (Studien zur Deutschen Kunstgeschichte), Strasbourg 1918.

Philippe 1971 J. Philippe, *Liège. Terre millénaire des arts*, Liège 1971.

Pijoan 1947 J. Pijoan, *Artis: Historia General del Arte*, 11, Madrid 1947.

Pinchart 1860 A. Pinchart, *Archives des Arts, Sciences et Lettres. Documents inédits*, 1ᵉ serie,1, Ghent 1860.

Pinder 1923 W. Pinder, Zum Problem der "Schönen Madonnen" um 1400, in *Jahrbuch der Preussischen Kunstsammlungen* 44 (1923), 148–170.

Pinder 1924 W. Pinder, *Die Deutsche Plastik vom ausgehenden Mittelalter bis zum Ende der Renaissance*, Berlin, 1 (1924); 2 (1929).

Plummer 1966 J. Plummer, *The Hours of Catherine of Cleves. Introduction and Commentaries*, London 1966.

Plummer and Clark 1982 J. Plummer and G. Clark, *The Last Flowering: French Painting in Manuscripts, 1420–1530, The Pierpont Morgan Library*, New York 1982.

Poumon 1967 E. Poumon, *Hainaut – La sculpture*, Vilvoorde 1967.

Poupeye 1912 C. Poupeye, Les jardins clos et leurs rapports avec la sculpture malinoise, in *Bulletin du Cercle Archéologique, Littéraire et Artistique de Malines* 22 (1912), 51–114.

Pradel 1947 P. Pradel, *La sculpture belge de la fin du Moyen-Age au Musée du Louvre*, Brussels 1947.

Proske 1951 B. Proske, *Castilian Sculpture: Gothic to Renaissance*, New York 1951.

Rademacher-Chorus 1972 H. Rademacher-Chorus, Ein geschnitztes Marienbild der Brabanter Spätgotik, in *Pantheon* 30 (1972), 373–382.

Randall 1985 R. Randall, *Masterpieces of Ivory from the Walters Art Gallery*, New York 1985.

Randall 1993 R. Randall, *The Golden Age of Ivory. Gothic Carvings in North America Collections*, New York 1993.

Recht 1987 R. Recht, *Nicolas de Leyde et la sculpture à Strasbourg (1460–1525)*, Strasbourg 1987.

Reiners 1943 H. Reiners, *Burgundisch-Alemannische Plastik*, Strasbourg 1943.

Reinke 1988 W. Reinke, *Dortmunder Kirchen des Mittelalters*, Dortmund 1988.

Ring 1922 G. Ring, Das Heilige Grab von Soignies, in *Zeitschrift für Bildende Kunst* 33 (1922), 36–41.

Ring 1923 G. Ring, Beiträge zur Plastik von Tournai im 15. Jahrhundert, in *Belgische Kunstdenkmäler*, P. Clemen (ed.), 1, Munich 1923, 269–291.

Ring 1979 G. Ring, *A Century of French Painting, 1400–1500*, London 1979.

Roggen 1934 D. Roggen, Hennequin de Marville en zijn atelier te Dijon, in *Gentse Bijdragen tot de Kunstgeschiedenis* 1 (1934), 173–213.

Roggen 1936 D. Roggen, Het beeldhouwwerk van het Mechelse Schepenhuis, in *Gentse Bijdragen tot de Kunstgeschiedenis* 3 (1936), 86–103.

Roggen 1938 D. Roggen, Gentsche Beeldhouwkunst der XIVde en de XVde eeuw, in *Gentse Bijdragen tot de Kunstgeschiedenis* 5 (1938), 51–73.

Roggen and Withof 1944 D. Roggen and J. Withof, Grondleggers en grootmeesters der Brabantsche gothiek, in *Gentse Bijdragen tot de Kunstgeschiedenis* 10 (1944), 83–209.

Rolland 1932a P. Rolland, *Les Primitifs tournaisiens, peintres et sculpteurs*, Brussels–Paris 1932.

Rolland 1932b P. Rolland, Une sculpture encore existante polychromée par Robert Campin, in *Belgisch Tijdschrift voor Oudheidkunde en Kunstgeschiedenis* 2 (1932), 335–345.

Rolland 1944 P. Rolland, *La sculpture tournaisienne*, Brussels 1944.

Rombouts and Van Lerius 1864–76 Ph. Rombouts and Th. van Lerius, *De Liggeren en andere historische archieven der Antwerpsche Sint-Lucasgilde*, Antwerp–The Hague 1864–76.

Roosval 1903 J. Roosval, *Schnitzaltäre in Schwedischen Kirchen und Museen aus der Werkstätt des Brüsseler Bildschnitzers Jan Borman*, Strasbourg 1903.

Rowe 1979 D. Rowe, *The First Ten Years. The Martin d'Arcy Gallery of Art, The Loyola University Museum of Medieval and Renaissance Art*, Chicago 1979.

Rudolf 1930 M. Rudolf, *Die erfurter Steinplastik des XV. Jahrhunderts* (Studien zur deutschen Kunstgeschichte, 276), Strasbourg 1930.

Rydbeck 1975 M. Rydbeck, *Medieval Wooden Sculpture in Sweden, The Museum Collection, 4–5, Museum National Antiquities*, Stockholm 1975.

Saint-Omer 1992 Musée Hôtel Sandelin. *Trésors des églises de l'arrondissement de Saint-Omer.*

Schädler 1969 A. Schädler, Beiträge zum Werk Hans Multschers, in *Anzeiger des Germanischen Nationalmuseums* (1969).

Schädler 1987 A. Schädler, *Die Fränkische Galerie, Zweigmuseum des Bayerischen Nationalmuseums. Veste, Rosenberg, Kronach*, Munich 1987.

Scher 1992 S. Scher, Bourges et Dijon: Observations sur les relations entre André Beauneveu, Jean de Cambrai et Claus Sluter, in *Actes des journées internationales Claus Sluter (sept. 1990)*, Dijon 1992, 277–293.

Schmidt 1970 G. Schmidt, Bemerkungen zur Königsgalerie der Kathedrale von Reims, in *Wiener Jahrbuch für Kunstgeschichte* 23 (1970), 108–153.

Schmidt 1972 G. Schmidt, Bemerkungen zur Königsgalerie der Kathedrale von Reims, in *Wiener Jahrbuch für Kunstgeschichte* 25 (1972), 96–106.

Schmidt 1977–8 G. Schmidt, Die Wiener "Herzogswerkstatt" und die Kunst Nordwesteuropas, in *Wiener Jahrbuch für Kunstgeschichte* 30–31 (1977–8), 179–206.

347

Schmidt 1977 G. Schmidt, Vesperbilder um 1400 und der "Meister der Schönen Madonnen", in *Österreichische Zeitschrift für Kunst und Denkmalpflege* 31 (1977), 94–114.

Schmidt 1978 G. Schmidt, Review of K. Clasen, Der Meister der Schönen Madonnen, in *Zeitschrift für Kunstgeschichte* 41 (1978), 61–92.

Schmidt 1986 G. Schmidt, Die Madonna von der Wiener Neustädter Wappenwand, in *Orient und Okzident im Spiegel der Kunst. Festschrift Heinrich Gerhard Franz zum 70. Geburtstag*, Graz 1986, 315–327.

Schmidt 1992 G. Schmidt, Jean de Marville: artiste suranné ou innovateur?, in *Actes des journées internationales Claus Sluter (sept. 1990)*, Dijon 1992, 295–304.

Schmitt 1966 G. Schmitt, La sculpture romane et la sculpture gothique, in *L'Art au Luxembourg*, 1, Luxemburg 1966, 391–569.

Schmoll gen. Eisenwerth 1958 J.A. Schmoll gen. Eisenwerth, Madonnen Niklaus Gerhaerts von Leyden, seines Kreises und seiner Nachfolge, in *Jahrbuch der Hamburger Kunstsammlungen* 3 (1958), 52–102.

Schmoll gen. Eisenwerth 1967 J.A. Schmoll gen. Eisenwerth, Marginalien zu Nicolaus Gerhaert von Leyden, in *Festschrift Karl Oettinger zum 60. Geburtstag …*, Erlangen 1967.

Schoenberger 1937 G. Schoenberger, Alabasterplastik, in *Reallexikon zur deutschen Kunstgeschichte* (1937), 297–299.

Schommers 1990 A. Schommers, Das Grabmal des Trierer Erzbischofs Jakob von Sierck († 1456). Deutung- und Rekonstruktionsversuch von Inschrift und Grabaufbau, in *Trierer Zeitschrift* 53 (1990), 311–333.

Schwarz 1986 M. Schwarz, *Höfische Skulptur im 14. Jahrhundert: Entwicklungsphasen und Vermittlungswege im Vorfeld des Weichen Stils*, Worms 1986.

Sint-Truiden 1985 Provinciaal Museum voor Religieuze Kunst, Begijnhof. *Religieuze kunst uit het oude landdecanaat Tongeren*.

Sint-Truiden 1990 Provinciaal Museum voor Religieuze Kunst, Begijnhof. *Laatgotische beeldsnijkunst uit Limburg en Grensland*.

Skubiszewski 1989 P. Skubiszewski, Le retable gothique sculpté: entre le dogme et l'univers humain, in *Le retable d'Issenheim et la sculpture au Nord des Alpes à la fin du Moyen-Age. Actes du colloque de Colmar (2–3 nov. 1987)*, Musée d'Unterlinden, Colmar 1989, 12–47.

Smeyers 1977 M. Smeyers, Het inwendig gebeeldhouwd decor van het Leuvense stadhuis, in *Arca Lovaniensis* 6 (1977), 257–349.

Soil de Moriamé 1912 E.J. Soil de Moriamé, Les anciennes industries d'art tournaisiennes à l'exposition de 1911, in *Annales de la Société d'Histoire et d'Archéologie de Tournai* 15 (1912), 67–96.

Soil de Moriamé 1923–41 E.J. Soil de Moriamé, *Inventaire des objets d'art et d'antiquité existant dans les édifices publics (du Hainaut)*, Charleroi, 1–10, 1923–41.

Sonkes 1969 M. Sonkes, *Dessins du XVᵉ siècle: Groupe van der Weyden. Essai de catalogue des originaux du maître, des copies et des dessins anonymes inspirés par son style* (Les Primitifs Flamands, 3, Contribution à l'étude des Primitifs Flamands, 5), Brussels 1969.

Stange 1936 A. Stange, *Deutsche Malerei der Gotik, 2, Die Zeit von 1350 bis 1400*, Berlin–Munich 1936.

Steinberg 1983 L. Steinberg, *The Sexuality of Christ in Renaissance Art and in Modern Oblivion*, New York 1983.

Steingräber 1969 E. Steingräber, Nachträge und Marginalien zur französisch-niederländischen Goldschmiedekunst des frühen 15. Jahrhunderts, in *Anzeiger des Germanischen Nationalmuseums* (1969), 29–39.

Steppe, Smeyers and Lauwereys 1973 J. Steppe, M. Smeyers and J. Lauwereys, *Wereld van vroomheid. Laatgotische koorbanken in Vlaanderen*, Kasterlee 1973.

Sterling 1974–80 Ch. Sterling, Le Maître de la Vue de Sainte-Gudule. Une enquête, in *Bulletin van de Koninklijke Musea voor Schone Kunsten van België* (1974–80), 9–27.

Sterling 1979 Ch. Sterling, La peinture sur panneau picarde et son rayonnement dans le nord de la France au XVᵉ siècle, in *Bulletin de la Société de l'Histoire de l'Art français* (1979), 6–45.

Sterling 1987 Ch. Sterling, *La peinture médiévale à Paris 1300–1500*, Paris 1987.

Steyaert 1974 J. Steyaert, *The Sculpture of St. Martin's in Halle and related Netherlandish Works*, Diss. University of Michigan, Ann Arbor 1974.

Steyaert 1981 J. Steyaert, Some Observations Concerning the Pieta from O.-L.-Vrouw van Ginderbuiten in Leuven, in *Archivium Artis Lovaniense. Bijdragen tot de geschiedenis van de kunst der Nederlanden opgedragen aan Prof. Em. Dr. J.K. Steppe*, Leuven 1981, 15–27.

Sveriges Kyrkor *Sveriges Kyrkor. Konsthistoriskt inventarium*, Närke, S. Curman and J. Roosval (ed.).

Swarzenski 1921 G. Swarzenski, Deutsche Alabasterplastik des 15. Jahrhunderts, in *Städel Jahrbuch* 1 (1921), 167–196.

Swillens 1948 P.T.A. Swillens, De Utrechtsche beeldhouwer Andraen van Wesel 1420–(na) 1489, in *Oud Holland* 63 (1948), nos. 1–6, 149–164.

Thieme and Becker 1913 U. Thieme and F. Becker, *Allgemeines Lexikon der bildenden Künstler von der Antike bis zur Gegenwart*, 8, Leipzig 1913.

Timmers 1949 J. Timmers, *Houten beelden*, Amsterdam–Antwerp 1949.

Tondreau 1965–7 L. Tondreau, Les bas-reliefs funéraires du XVᵉ siècle conservés dans l'arrondissement de Mons, in *Annales du Cercle Archéologique de Mons* 66 (1965–7), 1–76.

Tondreau 1973–5 L. Tondreau, Saint-Antoine-en-Barbefosse, in *Annales du Congrès Archéologique de Mons* 69 (1973–5), 205–212.

Tournai 1949 Halle aux Draps. *Exposition des arts religieux anciens et modernes*.

Tournai 1956 Halle aux Draps, Casino Communal, Musée d'Histoire et d'Archéologie, Musée des Beaux-Arts, *Scaldis*.

Tournai 1958 Cathedral. *Arts religieux*.

Tournai 1960 Cathedral. *La Madone dans l'art en Hainaut*.

Tournai 1964 Cathedral. *Hommage à Roger de le Pasture–Van der Weyden, 1464–1964*.

Tournai 1971 Cathedral. *Trésors sacrés*.

Tournai 1975 Cathedral. *Saints populaires dans le diocèse de Tournai*.

Trésor 1890 *Trésor de l'église Notre-Dame à Tongres*, Tongeren 1890.

Trier 1988 Bischöfliche Dom- und Diözesanmuseum. *Das neue Bischöfliche Dom- und Diözesanmuseum. Bildband zur Wiedereröffnung*, Trier 1988.

Troescher 1940 G. Troescher, *Die Burgundische Plastik des Ausgehenden Mittelalters*, Frankfurt 1940.

Tubize 1969 Musée de la Porte. J. de Borchgrave d'Altena, *Trésors d'art du Doyenné de Tubize*.

Uden 1992 Museum voor Religieuze Kunst. *Heilige Anna, grote Moeder. De cultus van de Heilige Moeder Anna en haar familie in de Nederlanden en aangrenzende streken*.

Utrecht 1990 Rijksmuseum het Catharijneconvent. E. Szmodis-Eszlry and S. Urbach, *Middeleeuwse Nederlandse Kunst uit Hongarije*.

Valenciennes 1987–8 Musée des Beaux-Arts. *Richesses des anciennes églises de Valenciennes*.

Valladolid 1988 Las Edades del Hombre. *El Arte en la Iglesia de Castilla y León*.

Vandenberghe 1984 St. Vandenberghe, *Gruuthusemuseum* (Musea Nostra), Bruges 1984.

Van der Haeghen 1898–9 V. van der Haeghen, *Mémoire sur les documents faux relatifs aux anciens peintres, sculpteurs et graveurs flamands*, Brussels 1898–9.

Van der Haeghen 1914 V. van der Haeghen, *Enquête sur les dalles, lames de cuivre et autres monuments funéraires provenant d'ateliers de tombiers gantois XIVᵉ–XVIᵉ siècle. Communication faite au XXIIIᵉ congrès de la Fédération archéologique et historique de Belgique (1913)*, Ghent 1914.

Van de Velde 1909 A. van de Velde, *Het ambacht van de timmerlieden en de schrijnwerkers te Brugge*, Ghent 1909.

Vandevivere 1972 I. Vandevivere, Un retable sculpté bruxellois du second tiers du XVᵉ siècle au Musée de la "Quinta das Cruzes" de Funchal, in *Revue des Archéologues et Historiens d'Art de Louvain* 5 (1972), 67–80.

Vandevivere and Asselberghs 1971 Tournai, Cathedral. I. Vandevivere and J.P. Asselberghs, *Tapisseries et laitons de chœur, XVᵉ et XVIᵉ siècles*.

Vandewalle 1976 A. Vandewalle, Het Brugs Stadhuis: 600 jaar geschiedenis, in *600 Jaar Brugs Stadhuis 1376–1976*, Bank Brussel Lambert, Bruges 1976, 7–18.

Van Driessche 1980 R. van Driessche, *De Sint-Pietersabdij te Gent. Archeologische en Kunsthistorische studie*, Maatschappij voor Geschiedenis en Oudheidkunde te Gent, Ghent 1980.

Van Duyse 1886 H. van Duyse, *Musée archéologique de la ville de Gand, Catalogue Descriptif*, Ghent 1886.

Van Eeckhoudt 1988 L. Eeckhoudt, *Het Drie-Maagdenretabel in de kerk van de Goddelijke Zaligmaker te Hakendover (Tienen) en Oost-Brabant* 1988.

Van Herck 1948 Ch. and L. van Herck, *Stad Antwerpen. Musea van Oudheden en Toegepaste Kunst, Steen, Vleeshuis, Brouwershuis, 2, Glasschildering, Beeldhouwwerk*, Deurne–Antwerp 1948.

Van Molle 1961 F. van Molle, Namaak van de koperen grafplaat van Griele van Ruwescuere († 1410), in *Bulletin van het Koninklijk Instituut voor het Kunstpatrimonium* 4 (1961), 117–179.

Vanroose 1970–1 M. Vanroose, *Enkele aspecten van de Brugse beeldhouwkunst tijdens de periode 1376–1467*, thesis Rijksuniversiteit Ghent, 1970–1.

Vanroose 1974 M. Vanroose, Twee onbekende 15de-eeuwse dokumenten in verband met de Brugse "beeldesniders", in *Handelingen van het Genootschap "Société d'Emulation" te Brugge* 90 (1973), Bruges 1974, 168–178.

Van Schoute 1963 R. van Schoute, *La Chapelle Royale de Grenade* (Les Primitifs Flamands 1, Corpus de la peinture des anciens Pays-Bas méridionaux au quinzième siècle, 6), Brussels 1963.

Van Spilbeeck 1883 Fr. W. van Spilbeeck, *De voormalige abdijkerk van Tongerloo en hare kunstschatten*, Antwerp 1883.

Van Vlijmen 1982 P. van Vlijmen, Pijpaarden plastiek vervaardiging en verspreiding, in *Vroomheid per dozijn*, Utrecht, Rijksmuseum het Catharijneconvent.

Venner 1989 G. Venner, *De grafmonumenten van de graven van Gelder*, Venlo 1989.

Verdier 1973 Ph. Verdier, Le reliquaire de la Sainte-Epine de Jean de Streda, in *Intuition und Kunstwissenschaft. Festschrift für Hanns Swarzenski*, Berlin 1913, 319–344.

Verhaegen 1962 N. Verhaegen, The Arenberg "Lamentation" in The Detroit Institute of Arts, in *The Art Quarterly* 25 (1962), no. 4, 295–312.

Verheyden 1943 P. Verheyden, Gebeeldhouwde kraagsteenen in Mechelsche huizen (14de–15de eeuw), Antwerp 1943. Reprint from *Mechelse Bijdragen*.

Vermeersch 1969 V. Vermeersch, *Gids Gruuthusemuseum*, Bruges 1969.

Vermeersch 1975 V. Vermeersch, Oorsprong van een Grafplaat met Schilddragende Engel uit de Koninklijke Musea voor Kunst en Geschiedenis, in *Bulletin des Musées Royaux d'Art et d'Histoire* 47 (1975), 173–190.

Vermeersch 1976 V. Vermeersch, *Grafmonumenten te Brugge voor 1578*, Bruges 1976.

Voegelen 1923 M. Voegelen, Die Gruppenaltäre in Schwäbisch Hall und ihre Beziehungen zur Niederländischen Kunst, in *Münchener Jahrbuch* 13 (1923), nos. 3–4, 121–160.

Vogelsang 1911 W. Vogelsang, *Die Holzskulptur in den Niederländen, 1, Das Erzbischöfliche Museum zu Utrecht*, Berlin–Utrecht 1911.

Voisin 1860 Voisin, Drames liturgiques à Tournai, in *Bulletin de la Société Historique et Littéraire de Tournai* 6 (1860), 261–291.

von Euw 1965 A. von Euw, Der Kalvarienberg im Schnütgen-Museums, in *Wallraf-Richartz-Jahrbuch* 27 (1965), 87–128.

von Euw 1968 A. von Euw, Eine Neuentdeckung zum Kalvarienberg im Schnütgen-Museum, in *Wallraf-Richartz-Jahrbuch* 30 (1968), 349–353.

von Nostitz 1978 C. E. von Nostitz, *Late Gothic Sculpture of Cologne*, Diss. New York University, 1978.

Weinberger 1940 M. Weinberger, A Bronze Bust by Hans Multscher, in *The Art Bulletin* 22 (1940), 185–189.

Weise 1925–30 G. Weise, *Spanische Plastik aus Sieben Jahrhunderten*, Reutlingen 1925–30.

Wentzel 1960 H. Wentzel, Die Marienklage aus Alabaster in Mergentheim, in *Jahrbuch der Berliner Museen* 2 (1960), 55–74.

Williamson 1988 P. Williamson, *Northern Gothic Sculpture*, Victoria and Albert Museum, London 1988.

Wixom 1970 W. Wixom, An Enthroned Madonna with the Writing Christ Child, in *The Bulletin of The Cleveland Museum of Art* (1970), 287–302.

Zanettacci 1954 K. Zanettacci, *Les Ateliers Picards de sculptures à la fin du Moyen-Age*, Paris 1954.

Ziegler 1992 J. Ziegler, *Sculpture of Compassion: The Pieta and the Beguines in the Southern Low Countries, c. 1300–c. 1600* (Belgisch Instituut te Rome. Studies over Kunstgeschiedenis, 6), Brussels–Rome 1992.

Zimmerman 1985 E. Zimmerman, *Die Mittelalterlichen Bildwerke in Holz, Stein, Ton und Bronze mit Ausgewählten Beispielen der Bauskulptur, Badisches Landesmuseum*, Karlsruhe 1985.

Zykan 1966 J. Zykan, Der Antwerpener Altar in der Wiener Votivkirche und seine Restaurierung, in *Österreichische Zeitschrift für Kunst und Denkmalpflege* 20 (1966), 129–146.

Index

Photographic Credits

Aachen, Anne Gold: Catalogue fig. 83a
Amsterdam, Rijksmuseumstichting: Brussels fig. 11; Catalogue no. 20
Antwerp, Felix Tirry: Catalogue nos. 25, 33, 68, 69, 70, 84, 105
Arras, Musée des Beaux-Arts: Catalogue no. 102
Arras, Leroy: Tournai fig. 12
Baltimore, Walters Art Gallery: Tournai figs. 31, 40; Catalogue fig. 35c
Barnard Castle, The Bowes Museum: Catalogue no. 29
Beauvais, Musée départemental de l'Oise: Catalogue no. 36
Berlin, Staatliche Museen: Catalogue figs. 59b, 104a
Brussels, Christian Carleer: Catalogue no. 3; figs. 3a, 3b
Brussels, Galerie De Bruyn: Catalogue fig. 8a
Brussels, Institut Royal du Patrimoine artistique (KIK/IRPA): Introduction figs. 1, 2, 3, 5, 7, 11, 12, 13; Tournai
 figs. 1, 2, 3, 4, 6, 7, 10, 13, 14, 15, 16, 19, 21, 23, 24, 25, 26, 28, 32, 34, 35, 36, 37, 38, 39, 42, 43, 44; Brussels
 figs. 1, 4, 6, 8, 12, 26, 30, 32, 35, 36, 37, 38, 39, 40, 41, 42, 43, 44, 45, 46, 47, 48, 50, 51; Catalogue nos. 15,
 31, 37, 47, 67, 73, 76, 85, 88, 89, 90, 91, 92; Catalogue figs. 5a, 6c, 7a, 9b, 9d, 10a, 10b, 11a, 12a, 12b, 13b,
 13c, 20d, 21b, 21d, 30c, 30e, 31a, 31b, 33a, 34a, 35d, 36b, 37a, 38c, 39a, 42a, 44a, 44b, 44c, 46a, 47a, 51a,
 58a, 66a, 67b, 71a, 74a, 74b, 74c, 75b, 75c, 79a, 86a, 86b, 90a, 90b, 96b, 96c, 98b,
Budapest, Szépmüvészeti Muzeum: Catalogue figs. 35b, 59c
Burgos, Deputación de Burgos: Brussels figs. 13, 21
Cleveland, Museum of Art: Catalogue fig. 96a
Cologne, Rheinisches Bildarchiv: Catalogue figs. 15b, 35a
Detroit, Institute of Arts: Catalogue fig. 9a
Dortmund, Museum für Kunst- und Kulturgeschichte: Brussels figs. 7, 9; Catalogue fig. 23b
Douai, Musée de la Chartreuse: Introduction fig. 9
Eindhoven, Korff en Van Mierlo: Catalogue no. 23
Funchal, Museu Quinta dos Cruzes: Brussels fig. 20
Ghent, Bart Cloet: Tournai fig. 20; Catalogue nos. 1, 4, 5, 6, 8, 9, 11, 14, 16, 17, 19, 21, 24, 30, 31, 34, 35, 38,
 39, 40, 42, 43, 44, 45, 46, 49, 54, 55, 56, 57, 58, 65, 66, 74, 75, 77, 78, 82, 93, 94, 96, 97, 98, 99, 103, 104
Ghent, Monique Tahon-Vanroose: Catalogue fig. 45a
Ghent, Marhilde Wiels: Introduction figs. 4, 8 10; Tournai fig. 41; Brussels fig. 16; Catalogue nos. 7, 10, 12, 13,
 26, 27, 50, 87, 100, 101; figs. 6a, 6b, 38b, 88a
Ghent, Oudheidkundige Musea: Catalogue nos. 48, 51, 52, 53
Laredo, E. Campuzano Ruíz: Brussels figs. 22, 23, 25, 27, 28, 31, 33, 34
London, Sotheby's: Catalogue figs. 13d, 76a, 76b
Lille, Girondal: Catalogue fig. 103b
Lille, Musée des Beaux-Arts: Catalogue nos. 28, 59, 60, 61, 63, 95; fig. 58d
London, Victoria and Albert Museum: Catalogue fig. 67a
Madrid, Museo del Prado: Catalogue no. 41
Marburg, Bildarchiv: Brussels fig. 2; Catalogue figs. 35e, 35f, 36a, 66c, 88b
Minneapolis, John Steyaert: Introduction fig. 11; Tournai figs. 9, 18, 27, 29, 30, 38; Brussels figs. 3, 5, 15, 17, 48;
 Catalogue nos. 13 (detail), 14 (side view), 16 (detail), 21 (from below), 38 (side view), 41A–D (details), 42
 (detail), 43 (detail), 43 (side view), 44 (side view), 80 (three details), 83 (side view); figs. 9a, 10c, 13d, 13a,
 15a, 21b, 21c, 21d, 23a, 30d, 43a, 54a, 56b, 58c, 60a, 63a, 69a, 73a, 75c, 95d, 98c, 101b, 101c, 101d
Munich, Bayerisches Nationalmuseum: Catalogue fig. 102a
Nancy, Musée Historique Lorrain: Catalogue no. 32
New York, Metropolitan Museum of Art: Brussels fig. 10; Catalogue figs. 32b, 57a, 95b
Paris, Caisse nationale de Monuments historiques: Catalogue fig. 55a
Paris, Gérard Dufrêne: Catalogue no. 62
Paris, Réunion des Musées nationaux: Tournai figs. 17, 65a, 65b
Rouen, Elben: Catalogue fig. 27b
Hans Sibbelee: Catalogue fig. 79c
Sint-Truiden, Provinciaal Museum voor Religieuze Kunst: Catalogue no. 72
Stockholm, Antikvarisk-Topografiska-Arkivet: Brussels fig. 49
Stockholm, Statens Kunstmuseet: Brussels fig. 29
Stuttgart, Württembergisches Landesmuseum: Brussels figs. 17, 18, 19; Catalogue fig. 17a
Tournai, Jules Messiaen: Tournai fig. 33
Trier, Basilika St. Matthias: Catalogue no. 83
Troyes, Françoise Monsallier: Catalogue no. 22
Utrecht, Centraal Museum: Catalogue fig. 89a
Utrecht, Ruben de Heer: Catalogue nos. 79, 80, 81, 84, 86; fig. 32c
Valenciennes, Musée des Beaux-Arts: Catalogue no. 71; fig. 66b
Valenciennes, C. Theriez: Catalogue no. 64
Vienna, Dom- und Diözesanmuseum: Catalogue fig. 33b
Württemberg, Landesbildstelle: Catalogue fig. 32a